The Byzantine Eye:
Studies in Art and Patronage

Photograph: The Observer

Robin Cormack

The Byzantine Eye:
Studies in Art and Patronage

VARIORUM REPRINTS
London 1989

British Library CIP data Cormack, Robin
The Byzantine eye: studies in art and
patronage. — (Collected studies series;
CS296)
1. Byzantine visual arts
I. Title
709'.02

ISBN 0-86078-244-1

Copyright © 1989 by Variorum Reprints

Published in Great Britain by Variorum Reprints
20 Pembridge Mews London W11 3EQ

Printed in Great Britain by Galliard (Printers) Ltd
Great Yarmouth Norfolk

VARIORUM REPRINT CS296

CONTENTS

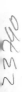

This volume contains xii + 348 pages.

PUBLISHER'S NOTE

The articles in this volume, as in all others in the Collected Studies Series, have not been given a new, continuous pagination. In order to avoid confusion, and to facilitate their use where these same studies have been referred to elsewhere, the original pagination has been maintained wherever possible.

Each article has been given a Roman number in order of appearance, as listed in the Contents. This number is repeated on each page and quoted in the index entries.

The illustrations accompanying Studies I, II, III, IV, V, VI and VIII have been gathered together in the section of plates at the end of the volume. Each plate is marked with the Roman number of the study to which it relates.

PREFACE

"Art-history is deeply infected with positivism, and central to positivism are the overestimation of fact, the rejection of cause, and the failure to grasp the centrality of explanation. Positivism is a pernicious disease, and in particular it ravages those who did not gain immunity through close contact with it at some early moment in their lives"

R. Wollheim, *Painting as an Art*, (London, 1987), p. 9.

These studies first appeared between 1967 and 1986. Together they show a number of recurrent themes and common interests. But they also document a changing approach to the analysis of works of art. The later papers increasingly question the positivist approach of traditional art history. But it will be clear to the reader that, if I can now claim some "immunity" from positivism, this is due (in the words of Wollheim) to "close contact with it" in past years.

When I entered art history (as a graduate student at the Courtauld Institute of Art in 1962), the subject was characterized by its empiricism and by its single-minded pursuit of a body of knowledge. It was essentially antiquarian. But, at the same time, it was impossible not to admire the practitioners, and to enjoy the common discourse of chronologies and attributions which united all the periods of European art, despite the different historical circumstances within which this art was produced and originally viewed. Common to all fields was a confidence in the explanatory powers of stylistic analysis, and a belief that a skill in handling style would lead both to the formulation of questions and to answers. Under the influence of scholars such as E.H. Gombrich, it was seen not only that style had a history, but supposed that change in history could be identified through the close description of style.

I have had to learn that to focus on style is not to find a conjuror's hat from which interesting questions emerge ready made. This is particularly clear for the student of early Christian and Byzantine art, where, in fact, "style" *conceals* rather than *reveals* the problems. Early Christian art can seem to be a continuation of pagan art; but similarities in style obscure the momentous changes

which occurred in religion and thought in Late Antiquity. And in the search for "renaissances" of the classical ideal, the historian of style has constructed "periods" in Byzantine art, which may give an altogether misleading framework of its development and functions. Even the ambiguities in the terms of analysis are insufficiently recognised ambiguities; so, only recently, does Wollheim's distinction between individual style and general style at least open up a clear differentiation between the search for hands through stylistic analysis and the analysis of forms of expression in common between works of art.

In the earlier papers in this collection, questions of style lead the argument. In the essay on Cappadocia (Study VI), the wallpaintings of Cappadocia are used as evidence for the art of Constantinople in the period after Iconoclasm. A connection is assumed to exist (despite the distance between the two places) through the indications of style. The Cappadocian material is handled less for its own sake than for supposed more central questions located in the capital of the Empire. Underlying the paper is a sense that Byzantine art was primarily the art of Constantinople; or rather the "highest quality" art of Constantinople. This bias towards the Great Artist, or, in the case of supposedly anonymous medieval art, towards Great Art, was certainly a feature of the 1960s; and it had a surreptitious influence not only on what was studied, but also on what was not studied. Within Byzantine art, Cappadocia was literally a fringe subject. Perhaps my approach gave Cappadocian art respectability by domesticating it within the art of Constantinople (even in the case of Tokalı kilise locating it within the canon of tenth-century Constantinopolitan manuscripts). I doubt now that this is the most fruitful way to approach such a rich amount of material, located within a social and historical setting that can be explored independently of the capital.

Two monuments in Thessaloniki are prominent in this collection. I chose to centre my Ph.D. thesis on the church of St Sophia, with the aim of using its decoration as a paradigm of the "revival" of figurative art after Iconoclasm. In the event my treatment was more archeological than I had anticipated; and the small amount of surviving material from Thessaloniki in the eighth and ninth centuries meant that the deductions were necessarily limited. I now see that the more fundamental issue is the very nature of revival or "renaissance", which needs to be seen as a conceptual problem in its own right (as in Study X). Even so the study of Thessaloniki continues to be dominated by archeological considerations. The dating of the various decorations and the structural changes in St Sophia are still under debate; so are the precise date of the building of St Demetrios and the character of the changes made to that church in the course of its history. These debates necessarily involve questions of the character of Thessaloniki as a city and of the forms which Christian cult and ritual took there.

Studies I and II on St Demetrios set out the visual material for the study of the church which I published from the papers of the British School of Archaeology. I have focussed on the relevance of these to the history of the church before Iconoclasm. Studies III and IV set out the basic material which can be used in the study of surviving art from the period of Iconoclasm and the century immediately following it. Study V sets out the problems of dating the mosaics and wallpaintings from St Sophia at Thessaloniki, treating the material as belonging to the eight, ninth and eleventh centuries. Study VI covers material from Cappadocia from the same period. Study VII takes a broader view of the city of Thessaloniki over a longer period and by a comparison with the city of Caria (Aphrodisias) in Asia Minor.

The final three Studies (VIII, IX and X) represent a move away from an empirical approach towards the broader issues of cultural history. They attempt to integrate the evidence of the visual material into the important *historical* questions of the period. They attempt, that is, to locate art history within history — rather than as a marginal subject, concerned with its own private problems of dating and attribution. This involves a change of aim rather than (necessarily) a change in the details of method. So, for example, Study VIII remains openly reductionist — an approach specifically criticized in Study X.

The material included in this volume represents the work that we still perceive as the "quality" production of Byzantium. Its Byzantine audience was wide enough, but its producers were almost certainly located among a limited network of artists and élite patrons in a small society. But I hope, particularly in the later pieces, to have indicated that the way towards an understanding of this culture is not to attempt to enter into the "minds" and "intentions" of these producers and patrons. It is rather to face the more complicated, but the same time more challenging, question of the perception and meaning of visual images among a much wider group — the role, that is, of the society that viewed, as much as the few who produced.

At the end of the papers I have added a short section of comment. The purpose of these additions is not to give a complete bibliography of the material which has appeared since writing, though some additional bibliography is included. They are more by way of critical reaction to the pieces in retrospect.

ROBIN CORMACK

Cambridge
August 1988

I

THE MOSAIC DECORATION OF S. DEMETRIOS, THESSALONIKI

A RE-EXAMINATION IN THE LIGHT OF THE DRAWINGS OF W. S. GEORGE

THE important mosaics in the north inner aisle of the Church of S. Demetrios were largely destroyed in the fire of 1917. They had been unrecorded until ten years previously when their covering of Turkish plaster was removed.

On 1 August 1907, the Turkish authorities set under way major repairs of the Casimir Çamii (Κασιμιὲ Τζαμισί) in Thessaloniki, at that time a somewhat dilapidated building which had been last renovated in 1841.[1] Operations were completed by June 1908. The name of the mosque did not conceal its original dedication as the Byzantine church of S. Demetrios, which had been one of the most famous centres of pilgrimage for Orthodox Christians until its Muslim conversion in 1492–3.[2] In the course of these repairs occurred the unexpected discovery of surviving Christian mosaics and wall-paintings under a coating of plaster. The first mosaics were revealed in December 1907, and comprised three bust figures within medallions, situated in the central part of the north inner aisle (PLATES 1a, 15a).[3] The discovery was greeted with excitement by P. N. Papageorgiou, who took photographs which he communicated to the Turkish Nomarch and the Oecumenical Patriarch. The news was published in ecclesiastical news-sheets in Thessaloniki (December 1907) and Istanbul (26 January 1908). Meanwhile further soundings and discoveries continued in the mosque.

The fortuitous discovery of these surviving mosaics and wall-paintings and its speedy announcement in Turkey coincided with a period of energetic activity in the Eastern Mediterranean among several groups of Byzantine specialists. Their aim was exploration, recording, and publication of monuments.[4] The first of these scholars to arrive in Thessaloniki were members of the Russian Archaeological Institute in Constantinople, whose director T. E. Uspenskij came at the end of February 1908. He arranged for the photographer and painter of the Institute, N. K. Kluge, to expose fifteen photographic plates and to record in five paintings some details.[5] To Uspenskij's chagrin, the repairs to the building were virtually

I am grateful to the Management Committee of the British School at Athens for allowing me to publish this set of drawings.

[1] P. N. Papageorgiou, 'Μνημεῖα τῆς ἐν Θεσσαλονίκῃ λατρείας τοῦ μεγαλομάρτυρος ἁγίου Δημητρίου', *Byzantinische Zeitschrift* xvii (1908) 321–81 (afterwards cited as Papageorgiou (1908)). An account of the building previous to 1907 is supplied by C. Texier and R. P. Pullan, *Byzantine Architecture* (London, 1864) 123–30.

[2] The Turkish record in the form Hegira 898 was already known by Texier and Pullan; various transcriptions are on offer in the literature.

[3] For plans of the church see G. and M. Soteriou, Ἡ Βασιλικὴ τοῦ Ἁγίου Δημητρίου Θεσσαλονίκης (Athens, 1952), afterwards cited as G. and M. Soteriou (1952).

[4] The value of the activities of Strzygowski, Millet, van Millingen, and Mordtmann has long been recognized. C. Mango, in his editor's preface to D. V. Ainalov, *The Hellenistic Origins of Byzantine Art* (New Brunswick, N.J., 1961), pays tribute to the fundamental contribution of Russian specialists in this field. The work sponsored by the Byzantine Research Fund of the British School at Athens, of which the material published in this paper is only one example, belongs to this period of research.

[5] The expedition is recorded in the Report of the Institute's activities in 1908 in the *Извѣстія Русскаго Археологическаго Института въ Константинополѣ* xiv (1909) 169–71. Their visual record appears as plates 1–20 of this periodical. The results of their observations were published in two papers in the same tome: T. E. Uspenskij, 'О вновь открытыхъ мозаикахъ въ церкви св. Дими-

completed—work in the apse and on the roof was finished, and the scaffolding already taken down. He was able to see the mosaics and wall-paintings on the north inner aisle arcades, a painted panel of Joasaph, four mosaic panels on the sanctuary piers, and the mosaic panel on the west wall of the south inner aisle.

The restoration of the mosque was completed by plastering over the wall-paintings, but the mosaics were left exposed to view. Papageorgiou rapidly published the finds, blending his scholarly commentary with impetuous enthusiasm, and illustrating his article with a murky set of photographs.[6] The publications of Uspenskij and Kluge were more professional in appearance, with good illustrations. Uspenskij attempted a chronology, and set the iconography of the mosaics within the historical context defined by the *Miracula Sancti Demetrii*. Kluge gave a concise report on the condition, materials, and colours of the mosaics.

By the spring of 1909 these discoveries in S. Demetrios had reached specialist circles in Europe. The French scholar Diehl decided to accompany le Tourneau to Thessaloniki during that summer. The latter had already spent some seasons assisting in Turkish maintenance work on monuments there, notably the Ayasofya Mosque,[7] but he had not been present at the time of the S. Demetrios discoveries. Le Tourneau painted his impressions of three mosaics, only one of which, the enthroned Virgin between angels, belonged to the series on the north inner aisle arcade.[8] His rendering of the others is not distinguished by close attention to the laying of tesserae or to their actual colours. The French publication was also illustrated by photographs, and one suspects that, as in the case of the S. Sophia mosaics,[9] Diehl relied excessively on these, rather than on his first-hand observations. Nevertheless their description and critical discussion of the mosaics is of value, and supplements the previous accounts, for instance by the mention of the decorative mosaics of the arch soffits. Diehl and Tafrali, another contributor at this period,[10] knew the two pioneering publications, and were critical of the chronological proposals offered in them. Tafrali aimed to set the finds within a coherent account of the history of the church derived from the *Miracula* text.

There was little more publication based on first-hand observation. A few photographs were taken in 1913, soon after the restoration to Christian use, by Boissonnas,[11] but in these difficult years the building failed to stimulate any further archaeological exploration before the fire of August 1917. In the course of this fire, the north arcade collapsed and only a few fragments of mosaic could be recovered.

All accounts subsequent to 1917 which have treated the north inner aisle mosaics or compared these with other works (including the fresh finds in S. Demetrios after 1917), have derived

трія въ Солуни', 1–61, afterwards cited as Uspenskij (1909); and N. K. Kluge, 'Техника мозаичной работы въ церкви св. Димитрія въ Солуни', 62–7, afterwards cited as Kluge (1909).

[6] Papageorgiou (1908). His transcriptions were not free from errors (e.g. Κώστας for κτίστας).

[7] For an account of this restoration work and of problems connected with S. Sophia, see my Ph.D. thesis, *Ninth Century Monumental Painting and Mosaic in Thessaloniki* (University of London, 1968).

[8] C. Diehl and M. le Tourneau, 'Les Mosaiques de Saint-Démétrius de Salonique', *Monuments et Mémoires (Fondation Piot)* xviii (1910) 225–47, afterwards cited as Diehl (1910). This account formed the basis for the section in C. Diehl, M. le Tourneau, and H. Saladin *Les Monuments Chrétiens de Salonique* (Paris, 1918), and afterwards cited as Diehl (1918)

[9] M. le Tourneau and C. Diehl, 'Les Mosaïques de Sainte-Sophie de Salonique', *Monuments et Mémoires (Fondation Piot)* xvi (1908–9) 39–60. Diehl is responsible for the notion of a chronological division between the peripheral figures and mandorla group in the cupola, rejected by all critical observers.

[10] O. Tafrali, 'Sur la date de l'église et des mosaïques de Saint-Démétrius de Salonique', *Revue Archéologique*, 4th series, xiii (1909) 83–101, afterwards cited as Tafrali (1909); and O. Tafrali, 'Sur les réparations faites au viiᵉ siècle à l'église de Saint-Démétrius de Salonique', ibid., 4th series, xiv (1909) 380–6.

[11] F. Boissonnas, *Salonique et ses Basiliques*, avec une introduction de D. Baud-Bovy (Geneva, 1919), afterwards cited as Boissonnas (1919).

their information from these early publications.[12] In recent years, however, the existence of an unpublished record of the north inner aisle mosaics has become known. G. and M. Soteriou (1952), for example, curtailed their discussion of these mosaics pending the publication of a set of coloured drawings of them commissioned by the Byzantine Research Fund, which had passed into the possession of the British School of Archaeology at Athens. Slides of this collection were shown to delegates at the International Congress of Byzantine Studies at Thessaloniki, 1953.[13] Subsequently, publication of this material has been expected.[14] It is the object of this paper to make this material available, and to assess its value. Mention should be made of one previous treatment of this material: in his Manual, published in 1911, O. M. Dalton did actually derive his description of the mosaics from these drawings. He even published two of them, though in the event both of the mosaics survived the fire. The unique value of Dalton's account seems generally to have escaped the notice of art historians.[15]

THE DRAWINGS

The drawings owned by the British School are at present stored among other papers in the Photographic Library of the Warburg Institute in London. The material consists of eighteen numbered sheets, and all are the work of Walter S. George. There is a note to the effect that a special donation was made under the auspices of the Byzantine Research and Publication Fund (formed in 1908 under the presidentship of E. Freshfield in association with the British School at Athens) by John, the fourth Marquess of Bute, in order to enable W. S. George to go to Thessaloniki and make this set of coloured drawings. The eighteen sheets were received on 1 September 1909, presumably by one of the two secretaries of the Fund. One of these, O. M. Dalton, was at that time Assistant Keeper in the British Museum. The other, R. W. S. Weir, ultimately became the trustee for the whole collection and in his will (1951) handed it over to the British School. In this year, the collection was found to be stored in the British Museum (Department of Greek and Roman Antiquities), and possibly this had been its permanent home since 1909. In 1960, the collection was transferred to the Warburg Institute.

The Annual Reports of the British School divulge the information that W. S. George, a student of the Royal Institute of British Architects and Soane Medallist, joined the School in 1906–7, and went to Thessaloniki to participate in a project to publish a corpus of its monuments. His name appears frequently in reports until the war in 1914 stopped activities, and much material was left unpublished.[16] He died on 7 January 1962. The accuracy of his recording is complimented in these reports. Indeed he left a record of his abilities of recording and analysis

[12] The lack of records is lamented by A. Grabar, *Martyrium* (Paris, 1946) vol. 2, 87 n. 2. This study relies mainly on the Russian material (afterwards cited as Grabar (1946)). A. Grabar, *L'Iconoclasme byzantin* (Paris, 1957) 84 ff. submits the same material to a further scrutiny; afterwards cited as Grabar (1957). The Russian material was partly reprinted by N. P. Kondakov, *Иконографія Богоматери,* vol. 2 (Petrograd, 1915); and used also by R. F. Hoddinott, *Early Byzantine Churches in Macedonia and Southern Serbia* (London, 1963); afterwards cited as Hoddinott (1963). V. N. Lazarev, *История византийской живописи* (Moscow, 1947) selected his illustrations from both the Russian and French collections.

[13] D. Talbot Rice, 'The lost mosaics of St. Demetrios, Salonica' Πεπραγμένα τοῦ Θ' Διεθνοῦς Βυζαντινολογικοῦ Συνεδρίου, vol. 1 (Athens, 1955) 474. A detail of the set was photographed to assist the research of N. Theotoka,

'Περὶ τῶν κιβωρίων τοῦ ἁγίου Δημητρίου Θεσσαλονίκης καὶ Κωνσταντινοπόλεως', Μακεδονικά ii (1953) 395–413. The Byzantine Research Fund collection also includes photographs taken in S. Demetrios by W. M. Harvey before 1917 (PLATE 15).

[14] E. Kitzinger, 'Byzantine Art in the period between Justinian and Iconoclasm', *Berichte zum XI Internationalen Byzantinisten-Kongress* (Munich, 1958) 20 and n. 74. Afterwards cited as Kitzinger (1958).

[15] O. M. Dalton, *Byzantine Art and Archaeology* (Oxford, 1911) 378–82, and figs. 198 and 224. Afterwards cited as Dalton (1911).

[16] A plan was drawn up in 1933 for a joint English–Greek corpus on the churches of Thessaloniki, and work was begun by A. H. S. Megaw and others. G. and M. Soteriou (1952) incorporated some of the survey material into their monograph.

in a fundamental monograph on S. Eirene.[17] It can be deduced that he made this set of drawings in the summer season of 1909 before he went on to Istanbul to carry out his survey on S. Eirene, and this is confirmed by Dalton (1911). His record was therefore made in the same year as that of le Tourneau.

All these sheets are loose folios, and refer to the mosaics of S. Demetrios. The numbers are those written on the sheets.

1–4. Four sheets (standard size 14 × 18 in.) Consecutive series of water-colour copies (scale 1 in. to 1 ft.) of the north inner aisle mosaics, ordered from left (west) to right (east). PLATES 2–5; 6–9 (colour).

5. Water-colour copy (scale 1 in. to 1 ft.) of panel on east face of narthex wall at the west end of the south inner aisle (S. Demetrios and Donors).

6. Two water-colour copies (scale 1½ in. to 1 ft.) of the two panels on the right pier flanking the entrance to the chancel at the south-east corner of the nave (S. Demetrios and Founders on north face, and S. Sergios on west face).

7. Two water-colour copies (scale 1½ in. to 1 ft.) of the two panels on the left pier flanking the entrance to the chancel at the north-east corner of the nave (saint with two children on west face, and Virgin with saint on south face).

8. Full-size water-colour copy of head of S. Demetrios. Annotated 'no. 8 ref. to no. 4'. It is therefore a detail of head of saint incorporated in sheet 4 (north inner aisle mosaics). PLATE 11a (colour).

9. Full-size water-colour of a head of a Founder. Annotated 'no. 9 ref. to no. 6'. It is therefore a detail of the head of the secular Founder on the right of S. Demetrios on the right pier panel.

10. Coloured squeeze of an inscription in mosaic. Annotated 'no. 10 ref. to no. 1'. It is therefore a detail from sheet 1 (north inner aisle mosaics). PLATE 12a.

11. Also labelled E. Coloured squeeze of an inscription in mosaic. Annotated 'no. 11 ref. to no. 3'. It is therefore a detail from sheet 3 (north inner aisle mosaics). PLATE 13a.

12. Also labelled D. A coloured squeeze of an inscription in mosaic. Annotated 'no. 12 ref. to no. 4'. It is therefore a detail from sheet 4 (north inner aisle mosaics). PLATE 13b.

13. Also labelled C. A coloured squeeze of an inscription and donor's head in mosaic. Annotated 'no. 13 ref. to no. 4'. It is therefore a detail from sheet 4 (north inner aisle mosaics). PLATE 11b (colour).

14. Two coloured squeezes (mounted) of the left and right section of a mosaic halo, including the saint's name. Annotated 'no. 14 ref. to no. 4'. It is therefore a detail from sheet 4 (north inner aisle mosaics). PLATE 14a.

15. Black water-colour tracing of an inscription in mosaic. Annotated 'no. 15 ref. to no. 7'. It is therefore a detail of sheet 7, and may be identified as the prayer on the scroll held by the Virgin in the panel on the south face of the left pier.

16. Black water-colour tracing of an inscription in mosaic. Annotated 'no. 16 ref. to no. 7'. It is therefore a detail of sheet 7, and may be identified as the inscription running below the panel of the Virgin with saint on south face of the left pier. PLATE 14b.

17. Black water-colour tracing of an inscription in mosaic. Annotated 'no. 17 ref. to no. 6'. It is therefore a detail of sheet 6, and may be identified as the two-line founder inscription below the panel on the north face of the right pier.

18. Coloured squeeze of a saint's name in a halo (right side). Annotated 'no. 18 ref. to no. 2'. It is therefore a detail of sheet 2 (north inner aisle mosaics). PLATE 12b.

A total of eleven sheets is concerned with the north inner aisle mosaics. The value of the remainder is limited to a record of the state of the mosaics soon after their uncovering,[18] except

[17] W. S. George, The Church of Saint Eirene at Constantinople (Oxford, 1912). For an appreciation of the accuracy of this survey, see J. B. Ward Perkins in The Great Palace of the Byzantine Emperors, Second Report, edited by D. Talbot Rice (Edinburgh, 1958) 73.

[18] For example, the two panels on the left pier. Sheet 16 is a complete tracing of the inscription below the south face. It begins with an area of loss followed by broken letters (PLATE 14b). The distance between the left end of the panel and the alpha of ἀνθρώποις was 6¾ in. (17 cm.). Uspenskij (1909) restored this as [Δῶρ] ον after considering [Δόμ]ον. G. and M. Soteriou (1952) 195 give ['Ο ἐν]. Neither solution appears satisfactory. The inscription reads: [...]ον ἀνθρόποις ἀπελπ[ισ]θείς παρά δὲ τῆς σῆ(ς) δυνάμεως ζωοποιηθὶς εὐχαριστῶν ἀνεθέμην. The proper name Κλήμης given by G. and M. Soteriou (1952) 195, did not appear in 1909. The palaeographical evidence in this church still awaits treatment. For example, the similarities of this inscription with the forms exhibited on the founder's panel facing it on the right pier require assessment to test the hypothesis that stylistically this Virgin panel is homogeneous with phase two mosaics. Cf. Hoddinott (1963) 154–5; to whose arguments might be added the use of the lotus ornament of the architrave in this panel, which appears in the ornamental mosaics of the north inner aisles; and the comb-like hatching on the saint's arm in this panel, which recurs on the saint's arms on the east panel of this pier.

Concerning this east panel, George's record confirms that no inscription was preserved to identify the saint. G. and M. Soteriou (1952) 194–5 identified him as S. Demetrios, but Kitzinger (1958) suggested S. Bacchos, as a pendant to S. Sergios on the right pier. P. A. Underwood, 'The Frescoes in the Kariye Çamii', Dumbarton Oaks Papers xiii (1959) 189 n. 9, rejects both identifications and proposes that this type represents S. George. If this is correct, the three panels of the left pier may be the trio of warrior saints, George (west), Theodore (south), and Demetrios (east).

that for our purposes these sheets offer a control for checking against still surviving mosaics George's accuracy of recording. In this respect, the indications are encouraging. Sheet no. 9, for example, allows us to compare a full-size water-colour[19] of the head of the Founder with sceptre and mappa (to the right of S. Demetrios on the right pier) with the original. The copy corresponds in all aspects with a detailed description made from the ground, and adds certain subtle distinctions of colours only recognizable from close to, such as variations of pink tesserae, some of which appear simply as white from the ground.[20] The scale water-colours of the pier panels are likewise faithful, although the diminution in size does naturally cause some apparent over-saturation of colour values. In only one case is a significant loss of information apparent; sheet no. 5 in recording the south aisle panel does not render gold or silver areas as such, but employs yellow or off-white.[21] It appears that George generally confined the use of gold and silver in his record to the full-size copies or 1½-in. scale sheets. This must be remembered in interpreting the 1-inch scale sheets of the north inner aisle mosaics.

THE ARCHITECTURAL SETTING AND THE TWO PHASES OF MOSAIC

In type, the church of S. Demetrios was a cross-transept basilica, with a nave and four aisles, surmounted by a timber roof. As it stood in 1909, the area of the church to the north of the nave was divided into two aisles by a colonnaded arcade, supporting a low gallery over the outer aisle. A second order of columns was continued above to carry out the double function of supporting a higher gallery over the inner aisle and the roofing system. The surface of this lateral arcade, visible from the interior of the church (PLATE 1a–b), had been decorated with mosaics.[22] The complete length of this arcade was, according to George's measurements, approximately 106 ft., which corresponds with the improbable measurement already given by Texier and Pullan as 106·549 ft.[23] The twelve intervals of the arcade varied slightly in size, since the visual device of slightly broadening each span towards the east was employed. The variation was from approximately 6¾ ft. to 8¼ ft., measured by George (between columns), although the final span at the east end was excessively out of scale at 9¾ ft. and was possibly not original. The average height of each arch from the pavement was 13¾ ft. Along the surfaces of the arcade, the area available for mosaic decoration has a height of from a maximum of about 7 ft. over the spandrels down to about 4 ft. above the apex of the arches.

The mosaicists who worked on this surface had to take into account certain physical facts; for example, the relatively small dimensions involved would have limited the possible size of figures represented, and the lowness of the arcade would automatically have tended to involve a spectator in an intimate setting. As for the lighting of this surface, while accretions to the building had inevitably darkened this section, yet it must always have been relatively dark, lacking direct light. Most light would have penetrated from the south, out of the nave of the church.

[19] Sheet 9 published in black and white by Dalton (1911), fig. 198.

[20] Description by P. J. Nordhagen, 'The Mosaics of John VII (705–707 A.D.), *Acta ad Archaeologiam et artium historiam pertinentia* ii (1965) 121–66, esp. 158–9. Afterwards cited as Nordhagen (1965). Nordhagen apparently underestimates the significant proportion of green tesserae in the beard. The predominant colour in the neutral flesh parts of the face is buff. The possibility of fading since 1909 must be reckoned with.

[21] Sheet 5 published in black and white by Dalton (1911), fig. 224.

[22] R. Krautheimer, *Early Christian and Byzantine Architecture* (London, 1965) pl. 32, reproduces Boissonnas (1919) pl. 27, of the north side of the church (taken in 1913).

[23] C. Texier and R. P. Pullan, *Byzantine Architecture* (London, 1864) 123–30.

Papageorgiou (1908) expressed surprise that the colonnade was still standing in his time and had not succumbed to earthquake shocks, for the columns were leaning dangerously towards the east, while the arcade was inclined outwards towards the north. This movement had at some time been treated by use of tie rods. Lack of maintenance had allowed the mosaic to deteriorate, but the period during which the losses were sustained is unknown.

Any study of the mosaics of S. Demetrios must exploit the mosaic inscription referring to a fire and the consequent restoration of the church. This is without doubt the fire described in the *Miracula*, datable to the seventh century (see below). The severe nature of the fire, despite its brief duration, is made evident by the text. It describes the despair of one of the clergy of the church of obtaining workmen (ἐργάται) or money (χρῆμα) for a restoration (κατασκευή), though in the event his pessimism was unjustified.[24]

Kitzinger (1958) characterizes the two main groups of mosaics, those made before and those made after the fire. Probably the surface area of mosaic decoration was extended after the fire, for although only the south part of the church was severely damaged,[25] yet a fresh set of mosaics is found on the two flanking piers of the chancel. Apparently the opportunity was taken after the fire to strip these piers of marble revetment and to replace it with mosaic. A predilection for setting icons low down and close to the main liturgical region in a church was seen by Kitzinger (1958) as an innovation characteristic of this period.

This division of the mosaics into two groups is necessary for the study of the north inner aisle mosaics. Here we find, not the addition of discrete new panels, but a disjunction across the surface into two separate phases, one of which is specifically connected by its inscription with the restoration work. In his description, Kluge (1909) distinguished the two component phases, but unfortunately his observations cannot be coherently followed on the illustrations. Diehl ignored both Kluge's observations and the indications of the mosaics themselves which he had seen. He stated that the fact that the three central medallions intruded into the ornamental frieze indicated that the frieze dated before the fire and the medallions after. This erroneous principle was applied yet further when the positioning of other medallions and haloes was noticed.[26]

Our water-colour drawings offer a complete vindication of Kluge's description. George took special care to mark this 'joint' on his copies (PLATES 2–9), and it can also be discerned in some of the photographs. Moreover the impression of this suture appears on the squeeze, sheet no. 13 (PLATE 11b). It is seen as a depression or crack of irregular width. It was of sufficient depth to have caused the paper to tear, and of sufficient width to have accommodated more tesserae. This was probably as close as the new plaster could be taken without removing too much of an already existing setting bed. Possibly the restoration work had re-exposed the suture. It may originally have been satisfactorily masked by a filling of painted plaster, as was most likely the case around the faces substituted for the originals in the Zoe panel in S. Sophia in Constantinople.[27] The position of the part of the suture recorded in George's squeeze was at the extreme east end of the recorded north inner aisle mosaics. At this point,

[24] Tafrali (1909) prints the additional text found in Paris, Bibliothèque Nationale, gr. 1517. The priest mentioned may be the figure portrayed on the east face of the right pier, cf. Hoddinott (1963) 152–3; the portrait reappears in the left of the three central medallions in the north inner aisle mosaics (PLATE 4).

[25] G. and M. Soteriou (1952), esp. 143–6.

[26] Diehl (1910) 238 ff., Diehl (1918) 104 ff., and C. Diehl, 'A propos de la mosaïque d'Hosios David à Salonique', *Byzantion* vii (1932) 333–8. Cf. C. Bertelli, *La Madonna di*

Santa Maria in Trastevere (Rome, 1961) 111, n. 15, who applies this principle to the enthroned Virgin panel, and deduces a seventh-century date, preferably in the time of Justinian II in Thessaloniki. Grabar (1946) and (1957) assumes a licence of similar free dissociation in dating panels.

[27] The nature of mosaic sutures is discussed by P. A. Underwood, 'The evidence of restorations in the sanctuary mosaics of the Church of the Dormition at Nicaea', *Dumbarton Oaks Papers* xiii (1959) 235–42.

it ran approximately vertically through an inscription. The ground colour of the inscription was blue, but neither of the two hues of blue used on the right actually matched that on the left. The mosaic on the right was blank, so that neither the lines nor even the letters of the inscription on the left side were completed on the right. This deficiency indicates that two different periods of work were involved, and that the left section here must be the earlier. This relative order is confirmed at several other points in the mosaics, where saints' inscriptions are mutilated. The inscription on the later part states that it was done after the fire.

The ease with which the suture could be traced[28] explains the confidence of Kluge in stating the extent of the later work. His list is as follows: the whole of the ornamental frieze, the uppermost parts of most heads, the central three medallions and 'restoration inscription', the head of the right-hand angel and head of the right donor in the standing Virgin group, parts of the head of 'Christ' in the medallion to the right of the 'sarcophagus',[29] and most of the left medallion in the easternmost panel. Kitzinger (1958)[30] has independently accepted the accuracy of Kluge's statement that the greater part of the north inner aisle mosaics antedates the fire.

The work done after the fire clearly belongs to one time. It has frequently been assumed that the other mosaics are on the contrary a conglomeration of work done over several decades. This opinion derives from the observation that the series is divided into several panels of varying lengths, each with its own border, and that these contain separate votive inscriptions. It does not, however, necessarily follow that the individual panels were set separately over a long period of time, whenever rich donors presented themselves. In another medium where a similar system of financing church decoration occurred, namely floor mosaics, it does not seem likely that the floor was laid piecemeal as subscriptions from wealthy citizens were received.

The execution of the *ex voto* panels, even if independently financed, may feasibly be imagined to have been carried out as one programme. Certain indications support this. Both Kluge and George submitted the whole surface to minute examination, but did not discover any significant section of disharmony in this phase. Further, the surviving series of mosaics opened and closed with panels of very similar format and technique. The fact that the mosaics did not nearly reach the east end of the available wall space is relevant to this argument. If these do actually indicate the extent of the earlier work, then it seems likely that at a certain time sufficient offerings had been made to finance just this area of mosaic.

I shall refer to the recorded mosaics belonging before the fire as phase one, and to the restoration work after the fire as phase two. One does not expect votive mosaics to form a narrative sequence, yet since the longest panel at least was meant to be read from left to right, it seems preferable to describe the whole series from west to east. For clarity of reference, each arch is numbered from 1 to 12, corresponding with the notation given in the original publication of the mosaics by Papageorgiou (1908). In addition, each column and the spandrel above it is designated by a letter (A–K) (see diagram).

[28] Dalton (1911) 378–82, quotes George as saying, 'the dividing line between the work of the two periods is conspicuous'.
[29] This medallion head is the only part where the line of the suture was obscure. George (sheet 3) writes, 'halo certainly belongs to the restoration, probably the whole panel also'. On this point Kluge appears the more careful observer. At another point (arch 4), George may be the more correct in seeing the donor below S. Matrona as homogeneous, cf. Kluge (1909) 65. [30] n. 74.

Phase One

The westernmost composition was severely damaged. It was in the spandrel A (PLATES 2 and 6).[31] A frontal saint (head lost) stood within a niche, with his hands raised in prayer. At the left was preserved a diminutive frontal face, and on the right an inscription. The saint wore the stiff consular chlamys decorated all over with a diamond-shaped reticulation containing a quincunx of dots. A plain tunic showed down the left side: its cuffs and exposed shoulder were embroidered. His high rank was indicated by the attachment of a tablion. This was pink, and patterned like the chlamys. George coloured the chlamys light grey, with outlines in yellow. To interpret his colour convention here, we turn to the similar figure at the opposite end of the mosaic series, which he illustrated in sheets 4 and 8 (PLATES 5, 9, and 11a). This latter figure happens to be the one of which fragments (now kept in the crypt) were preserved after the fire.[32] These fragments reveal that the reticulation of this chlamys is shown by gold, silver, and white marble tesserae. The cuff and shoulder ornament is delineated with very dark tesserae.

This information can probably be applied to interpret the westernmost figure, which George coloured in the same conventions as the easternmost saint. It was, therefore, richly set with gold and silver tesserae. The parallel can no doubt be applied to the *aedicula* posts, niche, and pear-drop hangings on the green curtain behind the saint, all of which are in the easternmost panel constructed with gold tesserae. The gold ridges of the shell niche alternate with blue hollows. The hanging ornaments along the architrave are probably silver. The capitals are drawn in red.

The saint in this composition can, as in the east panel, be confidently identified as S. Demetrios. The combination of a magistrate's apparel with a halo conveys both earthly and heavenly power. Kitzinger (1958) sees echoes of the mosaics of the Rotonda in the scheme of an orant saint in front of ornate architecture.[33] The closest parallel for the form of the background here (shell-niches, and curtains) is in the figured ambo from the Rotonda.[34]

The scheme of a diminutive worshipper portrayed beside a cult figure was taken over from Late Antique pagan art,[35] and was a formula often used in the phase one mosaics. S. Demetrios measured about $4\frac{1}{2}$ ft. in height, and this figure must have been less than half this size.

The inscription (referred to below as number one) was set on the blue ground under the architrave. It filled all the available area, thus ignoring the space defined by the enclosing *aedicula*. The latter consisted of two columns to the right of the saint, each of which supported a beam. A small part of another supporting column for the rear beam could be discerned at the right of the inscription.

The squeeze by George (sheet 10) failed to catch a sharp impression of each tessera, possibly because the surface was evenly and tightly set. He did not colour the tesserae of the letters. In two other squeezes of inscriptions (sheets 11 and 12), he notes that the letters were silver and crosses gold. All these inscriptions are shown with white letters in the scale copies. Inscription one was therefore most probably written in silver with a gold cross. The measurements

[31] Illustrated in sheets 1 and 10; Papageorgiou (1908) pl. 1, 1; Uspenskij and Kluge (1909) pl. 17; Boissonnas (1919) pl. 31.
[32] G. and M. Soteriou (1952) fig. 77. [33] n. 92.
[34] When studied by C. Bayet, *Mémoire sur un ambon conservé à Salonique*, in *Mémoire sur une mission au Mont Athos* (Paris, 1876) 249–99, the ambo was in two pieces, one outside the Rotonda and the other outside S. Panteleimon. G. Mendel, *Catalogue des sculptures* (Constantinople, 1914) 2, 392–405, attributed it to the Rotonda, and dated it to the

first half of the sixth century, presumably on the grounds that the mosaics of the church belonged to that time. Recently, A. Grabar, *Sculptures byzantines de Constantinople, iv^e–x^e siècle* (Paris, 1963) 81–4, has reaffirmed an early sixth century date by comparison with the S. Polyeuctos finds. But since the date of the church conversion of the Rotonda has been set by H. Torp, *Mosaikkene i St. Georg-Rotunden i Thessaloniki* (Oslo, 1963), at around 400, a similar dating for the ambo requires consideration.
[35] Cf. Grabar (1957) 85 n. 5.

Inscription one[36]

Ὑπὲρ εὐ
χῆς οὗ
οἶδεν
ὁ θ(εὸ)ς τὸ
ὄνο
μα
✠

of its blue surround were 17 in. high on the left, and 8½ in. on the right, and its width was 10½ in. The tesserae of the letters were generally square, about ¼ in.

This prayer is found widely in the pre-iconoclastic period, and is frequent in Thessaloniki. It reappears in the easternmost panel, in phase two (on east face of left pier), and in the tribelon mosaics of the Basilica of the Virgin.[37]

Below the inscription, on the west side of the soffit of arch 2, George recorded a fragmentary ornamental mosaic. Its pattern consisted of four petals formed by intersecting circles (about 1 ft. in diameter). Three combinations of colour were used on the petals: red, fawn, white; blue, light blue, white; or green, pale yellow-green, white. It could be regarded as a simple version of the similar geometric design found in a bay in the Rotonda.[38]

An area of loss separated the compositions in spandrels A and B (PLATES 2, 6).[39] However, the composition in spandrel B was clearly delimited on the right by a vertical border consisting of three ornamental bands, separated from the composition by a plain strip. The central band was a row of alternately pink and green rectangles against a yellow (or gold) background. The dark-coloured bands on either side were the ground for silver pear-shaped drops attached at an angle to the centre band. It will be observed that only two different border patterns were used in these mosaics, and that these alternate around successive panels. It can be seen on George's sheet one that the fragmentary border of spandrel A was of the same type as spandrel B. Since there was insufficient room in the area of loss for another self-contained panel, we can assume that spandrels A and B held parts of one homogeneous panel.

The saint in spandrel B again stood frontally with hands raised in prayer, and was set against some sort of *aedicula*. His halo was clearly in gold. He was wearing the same type of garments as the saint in spandrel A, but his tablion was dark red with dark blue shadows, and the chlamys was cream in colour. It differed from the garment of spandrel A in appearing to be of a soft material with folds falling more naturally down from the right arm. The closest parallel in the church to this relatively plastic treatment of drapery is found in the panel on the west wall of the south aisle.[40] Since we have already noticed that in his copy of this panel (sheet 5) George did not indicate the areas of gold tesserae, it is possible that in our composition too parts were set in gold. Such patches of gold would tend to reduce the plastic effect of the drawing.

The form of the *aedicula* is obscure. S. Demetrios was framed on either side by ornamented columns set on moulded bases.[41] The ground at his feet was green, changing to blue above.

[36] Translation: 'As a prayer for one whose name God knows.'

[37] G. and M. Soteriou (1952) pl. 71(a); and Diehl (1918) 57 and 95. I am throughout using the name Basilica of the Virgin for the present church of S. Paraskeue; for its full Byzantine appellation see S. Pelekanides, Παλαιοχριστιανικὰ Μνημεῖα Θεσσαλονίκης. Ἀχειροποίητος–Μονὴ Λατόμου (Thessaloniki, 1949), and A. Xyngopoulos, Αἱ περὶ τοῦ ναοῦ τῆς Ἀχειροποιήτου εἰδήσεις τοῦ Κωνσταντίνου Ἀρμενοπούλου, Τόμος Κωνσταντίνου Ἀρμενοπούλου (Thessa-

loniki, 1952) 1–26. [38] Hoddinott (1963) pl. 20(d).

[39] Illustrated in sheet 1; Papageorgiou (1908) pl. 1, 2 and pl. 2, 3; Uspenskij and Kluge (1909) pl. 12.

[40] Illustrated in colour by Hoddinott (1963) pl. 4, facing p. 142.

[41] This type of banded ornament must have been widespread in the Greek East; it occurs frequently in the manuscript Paris, Bibliothèque Nationale, gr. 510 (e.g. folios 71 verso, 149, 239, 355), whose artists must have been familiar with pre-iconoclastic models.

Behind his shoulders was a panel, whose upper part was lost. Immediately to the left of the column on the left side was a second marbled shaft supporting an architrave. This architrave was conceived as supported regularly on columns, cut off by the border round the actual arches of the church. Four capitals of these columns were visible. In front and between the two capitals on the extreme left was placed another column with brown spiral fluting, rising above the architrave. Filling the two spaces under this colonnade, to the left and right of S. Demetrios, were bushy leaves, with green veins and blue edges. The forms are again reminiscent of sculpture, such as the ambo of the Rotonda or of vegetal ornament commonly found on chancel barriers.

In the upper storey to the right of S. Demetrios was a bust of a bearded saint enclosed in a medallion. Behind this medallion hung a pink curtain. All of this panel except the upper right section belonged to phase one. The bust was set against a green ground, shading to blue, while the halo must have been gold. The diameter of the medallion was a little over 1 ft., and the width of the head about 6 in. The saint's mantle was puce, and there was a red line round his neck above his yellow tunic. His hair was long and white and his pointed beard also white. Diehl (1918) seems to suggest an identification as Zacharias, and this is certainly supported by the type and headgear (*modius*).[42] In the mosaics of saints this is the first of several enigmatic portraits, whose identification and precise purpose it was not apparently considered necessary to specify.

The representation of a saint against a naturalistic hanging is a recurrent feature of these mosaics, and is presumably widely found in the period; the device is found likewise in the evangelist portraits of the Armenian manuscript of the middle of the ninth century known as the Gospels of Queen Mlkē. Its miniatures, to judge from their style, depend on pre-iconoclastic models.[43]

Enough remained on the left of S. Demetrios to reconstruct another such medallion against a pink hanging in the panel of equal width (1½ ft.). Furthermore, a third such composition must have originally existed to the left of this, since there was another fragment of a pink hanging. There is no indication of the identity of these two postulated bust medallions. If this last panel was equally wide, then there would not have been room for any other such panel before the inscription of spandrel A. There is room for the two columns supporting the architrave over the inscription, plus the left-hand marbled column supporting the medallion panel reconstructed, and most probably for another brown spiral-fluted column to match the other.

To the right of S. Demetrios, a diminutive donor (1¾ ft. high) with his hands draped leaned forward across the column. His leg covering was blue; his garments were off-white with brown outlines and grey shading, while the hem at the bottom was finished with a fringe. He had brown hair and a thick brown beard. Grabar (1946) noticed that this was apparently the only donor in the series shown bearded, and on these grounds dated this as a post-Heraclian addition to the mosaics.

The next composition was almost entirely complete (PLATES 3, 7). It was centred on spandrel C, and stretched asymmetrically over arches 3 and 4.[44] This panel is a work of quality, and both Kluge and le Tourneau were moved to publish coloured copies of the Enthroned Virgin and Child with attendant angels. Kluge's two details are particularly valuable as a control in

[42] Cf. the representation in the manuscript Vatican, gr. 1613 folio 61. Since Diehl speaks of a prophet, Hoddinott (1963) 145, takes him to mean Zechariah.

[43] Illustrated and discussed by M. Janashian, *Armenian Miniature Paintings of the Monastic Library at San Lazzaro*, i (Venice, 1966); MS. no. 1144/86.

[44] Illustrated on sheets 2 and 18; Papageorgiou (1908) pls. 2, 3, and 4; Uspenskij and Kluge (1909) pls. 3 and 5 (in colour) and 10 and 11; Diehl (1910) pl. 16 (colour); and Diehl (1918) pls. 27 and 34, and fig. 45.

assessing our water-colour copies, and for their specific documentation of the areas of gold and silver tesserae. The composition extended over a width of 12½ ft. The seated Virgin occupied a height of 5 ft. (from the top of her halo to the base of the footstool). The two interceding saints were approximately 2½ ft. high. The bust medallions were 1½ ft. in diameter. The tops of the heads of all the holy figures in this panel were remade during the phase two repairs. Small patches of loss occurred at scattered points across the whole panel, and the surface of the child was particularly damaged. Most of the tesserae of the footstool had fallen out.

The composition was enclosed within a broad ornamental border outlined in white. This was composed of a scheme of alternate rectangular green and oval blue cabochon stones, outlined in gold. Between each stone were four pearls, set in a cross shape. The focal point of the panel was the enthroned Virgin, who occupied spandrel C. She was represented frontally, with the child seated in her lap. She rested her left hand on the child's left shoulder, and with her right held the child's right knee. She was seated on a throne seen from the right and slightly from above. The halo of the Virgin was set in gold with a thin outline of silver; this in turn was outlined with blue (at the top, the phase two replacement was carried out with dark red or brown tesserae). The pleated kerchief covering the Virgin's hair was light blue with white highlights. A minute cross (not shown in the water-colour) was drawn in the centre, according to Kluge's drawing, and confirmed by the description of Papageorgiou (1908). She was dressed in the usual stola and maphorion, both of which were dark blue and modelled with dark red or brown rows of tesserae. Her hands were outlined in red, and the features of her face were also drawn largely with lines of dark tesserae. Below the child's right leg emerged a light blue handkerchief, with a silver border. Her slippers were red. The Virgin sat on a red embroidered cloth, and rested her back against a red cushion.

The child was shown with his right hand in a gesture of blessing, and he held a scroll in the left. His right foot was seen from above, and his left from the side. The basic colour of his tunic and himation was gold. The cross in his halo, lines on the garments, and outline of the feet were in red. Some of the drapery folds across the body were in olive-green.

The throne appeared box-like, but perhaps the horizontal seat was meant to be supported by rectangular posts. It had a matching footstool, and its back rest was lyre-shaped. The colour of this back was olive-green. Its supports consisted of a central band of green rectangles on a gold ground which bulged out at the top into a large knob, surmounted by a silver pear-shaped knob (surviving on the right side only). These supports were outlined in blue, studded with silver. The lower part of the throne had a gold horizontal seat, set on its front and right side faces with oval and rectangular green cabochons, outlined in gold. A gold band ran vertically down the centre of the rectangular posts, and was crossed by two horizontal ornamental bands. The ground colour of these posts and of the upper surface of the footstool was olive-green. The two visible faces of the footstool were also ornamented with cabochons. This manner of abstract ornament on the rectangular posts is a type of decoration which reappears after Iconoclasm in the apse of S. Sophia in Constantinople.[45] By the middle of the eleventh century a more complex manner was in fashion, incorporating acanthus forms on the posts.

Standing behind the throne were two angels. Each gripped a knob with the inner hand and a staff with the other. Their posture has a parallel in the apse painting of Odalar Çamii in Istanbul, as recorded in a sketch by Schazmann.[46] Both angels had broad wings; the feathers

[45] C. Mango and E. J. W. Hawkins, 'The Apse Mosaics of St. Sophia at Istanbul', *Dumbarton Oaks Papers* xix (1965) 115–51.
[46] P. Schazmann, 'Des Fresques byzantines récemment découvertes par l'auteur dans les fouilles à Odalar Çamii, Istanbul', *Studi bizantini e neoellenici* vi (1940) 372–86. The dating of this composition requires re-examination.

were mainly brown, with some olive in the upper part, and with blue feathers in the lower part. The outlines were red. Their haloes were silver, and so were the highlights of their tunics. The outlines and cuffs of the left-hand angel were in blue (changing to red around the phase two repair of the halo). Grey and green tesserae were employed among the white in the lower part of the dress. Rather more olive and brown were used in the right-hand angel, and its outline was brown. On the part of the tunic draped over its left arm appeared a blue gammadion, in the primitive form of this sign. The presence of this feature here, previously unnoticed, is of some importance. Oakeshott[47] supposed that this decoration might have to be reckoned of Italian derivation, unless, for example, it could be found at Thessaloniki. Its appearance in these mosaics accordingly proves its actual wide currency in the pre-iconoclastic period.

The faces of the Virgin and both angels were composed as if illumined from a light source on the left. This seems to have caused difficulties in the rendering of the anatomical features of the right angel, which seems rather poorly drawn. A difference of execution between archangels is similarly apparent in the early eighth-century icon from S. Maria in Trastevere in Rome.[48] The head of the angel on the left was recorded in detail by Kluge, and he has in most parts indicated the tesserae. The accuracy of his work in general can be checked, for it was Kluge who in 1912 photographed and copied the mosaics of the church of the Koimesis at Nicaea.[49] His coloured copy of the angel Dynamis, if compared with the photograph, is an entirely satisfactory record of the positions of the tesserae (PLATE 10a and b).

The head of the left angel was turned in towards the Virgin and slightly inclined. Its abundant hair was gathered up in thick waves, and fell down the back of the neck on the left. The dark strands were represented in purplish-brown tesserae, and the light ones in yellow. The hair was tied together with a ribbon, light blue across the head, which fluttered in darker blue on each side of the face (according to Kluge; however, George gives the ribbon an equal value of blue throughout). The flesh parts of the face were set with tesserae of light colours with outlines in dark brown or purple. Three main colours were used—pale yellow, pink, and off-white, with slight variations within these colours. The pink tesserae were laid to follow the curve of the left cheek. The forms of eyes and mouth were suggested with a few tesserae rather than minutely drawn. The face was softly modelled and lacking in expression. Its stylistic character becomes apparent when a contrast is made with the Nicaea angel, although allowance must be made for the greater size, and hence scope for detail, of the latter. At Nicaea, the range of colours was much greater (extensive use of green, for instance), and the laying of tesserae into variegated colour patches is technically more complex and stylized. The comparison also shows a feature of the angel in S. Demetrios. This is the prominent parting of the hair in the centre of the forehead. The feature reappears in the angel in the apse of Hosios David, and is used, almost as a mannerism, in several heads in the apse mosaics of Panagia Kanakaria in Cyprus.[50]

Spatially, the two angels were in the further plane: their wings were behind the Virgin's halo and behind the two standing saints. On the left, the saint stood with his hand in front of the angel, and his other hand round the back of the donor. The latter was leaning towards the Virgin with his hands draped, and should logically be roughly on the same plane as the Virgin.

[47] W. Oakeshott, The Mosaics of Rome (London, 1967) 378–9.

[48] C. Bertelli, La Madonna di Santa Maria in Trastevere (Rome, 1961), esp. 88–9; he finds the contrast here sufficiently marked to postulate two painters.

[49] T. Schmidt, Die Koimesis-Kirche von Nikaia (Berlin and Leipzig, 1927).

[50] Illustrations of Hosios David in Hoddinott (1963) pl. vii, facing p. 174; and of the Cyprus apse in A. H. S. Megaw, 'The mosaics in the church of Panayia Kanakaria in Cyprus', Studi bizantini e neoellenici viii (1953) 199–200.

However, his small size, and the strong sense of recession given by the lines of the throne, caused him to appear somewhat in the background. On the right side, the orant saint stood in front of the angel's wing.

The left-hand beardless saint wore an off-white chlamys with a red tablion. The exposed right shoulder of his tunic was heavily embroidered. His halo (and possibly lights on his chlamys) was gold. The right-hand saint wore an olive chlamys with a blue tablion over a plain pink tunic. The identity of the two saints has been the subject of discussion. Kondakov (1915) suggested Cosmas and Damian, but Diehl (1918) would seem correct in proposing S. Demetrios for the figure on the left. The frontal saint on the right seems undoubtedly the same person as the one on the south panel of the left pier flanking the chancel, where he is likewise closely associated with the Virgin. This type of face with a pointed beard is most likely to be S. Theodore.[51] In pre-iconoclastic art, there seems no recognizable distinction between the Tiro and the General. We do not know to what extent the iconography of these mosaics was determined by already formulated prayers. An invocation addressed to this trio, the Virgin, S. Demetrios, and S. Theodore, was actually found written on the wall of the nave of this church, but without any indication of its date relative to these mosaics.[52]

The group was set against a plain blue background, but with some green areas around their feet. Around the head of the donor on the left side was an *aura* of light blue, which was cut off by the shoulder of the saint. This *aura* is a feature which recurred elsewhere in the series around the heads of the human figures. The left-hand donor was dressed in a voluminous pink cloak-like garment with a fringe. On the extreme right of this blue ground was a small enigmatic figure, who appears to be a second donor. George had no doubt that this was an original part of the panel. It appears to be a female figure, if the red spots beside the face are correctly to be identified as earrings. It was dressed in a yellowish cloak, stippled with blue spots, over a long pink garment, stippled with blue and red and finished with a patterned hem. It leaned forward towards the Virgin, with its hand draped by the cloak.

The remainder of the panel was occupied by five bust medallions of saints, of which only the two at the extreme right were identified. These two were female and of identical types. Presumably spectators were expected to recognize the other faces without written assistance. The group of two medallions above arch 3 and the group of three medallions above arch 4 were each set against a rectangular green foil. The medallions were encircled with a broad blue band (above arch 3, the phase two replacement of this was brown). The arch 3 rectangle bulged slightly around the bottom of its right side medallion. Both the donors of the figure group intruded slightly into the green rectangle. All the saints had gold haloes, outlined in red above arch 4, and in blue or brown above arch 3.

The male saint above arch 3 was dressed in grey or white. He had brown hair and a light beard. The male saint above arch 4 wore an olive-green himation over a light-coloured tunic. He had grey hair and an extensive but short cropped beard. There was an area of loss in the upper part of the medallion, mainly of the halo, but possibly a little of the top of the head. Both these male saints turn their heads towards the central group of the panel, but the arch 3 saint was certainly not looking at this group. Grabar (1946) ventured an identification of Paul (arch 3) and Peter (arch 4). He thought that the right saint, Peter, was tonsured and that this was an influence of Roman iconography on Thessaloniki, a city which was, at least officially,

[51] Cf. P. A. Underwood, 'The frescoes of the Kariye Çamii', *Dumbarton Oaks Papers* xiii (1959) 194 n. 20.

[52] G. and M. Soteriou (1952) 233–40, fig. 93. The close association of the cult of the Virgin and S. Demetrios was a commonplace of local religious attitudes. Cf. V. Laurent,

'Une homélie inédite de l'archevêque de Thessalonique, Léon le Philosophe sur l'Annonciation (25 mars 842)', *Mélanges Tisserant* (Vatican, 1964) vol. ii, 281–302, esp. 293–4.

within papal jurisdiction until the eighth century. George's record, however, is definite in indicating loss rather than a tonsure in this area. Grabar[53] introduced a further difficulty by suggesting elsewhere that the two saints in the apse of Hosios David might also be Paul (left) and Peter (right). However the left face in Hosios David has grey hair and a grey pointed beard unlike either of our saints. The right figure could plausibly be the same person as our arch 4 saint. The possibility that our saints are Paul and Peter remains.

The female saint above arch 3 has defied every attempt at identification. She wore red and pink with a light blue kerchief. The neck of her dress was ornamented with a row of dots in the drawing by George. A similar pattern ran round the edge of the hood of the central female saint of arch 4. This hood was olive-green, the pleated kerchief blue, and dress brownish. This person was identified by an inscription in her medallion as S. Pelagia ('H Ἁγί Πελαγία). The female on the extreme right was dressed entirely in brown or puce, except for a light pleated kerchief. A cross was seen in the centre of this kerchief by Papageorgiou (1908), but not recorded by George. She was identified by an inscription as S. Matrona ('H Ἁγί [M]ατρῶνα), who is known as a popular local martyr. The *Miracula* mentions the existence of a shrine dedicated to her near Thessaloniki.[54]

The Matrona inscription was recorded by George in a squeeze, sheet no. 18 (PLATE 12b). The letters were set with very small tesserae, with slightly larger ones for the ground. None of the letters was more than 1 inch high. The rim of the halo consisted of one row of red tesserae. This squeeze documents one technical device used by the mosaicists. The gold tesserae of the halo are set in horizontal rows, and the squeeze records clearly that each row is inclined downwards out of the plane of the wall. The device must have been frequently used in phase one, for George mentioned its occurrence in S. Demetrios in his monograph on S. Eirene.[55] George is also reported by Dalton (1911)[56] as saying that the gold tesserae of haloes, etc., in phase one were set with a forward inclination, whereas in phase two they were in the plane of the wall. However the practice of setting tesserae in horizontal rows was not universal in phase one: for while it is followed in the three medallions above arch 4, a concentric setting scheme was used, for example, in the two above arch 3. In the mosaics after the fire, the saint on the west panel of the left pier has a halo in which the tesserae were laid concentrically but at the same time are tilted both downwards and inwards to form a textured relief around his head. The use of tilted tesserae has been observed not only in the apse of S. Eirene (after 740) but also in the sixth-century mosaics in S. Sophia in Constantinople and on Mt. Sinai. The device survived Iconoclasm, and appears in the ninth- and tenth-century mosaics in S. Sophia in Constantinople; but the laying of tesserae in a horizontal or concentric field was not consistent there either, since both schemes were found in the north tympanum figures.[57]

The composition of this panel was exceptional in lacking a votive inscription. It is also notable for its remarkable balance despite its asymmetric space. Grabar (1946) was reminded of an apse scheme, and there is a parallel for the central group in the apse mosaic of Panagia Kanakaria in Cyprus. Moreover, the combination of such a group with bust medallions is a typical scheme of sixth-century apses, known from mosaics in Cyprus, Sinai, and Ravenna. However, the closest actual parallel to our central group is the small encaustic icon of the Enthroned Virgin with angels and saints, now in the collection on Mt. Sinai.[58] It would be

[53] Grabar (1946) 2, 98; and A. Grabar, 'A propos d'une icone byzantine du xive siècle au Musée de Sofia', *Cahiers archéologiques* x (1959) 289–304, esp. 298.
[54] J. P. Migne, *Patrologia Graeca*, vol. 116, 1278.
[55] W. S. George, *The Church of St. Eirene at Constantinople* (Oxford, 1912) 51–2. [56] p. 379 n. 1.

[57] Cf. P. A. Underwood and E. J. W. Hawkins, 'The Mosaics of Hagia Sophia at Istanbul; the Portrait of the Emperor Alexander', *Dumbarton Oaks Papers* xv (1961) 189–217, esp. 194 n. 25.
[58] K. Weitzmann and others, *Icons from South Eastern Europe and Sinai* (London, 1968) pls. 1–3.

difficult in this period of obvious cross-fertilization of artistic ideas to be certain about the precise medium or scale of the models which influenced our composition. The scheme of a donor before an enthroned divinity, with intercessors placed in medallions, reappears after Iconoclasm in the lunette mosaic over the Imperial Door in the narthex of S. Sophia in Constantinople.

The next panel was framed by the same ornamental bands as already found in the western-most panel. We find that this frame enclosed a cycle in several episodes stretching over spandrels D, E, F, and G. The narrative unity in this panel is apparent from the recurrence in the four episodes of the same mother and her daughter, who grows older from one scene to the next.

There is a little room for inscriptions in the areas of loss in spandrels D and E and their original existence may be implied by the nature of the statements inserted in corresponding positions in spandrels F and G. These are recorded by George in sheets 11 and 12.[59]

Inscription two (Spandrel F, PLATE 13*a*)

[καὶ] τὴν [Δ]εσποι
νὰν τὴν Θεο[τό]
[κο]ν τὴν ἁγ[ίαν]

Inscription three (Spandrel G, PLATE 13*b*)

✠ Καὶ σὺ Δέσποτά μο[υ]
῏Αγιε Διμήτ[ρ]ι [β]οήθι ἡμῖν
τοῖς δούλοις σου καὶ
τῆ δούλη σου Μαρί
ᾳ ἣν ἔδωκες ✠
ἡμῖν ✠

Both inscriptions were set in silver against a dark blue ground. The crosses of inscription three were in gold. George has failed to clarify the forms beside these crosses, but apparently the cross after ἡμῖν had a white dove on each side of it. The cross after ἔδωκες may have had a light blue fish beneath it. Inscription three was 14 in. wide across the base, and 9½ in. high.

The plausible deduction is that the donors of this panel were the parents of a child called Maria, for whose birth they thanked divine favour.[60] They were responsible for the largest and presumably most expensive panel. It differed from all the other panels in the church by the introduction of a narrative element.

The cycle opened on spandrel D[61] with a representation of S. Demetrios seated on a backless throne in front of his *ciborium*.[62] This representation of the *ciborium* provides an almost precise visual counterpart of the descriptions in the *Miracula* text. It was a hexagonal construction in

[59] Cf. Papageorgiou (1908), 342. Inscription two translation: 'And the Lady, the holy Mother of God . . .' Inscription three translation: 'And you, my Lord Saint Demetrios, aid us your servants and your servant Maria, whom you gave to us.'

[60] Cf. Diehl (1910). The notion of a 'miraculous' birth is perhaps too extreme.

[61] Illustrated on sheet 2; Papageorgiou (1908) pl. 3, 5; Uspenskij and Kluge (1909) pl. 10.

[62] N. Theotoka, 'Περὶ τῶν κιβωρίων τοῦ ἁγίου Δημητρίου Θεσσαλονίκης καὶ Κωνσταντινοπόλεως', Μακεδονικά ii (1953) 395–413, reconstructs the *ciborium*. She assumes its form

before and after a fire in 580 or 581 and its restoration before 586 to be unaltered. She accepts the hexagonal base found on the left side of the nave in 1917 to represent the position of the *ciborium* since the foundation of this church, and to indicate its shape throughout the Byzantine period. In her opinion, some church of S. Demetrios in Constantinople must have contained an octagonal *ciborium*, whose existence may be inferred from the reliquary copy in Moscow. A. Grabar, 'Quelques reliquaires de Saint Démétrios et le martyrium du saint à Salonique', *Dumbarton Oaks Papers* v (1950) 3–28, concluded that the *ciborium* in Thessaloniki was not altered in the eleventh century.

silver. Six panels supported a pyramidal roof, surmounted by a gilt ball. A cross above the ball may have originally been included before the phase two repairs. One side had a two-leafed door. The visible panel contained representations of busts of saints in two registers. George coloured the panels in various tones of grey, and articulated it with blue. It seems likely that silver tesserae had been used. Within the sloping triangular roof panel above the saint's head was an ornamental trifoliate form. The *ciborium* was set against a green curtain, hanging loosely in a curve. The space above it was blue. The scene took place in a setting of green grass, in which a large pink flower was growing. The actual *ciborium* of the saint was located halfway down the nave of the church, on the north side.

S. Demetrios sat before the open doors of the *ciborium*. Its interior was shown plain blue. His head and shoulders were frontal, but his feet were turned at right-angles towards the rest of the composition (and towards the east end of the church). His stiff chlamys was off-white and decorated with an all-over pattern of red circles. It hung in heavy folds, which modelled his two legs. His tablion was of brown and red. His cuffs were blue on white, and his tunic light green. The footstool had a plain yellow-green top and brown ornamental sides. The throne was probably gold. The end of one large red cushion was visible behind S. Demetrios and possibly the end of another small blue cushion. The scheme of a throne and an *aedicula* is more familiar in the representations of the Annunciation in later Byzantine art.

S. Demetrios with his right hand reached across to touch the shoulder of a baby held towards him on the draped arms of a woman. She was presumably kneeling, and can be assumed to be the child's mother. Both mother and child wore very pale grey-green garments, relatively softly modelled by light shadows and brown outlines. The mother wore a veil over her dark hair, which was bound with a gold band with some central ornament. A grey *aura* surrounded her head. The mother and child were represented on much the same scale as the saint. The lower 6 in. of the spandrel was lost.

S. Demetrios raised his left hand to the level of his shoulder. The tips of his fingers, outlined in red, almost met the outstretched hand of a figure reaching forward from a medallion on the right. This medallion was set against a plain brown foil above and behind the woman. It was badly damaged. It could be seen that the figure wore blue, stippled in red, and had a gold band across his right shoulder. A short dark beard can possibly be distinguished on George's drawing. The figure held a richly bound codex, its cover ornamented with green precious stones and pearls. Grabar (1946) argued, correctly in my view, that the only possible identification was Christ; it is of a Pantocrator type.[63] A parallel for Christ leaning out of a medallion may be found, for example, in the Theodore Psalter of 1066 (British Museum, Add. 19352), folio 42 verso, *et al.*

On the right of this medallion, against a pink foil, was a full-length standing female figure with a halo. In such a position, Grabar (1946) argued that the only possible identification was the Virgin. The figure extended her right hand towards the main scene; the other was held at shoulder level in the same gesture as S. Demetrios'. According to Diehl (1918) she wore

[63] On Christ types cf. J. D. Breckenridge, *The Numismatic Iconography of Justinian II* (New York, 1959), esp. 46–62. This bust would be closest to his type B, but a considerable variety of types is found in the pre-iconoclastic mosaics of Thessaloniki. Breckenridge argues that an unsupported book, implying the existence of a left hand, indicates a reduced version of a larger representation, and so cannot be strictly called an *imago clipeata* (which he defines as a medallion portrait complete within its frame). M. Chatzidakis, 'An Encaustic Icon of Christ at Sinai', *Art Bulletin* xlix (1967) 197–208, discusses prototypes influential on early representations of Christ, and suggests the Pantocrator Christ on the Sinai icon, shown with a small beard, might derive from the Chalke icon, which he dates after 532. However, the destruction of this postulated model in the 532 riots is not certain; and the developments leading up to this representation would require definition.

a yellow maphorion over a red tunic. George, however, shows her in a brown garment over a yellow-green tunic. She had red shoes. Her head, and most, perhaps all, of the gold of the halo were remade in the phase two repairs, when she was shown without a kerchief. An identification as the Virgin remains possible; a personification such as Eutaxia, mentioned in the *Miracula*, is unlikely.[64] The figure's significance remains in doubt.

The green ground of this composition continued on the right to the apex of arch 5 (PLATES 4, 8), but the interpretation of this zone is obscure. Below an architrave, supported by two columns with spiral fluting, was a grey object, with a triangular gable and roof. A grey cat-like animal was stretched along its ridge with its head to the left. From the centre of its back a thin vertical grey line ran up to the architrave. This line must have had some significance, since it was continued in the phase two repairs. The object has generally been interpreted as a sarcophagus, either with reference to the tomb of the saint (Grabar, 1946), or connected with a death in the donors' family (Hoddinott, 1963).

The detailed interpretation of the panel described so far is also in dispute. Hoddinott (1963) imagined the child was being given as a gift from the interceding saint to the mother. Grabar (1957) suggested an explanation on contrary lines. He noticed a cruciform mark on the forehead of the child, and interpreted this as a reference to some special baptism. He accordingly saw the theme as the formal dedication of the child to the saint, who in his acceptance gives an assurance of the benediction of Christ. There would be in this case an antique prototype for both the concept and the form, in the presentation of the infant Achilles by his mother to the centaur Chiron.[65]

The existence of the sign of the cross on the forehead of the child is confirmed in the watercolour copies. In addition to this occasion, the sign reappeared on each of the three subsequent representations of the child. It was probably delineated in gold tesserae in each case.

The suggestion of Grabar (1957) that the furniture on the right of this composition could be baptismal seems to have little justification. However, the identification and significance of the saint at the apex of arch 5 may be relevant. George recorded on sheet 3 his supposition that the whole bust within the medallion might belong to phase two, but Kluge (1909) was confident that only the cheeks and halo were repairs. The possibility that it was entirely of phase two must be kept in mind. The saint had long brown hair and a full beard. His eyes were turned to the left (George is incorrect). He was dressed in brown. Kluge (1909) and Grabar (1946) identified him as Christ. An alternative is S. John the Baptist, who commonly appears somewhat like this on sixth-century ivories.[66] The problem would remain as to whether this figure was connected with the child scenes, or whether an over-all scheme was devised in which the apex of some arches in the sequence held independent major portrait icons. The narrative scenes of the Castelseprio wall paintings are interrupted in somewhat the same manner, and this bust does have some similarity of appearance with the Christ medallion surviving there.

This medallion was oval in shape, just over $1\frac{3}{4}$ ft. high and $1\frac{1}{2}$ ft. wide. Below it was green, while the area above it, belonging to phase two, was blue. This blue continued around the *aedicula* on the right. The figure composition of spandrel E, however, is again set against

[64] Hoddinott (1963) 148-9, gives his approval to a syncretist theory of a Great Goddess–Eutaxia–Virgin fusion; but the relative values of historical fact and psychological speculation in his account are not clarified.

[65] Cf. K. Weitzmann, 'The Survival of Mythological Representations in Early Christian and Byzantine Art, and their impact on Christian Iconography', *Dumbarton Oaks Papers* xiv (1960) 45–68, esp. 55. Grabar (1957) fig. 87,

supplies a formal parallel, but the reference there is to the death of a child.

[66] e.g. the diptych in the State Museum, Berlin; illustrated by W. F. Volbach, *Early Christian Art* (London, 1961), pl. 224. Cf. also the Sinai mosaic medallion, illustrated by K. Weitzmann, 'The Classical in Byzantine Art', *Byzantine Art, Lectures* (Athens, 1966) fig. 132.

green.[67] Shifts between green and blue grounds unfortunately seem to lack any significance in these mosaics. The *aedicula* on the left of spandrel E probably had a symmetrical counterpart on the right. This left *aedicula* was formed out of four columns which supported a coffered ceiling with a triangular gable, from which hung a lighted lamp. The columns and gable were ornamented. The corresponding position to the right of spandrel E was almost entirely obliterated by phase two mosaics. However, still visible were the lower parts of two left columns of another *aedicula*, the base of a hanging lamp set against a blue ground, and a trace of the next column. It becomes obvious, therefore, that interpretations which have assumed the *aedicula* of arch 5 to be unique will almost certainly be invalid. Most of Grabar's suggestions can be eliminated for this reason. It is likely that the *aediculae* were *ciboria*.

Spandrel E was dominated by a standing Virgin. She wore a purple dress highlighted throughout with red hatching. Her kerchief and handkerchief were silver, and the gold halo was outlined in red. Her face was turned towards the spectator, but her eyes were turned to the left (George incorrectly made them look forwards). Her arms were held to the right in a gesture of intercession. The inserted medallions of phase two have removed the object of her prayer, but this can scarcely have been other than Christ. Probably, in the original scheme of phase one there was a medallion bust of Christ at the apex of arch 6, since a medallion appears centred over arches 5, 7, and 8.

The Virgin was $4\frac{1}{2}$ ft. high. The front of her footstool was lost; the surviving upper surface was gold.

Two angels accompanied the Virgin. Their wings were blue, outlined in red, and they lacked staffs. The whole face of the right angel was a phase two replacement. Both wore gold garments over a light blue or a silver tunic. The tesserae of their gold haloes were set concentrically and the haloes were outlined in silver and in blue. The hair of the left angel was light brown and luxuriant, and tied with a silver ribbon. Each angel turned its head towards the Virgin, and grasped with the outer hand the shoulder of a donor. On the left side, the mother and child of spandrel D made a reappearance. The child was larger, but still held in her mother's arms. The sign of the cross on the forehead remained visible. The child wore a gold mantle, outlined in red, over a silver tunic. Both mother and child had their feet outlined in red. The mother was dressed in silver over a gold tunic, whose base was ornamented with a green quatrefoil. On the right side, another figure, of uncertain sex, was introduced to the Virgin. This figure was dressed in a voluminous silver costume, ornamented with a diamond pattern in red. The tunic below was gold. Most of the face had been remade in phase two. The hands were draped.

The relative spatial position of the Virgin, the angels, and the other, smaller, figures are the same in this spandrel E as in the spandrel C panel of the Enthroned Virgin. If the reconstruction proposed is correct, the agency of S. Demetrios is excluded from this episode. Grabar (1946) characterized it as a theophany scene.

George preserved a record on sheet 3 of the soffit decoration on the arches on each side of this spandrel. Arch 5 contained within a border a grapevine set against a yellowish ground. It grew out of a crater, similar in form to the lamp in the *aedicula* of the arcade mosaics above it. At the apex of the arch was a gold latin cross within a medallion, correctly viewed from the nave side. The decoration is a much simpler version of a scheme found in one of the tribelon soffits of the Basilica of the Virgin.[68]

[67] Illustrated in sheet 3; Papageorgiou (1908) pls. 3, 5, and 6; Uspenskij and Kluge (1909) pls. 2 and 9; Diehl (1910), pl. 19, 2; Diehl (1918), pl. 30, 2 and fig. 46.

Kluge's colour plate is a valuable supplement to George's copy.

[68] Illustrated by Hoddinott (1963) pl. v, facing p. 156.

The soffit of arch 6 contained a garland in a grey-blue border set against a gold ground. It was tied with a blue, silver, and gold ribbon at its base and was composed of predominantly green and blue leaves, interspersed with pink fruit or flowers.

The third episode of the child cycle was in spandrel F, at the base of which was the fragmentary inscription two.[69] The whole composition was in poor condition, and was disturbed on the left side by phase two mosaics. This time the figure composition was set in an interior, flanked on each side by a grey arcade—its five supports on the left were surmounted by an architrave instead of an arcade as on the right; this alteration occurs in phase two mosaics. The scheme of the composition therefore seems again to have been symmetrical. For this reason, I suggest that a bust medallion should be reconstructed above an arcade on the left side to balance the unidentified female saint opposite. She was enclosed within a medallion which had a diameter of $1\frac{1}{4}$ ft. This female saint was dressed in grey marked with red outlines.

The centre part of this interior setting consisted of an *aedicula* formed from four columns supporting a flat covering. The front columns were probably gilded. The two further columns had spiral fluting. Between the latter was suspended a green curtain. The architrave was ornamented with oval cabochons and pearls set against a brown ground.

Four figures stood against this *aedicula*. S. Demetrios in the centre was frontal with both his hands raised in prayer. His light-coloured chlamys was ornamented with a diamond pattern in red. His tablion was grey. His light coloured tunic had blue ornament on the exposed shoulder and cuffs. The other three figures were shown suppliant, the two on the left being the mother and now standing child. The figure on the right was apparently a woman, who seems to have had her hands covered. All three figures are dressed in grey with yellow tunics (possibly silver with gold).

The mother and child, and possibly the figure on the right, each offered two candles to the saint. Grabar (1946) documents the offering of candles by means of texts and visual evidence. The *Miracula* (Book 1, Chapter 7) features an episode in which the sacristan in this church steals candles lit for S. Demetrios. The lighting of candles in front of icons of saints was one of several practices which steadily gained in popularity in the period before Iconoclasm.[70]

The fourth composition in this cycle (PLATES 5, 9) was centred on spandrel G, and the right side was in great part lost.[71] Exceptional here was the portrayal of a landscape vista receding into the distance, and possibly there was an arcade at the centre, set obliquely.

On the extreme left, above arch 7, a medallion of a little over $1\frac{1}{2}$ ft. in diameter can with certainty be identified as containing Christ. A black rim enclosed a ground set in three shades of blue. Christ with his right hand raised in blessing; the robes were light in colour, modelled in rows of white, light blue, and light brown tesserae. Across his shoulder was a red and blue embroidered band. His bushy hair and short beard were shown grey with light brown outlines. The upper part of the gold halo was carelessly repaired by phase two mosaicists; its original scheme must presumably be reconstructed as a chi-rho monogram, since three arms of such a form, outlined in red, did survive from phase one. It is of interest to find an example of this form of *nimbus* firmly located in the Greek East.[72]

This medallion of Christ was balanced on the right side by a second medallion at the apex of arch 8. Only the indications of a blue ground on the right, and, below it, a fragment of

[69] Illustrated in sheets 3 and 11; Papageorgiou (1908) pls. 3, 6 and 4, 7; Uspenskij and Kluge (1909) pl. 8.
[70] Cf. E. Kitzinger, 'The Cult of Images in the age before Iconoclasm', *Dumbarton Oaks Papers* viii (1954) 85–150.
[71] Illustrated in sheets 4 and 12; Papageorgiou (1908)

pl. 4, 7 and 8; Uspenskij and Kluge (1909) pls. 6 and 7; Diehl (1910) pl. 19, 3; Diehl (1918) pl. 30, 3; Boissonnas (1919) pl. 29.
[72] Cf. C. R. Morey, *Early Christian Art* (Princeton, 1942) 139, for the 'Italo-Gallic school' attribution of this form.

a shoulder, survived. The latter was light brown and blue. This figure must have been either another Christ (making the fourth or fifth in this panel, depending on the identification of the medallion over arch 5), or alternatively the Virgin. The latter may be the more appropriate since both medallions are part of a single composition within the cycle.

The landscape setting consisted of flowers, trees, and buildings, on grass; behind these were some rather stylized multicoloured striped mountains, although these are still far from the extreme stage of stylization for the portrayal of a mountain, as found in the post-iconoclastic Ascension mosaics in the cupola of S. Sophia in Thessaloniki. The sky, formed out of regular horizontal stripes, belonged to phase two. The precise significance of the architectural forms is disputed. Hoddinott (1963)[73] is ready to accept the tholos on a square plinth at the left as the *ciborium* of S. Demetrios, and the fountain on the right as either one in the atrium of the church or alternatively as the Chapel of the Spring outside the city. Grabar (1946), however, took the landscape literally, and so excludes the *ciborium*. The function of the three columns in the centre is debatable.

A group of five approached S. Demetrios from the left; and a sixth person can tentatively be recognized on the right. The foremost figure on the left was the same child as in earlier episodes, whose name Maria is given on inscription three in this spandrel. As before, she was marked with a gold cross on her forehead. She held a pair of doves in her hands. Over her white and yellow garment, and covering her head, she wore a dark shawl decorated all over with red pear shapes. She was about 2 ft. in height. This was about the same height as her mother behind, which suggests the child has now reached adolescence.

The mother pushed the child forward towards the saint with her right hand. She was dressed in white, and there was a gold ornament below each knee. Beside her was a male figure, dressed in a light ochre robe, which covered his hands. This is supposedly the father of Maria. He looks young and beardless. Two more women completed the group on this side of S. Demetrios, one in white and the other in a blue mantle over a light green dress. Grabar (1946) supposed a single family to be involved in this composition. It can be seen that in this composition, as in some of the other episodes of this cycle, the mother and child, and in this case a third woman, wore shoes that were outlined with red tesserae. Diehl (1918) argued that since the family wore red shoes, their pedigree should be royal.

The nature of the figure to the right of the saint is uncertain. The two robes comprised a greenish-yellow voluminous garment with a white fringe, over a pink tunic with blue spots.

The upper part of S. Demetrios was lost. Initially his stance somewhat resembles that of the Virgin in spandrel D, which suggests a reconstruction of the pose as a prayer of intercession towards the medallion on the right. However, the correct interpretation seems to be that his right hand did reach out towards the right, but his left hand, to judge from the drapery folds, was under his white chlamys and held across his waist. The tablion was blue with red hatching. These positions of his hands and feet indicate probably that his gestures were directed to the right, though like the Virgin in spandrel D his eyes might have been turned towards the left, towards the medallion there.

In this composition the left foot of the child Maria intruded into the border, and the right foot of S. Demetrios into the inscription. The obvious deduction is that the figures were executed before the border and the inscription.

The key iconographic feature of this scene and the preceding one was the offerings of gifts. It seems possible that the two doves on each side of the cross in the inscription below were

[73] p. 146, following Diehl (1918).

a deliberate reference to this theme. The representation of offerings of candles and doves appears in the scene of the Presentation of the Virgin at the Temple of Jerusalem. Grabar (1946) postulated that this mariological iconography of consecration might be the visual source for our ceremony, and that the theme of the dedication of a girl directly or indirectly to God might be common to both. Against this derivation, Lafontaine-Dosogne[74] pointed out that the attitudes of neither the Virgin nor the High Priest in such representations correspond with the figures in our composition. She proposed instead a common source for both in Old Testament or Antique versions of the same theme. Another explanation was offered by Papageorgiou (1908),[75] who referred the two doves to the Mosaic Law (Leviticus 12). This required such an offering after the birth of a child. The age of the girl would seem to exclude this reference. The carrying of candles or doves does in any case have a wide currency in Christian art.

The Maria cycle was terminated at spandrel H with a vertical border. A section of the soffit ornament of arches 7 and 8 was preserved. In arch 7, a plant with green and blue leaves and a gold flower was repeated against a dark ground. The soffit of arch 8 was ornamented with a scheme consisting of a garland with pomegranates rising from a basket, and enclosed by a tube at the central point of the arch. The ground was gold.

The next panel was on spandrel H, and was enclosed by the other border scheme.[76] The right-hand border and some of the composition belonged to phase two repair. This is the panel with which I compared the westernmost composition. S. Demetrios was shown orant, as in the opening panel, and his chlamys was virtually identical. The tablion this time was made up with dark blue and red tesserae. Again he stood in front of a gold *aedicula*, with a shell-shaped niche.

Sheet 8 (PLATE 11a) is a full-size water-colour copy of the head of this S. Demetrios figure. The powerful, almost hypnotic effect of the original is apparent from it. The preserved fragments of this original are now kept in the crypt of the church. The halo was outlined with a single row of red tesserae, disturbed at the top by a crack. The gold tesserae were tilted downwards. The mosaic field on each side of the face was laid in approximately horizontal rows, but above the head there was an adjustment into concentric rings. The clasp on the saint's left shoulder consisted of one row of gold tesserae outlined with one row of red. The collar of the chlamys included some silver tesserae. The hair was rendered in waves either of light green and olive or of blue or black and brown (probably these brown hues were more purplish than George's colours, to judge from Kluge's plate). It is just possible that the front green and olive band was not hair, but a laurel wreath. The ears were pink with red outlines. The face was outlined with one row of tesserae—black around the hairline and shades of brown around the rest. Red tesserae were used in the shadows of the nose and mouth, and at the inner corner of the eyes. Black tesserae were used for the pupils of the eyes, eyelashes, eyebrows, and at the corner of the mouth. The rest of the flesh areas were modelled with tesserae of light colours—off-white, grey-brown, pinks, yellow, and green. Of these, the grey-brown had the darkest tone, and was used in rows for shading within the main outline of the face, down the right side of the nose, and for much of the modelling around the eyes. The field of tesserae followed the main contours of the face, and so formed one of the agents for modelling cheeks, chin, and forehead. The device of laying two colours of tesserae alternately in a row is found within this face, as it is also in

[74] J. Lafontaine-Dosogne, *Iconographie de l'enfance de la Vierge dans l'Empire byzantin et en Occident* vol. i (Brussels, 1964) 149–50.

[75] p. 347.

[76] Illustrated in sheets 4, 8, 13, and 14; Papageorgiou (1908) pl. 4, 8; Uspenskij and Kluge (1909) pls. 1, 4, and 6;

Diehl (1910) pl. 19, 1; Diehl (1918) pl. 30, 1. See G. and M. Soteriou (1952), fig. 77, and A. Procopiou, *The Macedonian Question in Byzantine Painting* (Athens, 1962) pl. 10, for illustrations of the surviving fragment. (A colour slide is available from the firm Lykides.)

several faces in the Rotonda and in the apse of Panagia Angeloktistos, Kiti, in Cyprus, as well as many post-iconoclastic mosaics.[77]

The dimensions are:

Diameter of halo from outside of red rim	11 in. (28 cm.)
Height of head from top to chin	7¼ in. (18·25 cm.)
Maximum width of face, excluding ears	4½ in. (11·5 cm.)
Height of face, to lower edge of hair	4¾ in. (12 cm.)
Length of nose	2¼ in. (6 cm.)
Width of each eye	just under 1 in. (2·4 cm.)
Width of mouth	1 in. (2·5 cm.)
Over-all height of saint	approx. 4¾ ft.

The *aedicula*, whose columns were in inverted perspective, was not symmetrical, and was wider on the right. On each side of the saint stood donors, apparently suspended in mid-air, an impression which was heightened by the manner in which their feet overlapped the border. The donor on the extreme left was beardless, and dressed in a white garment with dark stippling, grey shadows, and a white fringe (no doubt there was some use of silver here). His legs and feet were dark blue, and his hands were draped.

A smaller figure hovered at the left side of S. Demetrios—similar in appearance to the last, except that his robes were patterned with pink spots and gold shadows. His hands were not covered but held forward in prayer. His fingers outlined in black are silhouetted against the saint's chlamys.

The donor on the right wore some kind of ceremonial robe over a silver tunic (colours shown in Kluge's plate). It was pink and red, and decorated all over with white and green crosses. His hands were draped. A blue *aura* was set around his head, mostly in two rows of tesserae, in light blue against a dark blue ground. The *aura* of the donor on the left of S. Demetrios was in light green against the dark green curtain. The third donor also had an *aura*.

Additional information on the right donor is given by the squeeze, sheet no. 13 (PLATE 11*b*). George has written a note on this sheet that 'the face "carries" very badly'. I am not certain what he means by this: possibly the surface of the tesserae was comparatively smooth and tightly set, and George was consequently unable to gain a very sharp impression of the individual cubes. In terms of mosaic technique, we learn firstly that the tesserae of the face were smaller than those used for the body. For example, the tesserae of the face went in size down to 3×2 mm. with the largest, in the hair, being 5×5 mm., whereas on the body they went up to 10×8 mm. These measurements correspond with Kluge's record of the maximum and minimum sizes found by him in the whole series. Secondly, the tesserae on the face were set tightly together, whereas over the body fairly wide and irregular interstices were left (nowhere greater than 3 mm.). Both these characteristics were found by Nordhagen in the Vatican oratory mosaics of 705–7; on the faces he recorded a range from 3×3 mm. to 5×5 mm., and he found interstices as great as 5 mm.[78] These two technical methods occurred, to judge from the photographs, throughout phase one mosaics. As Nordhagen observes, they are characteristic also of other pre-iconoclastic Byzantine mosaics, including phase two in S. Demetrios.

The colours of tesserae on the face were identical with those used in the rendering of S. Demetrios in this panel, except that no red tesserae occurred.

[77] Cf. O. Demus, *Byzantine Mosaic Decoration* (London, 1948) 38. [78] (1965), esp. 146–7.

Only the left side of the inscription four (PLATE 11*b*) was preserved:

✠ Ὑ[πὲρ ε]
[ὐ]χῆ[ςο]
ῦ οἶδ[εν]
ὁ θ(εὸ)ς [τὸ]
ὄνο[μα]
✠

No indication was thus given which of the figures on this panel was the donor: most likely the formula covered all three.

Over the architrave of the panel, set against fern fronds, were two small medallions of saints (about 10 in. in diameter). Both were beardless male busts, and had haloes in gold outlined in red, filling the medallion. Each had a gold clasp for his silver garment. Almost all of the left face belonged to phase two repair. Both these saints' names were originally given in silver against the dark blue rim of the medallion. All of the name of the left saint was destroyed, except for the final two letters ος, and it was not replaced in phase two. It can, however, be deduced from the position of these letters that it was a fairly short name.

Rather more letters survived in the right medallion inscription. This was first read by Papageorgiou (1908)[79] who gave Ὁ Ἁγι[ος] ['Ελλ]άδιος. Uspenskij (1909),[80] however, read the letters as Ἁγ αvος. Diehl (1918) consequently identified the two saints as Cosmas and Damian, whose devotion to healing was accepted by Hoddinott (1963) as being specially appropriate in an *ex voto* panel. Unfortunately for such a transcription the reading given by Kluge in his coloured drawing was Ὁ Ἁγι δρος.

George's sheet no. 14 (PLATE 14*a*) is his squeeze, which he has coloured to show the individual tesserae of the letters and background. The letters were minute—only $\frac{3}{4}$ in. in height. On the left we see Ὁ Ἁγι[ος]. After the lacuna, the surviving last four letters of the saint's name were . . . δρος (a crack runs through the rho). George had accordingly reconstructed the name as ['Αλέξαν]δρος. It must certainly have been a name of about this length. It might be noted that inscriptions only seem favoured in these mosaics for the more obscure saints (for whom there was incidentally no portrait tradition of any kind), which does make Cosmas and Damian unlikely candidates. Presumably the saints chosen for portrayal in these panels had some special importance for the donors.

Phase Two

Much of the upper part, including the whole of the top edge, of the mosaics had been totally eroded, so that a large proportion of the area of phase two mosaic was lost. Much of this, however, consisted of decorative bands.

With the exception of the medallions above arch 6, the new mosaics of phase two added no new figurative composition to the north inner aisle cycle. Indeed the restoration is characterized by its minimal nature and negative qualities. Lack of attention is evident in incorrect and careless repairs. For example, there was the lack of concern to restore the original nimbus in the medallion of Christ over arch 7, or to complete damaged inscriptions. Another feature was the apparent shortage of appropriate new tesserae for matching colours (for example, the dark blue).

George's comments on the technical differences between the two phases were reported by

[79] p. 343. [80] p. 59.

Dalton (1911),[81] and are as follows: the red of phase one was 'vitreous and of a carmine tint', whereas the red of phase two was 'bricky and vermilion'. The black of phase one was less opaque than phase two. Phase one used glass for white whereas phase two used marble. The pear-shaped drops in the alternate darker borders between panels were silvered in phase one but white marble in phase two. The 'gold tesserae of haloes etc.' were inclined forward in phase one, but in phase two they were in the plane of the wall.

An absence of silver tesserae, and a reduction in the number of glass tesserae in favour of marble (compared with certain earlier local mosaics) has been observed in Rome in the mosaics executed for Pope John VII (705–7) in an oratory in the Vatican.[82] Nordhagen interpreted the resultant combination of glass and marble tesserae as being a Byzantine workshop method imported into Rome, distinct from the local tradition using more glass. However, this particular correlation between the two phases in S. Demetrios and two phases of mosaics in Rome may have to be explained, at least in part, in broader terms, for example as due to an increased financial stringency or other practical considerations.

If we follow the area of phase two mosaics[83] from west to east, the first section was in spandrel B, where a small section of the *aedicula* and border was adequately replaced above the suture. The suture then ran along the upper edge of the panel of spandrel C. The argument that this panel is a later addition to the cycle on the ground that the haloes cut into the border above is clearly erroneous. On the other hand it is apparent that the horizontal level of the upper border was determined by the mosaicists of phase two, since the phase one mosaics run right up to, but never include any part of, the horizontal border above the panels. The original phase one border could therefore have been higher.

To the right of spandrel D, the level of the suture dropped a little, to cut off the head of the standing woman (Virgin?) and most of the medallion over arch 5. It rose again at the left side of spandrel E, but only to drop diagonally across the whole surface at the right side, below the head of the right angel and donor, and finally meeting the apex of arch 6. The suture then rose quite sharply to the base of the architrave of spandrel F, and was approximately horizontal across the remainder of the Maria episodes. Thus all the sections representing the sky in horizontal strips belong to phase two. Then the suture crossed spandrel H. The upper part of the left medallion was a phase two repair. The suture ('joint') touched the upper edge of the conch of the *aedicula*—though George also showed a crack running below the 'joint', touching the halo of the saint, and again crossing the right-hand medallion to meet the suture at the architrave. Finally, the suture ran roughly vertically, reaching arch 9 just to the right of the donor's feet. Thus all the vertical border concluding the cycle is the work of phase two.

A feature entirely belonging to phase two was the frieze surmounting the cycle. The main band was 9 in. in height, and consisted of a continuous spiralling ribbon against a brown ground. One side of the ribbon was red and the other green. The impression of turning in space was achieved by modelling successively paler shades of the same colour. Outside the ribbon, the spaces were occupied with an alternately upright and reversed decorative form, which George showed white or light brown. Many sections were missing.

The three medallions of arch 6 were set above inscription five, laid out in a *tabula ansata* (5½ ft. × 7 in.). All of these belong to phase two.

[81] p. 379 n. 1.
[82] (1965), esp. 150 ff. His theory has difficulties; e.g. SS. Cosmas and Damian must be interpreted as local work, and S. Lorenzo fuori le Mura must be severely carved up into sections.

[83] Illustrated in sheets 1–4; Papageorgiou (1908), esp. pl. 3, 6; Uspenskij and Kluge (1909), esp. pls. 8 and 9; Diehl (1918) pls. 30, 32 and fig. 46.

Inscription five (PLATES 4, 8)[84]

✝ 'Επὶ χρόνων Λέοντος ἡβῶντα βλέπεις
καυθέντα τὸ πρὶν τὸν ναὸν Δημητρίου.

The medallions were set on a plain green ground, and were slightly under 2 ft. in diameter, increasing slightly in size to the right. The S. Demetrios medallion was slightly to the left of the centre of the apex of the arch. The inscription also was placed to the left of centre, so that its left end was on the suture, where the wing of the angel should have been continued. Its right end did not reach the suture again, but the phase one *aedicula* was restored in this space; however, where I have postulated the existence of a medallion in phase one, the phase two workers seem to have left a blank mosaic surface.

The left medallion showed a cleric holding a codex. He was surrounded by white and blue bands, concentric with the medallion outline. His head was largely bald, his forehead wrinkled, and he had a large bushy white beard. His garment must be a sticharion, with a narrow orarion over his left shoulder. The codex was ornamented with green and red precious stones. There can be no doubt that this was the same priest who appeared together with S. Demetrios on the east face of the right pier at the entrance to the chancel. Moreover, the right medallion figure can be identified with the figure, probably an archbishop, on the right hand of S. Demetrios on the north face of this pier. It is accepted that the representations of these two figures in different parts of the church were contemporary in date. The right medallion figure wore an omophorion around his shoulders, and held a codex in draped hands. He had a thick dark beard, but his tidy black hair was lost in this medallion representation. Within the limits of the conventions of the period we seem to have an attempt to show the individual as he was. The prominence of these representations may be a reflection of the power in the hands of the local clergy in this period.

The medallion of S. Demetrios was placed slightly higher than the other two, but the saint was represented on the same scale as his companions. His gold halo was surrounded by concentric rings of shades of blue. He does, in George's copy, appear to be wearing a green wreath across his hair. He stared straight forward. His chlamys was fastened with the usual gold clasp, and decorated with a prominent green and red wheel shape and red trefoil. S. Demetrios wore an identically decorated chlamys in the panel with four ecclesiastics on the west wall of the nave, which may also be a part of the phase two work.[85]

This section of phase two mosaics raises two problems. Firstly, the precise reason for the choice of this particular arch is uncertain. The placing of the three medallions and their accompanying inscription is approximately in the centre of the arcade, and not, consequently, in the centre of the known mosaic area. Secondly, I have suggested above that the three medallions were substitutions for a phase one decoration over arch 6 consisting of an *aedicula* with a hanging lamp, a large medallion of Christ, and a smaller medallion of a saint. If this is correct, then the idea of having medallions here was not new. The problem is, however, whether the new scheme was meant to be understood as fully integrated into the old and, if so, whether the Virgin was now actually believed to be addressing her prayer to S. Demetrios.

It is impossible to be certain about the extent of mosaic decoration on the arcade in either phase. In 1907–8, when the complete arcade was cleared of Turkish plaster, the eastern section

[84] Translation: 'Made young again in the times of Leo, you see the church of Demetrios, previously burnt.' The theme is clearly restoration. The first vowel of Demetrios was written as η, not ι, as it was in the inscription three of phase one.

[85] Illustrated by Hoddinott (1963) pl. 33 (c). Probably it was this same wheel shape which appeared on the thigh of S. Onesiphoros in the Rotonda, obscured by his chlamys: illustrated by W. F. Volbach, *Early Christian Art* (London, 1961) pl. 126.

beyond spandrel H was found to be decorated with Byzantine wall-painting, instead of mosaic. When repair work was carried out, this wall-painting was once more plastered over, and the section was never again exposed to view before it was destroyed in 1917. Consequently knowledge of this wall-painting is confined to the inadequate verbal descriptions of Papageorgiou (1908) and Uspenskij (1909). The masonry of the arcade was never systematically surveyed.[86]

The cycle of wall-paintings began on the right side of spandrel H, and, stretching over arches 9–12, completed the decoration of the north inner aisle arcade. The scenes illustrated the martyrdom and miracles of S. Demetrios.[87] Uspenskij (1909) dated the paintings to the fourteenth century from a comparison with the decoration of the chapel of S. Euthymios, added to the church in 1303; but since Papageorgiou (1908)[88] had observed three layers of frescoed plaster, Uspenskij's dating would only apply to the latest layer. The precise extent of wall-painting throughout the church at different times cannot be defined, but G. and M. Soteriou (1952) date certain fragments before the fire, and others to the seventh century[89] and various later dates. Accordingly, the decoration of the church both before and after the fire must be characterized as a combination of various media. Indeed the integration of fresco, mosaic, and marble revetment is familiar in Byzantine churches from a variety of regions and dates. In Thessaloniki, the combination occurred in the Rotonda, the Basilica of the Virgin, S. Sophia, and the Holy Apostles, though mosaics and wall-painting are not contemporary in the former three. On the present evidence, it therefore seems impossible to specify whether this combination of mosaic and fresco on this arcade was the original scheme or a modification.

CHRONOLOGY

The importance of these mosaics is naturally impossible to assess without some consideration of their date. The chronological indications are of two kinds, firstly the historical evidence concerning the structure of the church, and secondly the internal evidence given by the mosaics themselves.

The mosaics of phase one are given a *terminus post quem* by the time of the structure of the church. Furthermore, according to the inscription the mosaics of phase two belong to restoration work after a serious fire. It follows that the determination of the dates of the fire and restoration would simultaneously place phase two and supply a *terminus ante quem* for phase one.

The documentary and structural evidence about the foundation of the present church (extensively rebuilt after 1917) has been most thoroughly evaluated by G. and M. Soteriou (1952). They duly emphasized the tradition given in the anonymous prologue of the *Miracula*, which attributes a church of S. Demetrios to a prefect of Illyricum named Leontios. The text offers no indication of his period of office, but he has been commonly identified with a prefect Leontios documented in 412 and 413. Their final conclusion was, however, that the material remains of the structure and also the coin finds all pointed to a time in the second half of the fifth century.[90] A date in the last years of the fifth century was proposed by Krautheimer (without apparently being aware of the conclusion of G. and M. Soteriou). He speculated that there

[86] The wall-painting is visible in Papageorgiou (1908) pl. 4, 8. The state of this section of the arcade is illustrated by Boissonnas (1919) pl. 27. G. and M. Soteriou (1952) date the extreme east end of the arcade to the seventh-century restoration.

[87] Papageorgiou (1908) pl. 11, 1; and Uspenskij (1909) 59–61, give their transcriptions of the *tituli*.

[88] p. 335.

[89] P. J. Nordhagen, 'The Frescoes of John VII (A.D. 705–7) in S. Maria Antiqua in Rome', *Acta ad Archaeologiam et Artium Historiam pertinentia*, iii (1968) 110, is ready to accept a mid-seventh-century date for at least one of the wall-paintings in S. Demetrios; cf. G. and M. Soteriou (1952) pl. 75, pp. 204 ff.

[90] See esp. pp. 246–7. Out of 108 fifth-century coins, only one belonged to the first half of the century.

must have been a previous fifth-century church of S. Demetrios, and that it was the apse of this which survives in part below the later building.[91]

Fundamentally, their attribution of the structure to the late fifth century depends on the research by Kautsch, who argued that no capitals in the church could be earlier than the last quarter of the fifth century, and so favoured a date around 500.[92] Current research does, therefore, favour a date towards the end of the fifth century for the construction of the church. Admittedly this conclusion can only be finally assessed when greater precision has been achieved on the dates of certain other major Balkan churches which seem contemporary with or dependent on S. Demetrios.[93] In particular, the proportions and sculptural decoration of the Basilica of the Virgin suggest a date close to that of Demetrios, and might even be attributed to the same masons. Krautheimer dates it a little earlier than S. Demetrios, but later than the Studios Basilica in Constantinople (c. 463).[94] He makes it contemporary with Basilica A at Nea Anchialos (which he puts c. 470). As for the two churches which may derive features from S. Demetrios, Krautheimer accepts a date around 500 for Basilica A at Philippi, and a time in the first quarter of the sixth century for the Basilica of Bishop Philip at Stobi. Such an account of Balkan architecture does have the advantage of consistency, and in my opinion must be accepted for the present, pending further research on sculptural decoration in this region. On this basis, I accept a date towards the end of the fifth century for the building, and this gives us our *terminus post quem* for the mosaics.

The dating of the fire which necessitated the restoration of the church is our next consideration. The *Miracula* text supplies some account of the history of the church; there is only one suitable major fire mentioned. The problem of its precise date has been the subject of several studies which have coincided in their conclusions without agreeing on the treatment of the textual evidence.[95] The first systematic discussion of a full text of the *Miracula* was contributed by Tafrali (1909).[96] He put the fire between 629 and 634, and eventually decided that the restoration work was carried out without much delay, probably in the reign of Heraclius (i.e. before 641).

The story of the fire is narrated in Book 2 of the *Miracula*, and its dating has to be fixed by establishing, where possible, at what time the other events described in this book occurred. The first three chapters are concerned with events soon before and after the death of Archbishop John (the author of Book 1), who is known to have come to office after 603 when his predecessor Eusebios is last documented.[97] The form of this section is narrative, unlike Book 1, which is an anthology of homilies. Chapter 3 describes as having occurred in rapid succession the death of John, the occurrence of earthquakes in Thessaloniki, the arrival of Slavs anticipating plunder, and the fire in S. Demetrios which destroyed the roof and some of the interior. It also tells of S. Demetrios's appearance in a dream to one of the clergy, promising the full restoration of the church. The author of Book 2 then refers to the church as he knew it as 'ὁ ὑπερκαλλὴς οὗτος καὶ ἰαματοφόρος οἶκος ἀνιερώθη', so that the restoration had been carried out when this book was written.

[91] R. Krautheimer, *Early Christian and Byzantine Architecture* (London, 1965) 96–7 and 328–9 n. 49. Certain of the chronological features adduced by him require proper documentation (e.g. 'patterns of marble revetment, brickwork of piers, and rhythm of support and arcades'). See pp. 90–101 for discussion of late fifth-century churches in the Balkans.
[92] R. Kautsch, *Kapitellstudien* (Berlin and Leipzig, 1936), esp. 72–5.
[93] For a convenient bibliography on these churches see

Krautheimer and Hoddinott (1963); the latter favours an early fifth-century date for the group, but with insufficient justification.
[94] Cf. Kitzinger (1958) n. 86, who accepts a date c. 450.
[95] On the secondary literature, see Kitzinger (1958) nn. 101–2. [96] Cited in n. 10.
[97] L. Petit, 'Les évêques de Thessalonique', *Échos d'Orient* iv (1900–1) 136–45, 212–21, and v (1901–2) 26–33, 90–7, 150–6, 212–19, has the documentation for the pre-iconoclastic archbishops.

This account can be correlated with only one externally documented fact. The death of archbishop John must have preceded 649, when the holder of the office is mentioned in a papal letter as being Paul.

The writer of Book 2 specifies that the events of chapters 4 to 6 occurred later than those of the previous chapter. The length of the hiatus, and the relative order of the episodes related in chapters 4 and 5 is not easy to ascertain (chapter 4 concerns Perbund and the 'long siege'; chapter 5 the Kouver episode). Tafrali's dating of the events of chapter 4 to 634 has been rejected.[98] Yet his attribution of the fire to a date around 630 is accepted. Lemerle put the death of John c. 620–30, the fire a little after it, and the restoration probably very soon after the fire. Barišić put the death of John c. 630, the fire c. 635, and the restoration c. 640–50 (though such a time-lag of twenty or so years seems excessive).

As for the date of composition of Book 2, by which time the restoration was definitely complete, Burmov proposes the 670s, and Barišić and Lemerle the 680s. The omission of any reference to the visit of the Emperor Justinian II to Thessaloniki presumably supplies a *terminus ante quem* of 688/9.[99]

Some additional information supplied by the mosaics is difficult to use. The dating indication of inscription five, ἐπὶ χρόνων Λέοντος, assumes that the reader is familiar with local events and chronology, as the *Miracula* text does (with a few exceptions): neither gives the period to which it refers a more than parochial label. The Leo referred to cannot be an emperor, for there are no candidates in this century. Probably a local official or archbishop is meant. Tafrali (1909) discovered an unedited rubric on folio 62 of the *Miracula* text contained in the twelfth-century manuscript in Paris (Bibliothèque Nationale, gr. 1517). This section referred to the fire and was headed: ἐπὶ τῶν χρόνων Λέοντος ἐπάρχου. He reasonably accepted that this prefect Leo was the Leo of the inscription.[100]

The inscription below the phase two Founders' panel on the right pier at the entrance to the chancel refers to an abortive naval attack on the city.[101] If this event is connected with the *Miracula* narrative of Book 2, two records of naval attacks need consideration; the Chatzon episode, described in chapter 1 and mentioned again in chapter 3 (usually dated c. 620), and the Perbund episode in chapter 4. In the latter, 25 July of a fifth indiction is mentioned, so that the possible years for the attack are 632, 647, 662, 677, or 692. Tafrali (1909) implies 632, Kitzinger (1958) and Burmov favour 647, and Barišić, Lemerle, and Breckenridge accept 677. Thus we cannot be certain when either attack occurred, nor even whether one of them is referred to by this inscription. The dating of this naval attack would supply a *terminus post quem* for phase two.

[98] F. Barišić, *Чуда Димитрија Солунског као историски извори* (Belgrade, 1953), esp. pp. 81 ff., proposed a lacuna of some considerable time between chapters 1–3 and 4–6, but this was not the opinion of two other scholars; P. Lemerle, 'La composition et la chronologie des deux premiers livres des *Miracula S. Demetrii*', *Byzantinische Zeitschrift* xlvi (1953) 349–61; P. Lemerle, 'Invasions et migrations dans les Balkans depuis la fin de l'époque romaine jusqu'au viiiᵉ siècle', *Revue Historique* ccxi (1954) 265–308; and A. Burmov, 'Славянските нападения Срещу Солун в „Чудесата на св. Димитра" и тяхната хронология, *Годишник на Философско-Историческия Факултет на Университет София, книга* ii (*история*) xlvii (1952) 167–213. Burmov dates Perbund to 645–7 and Kouver to the 660s; Barišić and Lemerle date the Perbund episode to 674–7. Barišić dates Kouver to 680–5, whereas Lemerle identifies him with the Bulgar Kouvrat or Kovratos, known to have been in revolt in 635, and thus dates chapter 5 to 635–. This

latter dating reverses the chronological order of chapters 4 and 5, and would give a *terminus ante quem* for the fire of 635–.

[99] Cf. J. D. Breckenridge, 'The "long siege" of Thessalonica; its date and iconography', *Byzantinische Zeitschrift* xlviii (1955) 116–22.

[100] For a definition of ἔπαρχος or ὕπαρχος see Lemerle (1954), cited in n. 98, pp. 270 ff.

[101] Traced in sheet 17: ✠ Κτίστας θεωρεῖς τοῦ πανε[ν]δόξου δόμου ἐκεῖθεν ἔνθεν μάρτυρος Δημητρίου/τοῦ βάρβαρον κλύδωνα βαρβάρων στόλω(ν) μετατρέποντος κ(αὶ) πόλιν λυτρουμένου ✠. As in inscription five, the first vowel of Demetrios was an η. The founders must be contemporary with the phase two restoration; one is probably the likeness of the living archbishop (later in date than John); the other of the prefect Leo, if Tafrali (1909) is right. If the priest on the east face of this pier is the one of chapter 3, then the restoration took place in his lifetime too.

To summarize: the most acceptable date for the building of S. Demetrios is one in the last quarter of the fifth century. The church was severely damaged in a fire which occurred after 603 and before 649, and was reconstructed soon after this, certainly by the time of the Justinian II visit in 688/9. This gives for phase one a *terminus post quem* of the last quarter of the fifth century and a *terminus ante quem* of 649; and for phase two a date between 603 and 688/9.

The additional information on the north inner aisle mosaics supplied by the drawings of George prompts a reconsideration of the date and context of the mosaics. The period from the fifth to the seventh century, within which both phases belong, is one in which scarcity of monumental art in the Eastern Mediterranean has deprived us of the evidence that would enable us to describe the growth and development of Justinianic art. Another effect of this lack is to make it difficult to distinguish the regional and other determining forces on the means of expression and content of art in Constantinople and other major cities. The contribution of the S. Demetrios mosaics to our understanding of the period can only be exploited when their place within the period has been ascertained.

Kitzinger (1958) dated the phase one mosaics on stylistic evidence to the end of the sixth or beginning of the seventh centuries, allowing the possibility that their execution was spread over several decades.[102] Secondly he dated the phase two mosaics after the fire, put on the historical evidence between 620 and 640, and before c. 650 at the latest.[103] In coming to a decision, Kitzinger reviewed previous dating attempts;[104] his decision was in close agreement with Lazarev,[105] who had in turn been influenced by Kondakov (1915). The latter had on stylistic and iconographic grounds excluded a date for the phase one mosaics before c. 600. Kitzinger, however, added substantial new arguments in favour of approximately 600 for this phase, based on stylistic considerations.

The crux of Kitzinger's reasoning lies in a recognition of a transformation of compositional manner between phase one and phase two (my terminology). He illustrated this with reference to the S. Demetrios and Donors panel, on the west wall of the south aisle, and the Founders' panel, on the north face of the right pier. He characterized the phase one composition as containing a relatively flat and linear depiction of the saint together with 'dematerialised', out-of-proportion donors; and pointed out the consequent odd contrast between these and their setting, a landscape with architecture boldly sketched in the manner inherited from 'hellenistic impressionism'. Thus the compositions of phase one were characterized by Kitzinger as an abstract linearism superimposed on to hellenistic impressionism. The resultant timidity in the compositions of phase one is contrasted by Kitzinger with a new firmness and precision of line and colour exhibited in phase two, both in figures and in the over-all organization. The figures achieve a new and successful abstract mode of expression; by abandoning realism, they have gained expressiveness and coherence. In contrast to this radical transformation of style, there is noticeable similarity in the portrayal of the saints, particularly the representation of the face of S. Demetrios, in both phases. Kitzinger accounted for this by arguing that phase two was close in time to phase one, but that it had been inspired by the new Constantinopolitan ideas. Kitzinger suspected that the work was not actually executed by Constantinopolitan

[102] Esp. p. 22.
[103] Esp. p. 26.
[104] Esp. p. 21. Among the number of those who deny or ignore the relevance of the fire as a *terminus ante quem* may be added Grabar (1957), esp. 85. No reassessment of the evidence has appeared since Kitzinger; cf. however comments by Hoddinott (1963), 141–55; G. Matthiae, 'La Cultura figurativa di Salonicco nei secoli V e VI', *Rivista di*

archeologia cristiana 38 (1962) 163–213; and K. Kalokyris, 'La basilique Saint Démétrius de Thessalonique: ses mosaïques', *Corso di cultura sull'arte ravennate e bizantina* xi (1964) 224–36.
· [105] V. N. Lazarev, *История византийской живописи* (Moscow, 1947) 56 ff. and 288–9 n. 12. The second edition reaffirms his opinion, *Storia della pittura bizantina* (Turin, 1967) 35 and 56 n. 24.

workmen (on grounds of quality), but he regarded the mode of expression as purely metro-politan, without any significant local characteristics. Thus, in Kitzinger's opinion, phase one marked the extreme point of an increasingly eccentric development of local art, whereas phase two marked the introduction of a contemporary fashion from the capital.

While recognizing the validity of Kitzinger's characterization of the general styles of the two phases, we must nevertheless reconsider his deductions in the light of the new details supplied by George's drawings.

The mosaics of phase two were of two kinds, either entirely new inventions (as the panels of the chancel piers, set near ground level) or else restoration work (as in most of the north inner aisle work). The boundary of this restoration work can be seen. There are three explanations as to what necessitated this work, which we are told was carried out in the restoration after the fire: firstly, that the earlier mosaics were already in poor condition, and that the oppor-tunity was taken to repair them; secondly, that the earlier mosaics had been damaged during the fire; or thirdly, that the earlier mosaics had to be partly replaced during the restoration or alteration of the structure. The condition of the mosaics in 1909, when a considerable area particularly along the upper edge of the mosaics had again been lost, makes the first explana-tion at least plausible. However, the existence in 1909 of a gallery over the north outer aisle, the joists of whose floor are supported above the arcade at the level of the phase two work points to one of the other explanations. The other end of the joists of this gallery had been inserted into a set of wall-paintings, which were mutilated by the new structure.[106] The evidence of these wall-paintings is that there was never an alternative level of flooring, and so it can be assumed that there was no gallery above the north outer aisle in the original structure. The arcade would have supported only the inner gallery and roof and an outer roof; the wall above the arcade would have been pierced for lighting purposes only (so that it could even have held further decoration of phase one).

That the phase one mosaics were damaged by the burning of the joists of an existing gallery is rendered unlikely for two reasons: one, that the fire was in the south part of the church, the other, that there was no evidence that the gallery had ever had to be substantially repaired.

The insertion of the joists of the new gallery would have necessitated the destruction and re-placement of the upper area of the phase one mosaics. The presence of a single suture thus implies that the phase two mosaics were the repair of this damage; and that the latter were put up during the restoration of the church after the fire is not in doubt. The frieze above the phase two work does terminate the mosaic decoration at the level required by the existence of the gallery. The mosaic evidence therefore supports the conclusion of G. and M. Soteriou (1952) that the addition of the outer gallery system belonged to the general enlargement of the capacity of the church undertaken after the fire. This satisfactorily explains the presence and position of the suture.[107]

The noticeably low standards in the execution of the phase two repairs, combined with anomalies in the portrayal of garments observed by Kitzinger (1958),[108] leads me to conclude that all this group of mosaics was in the hands of local artists. Certain other considerations seem to support this conclusion. It is compatible with the circumstances of Thessaloniki in the seventh century, when the city was surrounded by *Sclaviniae* and almost inaccessible from

[106] G. and M. Soteriou (1952) 103 ff.; 205, fig. 26; pl. 27.

[107] The only earlier possible occasion for major altera-tions known from the *Miracula* was the burning and recon-stitution of the *ciborium* between 580 and 586 (Book 1, Chapters 6 and 12). However there is no mention of serious damage or repair work to the structure. This occasion is of course also a possible one for the mosaics of phase one.

[108] See n. 105.

Constantinople.[109] It resolves two problems: firstly, Kitzinger used coins as evidence of contemporary artistic fashions and as an index of Persian influence in the court of Heraclius, yet this medium is frequently a conservative one. Secondly, Kitzinger was induced to shift the date of the Sinai mosaics to a time later than the foundation of the monastery between 548 and 562. The recent examination of these mosaics has, however, confirmed the attribution to the original Justinianic structure.[110] Thus the abstract principles which stimulated the formulation of the phase two style were evidently evolved almost a century earlier than the execution of these mosaics in S. Demetrios. For this reason, their attribution to a local workshop influenced at some time in the previous century by Constantinopolitan art seems more likely than a contemporary new metropolitan intrusion.

Kitzinger's observations on the local affiliations of the technical methods of the phase one mosaics do seem conclusive.[111] Thus we have in one church the work of two local workshops, the later of which has transformed its style under the influence of a school whose principles are first documented elsewhere in the Greek East around the middle of the sixth century. The obvious deduction is that the earlier phase one mosaics belong to a period before the middle of the sixth century. If a local context for both phases is acceptable, then the marked differences of style between the two are likely to be the consequence of a considerable lapse of time between them.

An earlier dating for phase one would remove one anomaly of Kitzinger's account. Granted the pervasive influence on local artists of the mosaics of the Rotonda, datable around 400,[112] it seems unreasonable that the artists of a major city of the Empire in a time of good communications could be so thoroughly influenced by one monument and yet remain open to no further outside stimulation for up to two and a half centuries. The very dependence of phase one on the Rotonda is an argument in favour of an earlier date than c. 600.

One factor which may be thought to support a close dating of the two phases needs consideration, namely the similarity of the portrayals of S. Demetrios. Kitzinger pointed out the over-all weakness of the phase one compositions, in which the presence of the cult figure is dulled in impact by the indecisive nature of its setting. The truth of this observation is demonstrated by the north inner aisle mosaics, especially in the Maria cycle. Yet Kitzinger was unable to recognize from the photographic record the quality and power of expression of individual faces of saints, which is revealed by George's record, as, for example, S. Demetrios in spandrel H (PLATE 11a).[113] It does not seem too much to suggest that such details of the phase one figures were a direct inspiration to mosaicists after the fire, when they had the opportunity to observe

[109] The theory of the middle and second half of the seventh century as a period of great artistic activity in Thessaloniki derives from J. Laurent, 'Sur la date des églises St-Démétrius et Ste-Sophie à Thessalonique', *Byzantinische Zeitschrift* iv (1895) 420–34, where it depends on erroneous attributions of the structures of both these churches to this period. A more realistic picture of conditions in Thessaloniki is given by J. L. Teall, 'The Grain Supply of the Byzantine Empire, 330–1025', *Dumbarton Oaks Papers* xiii (1959) 89–139 and G. Ostrogorsky, 'The Byzantine Background of the Moravian Mission', ibid. xix (1965) 3–18. It must be admitted that the *Miracula* despair over money and workmen (cited n. 24) might be seen as an indication of outside assistance for the restoration.

[110] Cf. K. Weitzmann, 'The Mosaic in St. Catherine's Monastery on Mount Sinai', *Proceedings of the American Philosophical Society* cx (1966) 392–405.

[111] His list on p. 23 may be increased: e.g. the ornamental use of oval and rectangular cabochons, cornice decoration on the *aediculae*, alternation of straight and twisted fluting on columns, forms of capitals, details of garments, etc. in the north inner aisle mosaics may derive from the Rotonda; so might the fir-cone form on the *aedicula* of the south aisle donor panel, which also appeared in the Onesiphoros panel.

[112] Lazarev (cited in n. 105) in 1947, p. 41, accepted an early sixth-century date for the Rotonda, but revised his opinion in 1967, p. 35 and p. 56 n. 24. When he accepted the attribution to c. 400, he made no corresponding adjustments to his dating of other mosaics in Thessaloniki.

[113] The face of S. Demetrios on the west wall of the south aisle has, I suspect, suffered from modern restoration work. The saint stands in front of a panelled door, presumably of his *ciborium*.

them closely from the scaffolding necessarily erected in the north inner aisle. Thus if we compare the face in spandrel H with, for example, the phase two S. Demetrios on the east face of the right pier,[114] the latter appears to be a slightly weaker derivative of the former. The phase two drapery is more advanced in stylization and schematization of folds. The mosaicists of phase two might have learnt their techniques from earlier works in Thessaloniki, and at the same time have developed the new compositional principles exhibited on the panels out of a knowledge of works in other media: for example, portable icons. If this were so, the similarity between the phases would not necessarily be an indication of a similar date.

Other arguments for a dating of phase one around 600 do not seem conclusive either. For example, the scheme of the enthroned Virgin with angels and intercessors seemed to Kitzinger a development of the seventh-century interest in cult icons. However a case can be made for dating the encaustic icon of the enthroned Virgin, belonging to the Sinai collection, to the middle of the sixth century at the latest.[115] The scheme of the Virgin enthroned between archangels is familiar on mid-sixth-century ivories, such as the Berlin diptych,[116] which does also include an *aedicula* with a shell niche and curtains similar to those found in phase one. The use of two stylistic 'modes' is seen in such works and distinguishes the cult figure from secondary persons. This device was, according to Kitzinger (1958), developed as a vehicle of metaphysical expression in the period between Justinian and Iconoclasm. However, leaving aside the question of the interpretation of 'modes', the formal composition is most likely a survival from Imperial Roman art, which employed the scheme in portraying the ruler between followers or allegorical figures.[117] The scheme appears on the base of the Theodosian obelisk, in consular diptychs, in the Dioscurides manuscript in Vienna (National Library, cod. med. gr. 1) folio 6, and elsewhere. The consular diptychs from Constantinople in the sixth century document a scheme of a consular figure set in an *aedicula*, against which are fixed medallion busts; but the scheme is found earlier in the Calendar of 354.[118] Such parallels, therefore, do not point particularly to a late sixth- or early seventh-century date for the phase one mosaics.

The possibility of a fifth-century dating for some of the mosaics before the fire was considered by G. and M. Soteriou (1952) and other scholars. No more than general principles seem to have contributed towards such a view. Presumably an interest in, but failure adequately to apply, 'hellenistic' ideas is seen in the purposeless backgrounds of the scenes, and in the stiffness of the figures and their schematic drapery, and this is felt to be typical of the fifth century. Or the growth of a non-naturalistic use of colour and the frequent but rather random application of gold might seem to fit in general terms into the same century which produced S. Maria Maggiore in Rome and the Mausoleum of Galla Placidia in Ravenna, and possibly manuscripts like the Cotton *Genesis* or Ambrosian *Iliad*. However, no systematic attempt has been made to justify a late fifth-century date for phase one, owing partly to the lack of comparative material, and partly to the common belief that the structure of S. Demetrios belonged right at the beginning of the century. As there seem to be no overriding considerations leading to the acceptance of a sixth-century date, we should consider whether a dating of the phase one mosaics to the time of the construction of the church in the last quarter of the fifth century is a more satisfactory solution.

It is a reasonable hypothesis that such a foundation, containing a wealth of silver and marble,

[114] Illustrated by Hoddinott (1963) pl. 32 (*b*).
[115] Cf. M. Chatzidakis, cited in n. 63, who believes the icon was part of a set sent from Constantinople for the foundation.
[116] Illustrated by W. F. Volbach, *Early Christian Art* (London, 1961) pl. 225.

[117] The scheme is characterized as 'Trabantenbild' by P. E. Schramm, 'Das Herrschbild in der Kunst des frühen Mittelalters', *Vorträge der Bibliothek Warburg* ii (1922-3) 1, 145-224, esp. 177 ff.
[118] Cf. H. Stern, *Le Calendrier de 354* (Paris, 1953).

was likely to have a considerable number of mosaics, as must its close contemporary, the Basilica of the Virgin. While it does not necessarily follow that the north inner aisle cycle was donated by subscriptions at the time of foundation, the similarity of these soffits with those in the Basilica of the Virgin does suggest the contemporary decoration with mosaic of this area of the church. At the time of foundation, the apse of the church was presumably decorated with mosaic. This seems likely to be the time also of the mosaic panel of the prefect Marianos on the western exterior façade of the church, which is mentioned in the *Miracula*, Book 1, Chapter 1.[119] One would indeed expect the person represented in this position to have been the Ktitor of the structure.

Other mosaics in the church which might have been original are the panels on the west wall of the south and north inner aisles. Lazarev did actually date these two around 500; in his opinion they were a century before the north inner aisle arcade mosaics.[120] Kitzinger (1958) accepted both panels as belonging before the fire, while pointing out that they were not identical in style.[121] He conclusively connected the south aisle panel with the style of the phase one mosaics of the north inner aisle arcade, and their contemporaneity may be confirmed in fuller detail by comparison of the panel with the figures of spandrel B or the setting of spandrel H. Furthermore Kitzinger (1958) demonstrated the affinities of style between the apse mosaics of Hosios David and the south aisle panel and phase one of the north inner aisle arcade.[122] Thus we have a group of mosaics produced by one or more local workshops for which a late fifth-century date must be considered: viz. the Basilica of the Virgin (soffit decoration), S. Demetrios (mosaics before the fire), and Hosios David (apse decoration). In the case of the last such a time would resolve another difficulty in Kitzinger's dating, namely that few or no traces occur of the approach or impact of Justinianic art.

The paucity of other survivals of the period precludes a systematic comparative analysis. A comparison of Hosios David with the Mausoleum of Galla Placidia is unsatisfactory, because even in datable mosaics of the period different functions and traditions make for incompatibility of reference.[123] On the other hand, some observable similarities between the Enthroned Virgin of spandrel C and the apse of Panagia Kanakaria are unhelpful, because the Cypriot monument could belong to either the fifth or the sixth century.[124]

Recently, however, one new mosaic fragment has been published and usefully compared with our group.[125] This fragment consists of two medallion heads which were fixed on to the base of a Roman statue when this was adapted for use as part of the ambo of Basilica B at Nicopolis. Since Bishop Alkisson was responsible for this church, a probable *terminus ante quem* of 516, when he died, is implied. The fragment is too small for the compositional style of the mosaics to be determined, but Xyngopoulos compared the two faces with heads from the Rotonda and with the angel in Hosios David. The Nicopolis mosaics appear at a slightly further remove in quality from the Rotonda than Hosios David, yet the method of

[119] See section 3. The episode is entitled: Περὶ τοῦ ἀπελπισθέντος ἐπάρχου. This verb appeared in the inscription below the south panel of the left pier, cf. Uspenskij (1909).

[120] Cf. the second edition (1967), cited in n. 105, p. 73, and p. 98 n. 17.

[121] nn. 74 and 90. He does not discuss at length the 'Apotheosis' of S. Demetrios panel (illustrated by Hoddinott (1963) pl. 4, facing p. 142. The stylized clouds and angel emerging from the sky could be forerunners as easily as 'echoes' of S. Vitale, since both features occur in S. Maria Maggiore in Rome.

[122] pp. 23-4.

[123] Cf. S. Kostof, *The Orthodox Baptistery of Ravenna* (New Haven and London, 1965), esp. 124-36. A case can be made for attributing the Orthodox Baptistery and Mausoleum to the same workshop, and for deriving its traditions from Rome. The analysis of mid-fifth-century art in Ravenna by Kostof does suggest the need for a revision of ideas on the growth of 'Justinianic' art.

[124] Cf. A. and J. A. Stylianou, *The Painted Churches of Cyprus* (Cyprus, 1964) pp. 23-7.

[125] A. Xyngopoulos, 'Αἱ δύο ψηφιδωταὶ προσωπογραφίαι τῆς Νικοπόλεως', *ADelt* xxii (1967) part 1, 15-20.

modelling flesh is similar, and competence is also shown in Nicopolis in portraying a three-quarter view of the face. There are only three heads of figures in the north inner aisle mosaics recorded in sufficient detail to be used for close comparison (PLATES 10b and 11a–b). However, even comparing only these with the Nicopolis medallions, we have striking similarities. The three-quarter face of the left-hand angel in spandrel C is close in general effect to the left medallion head, and some details of the drawing of eyes and brows, the chin, and the setting of the neck are almost identical. From George's scale copy of this spandrel (sheet 2), it seems probable that the right-hand angel would have been even closer, as the light falls on the other side, and the shadowing is similar to that in the Nicopolis face. The head of the donor on the right of spandrel H has features in common with the right Nicopolis medallion, despite its different type: the eyes are unequal in size and placing, the nose is similarly drawn, and the hair recedes sharply at the temples. A certain stiffness in the outlines is found both in phase one and at Nicopolis. Finally, the use of the border of the medallion as the outline of the halo is paralleled in S. Demetrios in the two saints above the architrave in spandrel H. The similarities are sufficiently marked, therefore, to conclude that a date before 516 might also apply to our group in Thessaloniki.

There are two other features of the right-hand donor in spandrel H which seem more appropriate to a period before the mid sixth century. I have referred to the two rows of light blue tesserae around his head as an *aura*, and this convention seems most likely to distinguish a living donor. In this case it is a less sophisticated method than that of the 'square halo' found in the Sinai medallions for living personages. The 'square halo' is used, apparently, in phase two where appropriate, except in the medallions on either side of S. Demetrios in the restoration inset. These latter medallions do not have the narrow light blue *aura* of phase one, but a broad-banded background centred lower down. Secondly, there appears to be an attempt to characterize this donor. His head is not simply one chosen from the range of conventional types, but is marked by selected features which presumably were those of the donor himself: a young, beardless face, with bushy hair receding at the temples. This patchwork method of a portrait likeness is seen much further advanced in the imperial panels at S. Vitale in Ravenna, and it is again apparent in the phase two donor figures.[126]

A case for the attribution of our phase one mosaics to the late fifth century can therefore be envisaged on the grounds of style. It would be hazardous to accept such a date without inquiring whether this kind of religious art, centred as it is on the visual rendering of votive prayers to a cult saint, was likely at this date. The religious atmosphere of these mosaics is, for example, precisely paralleled in verbal form in the *Miracula*, Book 1, which was compiled in the early seventh century. There are, however, two texts which elucidate the religious context of late fifth-century art.

The first text[127] describes an image set up in the Blachernae Church of the Virgin in Constantinople in 473. The Virgin was shown enthroned, together with the Emperor Leo I, his wife Veronica, and his daughter Ariadne. His wife held their grandson, Leo, in her arms. It may have been a mosaic, possibly in the apse. This is precisely the kind of votive composition found in our phase one.

The second text refers to Thessaloniki, and is a homily delivered there on the subject of the Annunciation. The text is contained in a twelfth-century manuscript, Athos Laura 357 (Γ 117). Whatever its date of composition, the author evidently had access to some accurate historical

[126] Cf. E. Kitzinger, 'Some Reflections on Portraiture in Byzantine Art', *Зборник Радова Византолошког Института* viii/i (1963) 185–93. [127] Cf. Grabar (1957) 21–4.

source, and he records an incident from the time of Archbishop Andrew, who is independently documented in office from before 491 to after 497 (possibly until *c.* 510).[128]

The story is of a fifteen-year-old Jewish girl in the city, who was deaf and dumb. In a dream, she saw a man dressed in white and a solemn lady. They led her to a church and vanished. She followed a group of people into its baptistery, thinking it was a public bath, and immersed herself three times with them. After this baptism, her two guides reappeared and told her to speak, upon which she found herself able to talk and hear. On awakening, the girl walked to the church of her dream, which is identifiable as the Basilica of the Virgin. She entered the baptistery, and was baptised by Archbishop Andrew. On gaining the power of speech, she reported her dream, and looking at the images in the building, pointed out the figures in her dream as S. Demetrios and the Virgin. A mass conversion of Jews followed this miracle. The girl consecrated her life to prayer and dispensing wisdom, and was given the name of New Anna.

This homily has important implications for us. It records a miracle not included in the *Miracula*, and shows that the cult of S. Demetrios was already advanced at the end of the fifth century, and that he was already closely associated with the Virgin. The episode has remarkable similarities with the Maria cycle of phase one, down to the coincidence of baptismal references. It is not, however, close enough to justify an actual identification, at least from this version, nor to suggest that the homily is a later interpretation of these mosaics. Further, this text confirms that the Basilica of the Virgin was complete by the end of the fifth century, and implies that it was the metropolitan church. It also establishes that at this time the church complex contained images, which included representations of S. Demetrios (λευχημονῶν) and the Virgin. In this respect, it is interesting to recall the surviving mosaics of the church; the principal votive inscription in the central arch soffit of the tribelon reads:[129]

$$\text{ὑπὲρ ε(ὐχῆ)ς}$$
$$\text{Ἀνδρέου (τα)π(ε)ινοῦ}$$

This Andrew has not been identified but could be the Archbishop of our homily; the term ταπεινός is found associated with an Archbishop, Theophilos, in the sanctuary mosaics of S. Sophia in Thessaloniki (780–97).

These two texts, then, make the late-fifth-century dating of phase one mosaics highly appropriate. On the one hand we have the existence already of votive compositions and of portraits of S. Demetrios and the Virgin, and on the other we have a current miracle story involving S. Demetrios and citing icons.

The acceptance of this dating would require certain adjustments in the current view of the period of pre-iconoclastic art. If we can assume that the Rotonda in Thessaloniki and S. Vitale in Ravenna had metropolitan parallels and that there were other metropolitan works of art in which the change of compositional style between the two was developed, then we can reasonably assume that the phase one group was influenced by some metropolitan works of intermediate date. The fact that the mosaicists of phases one and two learned their methods and techniques locally does not by any means imply a provincial art form. We can, on the contrary,

[128] V. Laurent, 'Une homélie inédite de l'archevêque de Thessalonique, Léon le Philosophe, sur l'Annonciation (25 mars 842), *Mélanges Tisserant* (Vatican, 1964) ii 281–302. The homily is attributed to an Archbishop Leo of Thessaloniki, whom Laurent identifies as the famous Iconoclast.

The emphasis on images would seem inappropriate to this candidate, and so the twelfth century (*c.* 1133–45) or a pre-iconoclastic candidate must be considered.

[129] Diehl (1918) 57.

use their works to supply indications of the manner of art which was being produced in the capital.[130]

The two phases of the S. Demetrios mosaics do, in my opinion, illustrate an earlier and a later stage in the expression of the religious attitude to cult figures. Most, probably all, of the mosaics in S. Demetrios belong to one or other of the two phases rather than to any intermediate stage.

The value of George's record of the lost mosaics of S. Demetrios lies particularly in his preservation of the appearance and content of a nearly complete scheme. The full scale sheets allow a great degree of precision to be attained about the technique, colour, and quality of these mosaics, and further allow the styles of the two phases to be differentiated with accuracy. The importance of the S. Demetrios mosaics in the study of early Byzantine art can now be better appreciated.

[130] The Nicopolis mosaic fragment may be an independent witness of such a general current of development in the Greek East; cf. R. Krautheimer, *Early Christian and* *Byzantine Architecture* (London, 1965) 98–9, who emphasizes the Italian affiliations of the structure of Basilica B.

NOTE: Only those illustrations not duplicated in Study II have been reproduced in the plates to this study. Cross-references to the plates omitted are as follows:

II

THE CHURCH OF SAINT DEMETRIOS: THE WATERCOLOURS AND DRAWINGS OF W.S. GEORGE

The medieval Church of St Demetrios at Thessaloniki remains to the present day one of the most conspicuous monuments in the centre of the city. It is easy to judge from the size and position of the church the historical importance both of the cult of the saint and also of the city itself already during the first centuries of the Byzantine Empire when the building was constructed. Yet the church which we now see is no longer in its pristine state. Among the various vicissitudes which have befallen both the structure and its decoration, the most serious catastrophe in the course of its history occurred in 1917 on 18-19 August (or 5-6 August according to the Julian calendar then current in Greece) when the great fire which consumed much of the city devastated the church. Although subsequently restored and rebuilt, the church of St Demetrios has lost much of its medieval fabric and decoration. This damage has obscured its archaeological history and destroyed forever most of its marble, mosaic and fresco decoration. Only the efforts of a small number of archaelogists and architects to record the church as it stood at the end of the nineteenth and beginning of the twentieth century have preserved for us the evidence from which the outstanding importance of the monument in the history of European Christian art can still be understood. Not all this evidence has yet been published or systematically studied. This exhibition sets before the public for the first time ever the full extent of the visual material relating to the church of

St Demetrios which exists as the result of the activities of members of the British School of Archaeology at Athens during the years when the building was still in use as an Islamic mosque and before the fire caused the collapse of its roof and of some of its walls.

The purpose of this catalogue is mainly to document the nature and the value of the material, and to set out some of the issues concerning the art history of the monument on which the material can cast light. It cannot provide a comprehensive account of all the questions which will be asked about the history and documentation of St Demetrios. The full appreciation of the archaeological value of this material will require further detailed studies of the monument itself and of all the various texts and documents concerning the church, published and unpublished, stretching back to the seventh century, and beyond.

The exhibition as a whole has more than a strictly archaeological interest. The drawings and watercolours of Walter George (one of the most frequent of the British visitors to the building in the early twentieth century) deserve particular appreciation for their draughtsmanship and artistic qualities over and above their scholarly value. Visitors to the exhibition will immediately appreciate the particular qualities of freshness and lightness traditionally associated with the British handling of the medium of the watercolour. One might say that while the advance of photography in the study of art in the course of the twentieth century has immensely benefited the scholar, yet it has inexorably eroded the range of talents devoted to the elegant recording af archaeological material.

The British School of Archaeology at Athens and its Byzantine Research

The British School of Archaeology at Athens has

a long history of interest in the monuments of the Byzantine period, and in particular in those of Thessaloniki. It has sometimes been supposed that the British archive of St. Demetrios was an idea conceived only after Greek, Russian and French archaeologists had been to the church and made and published their records. In reality the commitment of the British School to work on the Byzantine monuments of Thessaloniki and of other sites was both more systematic and much longer established than that.

Already in 1887, in the second year of the existence of the British School, two of its resident students dedicated themselves to the recording of Byzantine material in Greece. They were Robert Weir Schultz (who later changed his name to R. S. Weir), gold medallist and travelling student in architecture of the Royal Academy of Arts, 1887-89, and Sidney Howard Barnsley. They began their research with measured drawings of some of the Byzantine churches of Athens, and, financially supported by the School, they continued their fieldwork in 1889-1890 in, amongst other places, Thessaloniki where they produced architectural drawings, coloured copies of mosaics and photographs. All that they have recorded about their work in Thessaloniki is that their photographs were «taken often under hazardous conditions». They subsequently decided to publish out of all their collected material only their record of the church of Hosios Loukas. This was published in London in 1901 as *The Church of St. Luke of Stiris in Phocis* and it was noted that the whole cost of the publication was borne personally by Dr. Edwin Freshfield, whose support of Byzantine studies up to his death in 1916 will be noted several times in this catalogue.

Elsewhere also a substantial amount of work was sponsored by the School on Byzantine monuments, resulting in a number of important publications. *46*

Among these early articles on the Byzantine remains of Greece are H. M. Fletcher and S. Kitson «The Churches of Melos» in the *Annual of the British School of Archaeology at Athens*, 2 (1895-6), 155-68; and Theodore Fyfe «The Church of St Titus on Creté» in the *Architectural Review*, (1907). Fyfe was a travelling student of the Architectural Association and was appointed 'architectural student' of the School in 1899-1900; he looked at Byzantine material while working at Knossos. Other early visitors to Byzantine monuments working from the School were Peter Rodeck (gold medallist and travelling student of the Royal Academy) who joined in 1896-7, and A. E. Henderson (student of the RIBA) who joined in 1897-8. Ramsay Traquair joined the School in 1905-6, and worked on Frankish remains in Greece.

None of this group of students, however, showed any interest in following up the work of Schultz and Barnsley in Thessaloniki. Only with the appearance of Walter S. George (student of the Royal Institute of British Architects) in 1906-7 is there a further record in the School's archives of work undertaken on the churches at Thessaloniki. In 1907-8 is the first mention of William Harvey (a gold medallist of the Royal Academy) who was also to visit Thessaloniki and to photograph in its monuments, including St Demetrios, though his main activity was the measurement of a number of Byzantine churches in the Argolid. The present exhibition derives entirely from the work of these four researchers, who all made records, either photographic or drawn, of the church of St Demetrios.

An intensification and renewed commitment to Byzantine fieldwork was encouraged in 1908 when the *Byzantine Research and Publication Fund* was established. This *Fund* was organised by a committee under the presidency of Dr. Edwin Freshfield, LL. D. (who had been the sponsor of the publication of Hosios Loukas) 'in association with the British School at

Athens' and it was arranged that students sent out to Greece under its auspices were accepted as members of the School. No doubt the willingness of the School to support the development of work in the Byzantine field derived in part from the fact that both its director (R. M. Dawkins from to 1906 to 1914) and its assistant director and librarian (F. W. Hasluck from 1906 to 1915) were themselves major scholars in this field.

The *Fund* soon sponsored a number of highly important projects. Outside Thessaloniki a large number of Byzantine projects and individuals were helped by the sponsorship of the *Fund*. Ramsay Traquair (who returned to the School in 1909 under the arrangements of the *Fund*) published a paper on «The Churches of Western Mani» in the *Annual of the British School of Archaeology at Athens,* 15(1908-9), 177-213; and his studies of the Frankish material in Greece were published in the *Journal of the Royal Institute of British Architects* in 1923. H. H. Jewell (gold medallist and travelling student of the Royal Academy) studied the Church at Paros in 1910: this work was published by H. H. Jewell and F. W. Hasluck, *The Church of Our Lady of the Hundred Gates on Paros (Panagia Hekatontapyliani),* (London, 1920). The major study by A. van Millingen, *Byzantine Churches in Constantinople,* (London, 1912) directly records the contribution of the School and the *Fund* to the publication through the appearance on the title page of the names of R. Traquair, A. E. Henderson and W. S. George as secondary authors.

The *Fund* developed further the work of the School in Thessaloniki. Under its arrangements William Harvey worked there before going on to plan the Church of the Nativity at Bethlehem and to record its mosaics in coloured drawings (the originals are now in the possession of the Society of Antiquaries of London); he also studied the Dome of the Rock at Jerusalem. The book by W. Harvey and others, *The*

Church of the Nativity at Bethlehem was published in London in 1910. More important, Walter S. George returned to Thessaloniki under the auspices of the *Fund* and with the additional support of a special donation from John, the fourth Marquess of Bute, he was commissioned to make a coloured record of the recently discovered mosaics of St Demetrios. This work, which must have taken him several weeks, if not months, was done some time before September 1909; at the end of that year he went to Constantinople to prepare his record of the architectur and decoration of St Eirene in Constantinople (which took five months to complete). George also planned domestic architecture in Constantinople and later in Mistra. His book *The Church of St. Eirene at Constantinople* was published at Oxford in 1912, its whole cost being met personally by Edwin Freshfield.

The events leading to the outbreak of war in 1914 put an end to all this energetic activity in the field. This meant the conclusion of a period of patronage and cooperation unmatched since in the field of British Byzantine studies. The *Fund* thereafter became used mainly as a source of subventions towards publication rather than for the commission of fieldwork. The committee was finally discontinued as a separate body in 1984 on the logic that Byzantine research had been incorporated as an integral activity of the School itself. By then it had become no more than a subcommittee of the School.

This brief account of the support given to Byzantine fieldwork by the School in its early and of the character of the *Byzantine Research and Publication Fund* should be sufficient to show that British interest in the monuments of Thessaloniki, including the church of St Demetrios itself, was well established at the time of the remarkable discoveries of unknown mosaics and frescoes in 1907 and 1908. It was perhaps the very enthusiasm of the British students at the period that led to the failure to publish all the

extensive material that they collected before the political events in North Greece and the outbreak of the 1914-18 war diverted their plans.

The career of Walter S. George illustrates the consequences of world events on one student previously dedicated to archaeological recording. The annual reports of the British School show how extensive his interests were and how they were cut short by the outbreak of war. George arrived, according to these reports, as a Travelling Student in Architecture of the Royal College of Art and as Soane Medallist of the Royal Institute of British Architects; and by 1912 he was a fellow of the Society of Antiquaries of London. He went to the School in 1906-7, returning in 1908-9 and 1909-10 as Student of the Byzantine Research Fund. He was back in 1912-3 (together with his wife) and worked for the month of April 1913 on the recording of the architectural terracottas of Sparta. In 1914 he was elected a member of the Managing Committee of the School, but he resigned his place in 1915 on his departure to India. Later annual reports indicate that he acted there as Assistant to the Architects of Imperial India, but they mention no further archaeological activity before his death on 7 January 1962.

The British School did attempt in later years to revive its previous commitment to the study of the monuments of Thessaloniki. This became practicable in 1933 with the appointment to the Macmillan Studentship of A. H. S. Megaw who had been working on Byzantine architecture since 1931. It must have seemed obvious that the priority for publication was the material concerned with the church of St. Demetrios, a monument particularly well recorded among the material, and a monument which at that time existed only as a burnt ruin. Megaw consulted with George Soteriou who, as ephor in Thessaloniki at the time of the fire, was already working on the monument; together they agreed on a scheme of joint

Greek and British publications which it was decided should begin with a monograph on St Demetrios. The story of this cooperative plan has never been published, and, since the record deserves finally to be put straight, a brief account is given here, based on the records of the British School*.

* EDITOR'S FOOTNOTE

A quotation from the preface of Sotiriou book «The Basilika of St. Demetrios at Thessaloniki» (Archaeological Society of Athens, Series No 34, 1952) is given below, as an indication that alternative accounts on this subject exist.

«The publication of the monument was originally decided by the architect Zahos and myself and under his supervision a series of architectural plans was made of almost all the surviving sections of the church, the most important of which appear in this text.

In May 1933 a proposal was made to us by the memorable director of the English Archaeological School in Athens, Payne, for a joint Greek-English publication on the basilica of St. Demetrios. This publication would also have included older plans of the church made by Schultz, Barnsley and George, possessed by the English School, as well as a series of coloured copies of the mosaics destroyed in the fire. Professor T. Rice and the architect-archaeologist Mr A. Megaw would have participated in this publication. Later in 1935 after the proposal for the joint publication we collaborated with Mr. Megaw in examining certain parts of the church.

This publication was cancelled because of the death of Payne and later that of Zahos and the investigations were also interrupted by the war.

In November 1948 the proposal about a Greek-English publication was renewed by the current Director of the English Archaeological School Mr. Cook. The architect Mr. Corbett was sent to Thessaloniki, and made a series of plans of the basilica on the basis of Zahos' older plans as well as making new plans of the Crypt. Some copies of these plans were cordially given for publication in this text yet with some completions and changes necessary because of the continuing excavation. Finally –due to the reappearance of difficulties concerning the Greek-English publication– it was decided that this would appear in the future and that it would be preceded by a Greek publication on the monument made by me and my wife Maria Soteriou, who collaborated with me in all the periods of this research.

The Archaeological Society undertook the publication and funded the excavations in 1948-9.»

MUNICIPALITY OF THESSALONIKI

In 1934 the Director of British School (H. Payne) wrote formally to the Greek Archaeological Service submitting the scheme for a British School-Greek Archaeological Service joint publication of the churches of Thessaloniki, starting with St Demetrios. It allocated to Greek contributors all features discovered in St Demetrios since the fire of 1917. The architectural drawings and the watercolours of W. S. George of lost mosaics were envisaged as the main contribution of the School.

Megaw was soon informed orally that the scheme had been accepted and he worked in St Demetrios in 1934-5. He used the architectural drawings made before the fire as his basis of study and attempted to record all features exposed by the fire or revealed in Soteriou's excavations. This material belonging to Megaw is filed in the British School at Athens: 89 sheets of pencil drawings, two field notebooks and six small folders of reseatch notes.

In 1936 (October-November) an exhibition was held in London at the Royal Academy of Arts at Burlington House to commemorate the fiftieth anniversary of the School; it was entitled «British Archaeological Discoveries in Greece and Crete. 1886-1936». According to the catalogue published on this occasion the exhibition included fourteen of the drawings by Walter George, notably the watercolours of the north inner aisle mosaics. This was apparently the first time that the material was made available for public study.

It was not until 1948-9 that further work towards the joint still-unfinished publication was undertaken in earnest. G. U. S. Corbett was appointed a Student at the British School in order to produce the final ink drawings to illustrate the projected book on the church of St Demetrios. His field notebook is kept in the British School at Athens. Soteriou at this time had tracings made from a number of his drawings, for reference in preparing his text.

During 1949 Corbett and Megaw prepared revised proposals for the allocation of chapters in the publication, taking account of the death of one of the proposed contributors (Zachos) and of the inability of Megaw to take a leading role because of his commitments as director of Antiquities in Cyprus. Soteriou was unhappy with the substantial role in the architecture section suggested for Corbett, and later in the year the basis of the publication was altered. The Greek Directorate of Antiquities informed the British School that there was no objection to the publication of an Anglo-Greek monograph on the church of St Demetrios, provided that it was preceded by a Greek publication of the results of the Greek excavations.

1952 saw the publication of G. A. Soteriou and M. G. Soteriou, *The Basilica of St Demetrios of Thessaloniki,* (in Greek), (Athens Archaeological Society Series no 34, 1952). Full use was made in it of the drawings prepared by Megaw and Corbett, though without their express permission and with only the minimum of acknowledgement**. In the text, plates III, IV, V, and VI were mentioned as derived from Corbett. These happen to be the main architectural plans of the church. Also noted as the work of Corbett are figs. 24, 26, 28, and 61, while figs. 35 and 41 are attributed to Megaw. Other plans are not attributed to a British source, although it is obvious enough from Corbett's dossier that some are redrawn from that material (as for example fig 44). These drawings by Corbett and Megaw have their history too. They were in nucleus the work of W. S. George, refined through a knowledge of the building since the excavations after 1917. It is therefore reasonable to say that the fundamental architectural plans of the Soteriou book represent the first publication of the

** FOOTNOTE
See the Editor's Footnote above.

survey of Walter S. George. Perhaps this exhibition will now serve to act as recognition of the invaluable contribution which he made to the recording of the church. The plans published by Soteriou have been used as the basis for all subsequent architectural plans of the church; without knowing it, all those who have studied the modern literature on the church of St Demetrios are already familiar with the work of W. S. George.

In 1953 another proposal was made for an Anglo-Greek monograph, when the possibility was discussed with Soteriou by Megaw and D. Talbot Rice at the International Byzantine Congress at Thessaloniki. To arouse interest in the material the latter showed slides of the watercolours by W. S. George of the lost mosaics at a public session of the Congress. Nothing had been achieved before 1965 when G. A. Soteriou died and the project foundered.

The watercolours of George have not remained unstudied. One Greek scholar, N. Theotoka, had been given permission to use the George watercolour record of the north inner aisle mosaics for her article about the ciboria of St Demetrios; this appeared in 1952. In 1967 Talbot Rice and Megaw ceded publicatio of the watercolours of the lost mosaics to R. S. Cormack, who had fortuitously come across the materials in the Warburg Institute, London, without knowing any of their former history, and who published them in the *Annual of the British School of Archaeology at Athens,* 64(1969). Up to 1960, these papers had been stored in the British Museum, an arrangement no doubt due to the presence once there of one of the two secretaries of the *Fund,* O. M. Dalton.

The present exhibition is chosen from the material which is now available in London. The coverage is limited for practical reasons to the visual record of St. Demetrios, and it does not include notebooks or

50

other written documents. This is not all the evidence which must in due course be studied to enlarge our knowledge of the building. In 1976 an informal listing of original papers in Athens was made by W. E. Kleinbauer which shows the extent of the record which supplements the visual record. His checklist of manuscript papers indicates the existence of field notebooks of Schultz and Barnsley (from 1888 and 1890); three notebooks and a typescript by W. S. George; the field notebooks of Harvey; rough notes and a notebook of Corbett made in 1948-9; and the Megaw material of 1934 and 1935 (mentioned above). In addition there is in London a typescript of the notes of G. U. S. Corbett in 1948-9, presumably intended ultimately for publication in the projected monograph. Reference will be made in this catalogue to observations made in this manuscript, but not to the other documentary sources.

The complexity of the modern study of the church of St. Demetrios therefore arises from a multiplicity of factors-the state of the building, the incomplete publication of the archaeological materials, and the piecemeal character of the published studies. Even the extensive monograph by G. and M. Soteriou fails to set down a record of all the finds, and it is necessary to use in association with this book Soteriou's own earlier survey of the building published in the *Arcaeologikon Deltion* of 1918. Perhaps the present exhibition may help to encourage the collation at last of all these diverse sources of information.

The History of the Church of St Demetrios

When the British School of Archaeology and the *Byzantine Research and Publication Fund* sponsored the recording of the church of St Demetrios, it was a building which lay in a city still under the control of

the Ottoman Empire, and still dominated by the religious practices of Islam. St Demetrios itself was used as a mosque, not a church. Consequently no Christian figurative decoration could be left permanently open to public view in the building. It is apparent from the photographs that the expedient followed in the mosque was to conceal the mosaics beneath flexible covers which could be lifted up for those favoured visitors to whom permission had been given to observe the images.

The Ottoman Turks had not immediately converted the church to Moslem use after their final conquest of Thessaloniki in 1430. Indeed for sixty years it remained in Christian use, as is quite evident from the fact that a Venetian-style Renaissance tomb of Loukas Spandounis could still be installed at the north west end of nave of St Demetrios in 1481 or soon after.

Until the fire of 1917 an Arabic inscription recording the conversion of the church into a mosque was to be seen on a slab of marble set above the entrance door-then the south door of the west facade. It dates to the year 1492 (Hegira 898) and read (according to the translation by M. Kiel): «A dwelling I have put back into service, a good work for God, the Lord of the Worlds, Sultan Bayazid Khan, a creation for the benefit of the Moslems.

See you host of the servants (of the Lord) this chronogram: Serve (God) with knowledge. Truly, how beautiful is the reward for those who serve (the Lord. 898)».

This conversion of the Christian church to use as a mosque was carried out by Ceseri Kasim Pasha, a governor of Thessaloniki (during the reign of Bayazid II); hence its name the Kasimiye Camii. Kiel (1970): 143 suggested that another factor in the naming of the mosque was that in popular Islamic belief the holy men of the two religions, Demetrios and Kasim, were linked together. The period within which the building

served as a mosque dates from 1492 to 1912.

In the course of the Ottoman period various repairs and alterations were made to the structure. At the time of the making of the British records, the fabric of the church which was visible to any observer was obscured below the layers of plaster and decoration which had accumulated during the centuries of Byzantine and Islamic use. While this record is invaluable for showing the building in its state before the damage of 1917, it cannot document either the mosaics found after 1912 nor the indications of any masonry which was exposed after the mosque was converted back into a church. Such strengths and limitations need to be remembered.

The history of the building since 1917 can be briefly traced. Soon after the fire the architect Aristotle Zachos was put in control of the consolidation of the ruins and of the proposed reconstruction. This rebuilding was initiated in 1926, but work was discontinued after a few years. Work on the project was only resumed in 1945, when the the architect in charge was L. Thanopoulos, Zachos having died in 1939. By 1949 work was substantially completed, and the church was rededicated on the festival day of St Demetrios on 26 October. Further work of restoration was done in 1959. A feature of the reconstructed church is the use of stone masonry instead of brick as in the original structure; and the use of wood, as the culprit of so much damage in the past, was avoided. The decision to substitute different materials helps to demonstrate the extent of the restoration, but this brutal honesty has since met criticism as a distortion of the original character of the architecture.

The best way to assess the importance of the various items in this exhibition is against an awareness of the outstanding art historical problems about the Byzantine history of the church of St. Demetrios. The literature on the monument is substantial, as can be appreciated from the selective bibliography given

in this catalogue, but very little of this writing proposes definite conclusions. The difficulties in the study of the church arise from the need to bring together fragments of evidence from many sources, textual, historical and archaeological. The most controversial questions that have been at the centre of the archaeological discussions are two. What exactly is the date of the original church within either the fifth century or the sixth century? How extensively was the church remodelled after fire which is recorded in the first half of the seventh century? Fortunately a recent monograph on early Byzantine Thessaloniki (from the fourth to the sixth century) by J. – M. Spieser offers a most useful discussion of the chronology and original appearance of the church and has put the investigation of St. Demetrios on a new footing. All subsequent studies must acknowledge the fact that this book has lightened the task of understanding the issues, even though its chapter concerning the church, which relies for the most part on stylistic consideration, is of course far from the last word on the subject.

The occurrence of a fire around the year 620 is a historically documented event, but the damage it caused and the subsequent repairs carried out in the seventh century is not the only complicating factor in disentangling the structural history of the building. In the course of time the church of St Demetrios underwent a number of catastrophes, predominantly fires and earthquakes, and these have led to its repair and restoration on a number of occasions. Such alterations are known from several sources, both written and visual. The famous text of the *Miracles of St Demetrios,* for instance, mentions several occasions of damage and restoration; Books I and II of the *Miracles* were the work of two local writers (one, Bishop John of Thessaloniki, from early and the other, anonymous, from late in the seventh century). The fire of around 620 itself is described in the

Miracles in Book II and is also mentioned in an
inscription in the north inner aisle mosaics (cat. no.
34); and the subsequent restoration is also recorded
both in the *Miracles* and in the mosaic epigram below
the seventh-century panel on the north face of the
south pier of the sanctuary (cat. no. 40). This is a case
where texts and inscriptions in the church directly
coincide in their evidence. Other episodes of altera-
tion need to be deduced from the fabric itself. The
archaeological examination of the church by Soteriou
after 1917 uncovered evidence of later phases of
consolidation and change in the church and its
fittings as well as further epigraphical information.
For example, Soteriou uncovered a painted inscrip-
tion on the east side of the north pier of the sanctuary
which records an overhaul of the roof of the church
by Michael IX in 1319-20 (see Spieser (1973): 171-3).
Any study of the fabric of the building must therefore
remember the extreme length of time over which it
has been in perpetual use and the fact that continual
attention was given to its maintenance. As an object
of architectural study, the building is therefore one of
considerable complication. Any attempt to recon-
struct its original appearance and to decide its date on
the basis only of the style of its architecture and
decoration must remember the danger of oversimpli-
fying and underestimating the extent and frequency of
architectural change in any building in continous use
for so many centuries.

How far can the British record help not only to
visualize the building as it was at the beginning of the
twentieth century but also to reconstruct its appea-
rance at the time of its construction and to identify
some of the subsequent changes? One way to answer
this question is to turn directly to the drawings and
photographs and allow them to speak for themselves.
But it may be helpful to approach the visual material
with a brief conspectus of the problems in mind.

By the early twentieth century the exterior of St

Demetrios had changed its early Byzantine appearance in several conspicuous ways. Like other churches of its period it would have been preceded towards the west by an open court, an *Atrium,* which acted, among other uses, as a meeting-place for the congregation at the commencement of the liturgy. But very little of this original atrium was visible at the beginning of the twentieth century. Only when the Turkish minaret was taken down after 1917 and the area to the west of the church was excavated was the extent of the atrium made apparent. The drawings of George (cat. no. 1 and 3) show only a small Turkish courtyard in front of the mosque; this did still contain the remnants of a fountain, a *phiale,* which no doubt derived from the original fittings of the atrium.

The Byzantine church of St Demetrios which was in the early twentieth century the architectural frame of the mosque had been a large wooden-roofed basilica with a nave and four aisles. At the east end the sanctuary was surrounded by a high cross-shaped transept; below the sanctuary was an extensive lower church. The church could originally be entered on all sides by a good number of large impressive doorways. The masonry was of rubble reinforced by courses of brick, and the arches were constructed in brick. The church was surrounded by and partly founded over buildings from the Roman period of Thessaloniki. It is unclear whether the site was chosen for practical or symbolic reasons – this touches on the whole question of the «myth» of St Demetrios himself and the details of his integration into the history of the city after his supposed martyrdom around the year 300.

To visualize the east facade of this church requires the mental elimination of a number of alterations, the most intrusive being the late Byzantine small Basilica of St Euthymios, added as a side-chapel, a *parekklesion,* to the south of the apse in 1303. This chapel was built over a broad and shallow staircase which had originally passed from the street

to a doorway on the eastern side of the south transept; this opening is now the entrance from the transept of the church into the chapel of St Euthymios. Another problem is that by the early twentieth century the ground level to the east of the church had risen so that the lower church (below the sanctuary) had become a dark crypt, with only the tops of the arches of its eastern windows still showing. When the church was built, the level at the east end was much lower, and there were three entrances into the lower church off the street; the tops of the arches are all that were visible to George of the original doors.

The original appearance of the apse is even harder to deduce from the record of George, for most of the original openings here had been blocked up during the Turkish period. This is an area where the fire of 1917 and the subsequent excavations have had the benefit of the making the evidence much clearer! On each side of the apse (between the apse and the eastern entrance doors into each of the transepts) there were originally rectangular chambers extending eastwards, resting on Roman foundations. These walls of the chambers on the apse side were in the opinion of Corbett (1949) only at a later date in the Byzantine history of the church altered into arcaded stoas opening onto a court to the east of the semicircular wall of the apse; he deduced that they were not originally arcaded stoas from the way the first arch is cut into the apse wall. Soteriou (1952) thought the arcades were original, although the book reproduced (p. 146) the reconstruction drawing of Corbett of the seventh century church in which the chambers are shown with walls, not stoas.

There are even more problems in understanding the original appearance of the north and south walls of the church, both of which were altered when new galleries were built inside the church which had to be lit by new windows. Changes in the rooflines also occurred several times in the history of the building.

The south side is better recorded by George than the north (which was more inaccessible to any observer and which also had more elements incorporated in it from the previous buildings on the site).On the south wall the brick masonry was more easily visible – indeed Corbett deduced that from the beginning attention was given to the articulation of the brick-work of the whole exterior with the intention that it should be left visible and not rendered. Two large marble-framed doorways inside arched openings into the south aisle were in use when George made his record-both now replaced by modern doors-and three smaller doors in between, probably opened by lowe-ring the sills of some of the Byzantine windows. The brick arch of the large eastern door is seen to extend into the west wall of the transept; this tells us that this wall of the transept is a rebuilding further to the west than at the time of its foundation. The implications of this rebuilding, dated by Soteriou (1952) to the seventh-century alterations, will be considered further in a moment.

For the architecture of the interior the drawings give considerable information about the plan and arrangements of the building and give a great quantity of the measurements of the church as it stood before 1917 (cat. nos., 4, 5, 6, 9, 10, 11, 12, 13, and 18). The most lively current scholarly issue in looking at the building is, as already mentioned, how to distinguish all the various stages of alteration in the building, and in particular how to decide which features belong to the original church and which to the documented restoration of the church after the fire of around 620 in which the roof was destroyed. The information to be derived from the record of W. S. George does add a new dimension to the debate.

Soteriou (1952) set out a hypothesis about the extent of the changes to the church in the restoration of the seventh century. Essentially Soteriou proposed a programme of rebuilding in the western sides of the

transepts (replacing transverse masonry arches with colonnades between the transepts and galleries); adjustments to the west wall of the south transept; the installation of the lower galleries in the two outer aisles, and the extension of the upper galleries into the transepts; some rebuilding of the upper parts of the church, involving the reduction in height of the roofs of the nave and aisles by about 1.50 metres and the raising of the height of the narthex roof to match the level of the nave roof; alterations to the sanctuary fittings and the insertion of a prothesis and diaconicon in the transept; and, finally, major works of renovation along the nave colonnades, with the insertion of the piers which divide the nave into three bays, the replacement of many of the capitals and the restoration of the *opus sectile* marble revetment. At the same as these major structural alterations belonged the expansion of the mosaic decoration of the church, notably in the sanctuary area.

This hypothesis of massive rebuilding was influenced by a first-hand knowledge of the disastrous damage wreaked by the fire of 1917; Soteriou equated the effects of that fire with those of the earlier one of around 620. This view cannot easily be supported by the Byzantine account of the seventh-century fire (in the second book of the *Miracles of St Demetrios*), which describes it as of short duration only, although it did destroy both the wooden roof and the silver ciborion of St Demetrios located in the central part. The most difficult part of the hypothesis is the suggestion that the nave colonnades were almost entirely rebuilt and that the four piers were inserted. The idea of the insertion of piers has been abandoned by a number of subsequent commentators; their placement seems to be an integral part of the proportional planning of the original church, as argued by Spieser (1984), and the bay system is integrally reflected in the upper window articulation of the south facade (see cat. no 7).

The alternative hypothesis of Spieser (1984) is equally unacceptable as a whole. He argued for only minimal alterations after the fire of around 620; the repair of the roof, for example, and alterations to the wall between transepts and the aisles. He believed the insertion of the lower galleries above the outer aisles (and connected adjustments to the windows at this level) was done as part of some quite different operation, dating after the ninth century and to a period more historically conducive to major structural alterations. He denied that any rebuilding of the nave colonnades was undertaken. This hypothesis misunderstands the actual extent of the alterations that were made in the seventh-century restorations; as a result it seriously distorts the historical development of the cult of St Demetrios by underestimating the material changes made in the church which matched the growing popularity of the saint during the first half of the seventh century.

The record of W. S. George is discussed in the catalogue notes below in relation primarily to the additional archaeological information supplied by Soteriou (1952) and the unpublished notes of G. U. S. Corbett (1949). On this basis a modification of the hypotheses of both Soteriou and Spieser can now be suggested.

The west wall of the nave as recorded by W. S. George (cat. no. 21) must have been substantially as it was when the church was originally built; possibly some repair work was done after the fire of around 620 to the arch on the north side and a new mosaic replaced the previous revetment. As for the nave colonnades, the quality of the revetment may be inferior to that of the west wall, but it is hard to see it as a total replacement of the seventh century. However the detailed record of the capitals, several of which are ill-fitting on the columns below, reveals a conspicuous anomaly in the church; this is the contrast between the magnificent carved capitals of

the tribelon, apse and the transepts (see cat. nos. 19 and 20) and the heterogeneous nature of some of those in the nave colonnade. If it is accepted that the seventh-century restoration did include the insertion of late Antique columns and capitals into the western colonnades of the transepts, it seems equally sure that the fire had cracked some of the nave capitals and that these were replaced by a number of spolia from other monuments. This work does, however, seem to have been carried out with minimal interence to the opus sectile of the walls.

The record of W. S. George of the north inner aisle mosaics shows how the upper line of the replacement mosaics of the restoration after the fire marks the floor level of the lower galleries. The argument that these galleries were not part of the seventh-century works can therefore be dismissed. The view of Soteriou that the seventh-century restoration saw the insertion of new galleries over the aisles and around the transepts is supported by the British record. It follows that Spieser was wrong to imagine that the work done after the seventh-century fire was entirely in the nature of essential and limited repairs. On the contrary it is now clear that the damage caused by the fire was taken as the opportunity to gain sponsorship for a considerable expansion in the amenities of the church. Its capacities for housing a large congregation and pilgrims was greatly expanded and its decoration was greatly enhanced. The fire was converted from a major disaster into one further enhancement of the prestige of the saint and the church in the Byzantine world.

The seventh-century work after the fire of around 620 was as much in the nature of a cosmetic facelift to the church as an operation of repair. The conclusions of Soteriou seem in the main acceptable; only his suggestion of major rebuilding of the nave colonnades needs modification. The archaeological

study of the church of St Demetrios is rewarding; the material evidence offers a striking picture of the importance and expansion of the cult of the saint in early Byzantine Thessaloniki.

Once the seventh-century additions have been separated from the original elements of the church, it is possible to consider in better focus the date of the foundation of St Demetrios. Unfortunately any decision still rests primarily on stylistic analysis. In this analysis it is impossible to rely on the evidence of the mosaics which belong before the fire (those on the west wall of the church and those which up to 1917 decorated the north inner aisle). Doubt must remain whether these mosaics are part of the original foundation or are later ex voto offerings to the saint and his church. The argument of Spieser was that the answer to the dating of St Demetrios lay in the sculptural decoration of the nave. This was distinctive for its interest in a multiplicity of capital types and the richness of effect of the interplay of coloured columns and piers. More concretely he noted that some of the capitals could be dated not earlier than about 520.

Spieser dated the construction of the church of St Demetrios to the period 510-520. This fitted into his conception of the development of the city of Thessaloniki. Instead of there being a period of massive and rapid expansion in the city after 442/2 when it became the seat of the Prefect of Illyricum, Spieser suggested that the historical situation only allowed a slow and gradual series of building constructions: the construction of the Acheiropoietos church in the last quarter of the fifth century, the conversion of the Rotunda into a church at the beginning of the sixth century, the construction of St Demetrios (probably to replace the earlier oikiskos mentioned in texts, and the church of the Latomos (Hosios David) in the middle of the sixth century. The closest parallel in

56

date and style to the church of St Demetrios is to be found, according to Spieser, in the Bishop's Basilica at Stobi.

If it is accepted, as here, that the obviously sixth-century capitals of the nave are in fact re-used spoils inserted into these positions after 620, then the whole foundation of Spieser's argument collapses. Indeed his whole series of dates is founded on the weakest of evidence. A strong case for the dating of the Acheiropoietos to the third quarter of the fifth century (not long after the construction of the Studios Basilica in Constantinople in 453) can be made. There is no unanimity over the date either of the Rotunda or the Basilica at Stobi, and earlier dates than those proposed by Spieser are contended in the literature (for the Rotunda a date in the middle of the fifth century has been most stringently argued, and it is not countered by Spieser's useful discussion of the ornamental mosaic of the vaults). When all the original architectural sculpture of St Demetrios is considered together, a date for the foundation of the church in the second half of the fifth century or as late as around 500 seems still to be the most easily argued.

As for the dating of the mosaics which decorated the church before the fire of around 620, neither the record of George of the lost north inner aisle mosaics nor the evidence of the surviving panels on the west wall of the present church offer any definite clues, apart from their subject matter and style. The problem therefore remains whether they belong to the decoration of the church at the time of its foundation or whether the panels represent piecemeal addition, donated in thanks to the saint by the local aristocracy. The recent archaeological discovery of mosaics of a comparative style in a chapel built into the amphitheatre of Dyracchium (Dürres in Albania) does offer new evidence for a decision. Since these mosaics (which show saints and donors in a way

similar to those in St Demetrios) probably belong to a date later than the earthquake of 518 when it seems the amphitheatre went out of use, they may offer a reason for dating some of the mosaics in St Demetrios to a date in the sixth century.

In conclusion, the drawings and photographs chosen from the archives of the British School at Athens for this exhibition give the best opportunity to see the original Byzantine building in its final state. They can help us to unravel the layers of its history, both archaeological and symbolic.

Catalogue

All the items selected for this exhibition are the property of the British School of Archaeology at Athens. They are the work of students of the School, some produced under its direct auspices, and some sponsored by the *Byzantine Research and Publication Fund* after its formation in 1908. The bulk of the work in producing the drawings and watercolours can be attributed to the hand of Walter S. George (catalogue items 1-4). Some versions of these sheets are redrawn or supplemented by A. H. S. Megaw and G. U. S. Corbett. These sheets were stored in the British Museum from 1909 until 1960 when they were moved to the premises of the Warburg Institute in Woburn Square, London WCI. R. S. Weir, secretary of the *Byzantine Research and Publications Fund* was trustee for the collection, and in his will (1951) transferred the trusteeship to the British School.

Not all the drawings are signed or initialled W. S. G. and few are dated; some doubt must remain on the exact time of the production of most of them. Cat. nos. 2, 4 and 7 are annotated as drawn in 1907 (presumably no. 4 in April 1907, since the magnetic north is given as on 21 April), and cat. no. 1 is annotated as drawn in 1908. The records of the

British School confirm that George was in Thessaloniki in 1907, and that he was in Greece in 1908 and 1909 under the arrangement of the Fund. The watercolour drawings of the mosaics were received by the *Fund* on 1 September 1909. Since the north inner aisle mosaics were uncovered during repairs to St Demetrios which were carried out between December and February 1907-8, the watercolours must belong either to George's presence in Thessaloniki in 1908 or 1909. 1909 seems the more probable occasion, if it is supposed that George gave the watercolours to the *Fund* immediately on their completion, although the architectural drawings only document his presence in the building in 1907 and 1908. This dating would account for the nature of his research before he went to Constantinople late in 1909 to work at St. Eirene. George must have spent a conciderable amount of time in Thessaloniki in those years, for he also made some record of the Rotunda of St. George, the Acheiropoietos Basilica, St Sophia, St Elias, and Twelve Apostles. It is also clear from his results that George had access to ladders in order to carry out his survey work, and perhaps some kind of scaffolding. The Russian record, consisting of photographs and watercolours, was made in the Spring of 1908 and the French record, also photographs and watercolours, was made in the Summer of 1909. This means that the watercolours of George, whether painted in 1908 or 1909, showed the mosaics in exactly the same condition as in the other records. It is also clear that his architectural survey was initiated before the restoration work in the mosque began. The achievement of George is undoubtedly the most thorough and the most attractive artistically of the various copies that were made.

The external measurements of these sheets are given below in centimetres, but it should be remembered that the paper would have been supplied at that time in imperial sizes, and, most importantly, that all

the measurements which are written on them are recorded in feet and inches.* Pen here refers to Indian ink.

The photographs of Schultz and Barnsley (cat. nos. 43-4, & 46-51) were taken in 1889-90. Those of William Harvey (cat. nos. 45 & 52-6) are not easily dated, but seem most likely to belong to his time as a student of the School in 1908. Perhaps it was this particular photographic record of the mosaics that encouraged the committee of the *Fund* and the Marquess of Bute to support another visit by W. S. George to work in St Demetrios.

* Note: The plates in this volume are not reproduced to scale.

Drawings and Watercolours

1. West Elevation of the Church of St Demetrios.
 ref: B. 5 (plate IIIa. The West Facade).
 Pen and pencil on paper.
 Annotated: «West Facade as drawn by W.S.G. in 1908».
 Signed W.S.G. Titled «West Elevation».
 Scale 1/8 inch.
 h. 37.5 cm
 w. 50 cm

The view of St Demetrios from the west as in 1908 shows the marble basin of the phiale lying on its side in the Turkish courtyard, but not the structure of the phiale itself (for that see cat. no. 3). The ground level of the Turkish courtyard was between one and two metres higher than the floor level of the narthex. The floor level of the church is indicated by a hatched line (–·–). At this date only one door into the narthex from the courtyard was in use (the other three were bricked up). This entrance door was protected by a tiled wooden porch; and the doorway was surmounted by the plaque recording the conversion of the church into the Kasimiye mosque in 1492 by Ceseri Kasim Pasha. On the right of the elevation only the

II

indication of the base of the Turkish minaret is given, and no attempt made to record it further.

The drawing gives information about the forms of roof and windows as in 1908, and some indication of the nature and extent of the Byzantine brick masonry and Turkish stone infills. In the rebuilding of the church after the fire of 1917 the five windows in the Turkish western gable were reproduced in the new western facade of the narthex. G. U. S. Corbett (1949) suggested the possibility that the church was originally preceded by an exonarthex to the west: the two points adduced in support of this hypothesis were the use of mosaic decoration in the soffits of the windows and the indication (now lost) of the springing of an arch in the upper part of the wall which he saw in this drawing.

Corbett also thought that the brick masonry of the lower triple window might offer the most important clue towards the dating of some of the various sorts of masonry within the church. His argument was that three main categories of brick arches occur in St Demetrios, and that these may be dated to various phases in its history. The first type he defined as: «fully-turned arches of more than one ring; i.e. where there are inner and outer rings of brick voussoirs continuing from side to side through a full turn of 180°». The second type he termed «corbelled arches», and he described these as arches «where the horizontal brickwork of the jambs is corbelled outwards on either side to form the lower segments of the arch, while the radial voussoirs are confined to a segment of less than 180° in the crown of the arch». His third type consisted of all other arches, «such as fully-turned semicircular arches with only one ring of bricks, segmental arches and the pointed arches of the Turkish period».

Corbett thought that these three types represented chronological stages within the architectural history of the building. The second type, he thought,

59

was adopted by later Byzantine builders who thereby were able to economize in their wooden formwork. He noticed that the north and south springings of the western triple window were parts of fully-turned arches (the first type), whereas the central springings, where the arcade rests on two columns surmounted by Corinthian capitals slightly too large for the shafts (and so perhaps re-used), were made with corbelled arches (the second type). Corbett deduced that the central part of this window collapsed at some time and was rebuilt; if so, the fully-turned arches must be the earlier as the middle part of the arcade could not have remained standing if the ends were to fall down. He suggested that the first type of fully turned arches in two rings belong to the original building of the church, and that the second corbelled type might belong to rebuilding after the seventh-century fire. The corbelled type occurs in the church notably in centre of this western triple window, in the brickwork above the northern column of the tribelon, in the arcading of the nave (in all the places where the arches are visible), and in the western (but not the eastern) springings of the great transept arches. The possibility was mooted by Corbett that these corbelled arches denote areas of rebuilding after the seventh-century fire.

See Soteriou (1952): 70ff and fig. 17ff.

2. East Elevation.
 ref: B 7 (?) (plate V)
 pen on paper.
 Annotated: «Drawn by W.S.G. in 1907».
 h. 38.1 cm.
 w. 55.5 cm.

Another version of this drawing (in pen on tracing paper) is found among the collection of the British School; ref: no. 11. Size: h. 43 cm and w. 65 cm. Some additional information about the eastern

end of the building will be found on cat. no. 17 (sheet B 17).

By 1907 the ground level had risen substantially above the original street level at the east end of the church. During the first centuries of the existence of the church the level was marked by a paved street of the Antique period of the city. From this street there were three doors opening into the lower church (now the crypt). By the late Byzantine period, when the chapel of St Euthymios was built to the south of the apse, the street level had risen, and only the tops of the arches of the doors into the lower church would have been visible; the openings were now useful only as windows. By 1907 even these windows were barely visible above the sloping ground level.

George marked the various floor levels inside the church with a hatched line (_._) or the abbreviation FL; and he showed the state of the masonry of the eastern walls of the transepts where it was visible (for example, «rubble» in the north transept). The extent of the original brickwork in the apse walls was not visible to George; the fabric of apse and transepts was built substantially in rubble masonry bound with brick courses. The two windows in the east wall of the church over the apse were Turkish replacements of larger arched Byzantine windows — the triumphal arch and semidome of the apse may at some time have fallen in and been replaced in the Turkish period. In 1907 the apse was roofed with sheets of lead, folded down to the cornice.

See Soteriou (1952), 85ff. and 141ff. His fig. 61 (p. 146) reproduces the reconstruction drawing of G.U.S. Corbett, which was based on the information derived from this drawing of George and from the later British observations. The frontispiece of Soteriou (plate 1) shows a restoration drawing of the whole church, but it shows the stoas at the east end which Corbett believed from the masonry traces to have been later alterations to the eastern chambers.

Mango (1974): 74, fig. 79, is a reconstruction drawing based on that published by Soteriou.

3. The Fountain (Phiale) in the atrium.
 ref: B 11
 Pencil and pen on paper
 Scale of capitals: 2 inches to one foot.
 Scale of phiale: half an inch to one foot.
 Scale of capitals: 2 inches to one foot.
 Scale of phiale: half an inch to one foot.
 h. 68.5 cm
 w. 50.8 cm

On the left is the elevation and plan of the phiale; to the right, an example of one of the three ionic capitals, and of one of the abacus capitals with a cross decoration. The basin is recorded in three drawings.

The marble basin (see also cat. no. 1) belonging to the phiale dates back either to Antiquity or to the original church of St Demetrios (5th or 6th century). Likewise the eight (reused) columns, three ionic capitals and the simple cross capitals date back to Antiquity or to the early Byzantine period. The form of the structure and its position only three metres away from the west wall of the church points to its rebuilding at some later date; in the late Byzantine period, according to Soteriou, but in the Turkish period according to Corbett (1949) because of its position between one and two metres above the level of the Byzantine narthex. The phiale continued in use for ritual washing after the building became a mosque in 1492. The basin was removed in 1878 but later replaced below the canopy; at the time of George's drawing it was «at present lying outside of fountain». It fell to pieces in the fire of 1917; the drawing of George shows that already before then it had been broken and repaired with metal clips.

See Soteriou (1952): 68-70; fig 16; plate 3b.

4. Ground plan.
B 1
Pencil and pen on paper
Annotated: «Magnetic North April 21st 1907».
h. 56 cm
w. 76.2 cm

This is a worked up scale drawing of the plan of the building as it was in 1907. It must depend on the working drawing cat. no. 12, which one can therefore deduce was done in April 1907. This version must have been drawn at some date after cat. no. 12. Another version is found in the collection in pen on tracing paper — ref: no. 1 (h. 70.5 cm. w. 86.2 cm). This is published in Cormack (1985): 79, plate 20. The British School archive also includes a version drawn on the basis of this plan in which the relative dates of the masonry were indicated by hatching and in which the position of the ciborion in the nave was entered; this must postdate 1917.

The position of the Turkish platform, orientated towards Mecca, is marked; it lay over the sanctuary floor. The marble paving slabs are marked in the western part of the floor. This floor was severely damaged by falling masonry in the 1917 fire, and it may itself have been a replacement of the seventh century, if the pattern of damage at that time was similar. The slab with an engraved cross lay immediately to the west of the octagonal ciborion of St Demetrios. There are notes that the paving of the north aisle and north of the narthex was irregular, and that the rooms to the north of the narthex were earth-floored. Two types of flooring are recorded in the south part of the narthex. Other notes give information about the nature of the fabric of the north wall of the church and of the north transept.

Turkish additions, such as the buttresses along the south wall, are indicated in oblique hatching. The staires to the gallery in the western part of the south

transept are indicated in the same hatching. Soteriou
argued that the rebuilding of the west wall of the
south transept a few metres to the west was done as
part of the alteration of the structure in the seventh
century.

See Soteriou (1952): plate 5, which derives
through Corbett from this plan, as does Krautheimer
(1965), Mango (1974), fig 78, and Spieser (1984), 166,
fig 9. See Cormack (1985), 79, plate 20.

5. Plan of Lower Galleries
 ref: no. 2
 Pen on tracing paper
 h. 70.5 cm
 w. 86.2 cm

A less finished version of this scale drawing is
found in the collection — ref: no. 2 (?). The working
drawings on which this final worked up drawing is
based are: cat. nos. 12, 13 and 18. Since cat. no. 12
has been attributed here to April 1907, it follows that
this drawing too should represent the state of the
church at that date.

The colonnades, walls and windows are inked in
on the south side of the church, but only blocked out
on the north side. The staircase up to the south lower
gallery from the transept is shown, and one from the
south gallery to the upper gallery. One staircase in the
north gallery is shown. Between the colonnade of the
galleries are indicated (presumably) the balustrades:
one at the centre of the north lower gallery is shown
as missing.

The date of the erection of the lower galleries is a
matter of controversy, although it seems agreed that
they cannot belong to the time of the original church.
Soteriou (1952): 104 and 205 and plate 17 argued that
they were inserted into the church as part of the
seventh-century alterations after the fire. This opinion
was considered and supported by Cormack (1969),

46. Spieser (1984), 169-71 firmly rejects the seventh-century dating of these galleries, and attributes them instead to a later period in the history of the church, dating them to some time after the ninth century. His argument is that the wallpaintings of the north wall, which were, to judge from the photograph published by Soteriou, damaged by the insertion of the joists of the gallery, are paintings of the period after Iconoclasm; therefore the galleries also must be later than Iconoclasm. Spieser's view is unacceptable, as it cannot explain how the upper line of the seventh century mosaics in the north inner aisle is aligned to the floor of the lower galleries. The evidence of these mosaics is therefore that the galleries cannot be later than the restoration after the seventh-century fire. Soteriou dated the wallpaintings to the sixth or the seventh century; Nordhagen (1965 and 1968) accepted the pre-iconoclastic dating and saw their style as belonging to the seventh century.

6. Plan of Upper Gallery
ref: no. 3
Pen on tracing paper
h. 70.5 cm
w. 86.2 cm

As in the previous drawing, a less finished version of this plan on tracing paper exists in the collection: ref: B (?). The title on that version is written in the handwriting of W. S. George, and the scale is noted as 1/8 inch. The working drawings used in this plan are cat. nos. 12, 13 and 18. Additional information is written on these working drawings.

The upper galleries in 1907 lay over the inner aisles and around the transepts. The drawing indicates the position of windows on the south side, looking out over the roofing of the outer aisles. The balustrade slabs between the columns are marked in. The articulation of the colonnade of the gallery echoed

that of the ground floor colonnades; three bays divided by brick piers, with the intervals of three, four and three columns. The entry points of the staircases are marked.

Soteriou (1952) argued that the original church had galleries only above the narthex and the inner aisles, and that it was at the same time that the lower galleries were added over the outer galleries that new galleries were also built around the transepts, the western arches of which were rebuilt. On this analysis the transept galleries are to be dated to the restoration after the seventh century fire. Presumably substantial staircases up to the galleries in the original church would have been located at the west end of the church.

7. Section of Nave towards South (above) and
 South Elevation (below)
 ref: B 4; Plate VIIIa and Plate IVa.
 Pen on paper
 According to a note on another version of this sheet, the drawing was the work of W. S. George in 1907.
 h. 56 cm
 w. 76 cm

These are worked up drawings after the previous work by George; see cat. nos. 14, 15, 17 and 18. They show the profiles of the building as in 1907. The roof, for example, inevitably passed through several stages of rebuilding in the course of its history. Soteriou (1952) argued that in the seventh-sentury restoration only the roof of the transepts kept their original height: that of the nave and aisles were all reduced by about one metre and a half, and that of the narthex was raised to the new level of the nave to avoid the need to alter the windows. An inscription in the sanctuary record the complete overhaul of the roof in 1319-20. Further changes in the roof line were made

during the period of its use as a mosque.

Comparison of the section of the interior with the working plans of George (for example of the sculpture of the gallery parapets and capitals) reveals a number of discrepancies between the versions. Despite the attractiveness and apparent finality of this version, the working drawings need to be consulted together with this final version over matters of detail.

The nave colonnade is divided into three bays, divided by brick piers; the four columns in the centre bay on each side are of green Thessalian marble, and the groups of three in the other bays are distinguished by their white marble. Soteriou (1952) argued that the brick piers were inserted in the seventh-century rebuilding, but this opinion has been criticised by Mango (1974) and decisively rejected by later researchers, notably Krautheimer (1965) and, most convincingly, Spieser (1984).

The ground levels along the outside of the south side of the building in 1907 are visible in the lower drawing; it also gives some clues about the exterior articulation of the south facade of the transept, the west wall of which was rebuilt to the west and thereafter overlay the right side of the south east door into the south aisle.

See Soteriou (1952): 79ff. for a discussion of the articulation of the south wall; fig 24 derives from the drawings of Megaw and Corbett, which themselves depend in part on the record of George. See Cormack (1985), 80, 21 for a publication of this drawing.

8. Section through Transepts looking East.
 ref: B 47
 Pen and pencil on paper. The handwriting may be attributed to W. S. George.
 h. 39.8 cm
 w. 56.8 cm

A worked up drawing of this section also exists

in the collection; ref: no. 7. This scale here is 1/8 inch. The asterisk marked on the line of the lower colonnade of the transepts refers to the note below: «level with east impost of nave arcade and with floor of lower gallery (South)». The floor line marked (F. L.) is that of the nave. Apart from the annotation in the north transept «Traces of small window here», the other notes and the measurements were omitted from the worked up drawing.
Note: It is this worked-up drawing which is reproduced in this volume.

9. Plan, Sections and Door Moulding of Chapel of St Euthymios.
 ref: B 8
 Pen on paper
 h. 39 cm
 w. 56.2 cm

The small chapel of St Euthymios was added to the east end of St Demetrios in 1303. This date is recorded on its cycle of wallpaintings of Gospel scenes and of the life of the patron saint which were uncovered only after 1917. The structure of the chapel also needed consolidation after 1917; indeed the north east corner, as Corbett (1949) noted, was in frequent need of restoration. Its masonry of small rubble stones with minimal brick binding and its poor foundations on the underlying vaults (which were designed originally only to support the stairway to the south east door of St Demetrios) contributed to the unstable nature of its structure.

George produced scale drawings of the architecture, but was unable to observe the fabric in any detail. The monumental marble doorway of the chapel which he records was until 1303 a main entrance into the east end of the church; how long it had continued in use since the foundation of the church is unknown.

10. Plan and Sections of Undercroft below South

Transept
ref: B 9
Pen and pencil on paper. Titled: «Vaulted Chamber below South Transept»
h. 38.8 cm
w. 56 cm

The drawing can be attributed to W. S. George on the grounds of his initialled note W. G. The locations of the sections are recorded on the plan below. In the upper left is the section AA looking west, and in the upper right is the same section looking east. The section in the centre is BB. George marks the present floor level of the south transept, and the probable original level. To the left of the plan is recorded a tile used in the vault (no brick stamp), and the capital. The scale is 1/4 inch.

At the time of the work of George, the lower church had not yet been excavated, and access was limited. He called this the vaulted chamber below the south transept, and added the note that it was not a cistern. The drawing includes notes by George with his view of Byzantine building procedures in dealing with vaults, which he believed depended on the minimal use of centring.

11. The 'Tomb Chamber' at the North West of the Church. Plan and two Sections.
ref: B 10
Pen and pencil on paper. Titled: «S Demetrius. The Tomb Chamber»
h. 38.8 cm
w. 56 cm

The drawing can be attributed to W. S. George on the evidence of the handwriting. The scale is 1/4 inch. On the plan below the locations of the two sections are given (AA and BB). In the section AA on the upper left, the position of the east window is marked; it lay outside the north wall of the church.

Corbett (1949) notes that the walls were probably originally meant to be revetted with marble (there were fixing holes), and that both chambers were coeval. He asked if the semicircular chamber was originally the exedra of a building to the east. Since there was a lead pipe in the west niche, Corbett thought the function of the semicircular building was that of a Baptistery. Soteriou dated the chambers to the Roman period.

12. Ground Plan
 ref: B 17; plate XVII
 Pen on tracing paper, with blue wash.
 Signed W. S. G. Attributed here to April 1907.
 h. 27.2 cm
 w. 39 cm

It was suggested (under cat. no. 4) that this working drawing represents the earlier stage of work in the production of a ground plan; since cat. no 4 notes that the magnetic north reading is that of 21 April 1907, this seems a clear enough indication that the working drawing was done in that month.

The atrium is labelled on the right (the position of the phiale is marked). In the interior of the church, the central area of each transept is also named an «atrium». The bema is labelled, and the oblique line in front of it across the nave represents the line of a platform over the bema orientated towards Mecca. The chamber to the north of the narthex is described as the «tomb of Demetrius»; the semicircular building immediately to its south is repeated twice on the plan in order to give more information; its correct position is beside the «tomb», and there was no rectangular feature in the north part of the narthex. The notes written along the exterior of the north wall explain that in one section George could see traces of windows but could not get near enough to describe them; further to the west he see see no traces at all of

64

old windows. George was not in a position at the time of his work to unravel all the complications of the dates of the various walls on the north side of the church. Corbett (1949) accepted that the north wall of the north transept belonged to a structure which existed before the building of the church; Megaw had observed in the church before the modern rebuilding of the north transept that the north and east walls of this transept were quite separate and not bonded — indeed a skin of plaster coated the eastern extremity of the north wall, and separated it from the western face of the east wall (a fact no longer visible). Columns imbedded in the walls are recorded; as for example those which formed the stoa in the rectangular structures on each side of the apse. The foundations of the ciborion in the nave had not at this time been excavated.

See Spieser (1984): 185, fig: 10, for a recent measured plan of the nave and transepts of the present church.

13. Various Gallery Plans.
 ref: B 18
 Pen and pencil on tracing paper.
 Signed W. S. G.
 h. 43 cm
 w. 37 cm

The plans on this sheet are orientated to the east at the top and to the west at the bottom. In the upper part of the sheet are two plans of the east end of the north galleries, upper to left and lower to right. In the lower half of the sheet is the east end of the south galleries, upper to left and lower to right.

This sheet gives some information about the vertical junction between the gallery area and the western side of the transepts, one area which all researchers have agreed was rebuilt after the seventh-century fire, when a masonry arch was replaced with

red granite columns and re-used black marble capitals. George looked in detail at the stairs into the galleries and at the wooden beams (spars) and roofing system.

See also cat. nos. 5 and 6.

14. Three Sections of St Demetrios.
ref: B 16; plates XVIII and XIX.
Pen on tracing paper
Signed W. S. G.
h. 39.8 cm
w. 56.8 cm

These are the working drawings from which cat. no. 7. was produced, and, as noted under that item, the drawings need to be studied together; also related to these are cat. nos. 15, 16 and 21. Measurements and a scale are given. The section in the upper left is the nave looking east; in the upper right the nave looking west; and below nave looking south.

This sheet supplies a record of measurements in the area of the transepts and the west end of the church.

15. Folded Section of the central bay of the south nave colonnade.
ref: B. 20: plate XX
Pen and pencil on tracing paper.
signed W. S. G.
h. 40 cm
w. 29.5

The location of this section in the church has to be interpreted. It is proposed here that this sheet records the central bay of the south colonnade of the nave and that the right side of the drawing is a section turned at a right-angle to the colonnade (giving a north-south section across the aisles). Although this is not a common architectural convention, it was an

economical way of communicating a record. There is a scale at the bottom of the sheet.

This important record supplies a quantity of information, not only vertical measurements, but also about the sculptural details, mouldings, flooring and roofing timbers. George notes that the column bases are worked down from re-used antique bases. This sheet (and the drawn up section in cat. no. 21) gives a useful check for the section published by Soteriou (1952): 103, fig. 37, where the different roof and gallery floor heights of the original church and the seventh-century restoration are set out according to his hypothesis.

16. Folded Section of Nave looking West.
 ref: B 19; plate XXI.
 Pen and pencil on tracing paper with blue wash.
 Signed W. S. G.
 h. 37 cm
 w. 28.2 cm

This is a working drawing of the architecture of the west wall of the nave, the interior of the monumental tribelon between narthex and nave. For the final painted version of this section see cat. no. 21. This sheet is interpreted here as a folded section, like cat. no. 15. If this is the correct reading, the section on the right is of the narthex gallery (section west to east). It records measurements and some field notes.

17. Window measurements.
 ref: B 21.
 Pen and pencil on tracing paper.
 Signed W. S. G.
 h. 24 cm
 w. 29.7 cm

The main purpose of this sheet was to record various window measurements. The upper part of the sheet records these on an elevation of the south wall

of St Demetrios; below this to the left are the upper windows of the narthex, and at the botton left are the windows of the east facade. The pair of windows in the lower part of the sheet to the right is probably from the south side the church. «WL» stands for window level.

18. Plan of North Transept, various gallery plans, sections and an elevation of south aisle wall.
 ref: B 50.
 Pen on tracing paper.
 h. 51.8 cm
 w. 38.5 cm

This sheet can be attributed to W. S. George on the evidence of the handwriting. It comprises a heterogeneous collection of information, mostly from the area of the transepts (inluding the door of the chapel of St. Euthymios drawn out in cat. no. 9), but also from the south wall and the narthex gallery.

19. Architectural Sculpture of St Demetrios.
 ref: B 48.
 Pencil on paper.
 h. 56.3 cm
 w. 39.8 cm

These are scale drawings of sculpture, attributed to W. S. George on the evidence of the handwriting. In the upper left is a capital from a column in the arcade between the upper galley and the nave (labelled «the only finished capital in the Upper Nave Arcade»). In the upper right is a capital from the eastern stoa beyond the apse (labelled «Column built into wall to East of Apse»). In the lower left is a slab from the chambers to the north of the narthex (labelled «Slab in tomb chamber»). In the lower right is a capital from the apse (labelled «Capital in apse, inner range». At the bottom of the sheet are cornice mouldings from the apse.

The capital from the stoa is illustrated in Soteriou (1952): plate 42b and the apse cornice in plate 45b. The two capitals in the upper part of the sheet are similar to each other, and also identical to re-used capitals in the gallery of St Sophia at Thessaloniki (which were damaged in the fire of 1890 and replaced with modern capitals in the restoration of this building before 1912 (see M. Kalligas, *Die Hagia Sophia von Thessalonike* (Würzburg, 1935), whose (unconvincing) arguments about the dating of St Sophia rest largely on this correlation).

20. Architectural Sculpture of St Demetrios.
 ref: B 44.
 Pencil on paper.
 h. 56.5 cm
 w. 39.2 cm

Again this sheet is to be attributed to the hand of W. S. George on the evidence of handwriting. These are scale drawings. On the left side is one of the magnificent capitals and dosserets of the north transept (1/4 full size). It is noted that the extremities of the leaves are not integral, but separate pieces «pinned on». These capitals are close in style to those of the tribelon of the nave.

On the right side of the sheet are six fragments in one inch scale. They belonged to the ciborion in the lower church, see Soteriou (1952): plates 14 and 15.

21. Section of Nave looking West.
 ref: B 6
 Ink and Watercolour on paper. Scale 1/4 inch.
 h. 56 cm
 w. 77.5 cm

This sheet is not signed or dated. A preliminary version of this section is found in the collection, ref: B 21.

This is an example of a sheet of considerable

artistic quality, which is also of major archaeological value. It records the full extent of the marble revetment of the west wall; only fragmentary sections of this survived the fire of 1917 in the area below the gallery floor level.

The revetment of the pier to the right of the tribelon is disturbed in its upper section. It was below this replacement marble of the Turkish period that a damaged mosaic was found after 1917. Although the date of this mosaic is controversial (St Demetrios and four clerics), the most recent opinion is that of Spieser (1984): 198, note 194, who dates it firmly with the other mosaics belonging to the restoration after the seventh-century fire. This means that for some reason the restorers of the seventh century undertook alteration of at least some of the marble revetment of the church.

22. Marble revetments.
 ref: B 45
 Pen, pencil and watercolour on paper.
 Signed W. S. G.
 h. 31.5 cm
 w. 22.8 cm

The upper part of the sheet records the detailed marble opus sectile of the west wall of the nave, showing the closed door on the left of the tribelon and the open door to the right. The diamond shaped panels recorded below come from the nave walls.

23. Marble opus sectile of nave walls, including cornice frieze.
 ref: B 12
 Watercolour on paper
 h. 50.5 cm
 w. 38.8 cm

Various of the opus sectile panels of the nave and west wall are recorded here, including the closed door

panel, and a section of the fictive cornice, representing modillions in perspective. The draughtmanship of the cornice frieze is highly refined (and reminiscent of those in mosaic in the Rotunda of St George in Thessaloniki). It was noted, however, by Soteriou that the lines of the moulded nave cornices above the opus sectile do not quite match the line west wall cornice; this was one argument employed in support of a dating of the marble revetment of the nave colonnades to the seventh-century restoration. This attempt to date this opus sectile to a period later than the foundation of the church was rejected by Mango (1974) and Spieser (1984). Spieser (1984): 174ff. has a lengthy analysis of the opus sectile, on the evidence of the record of Diehl; he points out that the decoration is better preserved on the north side of the nave than the south.

24. Panels of marble opus sectile.
 ref: B 13
 Pen and watercolour on paper.
 Signed W. S. G.
 h. 50 cm
 w. 37.5 cm

Although George wrote on this sheet that it was «*not to be published as it stands*», it is a record of considerable interest. The panels are in one inch scale, and are put in order from the bema to the narthex (east to west). According to the notes of George, the panels when observed from close-to in the early twentieth century were seen not be made entirely out of cut marble pieces; some areas were in paint. At the bottom of the sheet is a record of the fictive curtains above the arches of the tribelon.

25. Marble revetment on colonnade of West Gallery.
 ref: B 14
 Pencil and watercolour.

Signed W. S. G.
h. 37.5 cm (the paper is folded over).
w. 50 cm

This sheet is in 1/2 inch scale, and represents an earlier version of the record (as noted on it by George). This part of the west wall of the nave was entirely destroyed in 1971 (see photograph in Soteriou (1952): plate 4b).

26. Marble revetments of nave colonnade. South side.
ref: B 23
Pencil and watercolour on paper.
Signed W. S. G.
h. 22.8 cm
w. 31.5 cm

It is difficult to identify the area of the church recorded here, but the information seems to coincide with the south side of the church (see cat. no. 7). If this is correct, the upper register represents the central bay of the south colonnade (four columns and five intervals and the lower register represents the western bay (three columns and four intervals). The fictive cornice was lost above most of the western bay; this would explain the note «wood to here». For some reason George did not draw up the eastern bay; but the written notes below the lower register must record what he saw there. Hence the cryptic heading «Bay nearest Bema».

27. Marble revetment of upper gallery colonnade.
South Side of Nave.
ref: B 22
Pencil and watercolour on paper.
Signed W. S. G.
h. 24 cm
w. 30.3 cm

This is identified by a comparison with cat. no. 7. *68*

The upper section is the bay nearest to the bema (with three columns and four intervals); the central section is the larger central bay (with four columns and five intervals); and the lower section is the western bay (again with three columns). George records the various colours of the marble, and that some shapes are in paint only. The issue raised in both this sheet and the previous one is again how far these areas of paint might be repairs dating to the seventh century restoration, or are simply the result of deterioration over the years.

28. Marble Linings to Arch Soffits.
 ref: B 46.
 Pencil and watercolour on paper.
 Signed W. G.
 h. 39.5 cm
 w. 56.3 cm

This sheet is in 1/2 inch scale. It records the highly refined decoration of the arch soffits in opus sectile. The two on the left are from the north arcade of the north transept; the central two are from the east arcade of the north transept. George noted that the east arcade of the south transept had presisely similar decoration. The two on the right record the soffits of the tribelon; the penultimate is the central bay, and the one on the right is the northern soffit. George notes that the southern soffit of the tribelon is similar to that on the north. Since these soffits are in association with some of the grandest capitals in the church (see cat. no. 20), it seems most likely that this marble too dates to the foundation of the original church.

29. Mosaic panel of St Demetrios and donors on west wall of south inner aisle.
 ref: B 30; sheet no. 5.
 Watercolour on paper.

h. 35.8 cm
w. 53 cm

This sheet is of some value in showing the state of the panel at the beginning of the twentieth century. It also offers some check of the recording abilities of W. S. George, since the copy can be checked against the original in the church. Such a comparison is encouraging; despite the small scale the recording is accurate. The left side of the panel had already been lost at this time. On this scale of work George indicated gold or silver tesserae with yellow or off-white pigments; in the full-size copies or one inch scale sheets he used gold or silver. The sheet was published by Dalton (1911), fig 224.

St Demetrios stands at the centre in front of a representation of his ciborion. To the right, in front of a doorway which opens onto a garden, a boy, held by a man, stands beside the saint. Similar figures were presumably once to the left, as the panel was no doubt a symmetrical composition at the end of the aisle. The panel was presumably an offering to the church by a member or members of the local aristocracy. In date this panel belongs with the group produced before the fire of around 620. It was either part of the original decoration of the church, or a piecemeal addition.

30. Mosaics of North Inner Aisle.
 ref: B 26; sheet no 1.
 Pencil and watercolour on paper.
 h. 36 cm
 w. 48. 2 cm

The copies of the north inner aisle mosaics are documented in the British School reports as the work of W. S. George. The care taken to record the mosaics in this area of the building was the consequence of a number of factors; they had the novelty of

being a recent discovery, a special donation was given for the work and being on the walls of an active mosque their future was uncertain. What was not of course anticipated was their enormous future value in the event of their almost total destruction in 1917. The only parts of the mosaic to survive the fire were pieces of the inscription (see cat. no. 34) and of the extreme east panel (cat. nos. 36, 38 and 57).

The left of the sheet shows St Demetrios and beside him to the left a donor; to the right is an incription with the common formula «As a prayer for one whose name God knows». The same panel is continued to the right with another representation of the saint and another donor, this time bearded. On each side of the saint was a medallion of a saint, set against a curtain. George marks a horizontal «joint» running across the top right of the mosaics in this sheet. This was argued by Cormack (1969) to be a suture between two periods of mosaic, the earlier below and the restoration after the fire of around 620 above.

For a discussion in detail of this and the other north inner aisle mosaics, see Cormack (1969), Grabar (1978) and Cormack (1985). Reference should also be made to the photographs of William Harvey in this exhibition.

31. Mosaics of North Inner Aisle. Inscription.
ref: B 35; no. 10 refers to (sheet) no 1.
Watercolour on paper. Painted Squeeze. Actual size.
h. 53 cm
w. 33.8 cm

This record of the mosaic surface was made in much the same way as a record of an inscription, and for this reason is described here as a «squeeze». The dampened paper would have been laid against the tesserae, and pressed into shape. Unfortunately the

result was not a very sharp one, presumably because the tesserae were evenly and tightly laid. Some of the other squeezes were more successful. The letters were probably in silver and the cross in gold, but George does not note the colours in this case.

The text is «As a prayer for one whose name God Knows».

32. Mosaics of North Inner Aisle.
 ref: no. 2
 Pencil and watercolour on paper. One inch scale.
 h. 36.5 cm
 w. 50.7 cm

The left of the sheet records a monumental composition, if on a small scale, of the Virgin and Child on a lyre-shaped throne with attendant angels, saints and donors. To the right is the first of a serial framed composition. This sequence records the events of the life of a child Maria. In the first scene Maria as a child is presented to St Demetrios, who is seated in front of his open ciborion, and who symbolically communicates with heaven.

33. Mosaics of North Inner Aisle. Inscription.
 ref: B 43; no. 18 refers to (sheet) no. 2.
 Pencil and watercolour on paper. Painted Sque-
 eze. Actual size.
 h. 20.1 cm
 w. 17.3 cm

This squeeze records the name of the medallion saint on the extreme right of the Virgin and Child composition. The name is undoubtedly Matrona, a popular local saint already in the early Byzantine period.

34. Mosaics of North Inner Aisle.
 ref: no. 3.
 Pencil and watercolour on paper.

h. 36.2 cm
w. 50.5 cm

This is the continuation of the Maria cycle, but the composition is interrupted in the centre by the inserted later mosaics which show St Demetrios and two clerics above an inscription recording the restoration after the fire: «Made young again in the times of Leo, you see the church of Demetrios, previously burnt».

Maria, still a child in arms, is now shown with the Virgin and her attendant angels. In the third scene to the right Maria with two women are each offering two candles to St Demetrios; in view of the cost of candles in Byzantium this gesture alone must have conveyed to the viewer the impression of the wealth of Maria and her family.

35. Mosaics of North Inner Aisle. Inscription
 ref: B 36; no 11 refers to (sheet) no. 3
 Pencil and watercolour on paper. Painted Squeeze. Actual size.
 h. 24.4 cm
 w. 53 cm

This squeeze records the inscription below the scene of Maria offering candles to St Demetrios. The letters were in silver set against a dark blue ground.
«And the lady, the holy Mother of God».

36. Mosaics of North Inner Aisle.
 ref: no 4
 Pencil and watercolour on paper
 h. 33 cm
 w. 50.7 cm

The fourth and final scene of the Maria cycle shows her in front of St Demetrios in a garden setting. The end of the series may indicate the death or the illness of the young girl, but the full meaning of

the cycle needs further research. To the right of this sheet is another single panel of St Demetrios and several donors.

37. Mosaics of North Inner Aisle. Inscription
 ref: B 37; no 12 refers to (sheet) no. 4
 Pen and watercolour on paper. Painted Squeeze.
 Actual size.
 h. 33.8 cm
 w. 53 cm

This records the inscription in the final scene of the Maria cycle: «And you, my Lord Saint Demetrios, aid us your servants and your servant Maria, whom you gave to us».

38. Mosaics of North Inner Aisle. Donor and Inscription
 ref: B 38; no 13 refers to (sheet) no. 4
 Watercolour on paper. Painted Squeeze. Actual size.
 h. 42 cm
 w. 34. 3 cm

This squeeze provides a valuable record of one of the donors of the final eastern panel. The inscription repeats the formula «As a prayer for one whose name God knows».

39. Mosaics of North Inner Aisle. Inscription
 ref: B 39; no 14 refers to (sheet) no. 4
 Watercolour on paper. Painted Squeeze. Actual size.
 left: h. 17 cm
 w. 11. 7 cm
 right: 17 cm
 11.5 cm
Note: diameter of halo from outside of the red trim around the gold is 20 cm.

This squeeze gives the surviving letters of the name of the medallion saint on the right of the last panel. George read it as «(Alexan)dros».

40. Mosaics of St. Demetrios and the Donors after the seventh century fire; and of St Sergios. Right pier of sanctuary.
 ref: B 31; sheet no. 6.
 Pen, pencil and watercolour on paper. Scale one and a half inch.
 h. 35.7 cm
 w. 52.8 cm

The commemoration panel of the restoration of the church after the fire of around 620 and that of St Sergios were not damaged in 1917, and the value of this sheet is simply as a record of their condition before 1917 and as an indication of the accuracy of the record of George on this scale. The mosaic panels in the eastern faces of the sanctuary piers were not visible in the time that George made his record; they were hidden below Turkish masonry.

41. Mosaic; Face of Donor (Prefect) with St Demetrios. Right pier of sanctuary

ref: B 34; no. 9 refers to (sheet) no. 6.
Watercolour on paper. Actual Size.
h. 54.4 cm
w. 39.6 cm

In this case George made a copy of the face of the donor on the right of the sanctuary panel, but did not record it in a squeeze. This figure, a secular one, is generally identified as the prefect (governor) of Thessaloniki at the time of the restoration.

42. Mosaic of a saint and two figures; and of the Virgin and St Theodore. Left Pier of sanctuary.
ref: no. 7.
Watercolour on paper. Scale one and a half inch.
h. 39.5 cm
w. 54.7 cm

These two panels survived the 1917 fire, but they have remained controversial in interpretation. Is the saint St Demetrios or St Bacchos? Are the figures children or donors? is the panel of the Virgin and St Theodore part of the restoration work after the fire of around 620, or is a work of a later period?

JULY 1985

Principal publications
concerned with aspects of

F. Tafel, *De Thessalonica ejusque agro,* (Berlin, 1839).

C. Texier and R. P. Pullan, *Byzantine Architecture,* (London, 1864).

J. Laurent, «Sur la date des églises St Démétrius et S^te Sophie à Thessalonique», *Byzantinische Zeitschrift,,* 4 (1895), 420-34.

P. N. Papageorgiou, «Mnemeia tis en Thessaloniki latreias tou megalomarturos hagiou Dimitriou», *Byzantinische Zeitschrift,* 17 (1908), 321-81.

T. E. Uspenskij, «On the newly discovered mosaics in the church of St. Demetrios at Thessaloniki» and N. K. Kluge, «The technique of the mosaic work in the church of St. Demetrios at Thessaloniki» (both in Russian), *Izviestiia Russkago Arkheologicheskago Instituta v Konstantinopolie,* 14 (1909), 1-61 and 62-7; and 169-71.

O. Tafrali, «Sur la date de l'église et des mosaiques de Saint-Démétrius de Salonique», *Revue Archéologique,* 4th series, 13 (1909), 83-101.

O. Tafrali, «Sur les réparations faites au vii^e siecle à l' église de Saint-Démétrius de Salonique», *Revue Archéologique,* 4th series, 14(1909), 380-6.

H. Delehaye, *Les légendes grecques des saints militaires,* (Paris, 1909).

Ch. Diehl and M. le Tourneau «Les mosaiques de Saint-Démétrius de Salonique», *Monuments et Mémoires (Fondation Piot),* 18 (1910), 225-47.

O. M. Dalton, *Byzantine Art and Archaeology,* (Oxford, 1911).

O. Tafrali, *La topographie de Thessalonique,* (Paris, 1913).

Ch. Diehl-M. Le Tourneau-H. Saladin, *Les Monuments chrétiens de Salonique,* (Paris, 1918).

G. Soteriou, «Ekthesis peri ton ergasion ton ektelestheison en ti ireipomeni ek tis purkaias Basiliki tou Agiou Dimitriou Thesalonikis kata ta eti 1917-1918», *Archaiologikon Deltion,* 4 (1918), Supplement 1-47 (also published as separate offprint as *O vaos tou Agiou Demetriou Thessalonikis,* Athens, 1929).

R. Kautzsch, *Kapitellstudien,* (Berlin-Leipzig, 1936).

Catalogue of the Exhibition, *British Archaeological Discoveries in Greece and Crete 1886-1936,* (Royal Academy of Arts, London, 1936).

II

(in chronological order)
St Demetrios at Thessaloniki

André Grabar, *Martyrium*, (Paris, 1946).

C. Edson, «Cults of Thessalonica», *Harvard Theological Review*, 41 (1948), 153-204.

G. Soteriou, «Anaskaphae en ti Basiliki tou Agiou Dimitriou Thessalonikis», *Praktika Arch. Etaireias*, 1949 (Athens, 1950), 135-44.

G. U. S. Corbett, *St. Demetrius', Salonika. Architecture*, (Unpublished notes, 1949).

G. and M. Soteriou, *The Basilica of St Demetrios at Thessaloniki* (in Greek), (Athens, 1952).

N. Theotoka, «Peri ton kiborion ton naon tou Hagiou Dimitriou Thessalonikis kai Konstantinopoleos», *Makedonika*, 2(1941-52), 395-413.

Paul Lemerle, «Saint-Démétrius de Thessalonique et les problèmes du martyrion et du transept», *Bulletin de correspondance héllénique*, 77 (1953), 660-694.

J. G. Breckenridge, «The 'long siege' of Thessalonika», *Byzantinische Zeitschrift*, 48 (1955), 116-22.

André Grabar, *L'iconoclasme byzantin*, (Paris, 1957).

E. Kitzinger, «Byzantine Art in the period between Justinian and Iconoclasm» *Berichte zum XI. Internationalen Byzantinisten-Kongress*, (Munich, 1958), IV/I, 1-50: reprinted in W. E. Kleinbauer (editor), *The Art of Byzantium and the Medieval World: Selected Studies by E. Kitzinger*, (Bloomington and London, 1976), 157-206 and additional notes 392.

R. F. Hoddinott, *Early Byzantine Churches in Macedonia and Southern Serbia*, (London, 1963).

K. Kalokyris, «la basilique saint Démétrius de Thessalonique. Ses mosaiques», *Corsi di cultura sull'art ravennate e byzantina*, 11 (1964), 225-236.

R. Krautheimer, *Early Christian and Byzantine Architecture*, (Harmondsworth, 1965; and second edition, 1975, esp. 132).

P. J. Nordhagen, «The Mosaics of John VII (705-707 A. D.). The Mosaic Fragments and their Technique», *Acta ad archaeologiam et artium historiam pertinentia*, 2 (1965), 121-66, esp. 158-9.

P. J. Nordhagen, «The Frescoes of John VII (A. D. 705-707) in S. Maria Antiqua in Rome», *Acta ad archaeologiam et artium historiam pertinentia*, 3(1968), 1-125, esp. 110.

Robin S. Cormack, «The Mosaic Decoration of S. Demetrios, Thessaloniki: a re-examination in the light of the drawings of W. S. George» *Annual of the British School at Athens*, 64 (1969), 17-52.

A. Xyngopoulos, *The Mosaics of the Church of Saint Demetrius in Thessaloniki* (Thessaloniki, 1969).

K. G. Bonis, *Die Slawenapostel Kyrillos und Methodios und die Basilika des Hl. Demetrios von Thessaloniki,* (Athens, 1969).

M. Vickers, «The Date of the Walls of Thessalonica», *Istanbul Arkeoloji Müzeleri Yilligi,* 15-16 (1969), 313-8.

M. Kiel, «Notes on the History of some Turkish Monuments in Thessaloniki and their Founders», *Balkan Studies,* 11 (1970), 123-48.

E. Kleinbauer, «Some Observations on the dating of St. Demetrius in Thessaloniki», *Byzantion,* 40 (1970), 36-42.

A. Xyngopoulos, *The Iconographic Cycle of the Life of St Demetrios,* (in Greek), (Thessaloniki, 1970).

C. N. Bakirtzis, *The Basilica of St Demetrios,* (in Greek), (Thessaloniki, 1972).

S. Pelekanides, « <<To Theatron to kaloumenon Stadion>> tis Thessalonikis», *Kernos* (Festschrift for Bakalakis), (Thessaloniki, 1972), 122-33.

J. -M. Spieser, «Les inscriptions de Thessalonique», *Travaux et Mémoires,* 5 (1973), 145-180.

Ch. Bouras, «The Tomb of Loukas Spandoulis in the Basilica of St Demetrius, Thessaloniki», (in Greek), *Aristoteleion Panepistimion Thessalonikis. Epistimoniki Epitiris tis Polutechnikis Scholis,* 6 (1973), 3-63.

Christopher Walter, «St. Demetrius: The Myroblytos of Thessalonika», in Cristopher Walter, *Studies in Byzantine Iconography,* (London, 1977), 157-78 — reprinted from *Eastern Churches Review,* (1973).

Michael Vickers, «Fifth-Century Brickstamps from Thessaloniki», *Annual of the British School of Archaeology at Athens,* 68 (1973), 285-94.

Michael Vickers, «Sirmium or Thessaloniki; A Critical Examination of the St. Demetrius Legend», *Byzantinische Zeitschrift,* 67 (1974), 337-50.

C. Mango, *Byzantine Architecture,* (first edition in Italian, Milan, 1974; second edition in English, New York, 1976).

R. Janin, *Les églises et les monastères des grands centres byzantines,* (Paris, 1975), esp. 365-372.

J. -P. Sodini, «L'ambon de la Rotonde Saint-Georges: remarques sur la typologie et le décor», *Bulletin de correspondance héllénique,* 100, (1976), 493-510.

A. H. S. Megaw and E. J. W. Hawkins, *The Church of the Panagia Kanakariá at Lythrankomi in Cyprus. Its Mosaics and Frescoes*, D. O. S. 14, (Washington D. C., 1977) esp 62 and note 179.

E. Kitzinger, *Byzantine Art in the Making*, (London, 1977).

J. A. S. Evans, «The Walls of Thessalonica», *Byzantion*, 47 (1977), 361-2.

Beat Brenk, *Spätantike und frühes Christentum*, (Propyläen Kunstgeschichte, 1977).

Brian Croke, «Hormisdas and the Late Roman Walls of Thessalonika», *Greek, Roman and Byzantine Studies*, 19 (1978), 251-8.

André Grabar, «Notes sur les mosaiques de Saint-Démétrios à Salonique», *Byzantion*, 48 (1978), 64-77.

C. Bakirtzis, «Sur le donateur et la date des mosaiques d' Acheiropoietos a Thessalonique», *Atti del IX Congresso Internazionale di Archeologia Cristiana*, II, 37-44 (Rome, 1978).

C. K. Papastathis, «Ena upomnima yia tin purkagai tis Thessalonikis sta 1917 kai tin perithalpsi ton thumaton», *Makedonika*, 18 (1978), 143-171.

V. Popović, «La descente des Koutrigours, des Slaves et des Avars vers la mer Egée: le témoignage de l' archéologie» *Académie des Inscriptions et Belles-Lettres: Comptes-Rendus*, (1978), 596-648.

P. J. Nordhagen, «S. Maria Antiqua: the frescoes of the seventh century», *Acta ad archaeologiam et artium historiam pertinentia*, 8 (1978), 89-142, esp. 140.

D. Feissel and J. -M. Spieser, «Les inscriptions de Thessalonique. Supplément», *Travaux et Mémoires*, 7 (1979), 303-348.

D. I. Pallas, «Le ciborium hexagonal de Saint-Démétrios de Thessalonique», *Zograf*, 10 (1979), 44-58.

Paul Lemerle, *Les plus anciens recueils des miracles de saint Demetrius*. I *Texte*. II *Commentaire*, (Paris, 1979-1981). This edition of the first two books of the *Miracles of St Demetrios* and the historical commentary supersedes all previous discussions. In particular, a date for the seventh-century fire of about 620 now seems certain.

J. -P. Sodini, «La sculpture architecturale a l'époque paléochrétienne en Illyricum», *Rapports présentés au Xe congrès international d'archéologie chrétienne*, (Thessaloniki, 1980), 31-119.

Jean-Michel Spieser, Thessalonique et ses monuments du IVe au VIe siecle. *Contribution a l'étude d'une ville paléochrétienne*, (Athens-Paris, 1984: B. E. F. A. R. no. 254).

Robin Cormack, *Writing in Gold. Byzantine Society and its Icons*, (London, 1985).

III

THE ARTS DURING
THE AGE OF ICONOCLASM

[35] My aim in this paper is to survey the arts in the period from 726 to 843, not to discuss the theory of images. Like any other period in the history of art, there are limitations in the evidence of surviving works and written sources.[1] A small number of the major buildings survive, which show it to be an influential time for Byzantine architecture. The position in monumental decoration is more obscure, and only one dated illustrated manuscript is extant.

Two surviving episcopal churches show the possible scale of work that could be achieved during the period. The church of St Eirene was substantially rebuilt on Justinianic foundations after its devastation in the earthquake of 740,[2] and the church of St Sophia in Salonica was erected over an earlier basilica as the new cathedral of that city between 780 and 797.[3] The massive new domed church in Salonica was presumably designed to impress the Slavonic settlers of Greece with the power of Byzantine imperial Christianity in this unconquered city, and also to emphasize to the citizens their required orientation to Constantinople, not Rome, in ecclesiastical affairs.

The study of Iconoclast art is hindered by three main factors, not all of which are connected with the ideologies of the age. The first factor is simply the distance in time from us, and the consequent erosion of the monuments. There is a paradox, however, for in Istanbul and its surroundings virtually as much material has survived from the Iconoclast period as from the tenth century, a century generally emphasized as more important in the history of art. One would not expect Iconoclastic [36] monuments to contain much material surviving in good condition from a time of execution over eleven centuries ago, but two "Great Churches" of the period do preserve some indications of their appearance. In St Eirene (fig. 2), apart from the large mosaic cross in the apse (never replaced with a figure), there are fragments of non-figurative fresco decoration recently uncovered in the south aisle; the prominence of the crosses here supports an eighth-century date. Fragments of marble plaques, no longer in position but broken up some time after 1453, survive as bases for the present disturbed north aisle colonnade. Their decoration with a monogram of Constantine suggests that these formed part of a decoration of between 741 and 775, perhaps a new templon screen to replace one shattered by falling masonry[4]. In St Sophia in Salonica, some of the original mosaics of the sanctuary

2 THE ARTS DURING THE AGE OF ICONOCLASM

survive: for example, the crosses decorating the barrel vault above the dating monograms of Constantine and Eirene (fig. 3), and the relics of the apse scheme of a large cross against a gold ground (replaced by the present Virgin and Child in the second quarter of the eleventh century, according to my interpretation of the style) (fig. 4). The structure suffered extensive damage in the fire of 1890, and the building was only consolidated in 1908 after some years of neglect, from when the incorrectly restored roofing of the galleries dates. To this restoration belongs the present wall decoration, which was executed then as an appropriate scheme for an early twentieth-century mosque (see figs. 5, 6).[5]

The second factor inhibiting the existence of Iconoclastic art is historical. Byzantium was struggling for its continued existence under the threat of Arab and Slavonic pressures. Day-to-day living was also threatened by an alarming number of natural catastrophes — several earthquakes (including the massive one of 740), volcanic eruptions, and plague. Consequently, the priority for building activities during the eighth century must have been defensive works and essential projects. Presumably, repairs to the walls of Constantinople by Leo III and Constantine V must have taken priority in 740 over the reconstruction of St Eirene or the repair of St Sophia (where work was [37] postponed until 768/9). The walls needed further attention during the reign of Theophilos.[6] Another work in this category was undertaken by Constantine V after the drought of 766. He resolved to restore the Aqueduct of Valens, which had been ruined over a century before by Avars in the reign of Heraclius, and imposed heavy taxes to pay for the operation. According to Theophanes, Constantine hired vast numbers of workers.[7]

The quantity of new church building and normal maintenance work must have been reduced in these times of military and economic crisis, and the great amount of building and repair undertaken by Basil I in the second half of the ninth century, as recorded in the *Vita Basilii*, can be taken as a confirmation of neglect during Iconoclasm. This is not to say that no prestige building was undertaken in the period, for even the delegates to the Council of Nicaea in 787 admitted that the Iconoclasts dedicated churches — the Council complained that such monuments had not received relics at the time of foundation.[8] The economic consideration may have influenced emperors that the State might be able to promote employment by financing building works.

The third factor is the Iconoclastic policy in attacking the monks. Even if the claim that the "reduction of the power of the monks is the key to most Iconoclastic policy" is an exaggeration (which Ostrogorsky has warned against),[9] yet these attacks must have reduced, though not eliminated, one area of substantial patronage of the period before Iconoclasm. There is evidence that monks were a considerable factor in the production of art in the sixth and seventh centuries; for example, the vast gold treasure of the Monastery of Sion

THE ARTS DURING THE AGE OF ICONOCLASM 3

in south Asia Minor (now divided between the Istanbul Archaeological Museum and the Dumbarton Oaks Collection), or the encaustic icons acquired by the monks on Mount Sinai (several, though not all, of great quality), or the high-quality frescoes which decorated the church of the Greek monastic Diaconia of Santa Maria Antiqua in Rome. The *Vita* of St Theodore of Sykeon portrays an Anatolian monk who prayed to icons, and who could commission a silver chalice from Constantinople.

[38] Monastic investment of money in art must have been reduced in the eighth century, but there is evidence of recovery under Empress Eirene, and in the first half of the ninth century, particularly in Bithynia.

Artistic Profile of the period

With these historical factors in mind, it is possible to sketch out the pattern of production.

Before his declaration of Iconoclasm, Leo III seems to have commissioned figurative painting: Patriarch Germanos describes "the icon in front of the palace" on which the Emperor represented the likenesses of the apostles and the prophets, and where were written their utterances about God, proclaiming the cross of salvation to be the proud ornament of their faith.[10] After his destruction of the portable icon of Christ on the Chalke Gate, there is no clear evidence that Leo III put up a cross in its place — though this seems likely.

The next moment of artistic patronage recorded in Constantinople is the temporary restoration of images under the usurper Artavasdos; some work is presumably to be deduced between June 741 and November 742, though specific information is lacking.

The reign of Constantine V showed a definite upsurge in artistic activity, for even the overt acts of Iconoclasm represent the employment of artists and builders. After the Council of 754, the *Vita* of St Stephen the Younger records the scraping down of images, but also the giving of "greater lustre" to pictures of trees, birds, or beasts, and of horse-races, hunts, theatrical and hippodrome scenes. In the Church of the Virgin of Blachernae, a cycle of the life of Christ was removed, but Constantine did commission mosaics representing trees, birds, beasts, ivy scrolls and such motifs. In the Milion, the scene of the prominent political use of the icon at the beginning of the eighth century under both Philippikos and Anastasios II, Constantine obliterated the representations of the six Church Councils and substituted a picture of a horse race and his favourite charioteer, called Ouranikos.[11]

[39] Surviving work from this reign is the rebuilding and decoration of St Eirene, as well as some work in St Sophia. In the Patriarchate of the Great Church, Niketas on his elevation as Patriarch may have had his own security in office in mind when he removed the figurative icons still visible there in 768/9

4 THE ARTS DURING THE AGE OF ICONOCLASM

and substituted crosses (fig. 7).[12] Perhaps the substitution of a cross in the apse of the Koimisis Church at Nicaea in place of a standing Virgin belongs to this reign.

[40] To the period of Eirene can be attributed a number of churches, for example, St Sophia at Salonica, St Sophia at Vize in Thrace, and several monastery churches in Bithynia, notably the Fatih Camii at Tirilye (probably the monastery of Trigleia).[13] A feature of all the churches datable to this period is their reliance on the re-use of marble sculpture from an earlier period for their fittings and decoration. This seems to confirm that the major quarries of Late Antiquity, such as those of the Marmara, had fallen into disuse by this period. The suggestion has even been made that the need to revamp any available materials led to the invention of the four-column domed church in Bithynia in the late eighth century, a region which teemed with classical remains.

A number of major artistic works undertaken by Eirene are known through the evidence of texts — and there seems to have been a conscious attempt to proclaim the return of a "Golden Age".[14] There is mention of statues in the round of Constantine VI and Eirene (the first statues of Emperors since Philippikos) and of a series of votive offerings (after an illness of Eirene) to the Church of the Virgin *tes Peges*. These included rich veils and curtains, a crown, liturgical vessels, and mosaic panels with portraits of the two imperial donors making their offerings and commemorating the "miracle" of the healing.[15] Eirene probably restored an image of Christ on the Chalke Gate between 797 and 802. The production and display of portrait icons, including pictures of famous monks and saints, has been deduced as taking place in the Studios Monastery — this depends on the interpretation of some epigrams of St Theodore as describing twenty four such icons around 800.[16]

[41] Leo V removed the new Chalke icon, but he did commission a cross in its place. There is a case for attribution to Second Iconoclasm of the invention of some of the pictorial models used after 843 in such Psalters with marginal illustrations as the Chludov. Certain of the anti-Iconoclastic illustrations of these manuscripts might have been first composed as appropriate visual propaganda in iconodule pamphlets — the icon party seems likely to have used art in this way. Such pictures perhaps appeared in the texts composed by Nikephoros in 818-820, for example to accompany the *Apologeticus pro sacris imaginibus*, where (section 8) he compares Iconoclasts with those who crucified Christ.[17] Nikephoros also accuses the Iconoclasts of simony. However the use of such pictures in Iconophile texts might be even earlier, for similar polemics had already flowed from the pen of St John of Damascus.[18] The representation of Nikephoros trampling upon Leo V and Theodotos now found beside an anti-Iconoclastic poem in the Athonite Psalter, *Pantokrator cod.* 61, might be an invention of the 820s.[19]

THE ARTS DURING THE AGE OF ICONOCLASM 5

Images of saints were certainly available for use during Second Iconoclasm. One official concession was that images high up in buildings were permitted to "fulfil the purpose of writing".[20] The apse mosaic of Hosios David in Salonica probably remained exposed to view after its discovery below a covering in the reign of Leo V.[21] The implication of this evidence is that Iconoclasm was losing its impetus. There is more support for this interpretation of the period. The "panel-worshipping" monks of St John of Pelekete in Bithynia were ordered to be scourged and expelled for their intransigence, but escaped any punishment.[22] The painter Lazaros painted an image of the Baptist in the church of St John the Baptist *tou Phoberou*, on the Asiatic shore of the Bosphoros near the Black Sea. Even the Empress Theodora had icons in the Palace, offering a Byzantine example of divergence between the public and private practices of the Imperial family in a period of Iconoclasm. Her husband, Theophilos, is well-known for his artistic patronage, especially in the building and decoration of palaces.

Even brief survey of this kind gives evidence of artistic activity throughout the period, though its quantity was less than in the period before and after Iconoclasm. The problem, therefore, is not whether there was art during Iconoclasm, but whether its appearance and style can be characterized. Since there is evidence of some continuity of production during Iconoclasm, my approach is to ask whether the three main visual currents known before, and still apparent in the period after Iconoclasm, might have survived through the period. I shall investigate these currents under three headings; the non-figurative and symbolic current, the "abstract" treatment of figure style, and the "illusionist" treatment of figure style.[23]

The non-figurative and symbolic current

Two examples from the reign of Constantine V exemplify this type of art: the apse mosaics of St Eirene, and the crosses in the Small Sekreton of the Patriarchate of St Sophia. The focus of these decoration is the cross, within an ornamental setting. This system of decoration was not an invention of the Iconoclastic period, but had occurred commonly for some centuries beforehand. The decoration of St Sophia in this manner by Justinian may even have been influential in its popularity.[24] This current of art is of such a traditional nature that it is difficult to date even the various parts of St Sophia.[25] In view of the history of this current, I doubt whether a strong case can be made that the development of ornamental art was an original feature of Iconoclasm.

Traditional schemes were used for the decoration of the Blachernae Church, and the current continues in the sanctuary mosaics of St Sophia at Salonica (which dates after the Byzantine triumphant campaign in Greece of 783, but may be before or after the restoration of icons in 787). The bronze decora-

6 THE ARTS DURING THE AGE OF ICONOCLASM

tions of the door into the south-west Vestibule of St Sophia carried out under
Theophilos might be adduced as a continuation of the same current; and in the
third *Antirrheticus* of Patriarch Nikephoros are described curtains and other
sanctuary furnishings on which images may appear for veneration, or zoomor-
phic elements "for decorative purposes".[26] Under this heading it [42] may be
appropriate to mention the manner of the representation of the Ecumenical
Councils known in the Nativity Church at Bethlehem, even if these particular
mosaics might be as late as the Crusader period.[27] For that this type of sym-
bolic representation of theology and christology through texts was known in
this period is suggested by the appearance of the decoration of St Julian de los
Prados at Oviedo in Spain. Perhaps the Milion panels destroyed by Constan-
tine V were of this type also.

The "abstract" treatment of figure style

This second current is characterized in the period before Iconoclasm by the
apse mosaics of St Catherine's on Sinai or by various panels in the Church of
St Demetrios in Salonica, and is continued up to the years before Iconoclasm
in the mosaic of the Presentation in the Kalendarhane Camii at Istanbul. To a
varying degree, these mosaics portray saints as stylized figures, particularly as
cult images to whom might be addressed prayers. This current of style entered
Byzantine art from Late Roman imperial art, and can be tracked in early sculp-
tural monuments in New Rome, as in the (old) Porphyrios base erected in the
Hippodrome around 500.[28] It seems likely that this traditional form of Hippo-
drome art would have reasserted itself in the representation of the charioteer
Ouranikos executed for Constantine V in the Milion. This suggestion is sup-
ported by the survival of the tradition in charioteer silk textiles, which have
been attributed to Constantinopolitan workshops of the late eight century, and
in New Testament scenes in silk from the Sancta Sanctorum in Rome, which
have been dated to Second Iconoclasm by reference to the descriptions in the
Liber Pontificalis.[29] The late-eighth-century mosaics of the Church of the Vir-
gin *tes Peges* seem likely to have been in this tradition.

The "illusionist" treatment of figure style

This third current of style entered Byzantine art as a legacy from the Hel-
lenistic art of Antiquity, and an artist working in this form of expression would
be concerned not only with solid treatment of figures but also with their set-
ting and emotions. An example of good quality work in this current by artists
from Constantinople is found in the frescoes commissioned by Pope John VII
in St Maria Antiqua in Rome (705-707).[30] Some stylistic features shared with
the John VII paintings in Rome and the indications that Lombard artists of the

middle of the eighth century were influenced by Castelseprio seem to provide a reasonable basis for attributing these frescoes to the first half of the eighth century.[31] Castelseprio is an outstanding work of Byzantine art; a comparison of the treatment of the scene of the Adoration of the Magi here and at St Maria Antiqua shows the common use of a similar iconography, but the Castelseprio artist shows his superiority in his success in designing an effective composition over the architectural surface with which he was confronted.

The work of the period of Pope Zacharias (741-752) in St Maria Antiqua, for example the Crucifixion scene in the Theodotus chapel, can be compared with painting of half a century earlier. On one interpretation, this comparison documents a steep decline of competence in the "hellenistic style" in the first half of the eighth century occurring in both the East and West Mediterranean. By about 750 it was a style of the past, never to be found again in monumental art, but forever limited to miniature reflections in the pages of manuscripts.[32] Another interpretation of this comparison is to see a new Byzantine influence in Rome, this time of the more abstract linear current; in this case the Crucifixion panel represents not the illusionist current in decline, but a new positive mode of expression. This interpretation depends on an identification of the source of the new influence in the Greek East because of similarities with a Crucifixion icon in the collection of St Catherine's on Sinai; this panel is not however dated, nor is it very similar to the rendering in Rome.[33]

I prefer to see the mid-eighth-century frescoes of St Maria Antiqua as examples of a stiffened degeneration of the "illusionist" current, but I do not wish to make any generalizations from this [43] material about the state of expertise outside Rome or in the Greek East. The problem therefore remains whether the "illusionist" current continued to be employed by Byzantine artists after the 720s. For example, were the non-figurative decorations of the Blachernae and other churches under Constantine V executed in an "illusionist" tradition, like the Great Palace mosaics in the sixth century and the mosaics of the Great Mosque of Damascus in the early eighth century?

To offer an answer to this question, it seems necessary to turn to the indirect evidence for the period available in the art of the West.[34] I mention — but only to reject — the possibility that the stucco figures of St Maria in Valle at Cividale reflect East Mediterranean prototypes from the Byzantine or Islamic world. It is more likely that this work is part of a local North Italian tradition, a mid-eighth-century cheap form of statuary. More crucial is the artistic production of the Carolingian court at Aachen, where the production of mosaics in the Palatine Chapel (790-800), and the illumination of certain manuscripts suggest the presence here of Byzantine artists. Nothing much can be said about the style of these mosaics; the manuscripts are more useful. Several embassies passed between Constantinople and the court of Charlemagne in the 790s and 800s, and since art is always part of such diplomatic missions, conditions existed

for the stimulus of Byzantine works of art or the presence of Byzantine artists. A case for the participation of Byzantine painters in Carolingian court workshops has been made for the production of four manuscripts, classified by Koehler as the "Group of the Vienna Coronation Gospels", and distinguished from the Palace School. Their Byzantine attribution depends on two factors, their technique and their style. The miniatures exhibit a specific Byzantine failing, the technical inability to make the paint adhere to the parchment without flaking. In style, the high quality of their "illusionist" figures is achieved by a facility in modelling and by the merging of wet colours, which makes other Carolingian painting look artificial. If it can be correctly claimed that such expertise in the application of pigments can only derive from a continuous tradition of workshop training and cannot be artificially revived, then it would seem that the "illusionist" style was passed down from master to pupil in eighth-century Constantinople, and had survived the first period of Iconoclasm.

A case can therefore be made from the Carolingian evidence for a continuity of this current up to the early ninth century; possibly during Second Iconoclasm there was a decline into harder forms[35]. This mode, perhaps more than any other, requires high quality practitioners who in this period of reduced patronage must have been in short supply. Although it is natural to assume that such artists were supported by Iconoclastic commissions, it is conceivable that they received underground Iconodule patronage. The suggestion that there was continuity of this current throughout the period may be supported by a parallel in education in profane literature, which can also be tracked continuously through the period.[36] A specific example of how the period could be bridged is given by Tarasios (born about 730) who taught verse to Ignatios the Deacon, who lived beyond 842, and whose letters prove his knowledge of classical literature.

My answer to the question of what was the appearance of Iconoclastic art is that the three main types of expression used at the time when Leo III banned the images did in fact continue throughout the period. The continuation of these modes, including that deriving ultimately from the Hellenistic period, does not make it a time of "renaissance", which would be a crude way of characterizing the relationship with Antique art. In short, Iconoclasm was not an entirely fallow period in the history of art, but it witnessed little stylistic advance. Even the developments in architecture seem partly negative, for they are an adaptation to available materials (spoils from the past) and are marked in Bithynia by a reduction in scale.

Relations with outside cultures

The period of Iconoclasm with its reduction in patronage and consequent deterioration in the conditions and numbers of artists may as a consequence

III

have increased the receptiveness of the community to influences from outside Byzantium. Such outside stimulation can be attributed to two cultures brought into contact with Byzantium for political reasons: the Islamic world and the Carolingian West.

An intention to imitate the art of the Abbasid court of Baghdad is specifically documented for the Emperor Theophilos by Theophanes Continuatus. This early ninth-century taste for Islamic permanently influenced the forms of Byzantine ornament, and is perhaps responsible for its profusion. Oleg Grabar has characterized this as the "orientalization of Macedonian art".

[44] Influence from the West is more difficult to substantiate, as the evidence is usually ambiguous. A similar ambiguity of the evidence is encountered in attempting to decide priority for the development of miniscule script. A controversial group of works, which share a linear, rather decorative, figure style, has been seen as an East Mediterranean source for the linear mosaics in Rome under Paschal I (817-24).[37] However, if the key members of this group are dated later in the ninth century, then this style in Byzantium would derive from Italian art during Second Iconoclasm. In this case, the style (and iconography) of the Paschalian mosaics would derive from Roman traditions. In my estimation, there is a strong case for the dating the manuscript of the *Sacra Parallela* (*cod. Paris gr.* 923) to the same period as the datable *Homilies of St Gregory Nazianzenus* (*cod. Paris gr.* 510) on grounds of palaeography and the style of some of the miniatures. The *Sacra Parallela* would in this case date around 880. As for the ivory in the Staatliche Museen in Berlin on which is represented the Coronation of an emperor named Leo, an identification with Leo VI would give a dating around 886. It is therefore possible that Byzantine art was stimulated in the ninth century by the vigorous Carolingian art of Rome; knowledge of this art might have been channelled through refugees from Constantinople, like the future Patriarch Methodios who was in close contact with Paschal in the 820s.

Conclusion

The Age of Iconoclasm was not a great period in the history of art, but traditions continued and some new influences were absorbed. The number of artists trained in Constantinople must have dropped, and the knowledge of some kinds of expertise must have declined, as, for example, the manufacture of mosaic cubes and their application to architecture. There was probably little work for artists outside Constantinople, though this trend had already begun before Iconoclasm, when the rich cities of Late Antiquity (like Alexandria, Antioch, Ephesus, Salonica and so on) were declining in the late sixth or early seventh centuries. The trickle of commissions during Iconoclasm must have centred on

10 THE ARTS DURING THE AGE OF ICONOCLASM

the imperial family rather than on monasteries or bishops. This patronage made it a distinctive period.

Notes

This text is a reset copy of the original lecture. The numbers in square brackets give the original pagination of the publication.

1. For methodology, see E. Kitzinger, "Byzantine Art in the period between Justinian and Iconoclasm,", *Berichte zum XI Internationalen Byzantinisten-Kongress* (Munich, 1958), Grabar, *L'Iconoclasme byzantin*, and Mango, *Art*.

2. W.S. George, *Saint Eirene*. A new study by U. Peschlow is in preparation.

3. R.S. Cormack, *Ninth-Century Monumental Painting and Mosaic in Thessaloniki*, (London University Ph.D. thesis, 1968); cf. J.-M. Spieser, "Les inscriptions de Thessalonique," *TM*, 5 (1973), 145-80, esp. 159.

4. T. Ulbert, "Untersuchungen zu den byzantinischen Reliefplattern des 6 bis 8 Jahrunderts", *IstMitt*, 19/20 (1969/1970), 338-57, esp. 349-50, and taf. 72.

5. H. Buchwald, *The Church of the Archangels in Sige near Mudania*, (Graz, 1969), esp. 40, discusses the original appearance of St Sophia.

6. R. Janin, *Constantinople byzantine*, (Paris, 1950), 245-82.

7. Theophanes, 440. Most of the workers came from Thrace, where Constantine also repaired a bridge: C. Mango and I. Ševčenko, "Three inscriptions of the reigns of Anastasius I and Constantine V", *BZ*, 65 (1972), 379-93, esp. 384ff.

8. Canon VII.

9. The quotation is from P. Brown, *EHR*, 346 (1973), 1-34; but see G. Ostrogorsky, *History of the Byzantine State*, 2nd English ed. (Oxford, 1968), 174, n. 2.

10. This is the dating maintained by C. Mango, *Brazen House*, 112ff.

11. For the sources, see Mango, *Art*, 149ff.

12. R. Cormack and E.J.W. Hawkins, "The Mosaics of S. Sophia at Istanbul: the Rooms above the Southwest Vestibule and Ramp", *Dumbarton Oaks Papers*, 31 (1977), 175-251.

13. C. Mango, "The Byzantine Church at Vize (Bizye) in Thrace and St Mary the Younger", *ZRVI*, 11 (1968), 9-13; and C. Mango and I. Ševčenko, "Some Churches and Monasteries on the Southern Shore of the Sea of Marmara", *Dumbarton Oaks Papers*, 27 (1973), 235-77.

14. C. Mango, "A forged inscription of the year 781", *ZVRI*, 8 (1963), 201-7.

15. Mango, *Art*, 156-7.

16. P. Speck, "Ein Heiligenbilderzyklus im Studios-Kloster um Jahr 800", *Actes du XII Congrès international d'études byzantines*, (Beograd, 1964), tome 3, 333-44; and Theodoros Studites, *Jamben*, edited by P. Speck, (Berlin, 1968), esp. 211-39.

17. PG, 100, col. 549C.

18. A survey of the literature is by J. Gouillard, "Art et Littérature théologique à Byzance au lendemain de la querelle des images", *CahCM*, 12 (1969), 1-13, esp. 3.

19. I. Ševčenko, "The anti-iconoclastic poem in the *Pantocrator* Psalter", *CahArch*, 15 (1965), 39-60.

20. Mango, *Art*, 157-8; Photios in 867 was emphatic on the value of icons for teaching, see Mango, *Photius*, 293-5 (Homily XVII).

21. Mango, *Art*, 155-6.

22. C. Mango and I. Ševčenko, as in note 13: see 246.

23. My formulation depends on E. Kitzinger, cited in note 1, but I prefer to avoid the term "hellenistic".

24. The lack of figurative mosaics may be due to practical considerations, such as speed of execution; however for a possible theological consideration, see M. Mundell, in *Iconoclasm*, paper IX.

25. See also A. Epstein in *Iconoclasm*, paper XIII.

26. Discussed by A.H.S. Megaw, "The Skripou Screen", *BSA*, 61 (1961), 1-32.

27. See M. Mundell, in *Iconoclasm*, IX, 67 and note 89.

28. Cf. A. Cameron, *Porphyrius the Charioteer*, (Oxford, 1973), 204-5.

29. This is the dating of J.G. Beckwith, "Byzantine Tissues", *Actes du XIVe Congrès international des études byzantines*, (Bucharest, 1974), 343-53. For a statement of scepticism, see H. Wentzel, "Byzantinische Kleinkunstwerke aus dem Umkreis der Kaiserin Theophano", *Aachener Kunstblätter*, 44 (1973), 43-86. The Vatican Ptolemy (*gr.* 1291) might be attributed to this current.

30. The arguments for deriving the artists from Constantinople are set out by P.J. Nordhagen, "The Frescoes of John VII (705-707) in S. Maria Antiqua in Rome", *ActaIRNorv*, 3 (1968).

31. D.H. Wright, "The Shape of the Seventh Century in Byzantine art", *Byzantine Studies Conference*, (Cleveland, 1975), 9-28.

32. P.J. Nordhagen, cited in note 30.

33. K. Weitzmann, "The Classical in Byzantine Art as a Mode of Individual Expression", *Byzantine Art*, (Athens, 1966), 151-77.

34. O. Demus, *Byzantine Art and the West*, (New York, 1970), esp. 60ff.

35. The frescoes of San Saba in Rome may give some indication of this current in its hardened form; see also H. Belting, *Studien zur beneventanischen Malerei*, (Wiesbaden, 1968).

36. P. Lemerle, *Le premier humanisme byzantine*, (Paris, 1971).

37. K. Weitzmann, "The Ivories of the so-called Grado Chair", *Dumbarton Oaks Papers*, 26 (1972), 45-91.

IV

PAINTING AFTER ICONOCLASM

[147] The Restoration of Icons in 843 marked the end of Second Iconoclasm as we know by historical hindsight, but there was no instant redecoration of churches. This delay in restoration may be attributed to practical considerations, prudence, or even to the personality of Ignatios. It took thirty years or so before large churches such as St Sophia or the Holy Apostles received, with imperial financial support, a mosaic figurative decoration (possibly in these cases for the first time ever). The question asked in this paper, whether the discussion on religious images stimulated by Iconoclasm changed the nature of Byzantine art, therefore needs consideration through a survey of the century of production after 843.

Some clues to the period are given by the little material surviving from the first generation after 843. For example, soon after 843 the coins of Michael III change the Iconoclastic types and represent on the obverse the bust of Christ. This type had only previously appeared in Byzantium just before Iconoclasm on the coins of the first reign of Justinian II. The inscription on the coins of the 840s reads simply "Iesous Christos", but there can be no doubt that the post-Iconoclastic issues copy the iconography of the actual coins of Justinian II (one error in the earliest issues in which locks of hair trail oddly in front of Christ's left shoulder must be a direct misreading of this actual model).[1]

In the sanctuary of the Koimesis Church at Nicaea, the mosaic decoration inserted during Iconoclasm, which featured a cross in the conch of the apse, was replaced after 843 with a figurative scheme (fig. 28). This ninth-century alteration cannot be dated precisely, unless a certain Naukratios who had his name inscribed in the new mosaics is to be identified with the Studite disciple of St Theodore who died in 848.[2] The post-Iconoclastic Virgin and the Angels are a correct restoration of the original figurative programme of the sanctuary (which may have dated from the late sixth century), as can be deduced from the inscriptions which survived from the first phase. Either Naukratios made this same deduction, or some record of the original decoration had been kept.

Both these examples witness a direct restoration of pre-Iconoclastic iconography after 843. In the matter of style, however, it is less easy to conclude that the artists had returned to the point where developments were cut off, for I think that the same stylistic currents had continued during Iconoclasm. Never-

2 PAINTING AFTER ICONOCLASM

theless, artists do seem to have looked at work surviving from before 726 and to have been stimulated by it. This procedure would at least account for some similarity of style between the head of the Virgin, executed by Greek mosaicists in an oratory in St Peter's in Rome between 705 and 707 (a fragment is now in San Marco, Florence), and the head of the apse Virgin of St Sophia, inaugurated in 867.

Such evidence confirms the description of the period as one of restoration of the past as expressed in the *Vita Basilii* and other texts. The idea of the regeneration of the Empire by an ideal ruler is not pure rhetoric but corresponds with the great amount of rebuilding and redecoration of the times. This renovation was stimulated, at least in the examples considered so far, by models dating from the period immediately before Iconoclasm rather than from earlier models from the Antique world. The period is characterized by Theophanes Continuatus as one of *palinzoia* and *palingenesia*, which means one of spiritual regeneration, not a revival of Classical Antiquity.[3]

Iconoclasm, then, did not radically change the direction of Byzantine art. Yet after more than a century of the lack of figurative icons in public places, there must have been a dislocation of the spectator's experience and perception of art, even though there was no new conception of the religious function of religious pictures. The mind's eye of the spectator in any period of Byzantine art is remote from ours, yet it is worth trying to enter it in this period of reorientation. The Council of Nicaea of 787 stated a principle of control over art, which offers a context through which to [149] approach the problem.[4] The reasoning of these theologians is that the painter's business is limited to his art, whereas its disposition is the concern of the Church. While it is not in practice possible to separate form from content, yet it seems worth making a selection of works, in roughly chronological order, where the treatment of iconography seems to document control by church patrons or theological dogma. These cases show the control of the patron, rather than the thinking of the artist.

1. The Chludov Psalter in the State Historical Museum in Moscow is one of a group of three Psalters with marginal illustrations attributed to the ninth century, but whose precise dating and context are uncertain.[5] Several principles are to be identified in the choice of passages to be illustrated with pictures, but I refer to those scenes with Iconoclastic references (figs. 29, 30). Such images were chosen for the Psalter while Iconoclasm was an issue, and were meant to indoctrinate those using the book for regular reading. The particular passages chosen for such illustration depend on the attitudes of the patron; the visual models seem likely to be earlier products from the period of Iconoclasm.

2. On 29 March 867, the Patriarch Photios delivered the homily (no. 17) in which he inaugurated the first monumental representation to be executed in St Sophia after Iconoclasm. In all probability, he was referring to the surviving

apse mosaics in the church (fig. 31).[6] In an earlier homily (no. 7), Photios had mentioned an adornment of St Sophia in March 863, but presumably his reference was to portable icons and so implies that after Iconoclasm the first type of artistic decoration was of a makeshift character. Around the new apse mosaic was inscribed a verse celebration of the restoration of images, written in an iambic distich which in its formulation refers back to the inscription placed over her new image of Christ Chalkites by Eirene after 787.[7]

The choice for the new apse decoration of an enthroned Virgin and Child between Archangels must have been made (or approved) by Photios not as an isolated decision but as part of a planned scheme for the whole church. The existence of such a blueprint is implied when towards the end of the his homily he appeals (for funds) to the Emperors (Michael III and Basil I) "to consecrate the remainder too with holy images." Since Photios placed the Virgin in the apse, he must already have envisaged a scheme in the dome which featured Christ. A patriarchal plan for the ninth-century decoration of the Great Church to be presented to the artists when employed seems the reasonable assumption.

3. The main apartments of the Patriarchate were redecorated after Iconoclasm. In particular, the large vaulted room off the South end of the West gallery of St Sophia received a scheme of mosaics incorporating about forty figures of saints (fig. 32). The precise dating of these mosaics, which seem to decorate the important apartment known as the Large Sekreton, is controversial, but in my judgement belongs to the early 870s and was planned by Patriarch Ignatios.[8] The cycle of figures conforms with the recommendations on art agreed by his Council of 869-70, for which Canon Three affirms that: the images of Christ, Mary, the apostles, prophets, martyrs, and all the saints and angels ought to be honoured and venerated in the equal of the Holy Gospels and representations of the precious cross. This Council also approved the idea that unless a man a venerates the images of Christ and the saints he may be in danger of not recognizing them on the Day of Judgement. The programme is composed of portraits of single saints. Christ, in a Deesis between the Virgin and the Baptist, holds a Gospel Book (fig. 33) and crosses are represented in the window soffits. André Grabar has suggested that this Council encouraged the portrayal of saints who had visions of God — there are several in this category in this room. Also selected for inclusion in the cycle are the four Orthodox Patriarchs concerned with outbreaks or terminations of Iconoclasm, who had believed that in contemplating an icon, a man contemplated God.

The choice of each figure in the programme may be attributed to patriarchal initiative and control over the mosaicists. The ordering of the figures along the vault is hierarchical. The youngest saint (Methodios), who is the only person to make direct contact through his eyes with the spectator, is placed fur-

thest from Christ, who is at the church end of the room. Such a principle of organisation is often observed in Byzantine art, yet it reflects less the visual conceptions of the artists than the mind of this society, as documented, for example, in the late ninth-century *Kleterologion* of Philotheos. This [151] allocates the seating and order of precedence at imperial meals, including the two occasions when the Patriarch entertained the Emperor and his court to breakfast after the liturgy in this actual room. As well as the hierarchical system, the portrait-types of saints may to some extent have been imposed on artists through written canons, such as those given in the text of Elpius the Roman.[9]

4. In the interior of St Sophia, some of the ninth-century decoration survives, and more can be reconstructed.[10] The theological control over the artists is obvious in the choice of the saints set in the Tympana below the dome — there is a significant reference in the Church Fathers to the liturgical calendar of the Great Church.

I am sceptical about the suggestion that a characteristic programme of this period was the portrayal of the heavenly community on earth through a hierarchical system of icons consisting of single figures only and without any scenes.[11] St Sophia did not have, as has been claimed, a decoration of this kind, for there were festival scenes in the galleries. The other decorations of this kind adduced are only known from written descriptions of churches whose scale is not known; nor are the descriptions likely to be complete. The cycle in the Large Sekreton of the Patriarchate decorated a private apartment, not a chapel, and so is of an exceptional type.

5. The luxury copy of the Homilies of St Gregory of Nazianzus (*cod. Paris gr. 510*), illustrated around 879 to 882, is a unique edition in which the pictures often illustrate the logic of the text, rather than the actual words. The illustrations succeed in drawing out imperial connotations as well as theological meanings from the texts included in the manuscript. This erudition implies careful control by the planner, who has been tentatively identified as Photios. He was by this time reconciled with the Emperor Basil I to whom the manuscript was presented.[12]

6. A recently published New Testament manuscript with a number of illustrations (divided between a private collection in Switzerland and the Walters Art Gallery, as *cod. Baltimore W. 524*) is an example of the paramount significance of ecclesiastical principles in the selection of iconography.[13] The illuminations seem to date from around 900 to judge from their style, but the principle of illustration is one known at a developed stage in a group of twelfth century (and later) books — for example the *Codex Ebnerianus* at Oxford (*cod. Bodl. Lib. Auct. T. inf. 1.10*). The feature of this series is the accompaniment of a portrait of the writer of each book with a scene. For example in the tenth-century manu-

script the portrait of Matthew was a full-page painting which faced a full-page Nativity. It is a reasonable assumption that the other surviving pictures (Baptism, Annunciation and Anastasis) also faced Evangelist portraits. As in the *Ebnerianus*, where the portrait and related scenes are placed within a notional architectural framing, the scenes chosen illustrate the liturgical festival during which a passage from the first chapter is read. The scenes were therefore selected not for primarily narrative reasons, but they make a theological point about the liturgical significance of the four Gospels and other New Testament books. The control of a church patron can be felt in the organisation of this tenth-century manuscript.

7. Another undated work I am including in this set of examples on grounds of style is the small painted wooden reliquary of the True Cross from the Sancta Sanctorum of St Peter's and now kept in the Vatican Museum (figs. 34, 35).[14] A Crucifixion is painted on the upper face of the lid; a portrait of St John Chrysostom on the underside of the lid; and on the box itself — so that they were facing Chrysostom — were shown Sts Peter and Paul (where the normal choice would have been Sts Constantine and Helena) below Christ, the Virgin and two Archangels. Chrysostom holds an open codex with an inscription: on the left page, it is the usual lectionary formula to preface a reading; on the right the text derives from the Gospel of John (either xiii, 34 or xv, 17) and is one used in the first reading in the morning office of Good Friday (there is no liturgy on this day). The message is: "The Lord said to his disciples; I command you that you love one another" (fig. 35). Chrysostom did write a homily on this text (no. 77), but this is insufficient to explain his representation on the reliquary. One explanation for the iconography, its stylistic dating in the first half of the tenth [153] century, and its presence in Rome in the Sancta Sanctorum collection at least by the second half of the twelfth century, is that the box was a gift from the Patriarch of the Great Church to the Church of Rome, perhaps made during the conciliatory period around 920. This was when the rival elements in the Byzantine Church, quarrelling over the tetragamy of Leo VI, came to agreement in a council of July 920 in the presence of papal legates and enabled Nicholas Mystikos to proclaim his success in a *tomos enoseos*.[15] This interpretation of the iconography would recognize the church use of art for visual politics.

The unusual iconography of the paintings must show the further influence of special theological attitudes. The Crucifixion is startlingly unusual in Byzantine art, for it features the motif of the Virgin Mary embracing the bleeding feet of the dead Christ. The daring of this rendering is made clear by a comparison with the Crucifixion in the ninth-century Homilies of St Gregory (*cod. Paris gr. 510*: fol. 30 verso) where Christ had been designed as dead on the cross in the underdrawing but in the final painting was shown alive, as in the earlier

normal convention. The dead Christ in this scene is, however, known in the ninth century, for example in the Chludov Psalter and in the mosaics of Holy Apostles as described by Constantine the Rhodian (probably executed for Basil I). The Crucifixion on the box also represents John the Theologian, holding his Gospels. Since the words of Christ as reported in John (xix) are inscribed, the picture may be said to be based on this description (fig. 34).

The unusual rendering by the artist suggests the influence in some manner of a theologian in its invention. Possibly the source of this stimulus can be identified, though this is not necessarily the direct source for this actual work. I refer to the supporter of Photios named George of Nikomedeia (Bishop of Nikomedeia before 867 and after 877).[16] One of his homilies is directly relevant to our iconography, his homily no. 8 for Good Friday, though it needs to be noted that other texts in this vein may be adduced, and that this text influenced other writers (for example Symeon Metaphrastes). George of Nikomedeia was an intellectual, who received a secondary education in profane literature. He devoted much time to the study of ancient poets, found fault with a barbarian word used by St Peter and criticized the style of St Paul's writing. In one sense his long homily no. 8 shows the influence of a traditional rhetorical education, for he envisages the events of the Crucifixion as if he were present at the historical occasion. However his language and the sentiments put in the mouths of the participants are as emotional as the Apocryphal Gospels. His style is far from the calm but mandarin prose of Photios. He uses the words of Christ as reported in John, xix, for his re-enactment of the events, and emphasizes the death of Christ out of which came life for the Christians. The climax of his dramatic description is the act of the Virgin after Christ's death on the cross — "she approached boldly so close as to be able to grasp the cross and she kissed His pure feet".

If it is correct to see the stimulation of a theological text on the painter of this box, it must be further conceded that the influence goes beyond just iconography: form and content cannot be set in separate compartments here. The bold narrative treatment and prominence of the figures without landscape elements results in an emotional style designed to involve the spectator. The Pope who received this reliquary must have been shocked (and apparently kept it away from the eyes of Western artists).

8. The cycle of miniatures in the Bible of Leo the Patrikios (*cod. Vat. Reginensis gr. 1*) shows a careful selection under theological supervision. The Bible, planned to include both Testaments, survives only with the Old Testament. The volume has, on the basis of the donor portraits, been dated to the second quarter of the tenth century.[17] Each book is preceded by a single full-page frontispiece scene with an inscription in iambic verses written around the frame. These texts, which were presumably composed for this manuscript and poss-

IV

PAINTING AFTER ICONOCLASM 7

ibly by the donor himself, are typological in content. An interest in Old and New Testament parallelism is of course traditional in Christian theological exegesis, and had occurred in art before Iconoclasm. Both the Rossano Gospels and the Sinope fragment portray Old Testament prophets holding their texts which foretold the New Testament scenes illustrated. However the treatment of typology in this manuscript is both new and individual.

In the selection of scenes, there may be some connection between the Bible of Leo and the dogmatic formulations in the *Synodicon of Orthodoxy*, the ninth-century statement of Byzantine theology.[18] Among those whose "memory be eternal" are: "Those who know that the rod and [155] tablets of the Law, the Ark of the Covenant, the Menorah, the table and the censer foretell and prefigure the Theotokos Mary, and who know that these things prefigure her but she was not these things, but that she was born a girl and remained a Virgin after giving birth to God; those who for this reason prefer to represent her in images rather than to symbolise her in these types: may their memory be eternal". This prescription may have been noted in planning the cycle of this Bible as an expression of Orthodoxy. The Virgin is represented in the frontispiece, and is likely to have been represented again in the lost New Testament pictures. That the beliefs stated in the *Synodicon* were known is explicit in, for example, the picture of Moses and Aaron with the Levites carrying the Ark of the Covenant. The text inscribed around this picture reads: "Here are the priests and Levites of the Old Testament: in this picture, they show mystically the bliss of the New Testament. They foretell that they are carrying the Ark to Christ. Just as the panels of the Ark contain the Law, so the body of the Virgin Mary will give birth to Christ, who will combine the human and the divine in his nature" (fig. 36). It may be seen that Leo the Patrikios was using the illustrations in his Bible to demonstrate (as the text alone could not) his theological knowledge and his Orthodoxy.

9. For the last example of this series, there is the luxury illustrated Psalter of the second half of the tenth century (*cod. Paris gr. 139*).[19] In a recent review of the problems posesd by this manuscript, Professor Buchthal has discussed the creation of the cycle – he believes that the Paris Psalter is merely a copy of a psalter commissioned by the Emperor Constantine Porphyrogennetos and presented to his son Romanos II in 952. This opinion would explain the words of Psalm lxxi which were chosen for the text held by David in the miniature, where he stands between Wisdom and Prophecy (the seventh picture in the present cycle, but possibly the representation which opened the cycle of the proposed model). The text chosen is a prayer by David to give judgement and righteousness to his royal son Solomon. This would therefore appear to be a case of the supervision of the patron over the illuminator.

Probably the influence of the patron went considerably further, and entered into the creation of the pictures. A prominent feature of the iconography is the proliferation of abstract personifications, a feature which may have its parallel in that literature of the period which favoured the artificial use of classical allusions, such as the *Philopatris*. Some of the models of the Paris Psalter may have included abstract personifications; perhaps the most obvious candidate for such a figure in the model is the scene of David as the harpist, accompanied by Melodia.[20] But once the idea was taken up by the artist or recommended by the patron, it would have been possible to add personifications to any picture if appropriate, or even if not. There is no need to postulate the presence of such personifications in every model used. Their use must represent the artistic taste of the patron.

The conclusion I wish to draw from this selection of examples is that after Iconoclasm the role of the patron in the creation of painting was substantial, both in the choice of iconography but also in the way the artist visualized the subject matter. I do not of course suggest that this is a novel development of the period; only that some notion of the role of the patron in the period after Iconoclasm can be glimpsed, and that the prescription that the "disposition" of art is the business of the church can, at least partially, be documented. However it is obvious even from a brief glance at this sequence of high-quality works that all participated in a general stylistic development over the period. A comparison of the miniatures of the two manuscripts now in Paris (*cod. gr. 510* and *cod. gr. 139*) exemplifies the change from stiff, linear figures to actors moving within a setting. Since all these different works seem to share a general development, it might be suggested that style was indeed the independent domain of the painters. Such a deduction can be criticized on several grounds, and the key problem is how to penetrate to the artists' own experience of style.

[157] The Byzantine experience of style can be approached through those works for which the environment of the patron can be documented and in which the artists could achieve the wishes of the patron. In an analysis with this aim, little direct help is given by works produced by painters whose expertise was inadequate for the stylistic expression used, since style is partly a factor of quality. This is the limitation of the important evidence of this period from Cappadocia for my present purposes. I regard the painter of Chapel 6 in the Göreme Valley as trying to work in the same mode as the manuscript *Paris gr. 510*, but failing to produce the same effect. Similarly, the painting of the mid-tenth century in the "New Church" of Tokalı Kilise, despite certain positive qualities, emulates the stylistic expression of the manuscript *Vatican Reginensis gr. 1*, but falls short of the level of achievement of even that production. On these grounds, it seems necessary to try to look through the eyes of the patrons and artists of the highest class of production; this milieu is that of the imperial

family, higher civil servants, and higher clergy — the group of educated men whose small number must be noted.[21]

A characterization of the writings of this clique on visual art has been made in a fundamental study by Cyril Mango.[22] Their critical attitudes can be exemplified by confronting the words of Photios delivered from the ambo of St Sophia on Holy Saturday, 29 March 867, on the occasion of the inauguration of a work of art which was, with all probability, the surviving mosaic of the Virgin and Child in the apse (fig. 31).[23] Photios speaks as if the artist has achieved an illusionist representation of a mother and child caught at a precise moment of time. The key term of appreciation used by Photios is "lifelike". In other words, Photios describes his experience of this mosaic in the critical terms appropriate to the standards of Antique art.

The Emperor Leo VI, a pupil of Photios, provides us with an insight into the process he followed when he too had to compose the inauguration homily for the foundation of a church and its mosaic decoration. When he came to describe the mosaic decoration of the apse of the Kauleas monastery church (dating between 893 and 901, and now lost), Leo VI obviously looked more closely at the appropriate section of the homily of Photios of some thirty years earlier than at the mosaic itself.[24] Like Photios, he appreciates the portrayal for its "life-like" qualities. From such examples, Mango reached the conclusion that Byzantines saw no difference aesthetically between ancient art and their own art; they saw only the distinction of subject matter.

Such descriptions of works of art couched in the traditional rhetoric of the *ekphrasis* obviously cannot be used as a direct channel through which we can enter the mind's eye of the Byzantine spectator. However, it is not acceptable that a Byzantine could literally not perceive any difference between the art of his own time and the illusionist art of Antiquity. Whatever he said in front of a work of art, the Byzantine spectator did not view the compositions of his period according to "rational" perceptions.[25] As a document for the history of art, the seventeenth homily of Photios illustrates two points. Firstly, that Photios is characteristic of educated men in most periods of history, and particularly in the Middle Ages, in his response to art. He is at a loss when trying to formulate a verbal response to a visual stimulus, for it is at any time eccentric to attempt this.[26] Photios' attempt shows the utter lack of development of any critical vocabulary on art during the period after Iconoclasm. He depends on already worn-out clichés, such as "life-like". His mandarin rhetoric tells us something about his education; very little about his artistic experience. The second feature of the homily is that in voicing critical standards which are entirely traditional, Photios conforms to the normal conservative taste of church leaders and civil servants. It is exceptional to break out of conventional patterns; more normal to patronise the "old master" trade, as in the Roman Empire. It is not surprising to find Photios expecting the contemporary artist to

copy the past and to produce "life-like" images. At a time when art was primarily conceived as carrying out a function (the visual expression of Christian Truth and of the permanence of the State), it was perhaps inevitable that the patron's conception of aesthetics was limited, and appreciation centred on technical expertise. The realities of artistic production were different.

Is it possible to detect any more positive side to the Byzantine response to art? One text written in a less elevated style than that of Photios gives some help. This is the Account of the image of Christ of the Monastery *tou Latomou* in Salonica written by a monk in that city, Ignatios, the abbot [159] of *tou Akapniou*.[27] It describes the miraculous manufacture of the mosaic figure of Christ, attributed to the period of Galerius (305-311), and its subsequent rediscovery in the reign of Leo V (813-820). The mosaic described by Ignatios is the surviving apse decoration of the small church in Salonica, now (incorrectly) called Hosios David. The text has to be dated by internal indications, which in my point of view point to the late ninth century. The author gives no critical assessment of the art of the mosaic (which was executed some centuries before his time), but he does show considerable abilities of description. He mentions accurately all the iconographic elements, and transcribes the inscriptions, both on the scroll of Christ and below the conch, with precision – he slightly changes the grammar, but not the meaning. Ignatios also ventures identifications for the two witnesses of Christ, who are not labelled, as Ezekiel and Habakkuk. These identifications satisfied later Byzantine artists who reproduced the icon of Christ *tou Latomou*.[28] The suggestion that the figures are prophets has satisfied some art historians too, although it may be no more than a popular tradition in Salonica or a guess.[29] Ignatios is [160] undertaking art history of a kind in accepting the mosaic as dating from the Tetrarchic period and in giving an explanation for the iconography of Christ in the apse.

The text of Ignatios the monk proves the abilities of Byzantine spectators to describe the iconography of works of art.[30] Another low-brow text where the value of reading inscriptions for the identification of works of art, especially statues, is noted, is the eighth-century *Parastaseis*.[31] The information given by such texts is that Byzantine spectators did study and could describe their art, but they were limited by the lack of a relevant critical vocabulary and terminology in evaluating it.

If the literate spectator in Byzantium was inarticulate in this respect, what can be said about the artists themselves? In a survey of education in tenth-century Constantinople, Lemerle suggests that artists belonged to the group who received a schooling up to the age of ten or eleven, and could read, write and count. Like many Byzantine monks, they were literate, but not "educated". On this view, the Byzantine artist would seem to be excluded from the possibility of personal contact with the *ekphrasis*, for this form of literature could not be

appreciated, nor probably even understood, without a secondary education (up to eighteen) which included the study of "profane", classical texts.[32]

The problem is to find any documentation on the career of the painter in Byzantium in the period after Iconoclasm. It does not seem possible to quantify the numbers of artists who could be supported by patronage in the ninth and tenth centuries, nor the relative proportion of lay or monastic painters. However, the names of a handful of painters of the period are recorded, and while the number is not statistically significant nor their social status necessarily typical, some are worth mentioning for the light they throw on the type of education and the social level which an artist could reach in the period. This information can be briefly sketched here.

According to Photios (in his fifteenth homily), the Iconoclastic Patriarch John the Grammarian was a trained painter. There seems no good reason to doubt that John painted icons in his youth during the interlude before the second Iconoclasm, perhaps while he was an *anagnostes* at the *Hodegetria* monastery.[33] The most famous artist of the first half of the ninth century was the Chazar Lazaros, who continued to paint icons despite torture and imprisonment by the emperor Theophilos.[34] During the Second Iconoclasm, he painted an icon of John the Baptist in the monastery of St John *tou Phoberou* which was described as miraculous in the mid-tenth century. After 843, the restoration of the Chalke mosaic of Christ (before 847) is attributed to the mutilated hands of Lazaros. The attribution of the apse mosaic of St Sophia to Lazaros, as told to the Russian pilgrim Antony of Novgorod in 1200, is less acceptable. Lazaros seems to have been painter and monk from an early age, but the Patriarch Ignatios considered him suitable to participate in a mission to the Pope in 855, and he died while accompanying a second papal mission soon after September 865. He was an ardent supporter of Ignatios, but his selection for a church envoy gives some indication of the status that a painter could reach. There is, however, a possible complication in the choice of Lazaros for the first mission, for its purpose was to obtain the Pope's consent to the deposition of Gregory Asbestas, bishop of Syracuse. Gregory himself seems to have had some kind of training in painting, for one of his actions in the campaign of support for Photios against Ignatios was to produce around 867 a manuscript containing seven synodal Acts against Ignatios.[35] This manuscript contained miniatures painted by Asbestas portraying Ignatios as the devil, Antichrist and so on. This abusive but inventive cycle may have been in the manner of the Chludov Psalter. Possibly Lazaros seemed to Ignatios a suitable opponent for Asbestas. For present purposes, both personalities give some indication of the possible place of the painter in Byzantine society.

In the legendary account of the conversion of King Boris of Bulgaria in 864 is mention of a Byzantine painter Methodios.[36] The story as told has some implications even if it is not literally acceptable as history. Methodios is sum-

moned into the presence of the king and told to decide for himself the subject matter for a painting, which must stimulate fear and amazement in its spectators. The painter chose to represent the Last Judgement. This version in Theophanes Continuatus assumes the possibility of a dialogue between Boris and the painter, and gives Methodios the responsibility for selecting the iconography. The passage also deserves consideration as a statement [161] [162] on the function of art here not as directly didactic, but as inducing an emotional reaction in the spectator.

Another indication of the position of painters is given in canon seven of the Ignatian Council of 869-70.[37] According to this Council, the beliefs of painters must be taken into account by the Church: painters who did not accept the canons of the Fourth Council of Constantinople were banned from working in churches. This canon seems aimed against the team of artists previously employed by Photios.

A few more names are known from the tenth century, including the Emperor Constantine Porphyrogennetos himself. Concerning the workshop which produced the illuminated *Menologion* for Basil II (*cod. Vat. gr. 1613*) and which consisted of eight named painters, perhaps both lay and monastic, it seems that the main master, Pantoleon, held a fairly high social status.[38]

The implication of this sample of artistic personalities is that the outlook of the Byzantine artist cannot be assimilated with any one category of society or education or literature, such as high-brow or low-brow. A certain social or intellectual mobility of artists is suggested. In this situation, how can written sources be used to understand the processes of artistic creation in Byzantium? How can we account for the current we see in Byzantine art after Iconoclasm towards a greater mastery in the handling of the human form within a more rationally convincing setting?

Since some artists may have received an education which enabled them to appreciate the literary form of the *ekphrasis*, such texts cannot be dismissed as without possible influence. Even if the aesthetic terms used in these writings were clichés, yet clichés have meaning. Some insight into the art of the period is given by considering another inauguration homily by the Emperor Leo VI, delivered between 886 and c. 893 on the opening of the church built by Stylianos Zaoutzes.[39] Leo is describing a decoration by a contemporary artist, and so this type of *ekphrasis* differs from such [163] descriptions as those of Constantine the Rhodian or Nicholas Mesarites on the established and well-known mosaics of the Holy Apostles. This homily of Leo VI contains some ideas which do not derive from Photios, and which suggest some original observation. One scene he describes in some detail is that of the Ascension. Although the mosaics of this church in Constantinople are now lost, a mosaic contemporary with them executed by artists from the capital has survived in the dome of St Sophia in Salonica datable to c. 885 (fig. 37).[40] The words of the homily are sufficient-

ly appropriate to the mosaic of the Ascension in the dome in Salonica to jus-
tify the use of this decoration in imagining the lost example (though the As-
cension here was not in the central dome). The description of Leo VI
concentrates on the appearance of the disciples. These standing figures, he
writes, are fashioned with such lifelike character by the painter that they seem
indeed to be seized by the various emotions of living persons. Leo then spe-
cifies some of their postures; one gives the impression of following the ascend-
ing Christ with his eyes, another is seen to be all ears (listening to the words
uttered above), another is pensive because of his astonishment, and another is
filled with wonder and fear.

The aptness of this description to the mosaic dome at Salonica encourages
the belief that the homily did give an accurate description of the lost decora-
tion, and that its artist, like the one in Salonica, was making some attempt to
characterize emotion (though no doubt his models were pictorial rather than
human). If this interpretation is correct, it means that the writer has recognized
that the artist was portraying a religious scene by visualizing the emotions felt
by the historical participants. There is a conscious intention to be "life-like".
Possibly sermons, such as those of George of Nikomedeia, stimulated further
artistic creation in this attitude of mind which gave meaning to the literary
terms of criticism. This might be a partial explanation for the artistic achieve-
ment of the Paris Psalter. Its miniatures need not derive from Antique models
unused by other painters of the period, but may represent the productions of
a workshop better able to recreate Antique ideals.

Some conclusions emerge from this survey of the period. To understand
the revival of church figurative art after Iconoclasm requires study of the co-
operation of patrons and artists. In attempting to penetrate to the visual ex-
perience of Byzantine society, only limited help is given by the formal literary
ekphrasis. It may be more useful to consider the texts which the patrons used
in planning decorations, and the sermons and commentaries through which the
artists were educated to understand Christian history. Since some of these texts
were written as part of the reaction to Iconoclasm, then, in a perhaps indirect
manner, Iconoclasm had an effect on art.

Notes

*This text is a reset copy of the original lecture. The numbers in square brackets give the original pagi-
nation of the publication.*
1. J.D. Breckenridge, *The Numismatic Iconography of Justinian II*, (New York, 1959), esp. 47.
There was a claim that a model dating from the reign of Constantine was being copied, see A.
Grabar, *L'iconoclasme byzantin*, (Paris, 1957), 210.
2. The stylistic evidence of Nicaea is discussed by P.J. Nordhagen, "The Mosaics of John VII
(705-707)", *ActaIRNorv*, 2 (1965), 121-66, and the documentary evidence by E. Lipšits, "Nau-
cratios and the Nicaean Mosaics", (in Russian), *ZRVI*, 8 part 2 (1964), 241-6.

14 PAINTING AFTER ICONOCLASM

3. K. Weitzmann, "The Character and Intellectual Origins of the Macedonian Renaissance", *Studies in Classical and Byzantine Manuscript Illumination*, (Chicago, 1971), 193, goes too far.

4. C. Mango, *Art*, 172-3.

5. In discussion during the Symposium, Dr R. Stichel referred to the use of the same antiphonic refrains in some South Italian Psalters; if these are not simply later copies of the service books of St Sophia in Constantinople, then the interpretation of the use of the ninth-century marginal psalters as monastic may after all be correct.

6. C. Mango and E.J.W. Hawkins, "The Apse Mosaics of St Sophia at Istanbul", *Dumbarton Oaks Papers*, 19 (1965), 115-51.

7. C. Mango, *The Brazen House*, 121.

8. R. Cormack and E.J.W. Hawkins, "The Mosaics of S.Sophia at Istanbul: the Rooms above the Southwest Vestibule and Ramp", *Dumbarton Oaks Papers*, 31 (1977), 175-251.

9. N. Oikonomidès, *Les Listes de préséance byzantines des 9e et 10e siècles*, (Paris, 1972): and M. Chatzidakis, "Ek ton Elpiou tou Romaiou", *EEBS*, 14 (1938), 393-414.

10. C. Mango, *Materials for the Study of the Mosaics of St Sophia at Istanbul*, (Washington, 1962); and C. Mango and E.J.W. Hawkins, "The Mosaics of St Sophia at Istanbul: the Church Fathers in the North Tympanum", *Dumbarton Oaks Papers*, 26 (1972), 3-41.

11. As S. der Nersessian, "Le décor des églises du IXe siècle", *Actes du VIe Congrès international des études byzantines* (Paris, 1951), tome 2, 315-20.

12. S. der Nersessian, "The Illustrations of the Homilies of St Gregory of Nazianzus, Paris gr. 510", *Dumbarton Oaks Papers*, 16 (1962), 197-228. A recent suggestion is that the manuscript was made for Basil's son Constantine, who died while it was under production: I. Spatharakis, "The Portraits and the date of Codex Par. Gr. 510", *CahArch*, 23 (1974), 97-105.

13. K. Weitzmann, "An illustrated Greek New Testament of the Tenth Century in the Walters Art Gallery", *Gatherings in honour of D.E. Miner*, (Baltimore, 1974), 19-38.

14. F.E. Hyslop, "A Byzantine Reliquary of the True Cross from the Sancta Sanctorum", *Art Bulletin*, 16 (1934), 333-40; and A. Frolow, *La Relique de la Vraie Croix*, (Paris, 1961), 487, no. 667.

15. Grumel, *Regestes*, no. 669. Cf. R. Jenkins, *Byzantium: the Imperial Centuries, 610-1071*, (London, 1966), esp. 237-8.

16. Some of his homilies are published in PG, 100; cf. Mango, *Photius*, 163.

17. C. Mango, "The Date of Cod. Vat. Regin. Gr. 1 and the 'Macedonian Renaissance' ", *ActaIRNorv*, 4 (1969), 121-6.

18. Gouillard, "Synodicon", esp. 49, lines 76ff. The miniatures and their accompanying inscriptions are published in *Miniature della Bibbia Cod. Vat. Reg. Gr. 1, e del Salterio Cod. Vat. Palat. Gr. 381*, (Collezione Paleografica Vaticana, fasc. 1), (Milan, 1905).

19. H. Omont, *Miniatures des plus anciens manuscrits grecs de la Bibliothèque Nationale*, (Paris, 1929); cf. H. Buchthal, "The Exaltation of David", *JWarb*, 37 (1974), 330-3.

20. This is the case argued by H. Buchthal, *The Miniatures of the Paris Psalter*, (London, 1938).

21. P. Lemerle, "Elèves et professeurs à Constantinople au Xe siècle", *CRAI*, (1969), 576-87.

22. C. Mango, "Antique Statuary and the Byzantine Beholder", *DOP*, 17 (1963), 55-75.

23. Mango, *Photius*, 286-96.

24. Mango, *Art*, 202-3.

25. I use "rational" only in the sense that a Byzantine presumably would not be amused by the cartoon by Harvey in *The Bulletin* (Sydney, Australia), reproduced as fig. 7 by E.H. Gombrich, "Visual Discovery through Art", *Arts Magazine* (November, 1965).

26. M. Baxandall, *Painting and Experience in Fifteenth-Century Italy* (Oxford, 1972), esp. 24-5.

27. Mango, *Art*, 155-6. V. Grumel, "La mosaique du 'Dieu-Sauveur' au Monastère du 'Latome' à Salonique", *EO*, 29 (1930), 157-75; and *idem*, "Le fondateur et la date de fondation du mon-

astère thessalonicien d'Acapniou", *EO*, 30 (1931), 91-5 interprets the text differently. He dates the uncovering of the mosaic to the first half of the eleventh century, and the text of Ignatios to the twelfth century. He dates the foundation of the *Akapniou* monastery to soon after 1018.
28. T. Gerasimov, "L'Icone bilatérale de Poganovo au Musée archéologique de Sofia", *CahArch*, 10 (1959), 279-88; A. Grabar, "A propos d'une icone byzantine du XIVe siècle au Musée de Sofia", *CahArch*, 10 (1959), 289-304; A. Xyngopoulos, "Sur l'icone bilatérale de Poganovo", *CahArch*, 11 (1960), 341-50; A. Grabar, "Sur les sources des peintres byzantins des XIIIe et XIVe siècles", *CahArch*, 11 (1960), 351-80. The wallpainting in the Bačkovo ossuary and the Poganovo icon reproduce the texts found in Ignatios and not those of the mosaic. The artists therefore may not have known the model directly but through some intermediary, perhaps an illustration attached to the account of Ignatios.
29. R.F. Hoddinott, *Early Byzantine Churches in Macedonia and Southern Serbia* (London, 1963), esp. 177-8, discusses the identifications, but misunderstands Grabar. For more guesswork, J. Snyder, "The meaning of the 'Maiestas Domini' in Hosios David", *Byzantion*, 37 (1967), 143-52.
30. For a parallel in Armenia, see S. der Nersessian, *Aght'amar, Church of the Holy Cross*, (Harvard, 1965). See also H. Maguire, "Truth and Convention in Byzantine Descriptions of Works of Art", *DOP*, 28 (1974), 113-40.
31. T. Preger, *Scriptores Originum Constantinopolitanum*, fasc. 1, (Leipzig, 1901), e.g. chaps. 27-8, 37, 38, 39 and 41.
32. P. Lemerle, as cited in note 21. R.J.H. Jenkins, "The Hellenistic Origins of Byzantine Literature", *DOP*, 17 (1963), 39-52, esp. 43-4, seems less precise in attributing a thorough rhetorical training "in the primary education of a Byzantine".
33. Mango, *Photios*, esp. 236-60. P. Lemerle, *Le premier humanisme byzantin*, (Paris, 1971), 138, note 121, is excessively sceptical.
34. C. Mango and E.J.W. Hawkins, as cited in note 6, esp. 144.
35. Mango, *Art*, 191-2, and C.Mango "The Liquidation of Iconoclasm", in *Iconoclasm*, p. 140.
36. Mango, *Art*, 190-1.
37. D. Stiernon, *Constantinople IV*, (Paris, 1967), 283.
38. I. Ševčenko, "On Pantoleon the painter", *JÖB*, 21 (1972), 241-9.
39. Mango, *Art*, 203-5.
40. R.S. Cormack, *Ninth-Century Monumental Painting and Mosaic in Thessaloniki*, (London University Ph.D. thesis, 1968); cf. J.-M. Spieser, "Les inscriptions de Thessalonique", *TM*, 5 (1973), 145-80, esp. 160-1.

V

THE APSE MOSAICS OF S. SOPHIA AT THESSALONIKI

(PL. 19 - 22)

The study of Byzantine mosaics has undergone a virtual revolution in recent years and this is due in the main to a new sensitivity towards the role of the individual artist in the execution of each decoration. Analysis of mosaic in its setting and a knowledge of the precise technical means through which the artist achieved his effects in each part of a building is now to be considered an essential part of the art historical study of the medium[1]. Such study can, however, only be successfully achieved with the help of close observation of the tesserae and their setting plaster which must be carried out from scaffolding. Since the erection of satisfactory observation platforms is expensive and infrequent, it is important not to miss the opportunity when scaffolding is set up to make a full technical record of the mosaic, and there is a strong case for special international cooperation of scholars to ensure that the mosaics are studied by experienced observers and, conversely, to ensure the existence of such experience. Unfortunately the modern study of the church of S. Sophia at Thessaloniki is a history of lost opportunities, and despite the fact that scaffoldings have already been set up in the church three times this century, the technical evidence of the mosaics has not been systematically studied[2]. As a result of the serious damage to the structure of the monument and fractures in the mosaics of the cupola caused by the earthquake and tremors in the summer of 1978, scaffolding has again been of necessity erected in the nave of the church. This time the opportunity for a thorough study of the important mosaics of the church must not be lost, and the aim of this paper is to state some of the questions which require examination in the sanctuary mosaics in the hope that

1. Cf. I. A n d r e e s c u, The Corpus for Wall Mosaics in the N. Adriatic Area, Bulletin de l'Association pour l'étude de la mosaïque antique 7 (1978), 317 - 323.

2. To my knowledge, scaffoldings were put up in S. Sophia in 1907 (for restoration as a mosque; the present interior painting belongs to this period), in 1941 (work began in September after bomb damage in February), and in 1961 (as part of a general project of restoration).

remarks which derive from study without the assistance of scaffolding will be soon superseded[3].

At the present time the only substantial technical observations which have been reported about the mosaic representation of the Virgin and Child in the apse were made by Andreas Xyngopoulos. He was able to see the mosaics on a scaffolding put up after repairs were necessitated in the church because of bomb damage in 1941; what he saw was subsequently reported by Kalligas and Galavaris[4]. Xyngopoulos, when I discussed these reports with him, maintained that he had been correctly reported and that his observation was correct. Again it is an issue which needs a new scaffolding for its resolution.

Despite the lack of information about the architecture of the church and its various structural phases as well as the absence of an objective description of the mosaics, scholars have not been reticent to express (divergent) opinions about the dating and hence the historical significance of S. Sophia and its mosaics[5]. There are only a few points on which there seems to be any unanimity, and it seems worth setting these down, not because they are necessarily correct but as a basis for discussion:

3. This paper depends in part on sections of my thesis Ninth Century Monumental Painting and Mosaic in Thessaloniki, London, 1968. My work has been assisted by the loan of a camera belonging to the Central Research Fund of London University.

4. M. K a l l i g a s, 'Εργασίαι εἰς τὸν ναὸν τῆς 'Αγίας Σοφίας τῆς Θεσσαλονίκης, Πρακτικὰ τῆς 'Αρχαιολογικῆς 'Εταιρείας 1941 - 44, 1947, 42 - 52, esp. 52; and G. G a l a v a r i s, The representation of the Virgin and child on a 'Thokos' on seals of Constantinopolitan Patriarchs, ΔΧΑΕ 2 (1960 - 61), 153 - 81.

5. The literature on this church has been marked by a more than usual repetition of unsubstantiated opinions. Early in this century many observations were made in Thessaloniki by the French architect M. le Tourneau during studies in 1905, 1907 and 1909. He sent his notes to Ch. Diehl, who published them and added his own interpretations e.g. M. l e T o u r n e a u et C h. D i e h l, Les Mosaïques de Sainte - Sophie de Salonique, Fondation E. Piot Monuments et Mémoires 16 (1909), 39 - 60. Diehl did not rethink his interpretation on his visit to the city in 1909, and was later (after the death of le Tourneau in 1912 at the age of 37) to incorporate the photographs and (undigested) notes in the joint publication: C h. D i e h l, M. l e T o u r n e a u, et H. S a l a d i n, Les Monuments Chrétiens de Salonique, Paris, 1918. The interpretations of Diehl have gained a surprising currency. For example, his division of the cupola Ascension composition into two periods, though rejected by all recent observers, is maintained as current opinion by R. J a n i n, Les Églises et les Monastères des grands centres byzantins, Paris, 1975, p. 410. The thesis on the church by M. K a l l i g a s, Die Hagia Sophia von Thessaloniki, Würzburg, 1935, was very concise, but its conclusions have often been accepted without any consultation of the publication.

1. The vaulting of the sanctuary and any part of the superstructure which is accepted as part of this phase cannot be later than 780 - 797 (the date given by the imperial monograms which appear in the mosaic decoration of this sanctuary vault)[6].

2. The sanctuary mosaics consist of (at least) two phases, for the throne on which the Virgin sits and the footstool on which she rests her feet cut into and interrupt the liturgical inscription which runs horizontally around the base of the conch. Consequently this representation of the enthroned Virgin and Child is relatively later than the liturgical inscription and any mosaics which are homogeneous with it[7].

3. The cupola mosaics consist of (at least) two phases, for the floral garland which runs around the base of the scene of the Ascension cuts into the two sections of a donor inscription which (assuming it was originally executed in a complete form) must therefore be relatively earlier than the garland beside it[8].

4. The fresco decoration of saints in the narthex represents a phase of work in the church which may be dated on the basis of style to the first half of the eleventh century[9].

In the form in which I have set out these propositions I believe they would command a measure of assent, but all are in need of refinement by

6. The most recent publication of the monograms is by J. M. S p i e s e r, Les inscriptions de Thessalonique, Travaux et Mémoires 5 (1973), 145 - 80, esp. 80 (this study needs supplementation, cf. review of H. H u n g e r in JÖB 23 (1974), 316, and D. F e i s s e l and J. M. S p i e s e r, Les inscriptions de Thessalonique, supplément, Travaux et Mémoires 7 (1979), 303 - 348.

7. The main studies are by S t. P e l e k a n i d e s, I Mosaici di S. Sophia di Salonicco, Corso di Cultura sull'arte Ravennate e Bizantina XI (1964), 337 - 349, and Bemerkungen zu den Altarmosaiken der Hagia Sophia zu Thessaloniki und die Frage der Datierung der Platytera, Βυζαντινά 5 (1973), 31 - 40. I shall cite this second paper as Pelekanides (1973). Both papers are reprinted in S t. P e l e k a n i d e s, Μελέτες Παλαιοχριστιανικῆς καὶ Βυζαντινῆς 'Αρχαιολογίας, Thessaloniki, 1977.

8. The problem of the disturbance of the cupola inscriptions was noticed by C. B a y e t, Mémoire sur une mission au Mont Athos, Paris, 1876, p. 325 - 32; and was duly emphasised by le Tourneau. The most recent consideration of the problem is by K. T h e o c h a r i d o u, Τὰ ψηφιδωτὰ τοῦ τρούλλου στὴν 'Αγία Σοφία Θεσσαλονίκης. Φάσεις καὶ προβλήματα χρονολόγησης, ΑΔ 31 (for 1976) (1980), 265 - 273. I shall cite this as T h e o c h a r i d o u (1980).

9. S t. P e l e k a n i d e s, Νέαι Έρευναι εἰς τὴν 'Αγίαν Σοφίαν Θεσσαλονίκης καὶ ἡ ἀποκατάστασις τῆς ἀρχαίας αὐτῆς μορφῆς, Πεπραγμένα τοῦ Θ' Διεθνοῦς Βυζαντινολογικοῦ Συνεδρίου, I, Athens, 1955, 398 - 407. I shall cite this as P e l e k a n i d e s (1955).

fresh technical observations. While one of the lessons for the Byzantinist of the recent excavations at the Constantinopolitan church now converted into the Kalenderhane Camii is the frequency of structural and decorative alterations on a site in church use from the pre-iconoclastic period[10], yet in a structure of the size of S. Sophia it is hard to believe that all the expensive alterations detected in various parts of the building were chronologically independent of each other. Although it is my intention here to concentrate on the question of the apse mosaics, it would be incautious to consider these as a unit whose history is independent from that of the rest of the monument, and some mention will be made of the other decorations in the church which affect the internal chronology of S. Sophia[11].

THE FIRST DECORATION OF THE SANCTUARY

The obvious place to begin an investigation of the chronology of the church and its decoration is at the mosaic monograms and inscription in the barrel vault of the sanctuary, for these supply the only objective fixed point. The three cruciform monograms on the south side of the vault are today legible, but on the north side the combination of damage and the overpaint of the 1907 restoration (when the building was planned to continue in use as a mosque) obscures all but the easternmost monogram. Fortunately the evidence was observed before this restoration and a transcription has been several times published[12]. On the north side the monograms contained an invocation for an emperor Constantine, while the equivalent three on the south side were on behalf of an empress Eirene. The third invocation was for a bishop Theo-

10. For the excavation of C. L. S t r i k e r and D. K u b a n and its implications cf. T. F. M a t h e w s, The Byzantine Churches of Istanbul, Pennsylvania State U. P., 1976, p. 171 ff.

11. K. Theocharidou has recently investigated the masonry phases of the church made more visible after the removal of plaster. G. Lavas informs me that a full architectral survey has been made since the earthquake of June 1978, and a number of new finds made. For a summary of archaeological work on the site, see P h. A. D r o s o - g i a n n e s, Θεσσαλονίκη. Ἁγία Σοφία, ΑΔ, 18 (Β' 2) (1963), Χρονικά, 235 - 242.

12. Cf. J. K u r t h, Die Mosaikeninschriften von Saloniki, Athenische Mitteilungen, 22 (1897), 463 - 472 (critical remarks on this transcription by E. W e i g a n d, Zur Monogramminschrift der Theotokos - (Koimesis) Kirche von Nicaea, Byzantion 6 (1931), 411 - 472). See also P. P a p a g e o r g i o u, Τῆς Ἁγίας Σοφίας τῆς ἐν Θεσσαλονίκῃ τρεῖς ἀνέκδοτοι ψηφιδωταὶ ἐπιγραφαί, Ἑστία, 1893, 218 - 219: this writer also treated inscriptions in the church in Ἑστία (1892), 394 - 395 and (1893), 317. J. M. S p i e s e r has a satisfactory entry.

philos and is written out in full between the monograms on each side of the vault [13]. The period to which these commemorations belongs can be deduced without ambiguity: the 'joint' reign of Eirene and Constantine VI may be dated between 9 September 780 and the Spring of 790 and between December 790 and 15 August 797, and Theophilos is documented by his signature in the acts of the Council of Nicaea of 787 [14].

Although these mosaics of the sanctuary are clearly dated to the late eighth century, so far there has been no careful technical examination to clarify the extent of the mosaics of this period or their precise relationship to the structure of the church [15]. It therefore seems justifiable to propose an interpretation in the hope that it will soon be tested during work on the church [16].

13. Pelekanides (1973) believed that this combination of monograms and inscription denoted the initiative for the work to the archbishop between 787 and 797; this idea lacks proof.

14. M a n s i, XIII, 133E. J. S m i r n o v, On the date of the mosaics of S. Sophia in Thessaloniki, (in Russian), VV 1898, 365 - 392, esp. 380, interprets Theophanes as referring to Theophilos as archbishop by 785. This conclusion is criticised by L. P e t i t, Les Évêques de Thessalonique, Échos d'Orient 4 (1900 - 1), esp. 215 - 216.

15. The present sources of information are the works of le Tourneau, Kalligas and Pelekanides mentioned above. Kalligas supposed that the monograms together with the panels above were an insertion into a previous scheme consisting of a cross against a gold ground in the apse, and a second cross in an aureole against a gold ground above the sanctuary. The second of Pelekanides' opinions was that the barrel vault decoration over the sanctuary was of the same date as the monograms, but that at a previous time the apse was decorated with a cross and the liturgical inscriptions. The cross at the apex of the sanctuary was made to replace that in the apse when that was removed to make way for the new figural composition. Neither of these observers justified their conclusions with a description of the technical evidence.

16. What follows is the hypothesis put forward in my thesis (1968). The same conclusion was reached by H. B u c h w a l d, The Church of the Archangels in Sige near Mudania, Graz, 1969, esp. p. 43ff. He also took the non-figurative mosaics of the sanctuary to be of one period, that of the foundation of the church. This conclusion was specifically rejected by R. K r a u t h e i m e r, Early Christian and Byzantine Architecture, second edition, Pelican, 1975, p. 514, on stylistic grounds; K r a u t h e im e r had in his first edition (1965), p. 290, followed Kalligas in dating the church "as early as the first quarter of the eighth century". A. G r a b a r, L'Iconoclasme byzantin, Paris 1957, esp. p. 153ff. and 172ff. assumed the non-figurative decoration of the sanctuary and the foundation of the church to belong to 780 - 797, and perhaps before 787. Pelekanides (1973) rejected this proposal. C. M a n g o, The Byzantine Church at Vize (Bizye) in Thrace and St. Mary the Younger, Zbornik Radova Vizantoloskog Instituta 11 (1968), 9 - 13, inclines to the late-eighth - century date for S. Sophia; and a dating to c. 784 - 787 is regarded as plausible by P. S p e c k, Kaiser Konstantin VI, Die Legitimation einer fremden und der Versuch einer eigenen Herrshaft, München, 1978, II, p. 533 - 534, note 220.

To the observer at floor level there is no apparent suture between the monograms and the mosaics of the barrel vault or between the mosaics of the barrel vault and those of the apse. It can therefore be proposed that the programme of work undertaken at the time of setting the monograms was as follows. In the extensive barrel vault of the sanctuary [17], above the monograms, were set two symmetrical panels consisting of a rectilinear framework of six horizontal courses (each staggered like a brick wall). Each frame encloses a small 'greek' cross of silver tesserae outlined in red or, alternately, a green vine leaf. The arms of these crosses are slightly flared and terminate in a pair of tear-drop serifs. The apex of this vault was decorated with a large cross inside a circular aureole against a gold ground. Superficially it appears 'greek' in form, but the arms on the east-west axis are actually longer than those on the north-south axis, and the east arm is slightly longer than that on the west side. The arms are filled with gold tesserae within an outline of three rows of red tesserae. The arms are slightly flared and terminate in a pair of tear-drop serifs, the cores of which consist of whitish marble tesserae, outlined by two rows of red tesserae. Rays of light radiate from between each arm and from the end of each arm. The ground of the aureole is made up of four concentric rings of four hues of blue. In the outermost ring are pairs of six-pointed stars of gold set against a lighter blue circle. The aureole is completed with a variegated ring of nine hues (inner to outer: dark blue or black; green; light olive; white; fawn; orange; vermilion; dark blue or black).

Below the monograms on the south side the painted early-twentieth-century border appears to be false to the design of the few tesserae which show through it [18]. The mosaic border (which fills in the space between the monograms and the moulded cornice) seems to have contained a plant scroll, reflected in two axes to form a symmetrical figure. This ornamental border would therefore seem to differ in its design from its continuation at right angles around the east side of the barrel vault. This vertical continuation is concave in shape and consists of alternating

17. Deep sanctuaries are found in Thessaloniki also at the Rotunda and Acheiropoietos: the suggestion is made by W. E. K l e i n b a u e r, Report on the Earthquakes in Thessaloniki, Archaeology, Sept. - Oct. (1978), 60, that the apses of both these churches were rebuilt in the sixth century.

18. B u c h w a l d, cited in note 16, p. 43, note 196, claims that the painted restoration is faithful to the mosaic design. This was not my impression but the point is far from certain, and needs investigation; one would expect this border to conform either with its continuation vertically or with the apse border.

plant and geometrical motives. Three points about it are to be noted: the similarities of the plant forms in the horizontal and vertical borders, the similarity of the framing element between both borders and the carpet decoration of the vault, and the absence of a visible suture at any place. Furthermore, there is no sign of a suture in the mosaic surface which completes the transition from the barrel vault to the conch of the apse. In this undulating area of transition there are three separate bands with four dividing frames, of which the two outer and two inner are mirror images of each other. The central flat band is composed of a monumental inscription, while the third convex band consists of alternating double forms with a trefoil between two entwined heart shapes. This band surrounds the conch of the apse, and in its turn appears entirely homogeneous with the gold ground and with the horizontal inscription which is set into the lowest of the three green registers[19].

The present representation of the Virgin and Child in the apse can be demonstrated today to be a later insertion into the decoration in this area on the grounds that the horizontal inscription is now incomplete and that its central part was removed to supply space for the insertion of the footstool of the throne. It was much easier to see evidence of this Byzantine alteration to the apse scheme before the restoration work in S. Sophia of 1941 when sections of the original tesserae around the Virgin were removed and replaced[20]. Fortunately some of the information lost at that time can be recovered by study of older photographs (see Plates 19a and 22)[21] These photographs show that the Virgin was surrounded by a suture which was most obvious on the right side of the halo. What can safely be deduced is that at some time the original central motive of the apse was cut out, and into this space was set the enthroned Virgin with a new trim around the figure and a new setting of the gold ground between the figure and the original ground of the apse. Since at some places the join between the two phases was not quite flush, it was visible

19. There are no significant discrepancies between the letter forms of the three inscriptions.

20. The lateral arms of the cross were replaced with reset tesserae, and the line of the suture was masked.

21. Plate 19a was photographed by le Tourneau in 1907 from the scaffolding: it was published in the article of 1909, p. 50, fig 8, and in the book of 1918, p. 140, fig. 59; Diehl incorrectly described it as taken from the ground.

Plate 22 is after D. B a u d - B o v y, Salonique, la Ville, des Belles Églises, Geneva, 1919, with photographs taken by F. Boissonnas after 1912; cf. also P. A. U n d e r - w o o d, The Evidence of Restorations in the Sanctuary Mosaics of the Church of the Dormition at Nicaea, DOP 13 (1959), 235 - 342.

to the naked eye and in the course of time it collected dirt. This suture around the Virgin is the only sign of any deviation from the original scheme to which all the rest of the sanctuary mosaics can therefore with some reason be ascribed. It is this conclusion which is proposed here.

Study of the photographs shows that the method of operation in inserting the Virgin did not entirely mask the original central motive of the apse. On each side of the Virgin at shoulder level, instead of hacking out the complete original mosaic, all that was done was to pick out the rows of coloured tesserae and to replace them with gold tesserae. Since the new tesserae were not identical in appearance, or in their plane, with the original gold tesserae, a 'ghost' of the original composition remained visible. The original motive can be reconstructed without difficulty. It was a vast gold cross, outlined by dark tesserae, similar in form to that in the apse of S. Eirene in Constantinople [22]. Its horizontal arms were plain, without any infilling decoration such as of jewels, and they were slightly flared and terminated in a pair of tear-drop serifs. The vertical arms were entirely removed at the time when the Virgin was set; they presumably resembled S. Eirene too. Probably, then, the plain cross was set on a stepped base, the bottom edge of which would have rested above the horizontal inscription.

The first decoration of the sanctuary of S. Sophia consisted, according to the interpretation offered here, of a non-figurative scheme which gave considerable emphasis to the symbolism of the cross. The problem remains whether this decoration, datable to the period 780 to 797, was contemporary with the building of the church. The content of the two liturgical inscriptions is a relevant factor in reaching a decision. The inscriptions read as follows:

22. The apse mosaic of S. Eirene dates after 26 October 740. Pelekanides (1973) repeats the mistake of G r a b a r, L'Iconoclasme byzantin, Paris, 1957, p. 153, (due to an incorrect transcription of Theophanes) that the earthquake was in 732. Pelekanides thought that the date 740 referred to the apse mosaic, and this misapprehension may have influenced his dating of the apse cross in Thessaloniki. Presumably the restoration and redecoration of S. Eirene took place in the reign of Constantine V, cf. R. C o r m a c k, The Arts during the Age of Iconoclasm, "Iconoclasm", edited by A. Bryer and J. Herrin, Birmingham, 1977 p. 35 - 44. Recently the curious view has been put forward by S. G e r o, Byzantine Iconoclasm during the reign of Constantine V, C.S.C.O. Subsidia 52, Louvain, 1977, p. 117, that "the only examples of iconoclastic art which can be securely attributed to the period of Constantine's reign are seals and coins". The surviving mosaics from the period and the literary records make this attempt to deny monumental church commissions during this reign quite untenable.

V

inscription one (around the face of the apse semidome)

† Πλησθησόμεθα ἐν τοῖς ἀγαθοῖς τοῦ οἴκου σου, ἅγιος ὁ ναός σου, Θαυμαστὸς ἐν δικαιοσύνῃ.

inscription two (around the base of the apse semidome)

† Κ(ύρι)ε ὁ Θ(εὸ)ς τῶν π(ατέ)ρων ἡμῶν στερέωσον τὸν οἶκον τοῦτον ἕως τῆς συντελεί[ας] τοῦ αἰῶνος ἀσάλευ]τον πρὸς δόξαν σὴν καὶ τοῦ μονογενοῦ(ς) σου υ(ἱο)ῦ καὶ τοῦ παναγίου σου πν(εύματο)ς.

Inscription one is a quotation from Psalm 64 (v. 5), and the same passage appears in the similar position around the apse of S. Eirene, but at greater length there since space was available to include the following verse. These words are spoken in the rite of the dedication of a church, and it was pointed out by Smirnov that *inscription two* is a conflation from various phrases also used in the encaenia ceremony. The mosaic inscriptions therefore from a visual and permanent record of the prayers spoken when S. Sophia was consecrated, and their content is one further (though not conclusive) argument that the first mosaic decoration dates from the time of the foundation of the church[23]. It is to be hoped that the question can be decided on the basis of careful technical observations[24].

The choice of a non-figurative scheme for S. Sophia in the late eighth century links it with the current decorations of the apses of S. Eirene and (presumably) S. Sophia at Constantinople, and it is unlikely that this connection with the Great Church of the capital is a coincidence, for there is a possible historical context for the building of the new large dom-

23. Cf. J. S m i r n o v, cited in note 14. For the texts, see P. N. T r e m p e l a s, Μικρὸν Εὐχολόγιον, II, Athens, 1955, p. 75 - 146. One problem is that, although such phrases occur in foundation decorations, in the apse of S. Eirene they occur at a time of a refoundation (for the use of the same phrases at the second inauguration of S. Sophia, in 562, see C. A. T r y p a n i s, Fourteen Early Byzantine Cantica, Vienna, 1968, p. 141). Another complication on this site is that at present the chronological relationship between the disuse of the earlier basilica and the foundation of S. Sophia is unclear. However, even if it were to be argued that the sanctuary mosaics of S. Sophia belonged to a refoundation, it seems to me unlikely that the superstructure would be earlier than 780.

24. M. le Tourneau, cited in note 5, reported that the tesserae were embedded in a plaster base which was laid directly onto stone which had been grooved diagonally to ensure adherence. This procedure has also been reported from San Marco in Venice, but it does not prove that the present mosaics belong to the original decoration of the apse. Presumably Le Tourneau made his observation at those areas of loss which were reset in 1941.

ed church, the largest built in this city since the fifth century and the latest of its size. The historical circumstance which may explain the need for a new impressive church in the late eighth century in Thessaloniki was the official reorientation of the ecclesiastical jurisdiction of Illyricum from Rome to Constantinople[25]. Was the dedication, scale, and even the form of S. Sophia chosen for S. Sophia so that the new church could fulfil the role of a new cathedral for the archbishop? Its function as cathedral does appear to be documented from the end of the eighth century and thereafter.

The earliest mention of S. Sophia is in a letter of Theodore the Studite written in banishment in Thessaloniki in 797[26]. Theodore was sent to pray in S. Sophia before his reception by the (unnamed) archbishop (Thomas?), and the archbishop too prayed in his oratory, which sounds to have been in S. Sophia. The choice of this church for the rendez-vous implies that it was near the episcopal residence, if it does not prove that it was the cathedral. Athonite documents of the eleventh century are less ambiguous, and include more than one reference to the clergy of S. Sophia as belonging to the 'Great Church' of Thessaloniki[27]. Pope Innocent III in a letter of 1212 refers to the church as the metropolis[28], and after the Latin Occupation, S. Sophia remained the cathedral during the Palaeologan period. From the time of Symeon of Thessaloniki a number of useful liturgical texts survive which explain how the architecture of the church was used and which claim that cathedral liturgy in this church was the most authentic in the Byzantine world[29]. S. Sophia

25. For a considerable period of time the ecclesiastical jurisdiction of Illyricum lay officially in the hands of the Roman see, and the archbishop of Thessaloniki was the vicarius of Rome. This situation, however nominal in practice, came to an end either in the reign of Leo III or of Constantine V: for a bibliography on this problem, see G. Ostrogorsky, The Byzantine Background of the Moravian Mission, DOP 19 (1963), 3 - 18.

26. Epistles of Theodore the Studite, I, 3: Migne, PG 99, cols. 913 - 20, esp. 917C. Annunciation Day (25 March) fell on a Saturday in 797, and this is the year adopted by the editor of Migne, and also by P. Speck, cited in note 16, II, p. 713, note 54. Up to this time, the evidence is that the cathedral was the Acheir opoietos Basilica.

27. Cf. R. Janin, cited in note 5, p. 407, where these documents are seen to refer to S. Sophia as the cathedral.

28. R. Janin, op. cit. 407 - 451.

29. Cf. O. Strunk, The Byzantine Office at S. Sophia, DOP 9 - 10 (1955 - 6), 177 - 202. For the dating of liturgical manuscripts to the initiative of Symeon, see J. M. Phountoules, Τὸ Λειτουργικὸν ἔργον Συμεὼν τοῦ Θεσσαλονίκης, Thessaloniki, 1966, and Συμεὼν 'Αρχιεπισκόπου Θεσσαλονίκης, Τὰ Λειτουργικὰ συγγράμματα,

probably continued as the cathedral up to its conversion into a mosque which probably occurred in the first half of the sixteenth century (after which the Rotunda took over this function for a few decades until it too became a mosque in Hegira 999)[30].

I Εὐχαὶ καὶ Ὕμνοι, Thessaloniki, 1968. Strunk reports that cod. Athens 2061 describes the psaltists in S. Sophia at Thessaloniki going up into the dome and from here singing their acclamations. Another manuscript, cod. Athens 2047 (dating between 1410 and 1423), gives the order of processions, mentions oratories, etc. On this see, J. D a r-r o u z è s, Sainte-Sophie de Thessalonique d'après un rituel, REB 34 (1976), 45 - 78. Another important text with information about S. Sophia at this period is the cod. Athens 2953, see S. K u g e a s, Notizbuch eines Beamten der Metropolis in Thessalonike aus dem Anfang des XV. Jahrunderts, BZ 23 (1914 - 9) (1920), 143 - 63.

30. The precise date of the conversion of S. Sophia into a mosque remains an unresolved issue despite the apparent precision of many writers. The firmest recent statement on the problem is in the useful paper by M. Kiel, Notes on some Turkish monuments in Thessaloniki and their founders, Balkan Studies 11 (1970), 123 - 48, but this author does not take into account all the evidence. He states that the transformation of S. Sophia took place at the end of the sixteenth century in the climate of millenarianism as the Muslim year approached Hegira 1000, and he parallels it with the Rotunda (conversion dated by inscription to H. 999 = 1590). Kiel supports his dating with reference to an Italian traveller who could in 1591 still see a representation of the Pantocrator in the dome of S. Sophia, a fact which Kiel interprets to prove that the conversion was very recent. This particular argument is unacceptable for several reasons: one is that the procedure of the concealment of Christian iconography was not undertaken immediately even in the church of S. Sophia at Constantinople. The overpainting of the figures in this dome (they were disguised as trees) may not have been much earlier than the fire of 1890.

The following dates for the conversion of S. Sophia into a mosque are met in the literature:

1523: P. N. P a p a g e o r g i o u, Ἀρχαία εἰκὼν τοῦ Ἁγίου Δημητρίου, BZ 1 (1892), 486 (transcription of Hegira 930).

1525: J. K u r t h, as cited in note 12, and G. I. T h e o c h a r i d e s, Ὁ ναὸς τῶν Ἀσωμάτων καὶ ἡ Rotonda τοῦ Ἁγίου Γεωργίου Θεσσαλονίκης, Ἑλληνικὰ 13 (1954), 24 - 70. Theocharides trusts the date given by Kurth on the grounds that there seems to have been more precise information in the nineteenth century and now lost, and that Kurth through J. H. Mordtmanns might have had access to Turkish material.

1575: D i e h l, L e T o u r n e a u, and S a l a d i n, cited in note 5.

1589: Ch. T e x i e r and R. P. P u l l a n, Byzantine Architecture, London, 1864, 143, give the date Hegira 993 without quoting their source; the proper transcription of the year is 1585. M. K a l l i g a s, cited in note 5, also gives this date.

The most important study on the problem in F. B a b i n g e r, Ein Freibrief Mehmeds II, des Erobers, für das Kloster Hagia Sophia zu Saloniki, eigentum der Sultanim Mara (1459), BZ 44 (1951), 10 - 20, who gives the reasons for dating th conversion between 1520 and 1536. The problems against accepting the opinion of Kiel lie in the following evidence:

a. The traveller who describes the Pantocrator in the dome was in fact the Venetian

If the motivation for the construction of S. Sophia lay in the wish to provide a symbol of the closer connection of the see with the Patriarchate of Constantinople, the best circumstances for the project arose towards the end of the eighth century when purely defensive building would no longer be the priority in the region. The situation changed in 783 when Eirene sent her general Staurakios to Thessaloniki and Hellas with a large army[31]. The success of this campaign against the *Sclaviniae* was such that Staurakios in January 784 celebrated a triumph in the hippodrome at Constantinople, and in May of the same year Eirene and Constantine VI made a ceremonial visit (accompanied by the army and

ambassador of 1591, see B. C e c c h e t t i, F. S t e f a n i, and G. B e r c h e t, Viaggio di un ambasciatore Veneziano da Venezia a Costantinopoli nel 1591, Venice, 1886. A translation of this text is given by K. D. M e r t z i o s, Μνημεῖα Μακεδονικῆς Ἱστορίας, Thessaloniki, 1947 p. 125. What the text actually says is that whereas the Rotunda was turned into a mosque some seven months before his visit at the end of May 1591, it was the case that S. Sophia had been converted many years previously ("fatta molti anni sono moschea").

b. According to S t e p h a n G e r l a c h, Tagebuch, Frankfurt, 1674, as quoted by Theocharides in the article given above (p. 56), the Metropolitan of Thessaloniki reported to the Patriarch in 1576 that the Turks held three large churches and three smaller ones. Since the Rotunda was still in Christian use, the large churches should be: the Acheiropoietos (converted immediately after 1430); S. Demetrios (converted in Hegira 898 = 1491); and S. Sophia.

c. B a b i n g e r, cited above, quotes the geographical writings of Mehmed ben Ömer ben Bayazid (1555 - 1600) as stating that the conversion of S. Sophia was ordered by the Grand Vizier of Sultan Suleiman I (1520 - 66), namely Ibrahim Pasha, who was strangled on 15 March 1536. He is said in this source to have founded a minaret and a fountain in the garden at the same time.

These three pieces of evidence seem to point to the conversion of S. Sophia between 1520 and 1536. Kiel however criticises point (c) without taking into account points (a) and (b): on the grounds that Babinger incorrectly gives here the place of birth of the geographer as Thessaloniki (though in another work Babinger gave it correctly as Trebizond), Kiel goes on to suggest that he places too much trust in this authority. Kiel admits that the geographer for several years lived and worked in Thessaloniki, but says that his compendium Menazir ül Avalim, despite efforts to be accurate, is not without mistakes over the monuments of Thessaloniki e.g. about the exact nature of the enlargement of the Hamza Bey Mosque, and over the date of conversion of the Rotunda. I do not find Kiel's arguments decisive, and prefer to keep the period 1520-36 as the most likely on the present evidence. Kiel may have exaggerated Turkish ideological reasons for church conversion, which might as often have occurred as the Muslim population expanded and caused the need for more mosques. It follows from this dating of the conversion of S. Sophia that the nineteenth century references to the Rotunda as the Old Metropolis probably refer to its status in the sixteenth century and not in the Middle Byzantine period, as Theocharides supposed.

31. T h e o p h a n e s, Chronographia, (ed. de Boor), 456 - 7.

musicians) into Thrace (going to Berroia, which was renamed Eireno-
polis –now Stara Zagora– and to Philippopolis, to found Anchialos). The
foundation of S. Sophia would fit well into this period of optimism and
expansion immediately after 783 [32]. Thessaloniki remained of course in an
isolated and dangerous position and prudence may have led to as rapid
as possible a building campaign for the church (using *spolia* as available).
The non-figurative character of the mosaics may then have been planned
and even executed before the Council of Nicaea in 787; alternatively the
absence of figures reflects ecclesiastical caution. It is conceivable that
the mosaic decoration was confined to the sanctuary at this period (a
feature, it would seem, of some pre-iconoclastic churches), but the whole
church might at this time have copied the decoration of the Great Church
at Constantinople and contained a cross at the apex of the dome.

It has been the aim of this paper to give reasons for dating the foun-
dation and a first decoration of S. Sophia to the period immediately
after the imperial campaign of 783 [33]. This conclusion would be impos-
sible to maintain if the interpretation of recent observations in the church
by Theocharidou is correct [34]. Her publication of new technical is to be
very much welcomed, but I must give reasons why her grounds for dat-
ing the superstructure of the church before Iconoclasm must be imme-
diately discounted [35].

Theocharidou believes it possible to date the cupola inscriptions in
or before 690, and this year would therefore constitute a *terminus ante quem*
for the construction of the church. What the inscriptions in their pre-
sent state tell us is this: – that in November of the fourth indiction in
the sixth millenium from the creation of the world in the time of arch-
bishop Paul was done "this work" [36]. The information is given in two

32. There is evidence of building activity in Thrace and Asia Minor, and also the
conscious proclamation of a Golden Age, cf. R. C o r m a c k, as cited in note 22.

33. The precise form of the original church is not yet clear; B u c h w a l d, cited
in note 16, criticises the earlier attempts.

34. T h e o c h a r i d o u (1980), as cited in note 8.

35. There is not space in the present paper to enter into a full discussion of the chro-
nology of the cupola mosaics, but it should be emphasised that further investigation
of the technical evidence of the garland is desirable. The study of Theocharidou seems
to establish firstly that the two inscription panels are relatively earlier than the Ascen-
sion; and secondly that there were originally two further inscriptions. Less conclusive
is the evidence so far presented that the garland was set relatively earlier than the com-
position above. The evidence of the setting beds needs to be investigated all along the
lower edge of the garland.

36. The order of the two inscriptions followed by Theocharidou seems to me pre-

separate sections, neither of which have survived in a complete form. The panel on the north (left) side of the cupola is complete in its lettering except for the ending of the date: only a stigma is preserved, and so the precise year within 6000 is no longer given. The other panel on the south (right) side of the cupola is more fragmentary, and has lost the first and last three letters of each line. These areas of loss were at some time made good by the setting of the garland in the missing areas. It is not possible to say what was the original lateral framing or full dimensions of these truncated inscriptions[37]. Although Theocharidou is able to mark in her photographs the sutures between the inscriptions and the garland, the alterations made in the red glass framing above the north inscription and the state of the original red ceramic framing of the south inscription effectively conceal the original format of the panels. It is therefore unconvincing to argue, as Theocharidou does, that because the upper two lines of the north panel are complete on their right side, consequently the third line which now ends with the first letter of the millenium could not have extended for more than one further letter. Indeed in the area which she believes was available for the missing letter, there is scarcely space for the candidates she ultimately proposes (nu, pi, or sigma). It must be admitted that so far this criticism of her reconstructions of the original panels rests on the lack of evidence, and that her description of the north panel may seem attractive on esthetic grounds, for it would make the inscription symmetrical. The suggestion that the year involved was one that could be expressed in two numerals only must therefore be followed further.

Any discussion of this inscription must work from the premise that the mosaicist correctly harmonised the indiction with the year of creation, and that the year in question is one in which November falls in the fourth indiction. Theocharidou considers there to be only two occasions after 690 when the conjunction of a two numeral year 6000 with this in-

ferable to that of J. M. S p i e s e r, as cited in note 6, p. 260 - 261 and plate 2 (the reverse order). Spieser summarises in his note the reasons given in my thesis for dating the inscription to November 885 (=6394).

37. The south panel now measures 1.07 metres in width and was originally wider to contain four missing letters; the north panel now measures 1.08 metres and in the opinion of Theocharidou contained only one more letter. For reasons given below, I believe that there are two or more likely three letters missing, and that therefore the original panels were of roughly equal width. As for the nature of the lateral completion of the panels there are several possibilities to judge from the pre-iconoclastic mosaics of S. Demetrios (e. g. a tabula ansata form, space-filling birds etc. in the ground, or plain borders).

diction occurs, namely 6500 (= 991) and 6800 (= 1291); these candidates she eliminates on the grounds that stylistically the Ascension mosaic cannot be as late as either of these two dates, but that it must postdate the inscriptions. She could have supported this conclusion by the evidence of palaeography, for the letter forms would seem to exclude a date later than the middle of the tenth century. Actually there is a much more conclusive reason for eliminating these two years: the November of 6500 as well as that of 6800 falls in the fifth indiction. No year of the Byzantine era of this kind could ever have its November in a fourth indiction, and it follows that if the inscription contained only two numerals, it could not be using the standard era. Theocharidou seems to have realised this, despite her miscalculation, for in turning to the pre-iconoclastic period she suddenly shifts into using the so-called Protobyzantine era, which differs from the standard era in its tabulation from the origin of the world[38]. At this point two difficulties must be mentioned which should have taken into account. The first is whether there is any justification for supposing that this system of dating was in use in epigraphy in Thessaloniki in the fifth, sixth, or seventh centuries. The second is whether the use of the era of creation could have been used in such an inscription before the late seventh century, since the earliest epigraphical examples are recorded only in 693 and 704 (in the graffiti of the Parthenon)[39]. One or other of these difficulties cast doubt on all the years envisaged by Theocharidou, viz. 6005, 6020, 6050, 6080, 6110, and 6200 (which she incorrectly transcribes as 495, 510, 540, 570, 600, and 690).

On the assumption that the cupola inscription refers to the Protobyzantine era, Theocharidou comes to the conclusion that it refers to one of the years 540, 570, or 690. Even if it had been possible to accept the steps leading this to this conclusion, all of which are doubtful, there is now found to be one inescapable flaw. The Protobyzantine system is

38. This term and the justification of its use is due to V. G r u m e l, La Chronologie, Paris, 1958, esp. p. 73 - 94. His interpretation is upheld by the recent analysis of the Chronicon Paschale: J. B e a u c a m p, R. B o n d o u x, J. L e f o r t, M. - F r. R o u a n, I. S o r l i n, Le prologue de la chronique pascale, Travaux et Mémoires 7 (1979), 223 - 301.

39. Cf. I. Š e v č e n k o, An Inscription commemorating Sisinnios, "curator" of Tzurulon (A. D. 813), Byzantion 35 (1965), 564 - 74. For the Parthenon graffiti, see now A. O r l a n d o s and L. V r a n o u s i s, Τὰ Χαράγματα τοῦ Παρθενῶνος, Athens 1973. C. F o s s, Three Apparent Early Examples of the Era of Creation, Zeitschrift für Papyrologie und Epigraphik 31 (1978), 241 - 146, reiterates the unlikelihood of documents with the use of the era of creation before the late seventh century.

V

discussed at length by Grumel who shows that its crucial feature is that the year begins on 21 March; he is aware of the consequent problem in determining where the indiction fell, and gives the rules for discovering this[40]. If these rules are followed for the Protobyzantine years proposed by Theocharidou, it is discovered that in each case November of these years falls not in the fourth indiction but in the fifth (the correct equivalent is November 541, 571, and 691). One can be quite categorical that any year where November falls in the fourth indiction cannot be expressed using only two greek numerals, whether the era is Byzantine or Protobyzantine. In other words, the cupola inscription must originally have contained three or four numerals, and the width of each panel was probably roughly equivalent[41]. The method followed by Theocharidou and the conclusion that the inscription must belong before Iconoclasm can be eliminated from further consideration. In the present state of research, it remains reasonable to propose the period 780 to 797 both for the foundation and the first sanctuary decoration of S. Sophia. The precise date of the cupola inscription remains an open question[42].

40. V. G r u m e l, p. 202 - 203.

41. Cf. note 37 above. If a three numeral date is to be canvassed, one candidate is the year 6304 (=November 795). The difficulty is in postulating an unknown archbishop Paul who would be responsible for completing the decoration of the church after the death of Theophilos; such a candidate is difficult to fit into the tight sequence in the period evidenced by P e t i t, Les Évêques de Thessalonique, Échos d'Orient 4 (1900 - 1), esp. 215 - 216.

42. If the inscription postdates 780, as proposed in this paper, its evidence remains extremely enigmatic, for there exists well-documented information on the sequence of archbishops from this date onwards (contrary to the belief of certain art historians about the existence of an archbishop Paul in the eleventh century). The key publications of the list in cod. Vatican gr. 172, folios 177 - 81, are: L. P e t i t, Le Synodicon de Thessalonique, Échos d'Orient 18 (1916 - 9), 236 - 254; V. L a u r e n t, La Liste épiscopale du Synodicon de Thessalonique, Échos d'Orient 32 (1933), 300 - 310; and J. Gouillard, Le Synodicon de l'Orthodoxie, édition et commentaire, Travaux et Mémoires 2 (1967), 1 - 316. To judge from other cities, such lists need to be use with care for they are not necessarily complete, with omissions from ignorance, carelessness, or deliberate falsification for reasons of theological odium. Usually, however, such list are in correct chronological sequence (cf. R. J. H. J e n k i n s and C. M a n g o, A Synodicon of Antioch and Lacedaemonia, DOP 15 (1961), 225 - 242, and V. L a u - r e n t, La liste épiscopale de la Métropole de Lacédémone, REB 19 (1961), 206 - 226). In the case of Thessaloniki, there may be a dislocation of Plotinos in the ninth century sequence, which adds to the difficulties of unravelling the dates in this period, see P. K a r l i n - H a y t e r, La date de Plotin, archevêque de Thessalonique, Byzantion 32 (1962), 129 - 131. The normal interpretation of the list must be that between 770

THE ENTHRONED VIRGIN AND CHILD

The second phase of mosaic decoration in the apse when the central cross was replaced by a figurative composition can only be dated by art historical considerations. The lack of any objective factors has led predictably to the usual discrepancy of solutions offered, which range from the eighth to the twelfth centuries [43]. In only one aspect is there any

and 1440 there were only two archbishops named Paul, and both held office in the ninth century; one is independently dated in the 880s and his term of office could have included November of the fourth indiction of the year 885 (6394). This date would of course be very satisfactory as the date for the style of the Ascension mosaic, which could in any case hardly be later than the middle of the tenth century at the outside. But it now appears from the observations of Theocharidou that this date belongs to an earlier period in the history of the cupola than the Ascension. One possibility that might be considered is that S. Sophia suffered serious damage at the time of the Saracen raid in 904 and the Ascension is a repair of this period (Arethas went to Hellas in late 905 - early 906 to reconsecrate churches, cf. J. H e r r i n, Aspects of the Process of Hellenization in the Early Middle Ages, Annual of the British School at Athens 68 (1973), 113 - 26). This possibility can only be seriously considered if the evidence of Cameniates is discounted and it is supposed that damage in the city was more extensive than usually believed cf. A. P. K a z h d a n, Some questions addressed to the scholars who believe in the authenticity of Kaminiates' Capture of Thessalonica, BZ 71 (1978), 301 - 314.

43. Pelekanides (1973) dated the Virgin to two operations, one of the late eighth century, and the other to the second half of the twelfth century. Galavaris likewise, cited in note 4, attributes the Virgin to two phases, apparently dating the first to the ninth century, and the second to the eleventh. Other opinions, of which a sampling is given here, had assumed the composition to be of one period. Kalligas, cited in note 5, dated it after 843.

A. G r a b a r, L'Iconoclasme byzantin, Paris 1957, p. 195, dated the Virgin to the same period as the cupola, the end of the ninth century. He considered the proposition that the mosaic contained as earlier version of the child, and rejected it; he did believe that the child had undergone some restoration.

V. N. L a z a r e v dated it to the ninth century, Painting of the eleventh and twelfth centuries in Macedonia, (in Russian), Actes du XIIe Congrès international d'études byzantines I, Belgrade, 1963, p. 105 - 134. An eleventh century date was proposed by K. P a p a d o p o u l o s, Die Wandmalereien des XI. Jahrhunderts in der Kirche Παναγία τῶν Χαλκέων in Thessaloniki, Graz-Köln 1966, esp. p. 112 - 120 and plates 38 - 39.

A date in the twelfth century was proposed by A. F r o l o w, La Mosaique murale byzantine, Byzantinoslavica 12 (1951), 180 - 209, and by P. J. N o r d h a g e n, The Mosaics of John VII (705 - 7 A. D.), Acta ad Archaeologiam et artium historiam pertinentia 2 (1965), 121 - 166, esp. 163, note 6. More specifically, V. J. D j u r i ć, La Peinture murale byzantine, XIIe et XIIIe siècles, Actes du XVe Congrès International d'études byzantines, I, Athens, 1979, 159 - 252, dates it to the first half of the twelfth century (unlike Pelekanides who opted for the second half of the century).

unanimity, and this is in the characterization of the execution of the present Virgin and child as one of the least successful of Byzantine mosaics, a work of mediocre quality. If true, this lack of finesse will need some discussion.

In the years before the severe fire of 1890, when S. Sophia was in use as a mosque, visitors reported the apse composition as obscured by placards and overpaint; Duchesne and Bayet record that what could be seen of the Virgin seemed very damaged [44]. By 1907, the mosaic had suffered further deterioration as a result of the fire, neglect, and the penetration of rain through the roof. Le Tourneau described the Virgin as heavy in appearance, poor in execution, and unpleasant in colour [45]. He observed the mosaic from close-to, and notes her garment with its complicated folds; he describes her flesh parts as highly modelled with highlights in white, colours in yellow and rose, and shadows in grey-green. Her features, he writes, are outlined in dark colours. The robe was richly coloured, with many scattered single tesserae of different hues (white, blue, green, red, etc.). The garment of the child was gold. Areas of loss in 1907 are visible on his photograph (Pl. 19a): a small round patch immediately above her halo, patches on the three parts of the maphorion where segmenta would once have been, and a patch in the garment over the right knee.

In the restoration of 1907, the roof was overhauled, the surface of the mosaic cleaned, and the areas of loss filled in with plaster (to be seen in Pl. 22). The next work in the apse was done in the 1941 restoration. Comparison of the earlier records with recent photographs shows that this work was not limited to the replacement of sections of the gold ground which were described above, but included the insertion of new tesserae into the areas of loss within the figure (Pls. 20 and 21).

It was from the scaffolding of 1941 that Xyngopoulos made his observation that has subsequently featured in discussion of the apse mosaics, and which has led me to choose this subject for this volume [46]. According

44. As cited in note 8: the garments of the Virgin were then described as 'bleu grisâtre'.
45. As cited in note 5.
46. The observation of Xyngopoulos is reported by Kalligas and Galavaris, cited in note 4. Only Grabar seems to have regarded it critically. Galavaris in his discussion of iconography is incorrect to describe this throne with one cushion only, and this mistake invalidates some of his generalisations about the 'thokos' before the fourteenth century. His dating of the apse of S. Sophia at Constantinople through comparisons with seals is not acceptable.

V

to Xyngopoulos, the mosaic has in it "traces of the foot of another child which must have existed before it was replaced by the present child. The traces of that foot indicated that the previous child was in a reclining position". This observation is crucial to the analysis of the apse mosaic made by Galavaris and Pelekanides, who both believe that a change of iconographic type occurred in the period[47]. After further observation from a scaffolding in 1961, Pelekanides wrote two papers on the subject and in these he interpreted the colour change visible at a level above the Virgin's right hand and running horizontally (see Pls. 20 and 21) as a suture; the lower part of the mosaic would then date from an earlier period than the upper part[48].

In order to assess the theory of Pelekanides, it is necessary to look closely at the figurative composition fitted into the pre-existing mosaics. The secondary work consists of the fill of the top of the vertical arm of the original cross, and of a composition of an enthroned Virgin and Child. The Virgin sits on a backless throne on which are placed two cushions (red in front, blue-green behind), which in turn are covered by a piece of decorated material. The Child is in a sitting position, but appears as if suspended against the Virgin's breast, for her left hand rests on the shoulder but her right, with a handkerchief, is held below the Child's feet and seems more to be supporting a cushionlike bunch of material over her abdomen.

It is true that some features of this composition might seem to point to two phases of execution: the line running horizontally across the sleeve of the Virgin's right arm just above the cuff is to be seen in recent photographs (where a lighter area above changes into a darker area below). Pelekanides might have added to this observation the odd way that the Child seems to levitate without support from the Virgin's right hand, and that various anomalies of colour and drapery emerge when an attempt is to describe the Virgin's garments. Despite these infelicities, however, the notion of two separate phases of work is difficult to maintain if the following points are all taken into account:

1) there is no clear line of suture across the composition;
2) some modelling lines of tesserae seem to run consistently through the area of colour change in the sleeve;

47. Pelekanides (1973) characterized this as a change from a "Hodigitria' to a 'Platytera'.
48. It is difficult to judge from the two studies of Pelekanides exactly how sharp a break he understood.

3) a 'levitating' Child is not unparalleled (for example in the apse of the Koimesis Church at Nicaea);

4) the Virgin does wear a recognisable stola and maphorion. Irrational changes of colour within garments occurs in other works (for example, in the enthroned Virgin in the Egbert Psalter in the Museo Archeologico Nazionale at Cividale);

5) if the two phases require a separation in date of the two hands of the Virgin, this is stylistically unconvincing.

Two final points need particular emphasis as they can only finally be resolved with investigation from a scaffolding. The first is the claim by Xyngopoulos that there were traces of the feet of an earlier Child than the one now represented. No photographs or observation in the church seem to confirm his identification. I believe that this observation should be discounted as a basis for argument. The second point requires study of records and photographs made before 1941 (Pls. 19a-b, 22). In these, the proposed line of suture on the sleeve is not visible. It could be that before 1941 the accumulation of dirt concealed the surface here, but it seems more likely that the cleaning undertaken at that time revealed artificial discoloration, due, for example, to seepage of rainwater or to some chemical condition or to some other damage. Discoloration in turquoise was one kind of deterioration noticed in the apse of S. Sophia at Constantinople [49].

The notion of two phases within the figure of the Virgin and Child can therefore be rejected on several grounds, but it is necessary to take a more positive approach and to ask whether the composition can be seen as the product of one operation and what can be learnt about the mosaicist. The first question to ask is whether the stylistic treatment is consistent throughout. Several similarities of treatment are easily recognised in the Virgin and in the Child: the flesh of both is modelled in the same way, and the garments modelled by thin rows of tesserae (dark on the Virgin's garment, and red on the Child's gold garment); the base of the abdomen is portrayed in both through wedge - shaped hatching; in both the upper garment is characteristically bunched up beside the hip on the right side. In addition to such consistencies of style, the homogeneity of the composition can be supported on technical grounds, for one method of working is to be observed throughout this

49. C. M a n g o and E. J. W. H a w k i n s, The Apse Mosaics of St Sophia at Istanbul, DOP 19 (1965), 115 - 151.

phase[50]. This is the deliberate admixture of silver tesserae into areas of gold. The occurrences of this technique can be listed:

1) in the fill of the vertical arm of the cross, and so distinguishing this area from the original gold ground;

2) a few silver tesserae occur in the four rows of gold trim of the halo of the Virgin on the right sides. The silver cubes are in the two interior rows;

3) a few silver tesserae occur in the Child's garment over his left shoulder between the fingers of the Virgin's left Kand;

4) one silver tessera in the gold band on the Virgin's right shoulder;

3) there is a scattering of silver tesserae across the gold upper surface of the footstool.

This technique, whether used to brighten a surface subject to changing light conditions or for some other reason, distinguishes the Virgin and Child composition from other mosaics in the church, and adds support to the opinion that this phase is homogeneous[51]. If the work was the responsibility of one mosaicist, what is the explanation for the awkward design and for the infelicities of drapery?

It was never easy to design a composition within the deeply curving apse semidome[52]. On this occasion the designer had to operate with economy within a space cut from the pre-existing ground. It must have been harder to draw a seated rather than a standing figure: even in the apse at Constantinople this difficulty was felt, and the Virgin's right knee is too small compared with her left. Critics of the Thessaloniki figure complain of squatness and heaviness, with the head too large for the body. There is some truth in these adverse judgements, although some photographs tend to exaggerate such trends, and the mosaicist seems to have experienced difficulty in carrying out his commission.

50. These observation are made from floor level only and need confirmation.

51. The admixture of silver and gold tesserae has been recorded in Constantinople over a limited time only: in S. Eirene, in the apse, and in S. Sophia, in the apse, north Tympanum, Alexander panel, narthex lunette, and south-west vestibule lunette. But I have also observed the technique in eleventh and early twelfth century mosaics in Kiev (to be attributed to artists from Constantinople): e. g. in the apse of S. Sophia, and in the panel of S. Demetrios from the Church of S. Michael (now in the Tretiakov Gallery, Moscow).

52. It was equally a matter of some expertise to design a cross in an apse to be seen correctly from the floor of a church, cf. U n d e r w o o d, cited in note. 21. Grabar thinks this Virgin was a total failure.

The mosaicist who designed the Virgin and Child composition in the apse of S. Sophia at Constantinople had the problem of an exceptional high and difficult vault, but at least he was able to work on a surface stripped of pre-existing mosaics. It has been demonstrated that he made his design from a platform more or less level with the windows of the apse semidome, and that the proportions of the figures are seen correctly by an observer in this position[53]. Consideration of photographs of the apse at Thessaloniki help to understand the process of its design. In a photograph from the scaffolding at cornice level (Pl. 19a), the seat and footstool appear horizontal, and the posts of the throne vertical, but the halo on the contrary is distorted. From the floor (Pl. 22), photographs can be taken looking sharply upwards where the halo is correctly circular whereas the footstool sags in the middle and the posts come apart at the base.

An explanation can be proposed for this incongruity of design. Did the mosaicist operate not from a single viewing point but from two separate points? This explanation does not imply two periods of work, but suggests that the work was done in two stages, presumably the upper part of the composition first. If this was the case, then one would expect the artist after working on a higher platform, to lower this to complete the second stage of the design. This procedure might have resulted in a junction between the two levels, which would be a possible explanation also for the horizontal 'suture'.[54]

It has been argued in this paper that the apse mosaics of S. Sophia belong to two separate phases, and that the first can be dated by the objective evidence of the monograms. It is not likely that second figurative phase was a replacement for the cross soon after the Council of 787 and which has survived the second period of Iconoclasm[55], and neither is there good reason to suppose that the cross was replaced immediately after the triumph of Orthodoxy in 843 (the precise date for the restoration at Nicaea is not known, there was a delay until 867 before the

53. Discussion by Mango and Hawkins, cited in note 49.

54. Such a *pontate* might also be the explanation of the horizontal line across the legs of the apostles in the Church of S. Michael at Kiev, see V. N. L a z a r e v, Old Russian Murals and Mosaics, London, 1966, plates 52 - 53. However these mosaics were the victims of the attempt to sweep away Old Kiev in the 1930s and the line may have occurred in restoration after its removal to its present location in the gallery of S. Sophia at Kiev.

55. Pelekanides (1973) thought the first version of the enthroned Virgin belonged to the period after the Council of Nicaea and before 797.

apse mosaic of S. Sophia at Constantinople was restored, and the apse
cross in S. Eirene was never replaced with a figure). One might have
expected the post-iconoclastic redecoration of the cathedral of Thessa-
loniki to have been inaugurated with a new apse scheme, but neither
the 'logic' of the present programme (the incarnation in the apse and the
Ascension in the cupola) nor a stylistic comparison of the apse with the
cupola give any good grounds for attributing the apse to the ninth centu-
ry [56]. Stylistic comparisons with later monuments are more convincing.
 A major difficulty in dating the Virgin is that so many of stylistic
elements (shapes of the lips and such like) belong to a standard reperto-
ry of forms, particularly in provincial wallpaintings. Indeed the streaky
modelling of the flesh is reminiscent of brushwork, and this is just one
more indication that the artist or artists involved may only rarely have
worked in the medium of mosaic. To me, the closest parallel for the
style of the face of the Virgin is to be found in wallpaintings; these are
to be found no further distant than in the narthex of S. Sophia itself.
In the face of S. Theodora of Thessaloniki all the features of the treat-
ment of the Virgin in the apse are to be found (such as the highlights
along the nose, and the shape of the shadows below the eyes, lips, and
chin) [57]. The date of the narthex paintings of S. Sophia has been generally
accepted as eleventh century, and probably in the second quarter of the
century. The point of reference for the dating is the high quality painting
of the church of the Panagia Chalkeon of 1028, and the artist employed
here exhibits all the characteristics of one trained in the current trends
of Constantinople and may have been the man responsible for intro-
ducing these into Macedonia [58]. Both the apse mosaics and the narthex

 56. A. G r a b a r, L'Iconoclasme byzantin, Paris, 1957, esp. p. 195 and 256 makes
a case for a ninth century date on grounds of style and programme.
 57. The basic publication of the wallpaintings is P e l e k a n i d e s (1955); for
Theodora, see plate 83, fig. 1. The eleventh century date is accepted by D. M o u r i -
k i, The Portraits of Theodore Studites in Byzantine Art, JÖB 20 (1971), 249 - 280,
who attributes the figure to be identified as Theodore (not Eleutherios, as by Peleka-
nides) to approximately the same date as the mosaics of Nea Moni on Chios. The date
in the second quarter of the eleventh century is also accepted by B. L. V o c o t o -
p o u l o s, The Concealed Course Technique; further examples and a few remarks,
JÖB 28 (1979), 247 - 260. He is prepared to connect the programme of wallpainting
with a Middle Byzantine remodelling of the church in the masonry of which he obser-
ved the recessed brick technique.
 58. The use of the recessed brick technique here (easily visible since the earthquake
and recorded by V o c o t o p o u l o s, op. cit.) is one argument for a Constantinopo-
litan mason, while the origin of the artist in the capital is supported by the compari-

paintings of S. Sophia can also be closely compared with the wallpaintings in the church of S. Sophia at Ohrid which belong to the rebuilding datable to 1037 - 1056[59]. Further comparisons can be made between the drapery of the apse Virgin at Thessaloniki and the Annunciation Virgin at S. Sophia at Kiev and in the naos of the catholicon of Vatopedi.

Stylistic considerations have led to a dating of the second phase of the apse and also of the narthex paintings of S. Sophia to the second quarter of the eleventh century. Presumably both areas were redecorated as part of a major restoration of the cathedral (another question is whether work was also done in the cupola on this occasion). I would like to suggest that the same artist was responsible for both areas, and that his experience lay in painting; but he had no choice in the apse except to replace mosaic with mosaic. His commission included the portrayal of a cycle of monastic saints in the narthex, a particular ecclesiastical interest in this period, and the long-delayed removal of the cross from the apse. It is possible that this programme of work was forced on the archbishop from some recent damage to the church – the severe earthquake of November to January 1037/8 might fit the chronology[60] – but there is a good historical context for the overhaul of the cathedral in this period. With the ending of the Bulgarian threat to this region after the triumph of Basil II, Thessaloniki entered a period of prosperity and this was marked by an expansion of church building in the city and surrounding region[61]. The dating of both phases of the apse mosaics proposed in this paper suggests that in each case art is a visual document of the economic and spiritual revival of the city, stimulated by imperial conquests in Macedonia.

son with the Laura Skeuophylakion Lectionary made by P a p a d o p o u l o s (following the dating of this manuscript to the reign of Basil II, as argued by K. Weitzmann).

59. Cf. A. W. E p s t e i n, The Political Content of the Paintings of Saint Sophia at Ohrid, JÖB 29 (1980), 315 - 325. An association between the apse mosaic at Thessaloniki and the sanctuary paintings at Ohrid was also suggested by Papadopoulos.

60. For a list of earthquakes see V. G r u m e l, La Chronologie, Paris, 1958, p. 476ff.

61. One documented personality in this period of expansion is S. Photios of Thessaly who is said to have founded several monasteries, and to have encouraged the citizens with prayers at the time of the Bulgarian threat; see V. G r u m e l, Le fondateur et la date de fondation du monastère thessalonicien d'Acapniou, Échos d'Orient 30 (1931), 91 - 95. For a dating of H. Anargyroi at Kastoria to the first third of the eleventh century, and probably soon after the Chalkeon church, see A. W. E p s t e i n, Middle Byzantine Churches of Kastoria: Dates and Implications, Art Bulletin 62 (1980), 190 - 207.

There is one further conclusion to be considered. Xyngopoulos has been much criticised for exaggerating the importance of Thessaloniki as a creative provincial centre [62]. Rightly so. Yet a modified theory of local patronage and local availability of artists seems to me unavoidable. Even in the case of S. Sophia which we have been considering and where the contacts of its clergy with Constantinople ought to have been very close, the indication of the quality of its decoration, if this factor can be taken seriously, is that the artist of the cupola Ascension was brought from the capital, but that the Virgin in the apse is one of the very few post-iconoclastic mosaics which could be attributed to an artist based in a provincial city.

62. His classic statement was: A. X y n g o p o u l o s, Thessalonique et la pein-ture macédonienne, Athens, 1955.

BYZANTINE CAPPADOCIA:
THE ARCHAIC GROUP OF WALL-PAINTINGS

BYZANTINE monumental painting of the eighth, ninth, and tenth centuries has been subject to enormous losses.[1] The object of this paper is to examine the chronology of Cappadocian wall-paintings attributed to this period, and to estimate their value in a reconstruction of lost Constantinopolitan art.

Monasticism grew up early in Cappadocia. Here, the soft volcanic rock in several valleys was suitable for excavation into dwellings for communities or hermits, and there were adjacent patches of fertile soil. The settlements were undisturbed until severe Arab raids were made in the middle of the seventh century. It is possible that monastic life continued during the following two centuries: some of the cells can be effectively sealed from the inside with specially cut rock 'doors', perhaps made during this period. When Cappadocia was reoccupied by Byzantines in the course of the ninth century, it became a frontier region bordering on Armenia and the Muslim Empire. Monastic communities were soon reinstalled on a large scale, as evidenced by the rapid expansion of ecclesiastical organization at the beginning of the tenth century recorded in the *Notitiae Episcopatuum*.

The first systematic publication of the rock-cut churches of the regions of the Göreme valley and Soğanlı Dere was by G. de Jerphanion.[2] His volumes arranged the churches in a geographical rather than chronological order. As the books were produced de Jerphanion published a series of articles,[3] the first proposing, and the later ones justifying, his chronology. His defence was in reply to the criticisms of E. Weigand,[4] who rejected a Byzantine dating for any of the region, instead explaining the paintings as archaizing post-Byzantine works under Western influence. This total dismissal of the monuments was based on evidence from a selection of such iconographical minutiae as the cutlery and tableware in scenes of the Last Supper, which he described as inconceivable luxuries for remote Cappadocian monks in the Byzantine period. Considerable time was spent by his opponents in searching for evidence to counter this, and the method was finally shown to be inapplicable.[5] Such polemics had the effect of causing those who supported the Byzantine dating to accept de Jerphanion's chronological sequence without any detailed analysis of the individual monuments. An

[1] Major surviving works are: S. Sophia, Constantinople (mosaic); S. Sophia, Thessaloniki (mosaic); apse of the Rotunda, Thessaloniki (wall-painting). The Church of the Koimesis, Nicaea (mosaic) was destroyed in 1922, but was previously photographed.

[2] G. de Jerphanion, *Une nouvelle province de l'art byzantin. Les Églises rupestres de Cappadoce* (Paris, 1925–42). Afterwards cited as Jerphanion.

[3] G. de Jerphanion, 'La chronologie des peintures de Cappadoce', *Échos d'Orient*, XXX (1931), 5–27. Id., 'La date des plus récentes peintures de Toqale kilissé en Cappadoce', *Orientalia Christiana Periodica*, II (1936), 191–222. Id., 'Sur une question de méthode, à propos de la datation des peintures cappadociennes', *Orientalia Christiana Periodica*, III (1937), 141–60.

[4] E. Weigand in *Byzantinische Zeitschrift*, XXXV (1935), 131–5; and E. Weigand, 'Zur Datierung der kappadokischen Höhlenmalereien', *Byzantinische Zeitschrift*, XXXVI (1936), 337–47.

[5] M. Chatzidakis, 'A propos d'une nouvelle manière de dater les peintures de Cappadoce', *Byzantion*, XIV (1939), 95–113.

acceptance without modification of this chronology is still to be found in the most recent study of the paintings.[1]

Another factor which delayed the examination of individual monuments was the inaccessibility of the region to scholars during the 1930s and 1940s after the Greek and Turkish exchange of populations. Field-work was resumed in the 1950s, resulting in a series of new discoveries both in the region studied by de Jerphanion and elsewhere.[2] The present study is based on my visit to the Göreme valley in April 1965, and is limited to those decorations described by de Jerphanion as the Archaic Group on the basis of their iconography and style. He attributed this group to the second half of the ninth century or first half of the tenth century.

Since the wall-paintings were not necessarily applied to the surfaces immediately after cutting, dating the architecture can provide only a *terminus post quem* for the paintings. The only method of arriving at a precise dating is to examine the paintings themselves. The painted decoration with the earliest datable inscription known to de Jerphanion was Tavşanlı kilise.[3] The inscription in Tavşanlı kilise gives the information that the church was embellished in the time of Bishop Leo and the Emperor Constantine Porphyrogenitos, on 20 March. It is incomplete, due to erosion of the rock. Leo cannot be identified, but Constantine VII Porphyrogenitos reigned from 913 to 959. During his reign he was sole emperor for two periods only, and so a strict historical interpretation of the wording would limit the dating to within one of two periods:

(1) from 7 June 913 until 17 December 920;[4]
(2) from 28 January 945 until some date between 6 April 945 and Spring 948.

[1] N. Thierry, 'Églises rupestres de Cappadoce', *Corsi sull'arte ravennate e bizantine*, XII (1965), 579–602, and afterwards cited as N. Thierry (1965).
[2] The following publications supplement Jerphanion: F. Dirimtekin, 'Les monastères et les églises rupestres dans la région d'Inceğiz', *Türk. Arkeolog. Dergisi* (1957), 32 ff. M. S. Ipşiroglu et S. Eyuboğlu, *Sakli kilissé, une église rupestre en Cappadoce* (Istanbul, 1958) (Turkish and French). N. et M. Thierry, 'Église de Kizil-Tchoukour, chapelle iconoclaste, chapelle de Joachim et d'Anne', *Monuments et mémoires publ. par l'Académie des Inscriptions et Belles-Lettres, Fondation Piot*, L (1958), 105–46. J. Lafontaine, 'Note sur un voyage en Cappadoce (1959)', *Byzantion*, XXVIII (1958), 465–77, and afterwards cited as J. Lafontaine (1958). N. et M. Thierry, 'Voyage archéologique en Cappadoce', *Revue des Études byzantines*, XIX (1961), 419–37. J. Lafontaine, 'Sarica kilise en Cappadoce', *Cahiers Archéologiques*, XII (1962), 263–84, and afterwards cited as J. Lafontaine (1962). (Supplements H. Rott, *Kleinasiatische Denkmäler aus Pisidien, Pamphylien, Kappadokien und Lydien* (Leipzig, 1908), pp. 208–9.) P. Verzone, 'Gli monasteri di Acik Serai in Cappadocia', *Cahiers Archéologiques*, XIII (1962), 119–36. N. et M. Thierry, 'Une nouvelle église rupestre de Cappadoce: Cambazli kilissé à Ortahisar', *Journal des Savants* (1963), 5–23. N. Thierry et A. Tenenbaum, 'Le cénacle apostolique à Kokar kilisé et Ayvalı kilise en Cappadoce: missions des Apôtres, Pentecôte, Jugement Dernier', *Journal des Savants* (1963), 229–41, and afterwards cited as N. Thierry and A. Tenenbaum (1963). N. et M. Thierry, *Nouvelles Églises rupestres de Cappadoce: région de Hasan Daği* (Paris, 1963), and afterwards cited as N. et M. Thierry (Paris, 1963). J. Lafontaine–Dosogne, 'Nouvelles notes cappadociennes', *Byzantion*, XXXIII (1963), 121–84, and afterwards cited as J. Lafontaine–Dosogne (1963). M. Gough, 'The Monastery of Eski-Gümüs—a preliminary report', *Anatolian Studies*, XIV (1964), 147–61 (previously known from H. Grégoire, 'Rapport sur un voyage d'exploration dans le Pont et la Cappadoce', *Bulletin de Correspondance hellénique*, XXXIII (1909), 132–4. N. et M. Thierry, 'Haçli kilise, l'église à la croix en Cappadoce', *Journal des Savants* (1964), 241–54. Id., 'Ayvalı kilise ou pigeonnier de Gülli Dere', *Cahiers Archéologiques*, XV (1965), 97–154, and afterwards cited as N. et M. Thierry (1965). J. Lafontaine–Dosogne, 'L'église aux trois croix de Gülli Dere en Cappadoce', *Byzantion*, XXXV (1965), 175–207. N. Thierry, 'Quelques églises inédites en Cappadoce', *Journal des Savants* (1965), 625–35.
[3] Jerphanion, 2, 1, pp. 79–80.
[4] For 920 see R. P. Grumel, in *Échos d'Orient* (1936), 333–5. Jerphanion gives the incorrect date of 919 in 2, 1, p. 81 and the correct one in 2, 2, p. 390.

From the mention of 20 March, we would conclude that the decoration was painted either between 914 and 920 or between 945 and 948.[1]

A double funerary church, known to de Jerphanion as Gülli Dere chapel 4, has recently been examined and found to have datable inscriptions. It is now known as Ayvalı kilise.[2] The two inscriptions are fragmentary but the information may be extracted that the paintings date from the sole reign of Constantine Porphyrogenitos. This gives the same intervals as Tavşanlı kilise, so that although the two might be approximately contemporary, they could be separated in time by as much as thirty-four years. Since one of the inscriptions in Ayvalı kilise mentions November, then if the accession of Romanos II occurred as early as 6 April 945, the only relevant interval of the sole reign of Constantine would be the earlier one (913–20).

A third datable tenth-century church was known to de Jerphanion as the Large Pigeonhouse at Çavuş In.[3] This high barrel-vaulted church has in the prothesis representations of an imperial family. Inscriptions identify the figures as Nicephoros and Theophano (beside one unidentified figure) together with a Caesar and Curopalates. In addition, on the North wall to the left of the prothesis are two figures on horseback, one of whom is labelled as Melias.[4] There is a Melias (in Armenian Mleh) documented as an Armenian leader in the third quarter of the tenth century.[5] The Imperial group are undoubtedly members of the Cappadocian family of Phocas: Nicephorus Phocas who reigned from August 963 until December 969 had as wife Theophano, father Caesar Bardas, and brother Curopalates Leo. Nicephorus and his wife Theophano (with her children by her first husband Romanus II) were in this region in 964–5. Theophano was left in the castle of Drizion in July 964, while Nicephorus went on to winter in Cappadocia. In 965 the Curopalates Leo Phocas joined his brother for a campaign.[6] The decoration therefore certainly dates between 963 and 969. The presence of the Imperial family in the region in 964–5 is generally interpreted as giving a likely context for inception of the work, but this is not a very cogent argument.

These three are the only datable inscriptions in churches associated with the Archaic Group. We should consider, however, three other datable decorations, since judging by their iconography and style, the churches were decorated in the manner which succeeded that of the Archaic Group. The church of St. Barbara in the Soğanlı region has a mutilated inscription giving the date of completion as 5 May of the fourth indiction of the reign of Constantine and Basil. Of the year, only the initial letters

[1] J. Lafontaine–Dosogne (1963), 131, gives the dating as 'probably 913–919' and N. Thierry (1965), 582, gives '913–920'. This attribution to the earlier interval on grounds of the inscription alone is not sufficiently rigorous. If Leo was bishop during both intervals, then the first is more likely, for an inscription in the second in these circumstances would be ambiguous and so perhaps avoided.
[2] N. et M. Thierry (1965).
[3] Jerphanion, 1, 2, pp. 520–50 and supplemented by J. Lafontaine (1963), 128–9. At the time of de Jerphanion's visit, it was still in use for collecting guano as fertilizer.
[4] Jerphanion, 1, 2, pp. 529–30 and J. Lafontaine (1963), 129–30, consider the two Armenians to be the donors, but their assessment of the significance of orthography and spelling mistakes as indicating Armenian artists is uncertain.
[5] H. Grégoire, 'Notes Épigraphiques VII', Byzantion, VIII (1933), 79–88. See also references quoted on p. 26, n. 5.
[6] Cedrenus in Migne, Patrologia Graeca, CXXII, section 367.

for sixty-five remain.[1] This must refer to the joint reign of Constantine VIII and Basil II, and the only years which satisfy the data are *6514* and *6529*, that is 1006 and 1021. A second church in the Soğanlı region, Karabaş kilise, gives Emperor Constantine Doucas, fourteenth indiction, *6569*. The inscription therefore belongs between September 1060 and August 1061.[2] Thirdly, one church in the newly explored Peristrema valley, Direkli kilise, has fragmentary inscriptions mentioning Basil and Constantine. These, the same names as at St. Barbara, were co-emperors during 963, and from 976 to 1025.[3] Taking this evidence into consideration gives at the most a definite *terminus ante quem* of 1021 for this group.

There are no other inscriptions before the thirteenth century, but a little more information is given by the earliest *graffiti* scrawled over the paintings, which give a *terminus ante quem*. Ballık kilise at Soğanlı has a *graffito* of 1031,[4] Kızlar kilise at Göreme of 1055,[5] and the prothesis of St. Eustathios at Göreme of 1148–9.[6] These give additional epigraphical evidence of a middle Byzantine dating for Cappadocian paintings. We therefore have evidence for dating three churches to the tenth century, as well as material for characterizing succeeding works of the first half of the eleventh century.

Owing to the crude quality of the style of Tavşanlı kilise and an incomplete knowledge of Ayvalı kilise, it is difficult to approach the Archaic Group in the methodologically more desirable manner of first characterizing the dated works and then using them as a standard of comparison for others. One preliminary observation, however, can be made if we compare the Presentation in Ayvalı kilise[7] with the Flight to Egypt in Tavşanlı kilise[8] (Pl. IV, 3). The figures in Tavşanlı have drapery folds indicated schematically by broad simple lines, whereas Symeon at Ayvalı has fine hatching on his garments. Their faces too differ in treatment: Symeon's, though mask-like, is given contour by colour and the features are in their proper relationships. These two styles of decoration can be easily distinguished, and if we compare them with the miniatures of a datable manuscript from Constantinople, Paris gr. 510 of 879–83,[9] we see that Ayvalı comes far closer than the other to these illustrations, which are part of the hellenistic current of Byzantine art. In Göreme, some paintings in Tokalı kilise are very close in style to Ayvalı.

In Tokalı kilise, the present barrel-vaulted chamber leading into the innermost church was distinguished from the latter by de Jerphanion under the name of the Old Church. It contains scenes in a style which is almost identical with that of Ayvalı. Mary in the Holy Women at the Tomb at Tokalı matches Mary in the Presentation at Ayvalı, while Symeon compared with the foremost Magi in the Adoration has his long flowing hair and beard drawn in an identical manner. The enthroned Apostles at

[1] Jerphanion, 2, pp. 309–11.
[2] Jerphanion, 2, pp. 334–6. Further study is required here to determine the sequence of the layers of plaster.
[3] Direkli kilise or the Church with columns, number 15, was published by J. Lafontaine (1958), 473–5, J. Lafontaine (1963), 144–7, and N. and M. Thierry (Paris, 1963), 183–92.
[4] Jerphanion, 2, pp. 269–70. [5] Jerphanion, 1, 2, p. 490.
[6] Jerphanion, 1, 1, 167. Lafontaine (1963), 127–8, re-examined this church and dated the sanctuary area, including the prothesis, to the early twelfth century; she compared the style and palaeography of the Nave with Tavşanlı kilise, and suggested a close date for both.
[7] N. Thierry (1965), 582; fig. 1. [8] Jerphanion, pl. 152, fig. 2.
[9] S. der Nersessian, 'The Illustrations of the Homilies of St. Gregory of Nazianzus, Paris gr. 510', *Dumbarton Oaks Papers*, XVI (1962), 197–228.

Ayvalı[1] have the same conventional patches of lines for modelling the drapery over the thighs as do the apostles in the Transfiguration at Tokalı. The lettering too is close. We are led to conclude that the paintings of Tokalı Old Church must be near in date to those of Ayvalı and are very probably by the same workshop. (The Ayvalı paintings are uneven in quality and so belong to a workshop rather than a single hand.) As we saw above, the extreme limits for the dating of Ayvalı are 913 to 959.

We may therefore approach the study of Tokalı kilise with some confidence about the dating of the outer church of this complex, whose decoration I shall ascribe to a Tokalı Phase 1. When decorated, it consisted of a single-aisled, barrel-vaulted hall.[2] The east wall is almost entirely cut away now (Pl. III, 1), but the apse probably contained a Christ in Majesty, as do most churches of the Archaic Group, and the tympanum over the apse contained an Ascension, of which a few fragments are extant. On the opposite wall over the entrance is the Transfiguration (Pl. III, 2). Along the apex of the vault is a line of medallion busts of twelve prophets. Three registers of narrative friezes of a Christological cycle are painted on the vault north and south of the prophets. It begins, with the Annunciation, in the upper register on the right of the apse, and is read towards the west from this register to the upper one on the left of the apse, continuing clockwise and downwards. It terminates on the left of the apse in the bottom register with the Anastasis (Pl. III, 3). The north and south walls contain a series of standing saints.

In his analysis of the scenes, de Jerphanion came to the conclusion that Tokalı Phase 1 and the other decorations of the Archaic Group were the faithful continuation of an East Christian monastic style and of the iconography of the Syro-Palestinian region, and that this was a local school which remained uninfluenced by Middle Byzantine painting until the eleventh century. Recent work has dissolved his concept of a distinctive regional Syro-Palestinian style[3] or iconography[4] in the pre-iconoclastic period. A re-examination of the paintings is therefore necessary. It is more important to establish whether or not the paintings have a single source, than to discuss Syria as a possible source. In order to demonstrate the complexity of models known to the artists, it is necessary to analyse the iconography of the scenes at Tokalı in several ways.

(1) Some scenes do reproduce the iconography of pre-iconoclastic monuments. For example, in the Nativity (Pl. V, 1), the position of Mary and Joseph on either side of the manger resembles the Early Christian orm. In the motif of The Child's First Bath, Christ is upright, held by a midwife. However in the course of the tenth century such a treatment of the subject was modified to show Christ reclining in a relaxed fashion either in the basin or on a midwife's lap.[5] This motif had survived from Hellenistic times in imperial and Old Testament art, but the extant

[1] N. Thierry et A. Tenenbaum (1963), figs. 6–7.

[2] Jerphanion, i, p. 263, fig. 33, gives a reconstruction of the East End. Photographs of the church in plates 62–69.

[3] E. Kitzinger, 'Byzantine Art in the Period between Justinian and Iconoclasm', *Berichte zum XI. Byzantinisten Kongress* (München, 1958).

[4] A. Grabar, *Les Ampoules de Terre Sainte* (Paris, 1958).

[5] P. J. Nordhagen, 'The Origin of the Washing of the Child in the Nativity scene', *Byzantinische Zeitschrift*, LIV (1961), 333–7, and E. Kitzinger, 'The Hellenistic Heritage in Byzantine Art' *Dumbarton Oaks Papers*, XVII (1963), 97–115.

evidence points to its incorporation into the Nativity scene at the earliest in the sixth and more likely in the seventh century. We can therefore ascribe the model to a recension beginning at this time.

The scene of the Trial by Water at Tokalı (and Kılıçlar) may be linked with the version at Castelseprio,[1] for these versions have in common the fusion of the two phases of the story, as well as other details, such as the Virgin's hands being covered by the paenula. The dating of Castelseprio remains controversial,[2] but if a dating in the first half of the eighth century is accepted, then the Cappadocian paintings may be seen as continuing a pre-iconoclastic tradition presumably known in Constantinople. Another scheme which points to a continuation of a pre-iconoclastic formula is the apsidal composition of Christ in majesty or 'liturgical maiestas'.[3]

There is one case in the Archaic Group where a pre-iconoclastic source is indicated where a local monumental model seems involved. It occurs in the church of Holy Apostles at Sinassos, which contains a decoration which has been associated with Tokalı stylistically and on the basis of their use in common of the term 'Mother of Christ' for Mary instead of the usual 'Mother of God'.[4] In this church is painted a verse inscription which may be identified as a six-line verse written in the fourth century by Gregory Nazianzus.[5] This same verse appears in the collection of Christian epigrams in the *Anthologia Palatina* (book 1, number 92). It is accompanied by a lemma: 'Ἐν Καισαρείᾳ εἰς τὸν ναὸν τοῦ Ἁγίου Βασιλείου.[6] Our church reproduces, then, the verse written on the wall of an early Christian church of St. Basil in Caesarea, the capital city of this region.

(2) Some scenes cannot be explained as a continuation of a pre-iconoclastic tradition, but can only be regarded as having been influenced by contemporary Byzantine developments. For example the Crucifixion in Tokalı (supplemented by the similar but better preserved version in Kılıçlar (Pl. II, 2)) can be compared with the same scene in the Rabula Gospels, dated 586 (Florence Syriac. Plut. 1, 56, folio 13 recto). In the manuscript, Mary and John stand together on the left, whereas the normal Middle Byzantine symmetrical placing of the figures on each side of the cross is followed in the wall-paintings. In the manuscript, Christ is shown still living, with his eyes open, and wearing the long colobium. In the wall-paintings, he is naked except for a loincloth, and his eyes are closed in death (Kılıçlar). But the portrayal of Christ as dead is a post-iconoclastic invention,[7] being part of Orthodox propaganda in the second half of the ninth century. The old and new versions occur side by side in different

[1] See K. Weitzmann, *The Fresco Cycle of S. Maria di Castelseprio* (Princeton, 1960), especially pp. 48–50.
[2] For a bibliography see E. Kitzinger, 'Byzantine Art in the Period between Justinian and Iconoclasm', *Berichte zum XI. Byzantinisten Kongress* (München, 1958).
[3] This apsidal formula is discussed with examples by C. Ihm, *Die Programme der christlichen Apsismalerei vom vierten Jahrhundert bis zur Mitte des achten Jahrhunderts* (Wiesbaden, 1960), especially pp. 42–51.
[4] Jerphanion, 2, pp. 59–77 describes the church cursorily, since the blackened paintings prevented photography. N. Thierry (1965), 584, and N. et M. Thierry (1965), 106, reiterate the Tokalı association. A photograph from this church appears as figure 8 of the latter publication.
[5] Text in Migne, *Patrologia Graeca*, XXXVII, cols. 306–7. The identification is due to H. Grégoire in *Revue de l'Instruction publique en Belgique*, LII (1909), 165.
[6] The apparatus in the Teubner edition (1894), p. 24, adds the scholia, 'ἤγουν εἰς τὴν μεγάλην ἐκκλησίαν'.
[7] J. R. Martin, 'The Dead Christ on the Cross in Byzantine Art', *Late Classical and Medieval Studies in honor of A. M. Friend* (Princeton, 1955), 189–96.

miniatures in the Chludov Psalter of the ninth century.[1] The Crucifixion in the datable manuscript Paris gr. 510 (folio 30 verso[2]) shows the living Christ wearing the colobium, but the paint has flaked off to reveal a preliminary version with Christ dressed in a loincloth and perhaps shown dead (Pl. IV, 1). This version was apparently considered unsuitable for its Imperial patron in 879–83. The earliest known monumental version of the new iconography was a mosaic in Holy Apostles in Constantinople, if this was done as part of the programme under Basil I (867–86); the new form is described explicitly by Constantine the Rhodian in his ekphrasis composed between 931 and 944.[3] The appearance of this controversial new iconography in Cappadocia indicates direct knowledge of the Constantinopolitan development.[4]

The Crucifixion in Tokalı is followed by the Deposition (Pl. III, 3). Joseph is seen supporting Christ's dead body, while Nicodemus removes the nails from Christ's feet with a pair of tongs. The Virgin clasps Christ's drooping arms. Such an active role played by the Virgin is absent from the Passion sequence of Paris gr. 510 (folio 30 verso) (Pl. IV, 1), and on the evidence of surviving works it has been argued that her presence and active emotional role in this scene were tenth-century Byzantine innovations.[5]

The Ascension was painted on the east wall above the apse (Pl. III, 1). Such a prominent placing of this scene is a feature of the Archaic Group, and in Kılıçlar, El Nazar, and the cruciform church at Mavruçan it is actually put in a central cupola. This emphatic position contrasts with a typical Middle Byzantine programme such as that of Nea Moni on Chios where the scene is placed on the wall of the narthex. However, this prominence is equally missing from pre-iconoclastic monuments. The form of this scene is that of a dogmatic theophany, and the source for its prominence may be found in the immediately post-iconoclastic monuments of Constantinople. Here the cupola of the church of the Theotokos τῆς Πηγῆς,[6]

[1] The precise dating within the ninth century of the Chludov and related marginal Psalters (Athos, Pantocrator 61 and Paris gr. 20) remains controversial. K. Weitzmann, *Die byzantinische Buchmalerei des 9. und 10. Jahrhunderts* (Berlin, 1935), pp. 53–57, dated them to around 900 on stylistic grounds. A. Grabar, *L'Iconoclasme byzantin* (Paris, 1957), especially pp. 196–7, dated them on the grounds of their programme to the first Patriarchate of Photios (858–67). A. Frolow, 'La fin de la querelle iconoclaste et la date des plus anciens psautiers grecs à illustration marginale', *Revue de l'histoire des religions*, LXIII (1963), 201–23, dated them within the second period of iconoclasm. This must be reckoned a failure, since he ignores the emphasis on the triumph of the iconodules, which is only feasible after 843. I. Ševčenko, 'The Anti-iconoclastic Poem in the Pantocrator Psalter', *Cahiers Archéologiques*, XV (1965), 39–60, postulates a 'Psalter Prototype' composed under Methodios (843–7) from which he derives the group of marginal psalters; but, while this dating might apply to the existing ninth-century psalters, the 'Psalter Prototype' is a superfluous hypothesis. A. Grabar 'Quelques notes sur les psautiers illustrés byzantins du IX siècle', *Cahiers Archéologiques*, XV (1965), 61–82, reaffirms his dating to 858–67.
[2] Omont, *Miniatures des plus anciens Manuscrits grecs* (Paris, 1929), pl. XXI.
[3] Text in E. Legrand, 'Description des œuvres d'art et de l'église des Saints-Apôtres de Constantinople, poème en vers iambiques par Constantin le Rhodien', *Revue des Études grécques*, IX (1896), vv. 929 and 934. For date of composition see G. Downey, 'Constantine the Rhodian: his Life and Writings', *Essays in honor of A. M. Friend* (1955), 212–21.
[4] The new form appears in the paintings of the Church of the Holy Cross at Aght'amar (915–21): see monograph by S. der Nersessian (Harvard, 1965). Christ, however, still wears the colobium.
[5] K. Weitzmann, 'The origin of the Threnos', *Essays in honor of E. Panofsky* (1961), 476–90.
[6] Described in epigram 110 of Bk. I of *Anthologia Palatina*. Mention of Basil and Constantine dates to 869–79. This church was the site of an Imperial ceremony on Ascension Day during reign of Leo VI (*Life of Euthymios*, p. 24, in edition of P. Karlin-Hayter, *Byzantion*, XXV-XXVII (1955–7), and Constantine Porphyrogenitos (*De Caerimoniis*, ch. 27 (18), ed. A. Vogt (1935)).

VI

and probably the central cupola of Holy Apostles[1] were each decorated with an Ascension in mosaic during the reign of Basil I. The only two late ninth-century decorations from Salonica likewise give prominence to the Ascension (cupola of S. Sophia and apse of the Rotunda). Theophanies assumed particular importance after 843 both in manuscripts[2] (Paris, gr. 510 and Paris gr. 923) and in monumental art[3] (the programme of S. Sophia, Constantinople, included several in the gallery mosaics). A similar Constantinopolitan influence may be adduced for the prominence given likewise to the Transfiguration, which is on the west wall over the entrance (Pl. III, 2); this direct vision of God reflects Orthodox propaganda of the second half of the ninth century. The same reasoning may account for the retention in apses of the pre-iconoclastic composition of Christ in Majesty.

(3) A third influence is that of Armenia. The clearest iconographical example comes from Ayvalı, closely associated with Tokalı. In the unusual scene here of enthroned Apostles, one of the twelve is labelled Thaddeus. His inclusion suggests an Armenian tradition, and this is confirmed by the fact that he holds in his hand an inscription giving the region of his evangelization as Gabadonia.[4] There are some churches around Ihlara in the Peristrema valley, which N. and M. Thierry include in the Archaic Group, which have so many Armenian elements that it would seem more likely that they are the work of a later Armenian colony, influenced by the Archaic Group.[5]

(4) Another source of influence seems to be that of contemporary Muslim art, both in the form of iconographical details like dress and in style (some of the prophets in medallions in Tokalı show this) (Pl. III, 3). It can therefore be concluded that the decoration of Tokalı is not derived from one type of model only. It is a complex creation, dependent on artistic, theological, historical, and geographical influences. Both metropolitan and local elements are combined in the formation of the decoration, and so to refer to it as belonging to a 'Cappadocian School' is misleading, although its appearance does depend partly on its geographical location. Secondly, this analysis of iconography confirms a dating in the first half of the tenth century suggested by the stylistic affinity of Tokalı to Ayvalı kilise. The establishment of this dating is of particular importance in Tokalı, and interesting implications follow an examination of the whole complex. The east wall of Phase I was cut away in order to excavate further in the rock the high transverse church, known by de Jerphanion as the New Church[6] (Pl. III, 1). This work destroyed the apse of the first church, leaving only fragments of the Ascension in the tympanum. Since these fragments are homogeneous with the rest of Phase I, it follows that the

[1] This depends on the interpretation of the rhetorical description by Constantine the Rhodian (vv. 737–41) as well as the controversial attribution of this decoration to Basil I.
[2] A. Grabar, L'Iconoclasme byzantin (Paris, 1957), pp. 241 ff.
[3] C. Mango, Materials for the study of the Mosaics of S. Sophia at Istanbul (Washington, 1962), p. 98, and afterwards cited as C. Mango (1962).
[4] N. Thierry and A. Tenenbaum (1963).
[5] See J. Lafontaine–Dosogne in review of N. and M. Thierry (Paris, 1963) in Speculum (1965), 555–7. The whole problem of Armenian artistic influence requires study; the extent of infiltration into this region is indicated by P. Charanis, 'The Armenians in the Byzantine Empire', Byzantinoslavica, XXII (1962), 196–240.
[6] For the east wall of Phase I, see Jerphanion plates 62 and 68. A plan and section of the whole complex is given by L. Budde and V. Schamoni in Göreme, Höhlenkirchen in Kappadokien (Düsseldorf, 1958), Abb. 6–7.

cutting of the inner transverse church was done later than the Phase 1 decoration, later, that is, than the first half of the tenth century, giving us a *terminus post quem* for any decoration in it.

The present condition of the paintings in the transverse church reveals two periods of decoration. A partly covered and hence earlier layer of painting consists of painted borders, crosses, and other aniconic forms decorating the rock surface which is carved with simple shapes—niches and a large cross are visible. I shall refer to this as Tokalı Phase 2. A layer of plaster was superimposed on the aniconic scheme, and the fresco on this I shall refer to as Tokalı Phase 3. This forms a vast figurative cycle of some quality, perhaps the highest in the Göreme valley. Many scholars have noticed the superimposition of a figurative over an aniconic layer in this church, and it has been widely assumed that this was painted during the Iconoclastic period (726–843). Aniconic decorations in other Cappadocian churches are likewise dated to this period.[1] However, the establishing of a *terminus post quem* for Phase 2 rules out the possibility of an Iconoclastic dating for this decoration. It follows conversely that an aniconic programme is not in itself any indication of Iconoclastic date. An explanation for the large number of aniconic decorations in Cappadocian churches, some covered by later figurative layers and other remaining exposed, must therefore be sought elsewhere. In any case to account for the existence of numerous monastic iconoclastic communities would be difficult.[2] No adequate explanation for these decorations can yet be offered. Perhaps these were apotropaic symbols put up by those who excavated the rock, like the still surviving practise in some European countries of fixing a cross or tree to buildings under construction. Alternatively it may be necessary to look for some Muslim or Jewish influence.[3] More simply these decorations may indicate a lack of trained figurative painters and were only intended as a temporary covering for the walls until a suitable painter became available. There are examples of even simple pattern decoration being very incompetently carried out, and others where crude childishly painted trees or animals are included in a largely abstract decoration scheme.

If the aniconic Phase 2 is not iconoclastic, a re-examination of the evidence about Iconoclastic programmes is indicated. There is some literary evidence enabling a reconstruction of the appearance of Iconoclastic churches to be made.[4] According to the Life of St. Stephen the Younger, Constantine V destroyed images of Christ and the Virgin but preserved images of trees, birds, and animals and also of hunting, theatre, and hippodrome scenes. In particular he suppressed a cycle of Gospel scenes in the

[1] R. Krautheimer, *Early Christian and Byzantine Architecture* (London, 1965), p. 281, puts a representative opinion of an Iconoclastic dating for Tokalı and other churches. This treatment of 'quincunx' caves is in any case too summary on architectural grounds, since a chronology may be traced by considering treatment of supports, drum of cupola, and vaults, see J. Lafontaine (1962).

[2] Some Iconoclastic monks are, however, recorded in Asia Minor. See F. Dvornik, *La Vie de saint Grégoire le Décapolite* (Paris, 1926), and F. Dvornik (*Les Légendes de Constantin et Méthode vues de Byzance* (Prague, 1933), especially pp. 119–21.

[3] See A. Grabar, *L'Iconoclasme byzantin* (Paris, 1957), pp. 98–99 and 174–80. Another opinion is that of D. Wood, 'Byzantine Military Standards in a Cappadocian Church', *Archaeology* (Spring, 1959), 38–46. She believes that several motives in the Church of S. Barbara at Göreme represent army standards in use in the eleventh and twelfth centuries.

[4] A. Grabar, *L'Iconoclasme byzantin* (Paris, 1957), pp. 143–5; certain ambiguities and omissions in this collection are noted by J. Gouillard in *Revue des Études byzantines*, XVI (1958), 261–5.

Blachernae Church and substituted trees, birds (cranes, crows, and pea-cocks), and animals in ivy rinceaux.[1] The Iconoclasts did especially favour representations of the cross, and went so far as falsifying texts of the Fathers in order to justify this. Thus the famous letter of St. Nilus to Olympiodorus was altered to read as advice to put a large cross in the sanctuary but to whitewash the rest of the church.[2] Programmes in churches of the eighth century must have resembled those of the fourth century under Constantine the Great. The second period of Iconoclasm reaffirmed this emphasis on the cross, and so Leo V, for example, replaced the image set up by Irene on the Chalke Gate by a plain cross.[3] The attitude of these ninth-century Iconoclasts is shown in the letter of Michael II to Louis the Pious, which refers to the restorations in the Iconodule period of 787–813: *honorificas et vivificas cruces de sacris templis expellebant et in eadem loca imagines statuebant.*[4] Visual evidence of Iconoclastic decorations still remains from a few datable mosaics. A large cross on a gold ground is still to be seen in the conch of the apse of S. Irene in Constantinople. This area was rebuilt after an earthquake in 740, which gives a *terminus post quem* for the decoration.[5] Iconoclastic crosses are known in the room over the south-west ramp in S. Sophia in Constantinople, where they are inserted into medallions to replace an earlier series of portraits of saints.[6] At the church of the Koimesis in Nicaea, the Iconoclasts substituted a single cross in the conch of the apse for a previous standing Virgin. This was later removed, and another standing Virgin inserted, but the outline of the cross can still be seen on the gold ground.[7] The first mosaic decoration of the sanctuary of S. Sophia in Salonica, datable from monograms to between 780 and 797, was also Iconoclastic in type. A large cross on a gold ground was placed in the conch of the apse, and at the apex of the barrel vault over the bema was a second cross within a medallion; the lower part of the vault on the north and south was ornamented with a decoration with many crosses alternating with vine leaves within a jewelled framework of squares.

On the basis of this evidence, various decorations have been attributed to the Iconoclastic period, and since these churches occur over a wide area, an acceptance of this dating would have important historical implications on the geographical extent of Iconoclastic support. A decoration excavated in Salonica[8] was dated in the first half of the ninth century, since the fragments of wall-painting in the church on the walls of the nave and niche of south parecclesion portrayed crosses and ornamental motives.

[1] Migne, *Patrologia Graeca*, 100, col. 1112D–113A and 1120.
[2] G. Millet, 'Les iconoclastes et la croix', *Bulletin de Correspondance hellénique*, XXXIV (1910), 96–109.
[3] C. Mango, *The Brazen House* (Copenhagen, 1959), p. 122.
[4] J. D. Mansi, *Sacrorum Conciliorum nova et amplissima collectio*, XIV (Venice, 1769), 420B.
[5] Structural analysis of the church due to W. S. George, *The Church of St. Eirene at Constantinople* (London, 1912). The incorrect date for the earthquake of 732 given by Grabar in *L'Iconoclasme byzantin*, p. 153, and other scholars, follows the transcription of Theophanes in Migne, *Patrologia Graeca*, 108, cols. 831–2, where it is not realized that 6232 is in Alexandrian chronology. The correct date of 740 may be restored from the information that it occurred on 26 October of the ninth indiction. Since Leo III died only a few months later and ordered an extensive rebuilding of the city walls, it is unlikely that the rebuilding of S. Irene was due to him.
[6] C. Mango (1962), p. 45.
[7] P. Underwood, 'Evidence of Restorations in the Sanctuary Mosaics of the Church of the Dormition of Nicaea', *Dumbarton Oaks Papers*, XIII (1959), 235–42.
[8] D. Evangelides, 'Εἰκονομαχικὰ μνημεῖα ἐν Θεσσαλονίκῃ', Ἀρχαιολογικὴ Ἐφημερίς, 100 (1937), 341–51. A complete publication of this excavation never appeared.

Similar aniconic decorations have been dated to the same period in the ninth century, four on Naxos[1] and one in Mani.[2] At the other end of the Empire, the first layer of the 'Geyikli' church in the Pontus has been attributed for the same reason to Iconoclasm.[3] A predominance of the cross has also led to Iconoclastic attributions in Anatolia, for example the rock-cut church of Al Oda in Isauria[4] and two churches in Cappadocia which have inscriptions defining the cross as 'protector' of the church.[5] De Jerphanion attributed the churches of St. Basil at Eleura and St. Stephen near Cemil to the Iconoclastic period, since both emphasized the cross, but since some figures of saints seemed to belong to the same phase he was led to argue the unsatisfactory explanation of a compromise between Icono-clastic and local Iconodule monks.[6] In fact an Iconoclastic dating for some of these decorations does remain possible, but the significance of our dating of Tokalı Phase 2 lies in a modification being needed of the criterion that an aniconic decoration giving prominence to the cross is a sufficient condition for attribution to the Iconoclastic period. De Jerphanion him-self felt that not all aniconic decorations in Cappadocia could be Icono-clastic, since they appeared on architectural forms which he dated later than the tenth century. In any case, the large numbers of such decorations which are encountered in the region hardly all belong to a period when historical and economic conditions must have reduced artistic potential in Cappadocia. Aniconic decorations are already known in the pre-icono-clastic period in the east of the Byzantine Empire; in Syria, an apse in an annexe of the Cathedral of Rusafa-Sergiopolis is painted with a cross within a rinceau, and, as it happens, none of the Early Christian churches studied by Lassus contained any figurative cycles.[7] After Iconoclasm, a group of manuscripts of the tenth and eleventh centuries containing only non-figurative illustrations have been attributed to Cappadocia.[8] Any Iconoclastic attribution must therefore be approached with great caution, and a prominence given to crosses cannot be regarded as a sufficient condition. An analysis of ornamental motives in monumental painting is needed to supplement the evidence.

So far only a *terminus post quem* has been suggested for Phase 2; an examination of the later Phase 3 seems to give a *terminus ante quem* for both layers as well as, it will be suggested, for the Archaic Group. De Jerphanion suggested that the church at Çavuş In (datable 963–9) copied the decora-

[1] A. Vasilaki, 'Εἰκονομαχικὲς 'Εκκλησίες στὴ Νάξο', Δελτίον τῆς Χριστιανικῆς Ἀρχαιολογικῆς 'Εταιρείας, Series 4, no. 3 (1964), 49–74.
[2] N. B. Drandakes, Βυζαντιναὶ τοιχογραφίαι τῆς Μέσα Μάνης (Athens, 1964), pp. 1–15.
[3] D. Winfield and J. Wainwright, 'Some Byzantine Churches from the Pontus', *Anatolian Studies*, XII (1962), 131–61.
[4] M. Gough, 'A church of the Iconoclast (?) period in Byzantine Isauria', *Anatolian Studies*, VII (1957), 153–61.
[5] G. Millet, 'Les iconoclastes et la croix', *Bulletin de Correspondance hellénique*, XXXIV (1910), 96–109.
[6] Jerphanion, 2, pp. 105–11 and 146–55.
[7] J. Lassus, *Sanctuaires chrétiens de Syrie* (Paris, 1947), pp. 299–302. The existence of figurative mosaics at Gaza (described by Choricius of Gaza) may indicate a dichotomy between urban and rural decorations in the region. Further pre-iconoclastic aniconic programmes are listed in A. Gra-bar, *Martyrium* (Paris, 1946), vol. II, pp. 275–90, and C. Ihm, *Die Programme der christlichen Apsis-malerei* (Wiesbaden, 1960), pp. 76–94. To these should be added an example at Sinai published by G. A. Soteriou, Τοιχογραφίαι τῆς σκηνῆς τοῦ Μαρτυρίου εἰς Παρεκκλήσια τοῦ τείχους τῆς Μονῆς Σινᾶ, *Studi Bizantini*, IX (1957), 389–91.
[8] K. Weitzmann, *Die byzantinische Buchmalerei* (Berlin, 1935), pp. 65 ff. and pls. 71 ff.

tion of Tokalı Phase 3,[1] and, while this suggestion has recently been criticized as superficial,[2] the possibility requires further discussion. One affinity between the two decorations is the naming and distribution in various places of the Forty Martyrs—elsewhere they are grouped together with or without names. The most significant parallel is their treatment of the Ascension with the Benediction of the Apostles. In Tokalı, these two scenes are painted over the central bay of the triple-bayed transverse barrel vault over the church. The Ascension is prominently placed on the east side of the vault, and so is immediately visible on entering the church through the sole opening in the west wall below this bay. Owing to the lack of space within this bay, which is defined by arches projecting slightly from the ceiling, only eight apostles are portrayed on the east side. The remaining four are displaced to the west side of the vault in two pairs on either side of the Benediction (Pl. IV, 1). The composition of the latter scene is close to two works which seem based on Constantino-politan models: an ivory of the second half of the tenth century (Paris: Molinier 34)[3] and a miniature in the Lectionary Leningrad 21.[4] Tokalı differs from these two examples in two features: the hands of the apostles are not draped (except for the left hand of the front figure on the right), and secondly in having a tree on each side of Christ, between him and the group of apostles.[5] This cannot be explained by the text (Matt. xxviii. 16–20), and must surely be regarded as a formal intrusion from the adjoining Ascension scene, in the portrayal of which Byzantine artists commonly use trees between the figures to give a vertical emphasis.

The same combination of the Ascension and Benediction of Apostles is found at Çavuş In[6] (Pl. VI, 1). The Virgin and group of eight apostles are placed on the north side of the east–west barrel vault immediately in front of the apse, and the Benediction and remaining four apostles on the south side. In order that the figure of Christ may be orientated towards the en-trance at the west, his mandorla is revolved to fit the east–west axis, but with a consequent weakening of the normal vertical emphasis from Virgin to Christ. Since at Çavuş In, unlike Tokalı, the vault is not articulated into bays by ribs, the reason for displacing four of the apostles over into the Benediction scene cannot be due to lack of space. There are other indica-tions too that the Tokalı composition was followed here: a tree is again introduced into the Benediction, but only one asymmetrical tree with even more schematized foliage. The hands of the apostles on the right are shown against the front surface of the tree, which emphasizes another affinity with the Tokalı version, bare and undraped hands. The upper-most apostle in each rank is drawn back slightly out of file, so that the grouping is one further remove from Tokalı and the Constantinopolitan iconography. This scene, then, at Çavuş In does seem to be related to Tokalı kilise, and the Çavuş In version must be regarded as the filiation. In other scenes at Çavuş In there is little suggestion of iconographic

[1] Jerphanion, 1, 2, pp. 544–8. [2] J. Lafontaine–Dosogne (1963), p. 130.
[3] A. Goldschmidt and K. Weitzmann, *Die byzantinischen Elfenbeinskulpturen*, vol. II (1934), cat. no. 100. Also illustrated in the Catalogue of the exhibition, *Byzantine Art: a European Art* (Athens, 1964), no. 87.
[4] C. R. Morey, 'Notes on East Christian Miniatures', *Art Bulletin*, XI (1929), fig. 71.
[5] Jerphanion, pl. 80. In the ivory, the two front apostles, Peter and Paul, have their hands bare, while the rest are draped. All have their hands draped in the manuscript.
[6] Jerphanion, pl. 140.

influence from Tokalı, except that in the Adoration of the Magi a half-length angel introduces the Magi to Mary; this is the common Constanti-nopolitan form and is found at Tokalı, whereas it is absent from the Archaic Group. The two programmes are also linked in their extension of the Crucifixion cycle. Çavuş In therefore reproduces only the most obvious innovations of one of its models, Tokalı, and for the most part continues the tradition of the Archaic Group. For example, the Transfiguration on the tympanum over the east apse is close to the version of Tokalı Phase 1 (Pl. III, 2; Pl. VI, 1). However, the style of Çavuş In shows a marked change from that of the Archaic Group by portraying elegant elongated figures and complicated drapery. In detail, though, over-elongated fingers, ill-drawn feet and the crudely organized structure of the body and illogical drapery reveal that the artists have only a very superficial ability to re-produce a new style. This phenomenon could be explained by regarding Tokalı Phase 3 as a new intrusion into the Göreme valley, and Çavuş In as an early but superficial response to this stimulus by artists who have learnt to work in a manner closer to Tokalı Phase 1. In this case Tokalı Phase 3 is to be dated shortly prior to Çavuş In (963–9). This may imply that Phase 2 was a very temporary decoration. Further, if Ayvalı kilise and Tokalı Phase 1 are roughly contemporary, then this adds a little more weight in favour of the earlier interval for Ayvalı (913–20 rather than 945–8).

The importance of the dating of Phase 3 requires a further analysis of its style. The difficulties here are the uncleaned state of the paintings coupled with the problems of dating, or locating the place of origin of works of the tenth century. Despite the high quality of this wall-painting compared with others in the Göreme valley, it is far from the best-known current of tenth-century art, that of aristocratic circles in Constantinople. One oddity of iconography certainly looks like the work of a provincial artist: in the Nativity, the ray of light from the star shines on the child being washed by the midwives, and not, as it should, on Christ in the manger. Nor is the Child in the bath yet portrayed in the new Constantinopolitan reclining position. Nevertheless, we can begin only by setting Tokalı against the documented current of development in Constantinople, that from Paris gr. 510 (879–83) through Paris gr. 139 (mid-tenth century).[1]

The stylistic differences between these two manuscripts may be seen by comparing their versions of the *Anointing of David by Samuel* (Paris gr. 510, folio 174 verso and Paris gr. 139, folio 3 verso). If we set against these the Presentation in Tokalı Phase 3 (this being well preserved and not dissimilar in composition) (Pl. VI, 3), more affinities are to be seen with the earlier than the later miniature. The figures of Tokalı and Paris gr. 510 have clearly defined outlines so that the figures stand out boldly in a row from the background, almost like silhouettes. The drapery of Paris gr. 510 is more florid and complex, being broken up into more sections and layers, but despite a subtle play of light and shade, the figures remain, as at Tokalı, flat and two-dimensional; the painters of both works treat gar-ments as a flat curtain on which to embroider geometrical patterns with-out defining any solid body beneath. This is unlike the far more plastic treatment of Paris gr. 139. The same attitude towards drapery as at Tokalı

[1] For the dating see H. Buchthal, *The Paris Psalter* (London, 1938).

is to be seen also in the Vatican gr. 699, another manuscript from Con-
stantinople; for example, in the Conversion of Paul (folio 34 verso), the
central figure of Paul has the same broad outline of the body as the male
figures in the Tokalı Presentation, the whole being bound together by
the sweep of garment outline rather than by any plastic organization of
parts of the body.

Another version of the Anointing of David may be considered, that in
Vatican Reginensis I,[1] which appears to be a version from slightly earlier
in the tenth century of the same model used by Paris gr. 139. The Reginen-
sis composition is built up by setting an asymmetrical group of figures
against a complex balanced background of architectural features, and this
device achieves some impression of movement towards the action on the
right. Action is also shown at Tokalı (Mary putting the child into Symeon's
arms), but the sweeping and clear-cut outlines of the row of figures
symmetrically disposed on either side of Christ, who is in front of the
obliquely seen ciborium, results in a static composition. A similar con-
trast may be noticed within the treatment of figures. Those at Tokalı appear
stationary, and a flat conventional treatment of broad planes of drapery
conceals the bodily form beneath. In the Reginensis, the figures show some
movement, and the bulky folds of drapery at least hint at the forms beneath,
even if the plastic stage of Paris gr. 139 has not yet been reached. However,
some of the differences between Tokalı and Reginensis seem partly qualita-
tive rather than stylistic, and Tokalı is closer to it in some ways than to
Paris gr. 510. For example, the use of architecture to bind the figure
composition together is an advance on the frieze treatment of Paris gr.
510. The overlapping of Symeon and Anna to form some depth of composi-
tion is closer to the Reginensis stage. The drapery of Tokalı, though
schematic and geometricized, is more bulky and less artificially built up in
contrasts of dark and shade than Paris gr. 510. The broad brushwork and
treatment of faces recall Reginensis. This suggestion of a later stylistic stage
than Paris gr. 510 may be strengthened by the similarities of posture and
drapery between Tokalı and the seated figures in Marciana cod gr. 538 on
folio 27 verso. This manuscript is unlocated but is dated 904–5.

Another gauge of tenth-century style is available in the form of ivories.
The closest parallels for the narrowly pleated drapery of Tokalı are to be
found in the Berlin *Entry into Jerusalem* and Munich *Dormition of the Virgin*.
These ivories are dated by Goldschmidt and Weitzmann[2] to the tenth
century, and their style explained as under the influence of painted models.
This implies the existence in Constantinople of models for the style of
Tokalı.

The style of Tokalı Phase 3 suggests knowledge of metropolitan painting
but only up to the first half of the tenth century. It has not imitated the
progressive developments of Paris gr. 139 or Stauroniketa 43. All the
same the radical change in style from the Archaic Group together with
the high quality suggest a direct contact of the artists with a metropolitan
workshop, perhaps in Constantinople itself. An interesting case is known

[1] H. Buchthal, *The Paris Psalter* (London, 1938), pp. 18–21. The dating and precise context in
Constantinopolitan art remain uncertain.
[2] A. Goldschmidt and K. Weitzmann, *Die byzantinischen Elfenbeinskulpturen*, vol. II (1934),
cat. nos. 1 and 3.

from the eleventh century, from the Armenian Gospels of 1066 (Etchmiad-zin 369/311). This manuscript was illustrated at Sebastia in Cappadocia, by the priest Grigor, whose family emigrated from Armenia. The style is byzantinizing but we do not know for certain if the artist went to Constantinople; but both his father and his workshop master went there, for the latter was asked to bring back a box (binding?) for the manuscript.[1] Certainly in Tokalı the placing of Saints in a row across the tympana is reminiscent of S. Sophia itself,[2] and one odd feature of the programme may connect Tokalı with Constantinople, namely the portrayal of a Crucifixion cycle in the central apse. A single standing figure of St. Basil was placed in the middle of this, below the conch and behind the altar. His prominence here coupled with the portrayal of a cycle of his life in the naos strongly suggests that this church was dedicated to this local saint. In the first half of the tenth century in Constantinople the relic of the True Cross was displayed at the beginning of January in the chapel of St. Basil in the palace.[3] Perhaps the apse of Tokalı reflects the Constantinopolitan association of festivals.[4]

With this chronological information concerning the three phases of Tokalı kilise, we are in a position to reconsider the Archaic Group. Phase I demonstrated that an analysis of iconography requires the evaluation of influences of several different kinds. Taking another church of the Group, the same procedure can usefully be followed. Analysis of iconography by this method of considering various independent influences reveals the diversity within the Archaic Group. The way in which a particular influence is made apparent is found to differ from church to church; and the extent or intensity of influence also changes. So for a given church we must not merely list the effective influences but give a qualitative and quantitative assessment for each. Kılıçlar, for example, whose quincunx form reflects the architectural type which only came into vogue in the second half of the ninth century,[5] has the greatest number of contemporary Constantinopolitan elements. Compared with Tokalı Phase I, the number of miracle scenes is shortened, and some of the apocryphal scenes like the Flight of Elizabeth and Death of Zacharias are lacking. The prominence given to the Ascension, here in the central cupola, parallels Tokalı, but some of the elements in the contemporary Byzantine grouping are new, like a Communion of Apostles in the prothesis, Koimesis of the Virgin, Benediction of the Apostles, and a Pentecost which is very close to the example known from drawings in the South Gallery of S. Sophia in Constantinople.[6] This form of the Pentecost differs from the pre-iconoclastic

[1] Cf. S. der Nersessian, *Armenia and the Byzantine Empire* (Washington, 1945), pp. 117–18.
[2] In neither church is this iconic scheme part of the original decoration of these niches. Another connexion with S. Sophia is possibly indicated by the coupling of the Baptism and the Transfiguration. The same two scenes with the explanatory linking text 'this is my beloved Son, in whom I am well pleased', were apparently later additions to the original decoration of the West Gallery of S. Sophia, see C. Mango (1962), pp. 42–43.
[3] *De Caerimoniis*, Bk. I, chap. 33, ed. Vogt (1935), and Bonn edition, pp. 529, 550, 559.
[4] A. Grabar, *Martyrium* (Paris, 1946), vol. 2, p. 273, n. 1, explains the placing of the Crucifixion in this apse by reference to Pseudo-Cyril of Jerusalem and Pseudo-Sophronios who speak of an apse as the image of the cave of the Nativity and Death of Christ.
[5] The central plan type with subsidiary domes apparently spread very rapidly into the provinces after the building of the Nea of Basil I; see A. H. S. Megaw, 'Byzantine Reticulate Revetments' in Χαριστήριον εἰς Ἀναστασίον Ὀρλάνδον (Athens, 1965).
[6] Mango (1962), pp. 35–38, argues a late ninth- or early tenth-century date for this mosaic.

type with the Virgin included in the centre of a standing group of Apostles, which is known in the Rabula Gospels, and which continued in Armenian art as late as the thirteenth century.

Another quincunx church, El Nazar, and Chapel 6 introduce the only examples of the conch of the central apse being decorated with an enthroned Virgin and Child attended by Archangels. El Nazar is reminiscent of the Nicaea mosaics, especially since the position of the underdrawing of the Virgin's head, now visible, suggests that the artist's original intention was to paint a standing figure. This change in design cannot be used to determine the date, since standing and enthroned Virgins are both used throughout Middle Byzantine painting, and both schemes, like that of the Christ in Majesty, occur in pre-iconoclastic apse decorations. Thus the complex derivation of iconography in the Archaic Group shows that these decorations were not stereotyped productions, but in each case there was a deliberate process of selection according to various factors, or at least those responsible were open to influences from a variety of sources.

The relevance of the dating of the aniconic Phase 2 lies in its implications for the analysis of the chronological development of ninth- and tenth-century programmes. Several scholars[1] have postulated a logical development in Cappadocia beginning with purely aniconic decorations featuring the cross, during Iconoclasm, which was followed by tentative iconic programmes still featuring the cross but adding single figures of saints (such as St. Basil of Eleura and St. Stephen near Cemil), and finally reaching the stage of Tokalı Phase 1 with figurative scenes predominating. If, however, we consider only dated decorations, the earliest belong to the first half of the tenth century and consist of long narrative cycles.

As for Phase 3, I have suggested that it represents a major intrusion of Middle Byzantine style into Cappadocia. Since we have already Constantinopolitan elements in the iconography of the Archaic Group, we must now go on to consider to what extent there are already Constantinopolitan elements in the style of the Archaic Group. We have already seen that the two datable churches of the Archaic Group are distinct in style. In fact, the other churches of the Archaic Group are roughly similar in style to either one church or the other. For example, near in style to Ayvalı kilise are Tokalı Phase 1, Holy Apostles of Sinasos, Kılıçlar, Chapel of Theotokos, Chapel 6 (now lost), and Haçli kilise. These use a wide range of colours and, with limitations, achieve some variety of modelling of figures and of delineation of architectural and other features. Like Tavşanlı kilise are the nave of St. Eustathios, St. Theodore, Ballık kilise (now lost), and El Nazar. Their colour range is limited to predominantly green, brown, and white and their quality sometimes very low indeed. Their decoration frequently consists of friezes of stereotyped and linear figures. This division of types raises one problem at once. Are we to see them as two contemporary modes, or is one type earlier than the other? The similar inscriptions dating Ayvalı and Tavşanlı could plausibly be interpreted as indicating contemporaneity, their differences being explained otherwise. In this case, it may be suggested that the Tavşanlı kilise group represents the very modest achievement of local monks, while the Ayvalı kilise group is the work of itinerant painters linked ultimately with Constantinople, perhaps

[1] For example, A. Grabar, *L'Art de Byzance* (Paris, 1963).

through Caesarea, and so working with a more sophisticated style and technique.

It is possible to find parallels for the style of the Ayvalı group by looking at ninth-century metropolitan Byzantine paintings. The treatment of the faces of the Apostles in the Ascension or Pentecost of Kılıçlar is close to that of the Ascension cupola of S. Sophia in Salonica. They have the use of elegantly simplified areas of colour to indicate contour, and the broad shadows on each side of the nose appear in both works, as well as the curving wedge-shape used to model forehead and neck. Thus Kılıçlar is influenced by the late ninth-century style which is similarly seen in Paris gr. 510 and Vatican gr. 699 (compare a typical figure at Kılıçlar, like Joseph in the Nativity or Joseph in the Flight to Egypt, with figures in the Cosmas manuscript). The artists would seem to have knowledge of late ninth-century works from Constantinople, but not of the later developments reflected in Tokalı Phase 3. Chapel 6 is closely connected with Kılıçlar in its repertory of ornamental motives, but the stylization of facial features and drapery are taken one stage further than in Kılıçlar (Pl. V, 2). If Chapel 6 is a later and more schematized stage of the Kılıçlar style, whose inspiration is due, as we have seen above, to Constantinopolitan influences from outside Cappadocia, then the question arises whether El Nazar, whose figure style is at an even more advanced stage of decorative abstraction, could be explained as a later member of this sequence. Similarly Tokalı Phase 1 compared with Kılıçlar is also more conventionalized and more linear in its figure style. But we cannot yet justify on these grounds an earlier dating for Kılıçlar, for, since the Middle Byzantine iconographical elements are apparently independently received in several churches, it follows that in style there might be several independent stimuli from Constantinople. This means that we are likely to find the presence of stylistic developments of two contradictory currents: firstly the development known from Paris gr. 510 through Paris gr. 139, which is a gradual evolution from a flat two-dimensional to a three-dimensional figure style; and secondly a current which increasingly formalizes boldly and freely. The first current may have been derived mainly from manuscript illumination; the second current is one highly suitable for monumental painting, and its development probably occurred in Constantinopolitan art itself, since it appears independently in Salonica and Cappadocia. In this case, the phase reached in Chapel 6 may reflect a new impulse from the capital rather than an internal development in Cappadocia itself; this may perhaps be supported by the presence of the Virgin in the central apse, a deviation from Kılıçlar, which may be due to a new independent Constantinopolitan contact.

This situation appears to prevent any firm relative datings by style alone, until we have found more objective methods of dating any two stylistically related decorations. In general, the churches of the Archaic Group do appear to reflect partially the stylistic stage of Paris gr. 510. The artistic situation in Cappadocia was then altered by another wave of imitation of Constantinopolitan style begun by the workshop which painted Tokalı Phase 3, and which shows contact with later, but not necessarily the most progressive, developments of Constantinopolitan art. Though we do not know how long the stocky-figure style of the Archaic Group

continued to exist after this intrusion, all the datable works of the second half of the tenth or first half of the eleventh century have been influenced by the elegant elongated figure style of Tokalı Phase 3. In the programme of Karabaş kilise (1060–1) we may see a slight new Middle Byzantine influence, but it is not until the three 'Churches with Columns' that a strong wave of metropolitan influence in style is again shown. De Jerphanion dated this group to the middle of the eleventh century, but it is difficult, in view of the dynamic arrangement of figures over the architectural forms, to accept a date for these before the late twelfth or early thirteenth century. This suggests that these three contemporary churches may represent the work of refugee artists from Constantinople itself after the Latin Occupation of 1204.

CONCLUSIONS

(1) The models for the Archaic Group of wall-paintings cannot be derived from any one single source, such as local pre-iconoclastic art. Their genesis is complex, and their style and iconography are due to various influences. These may be clarified by an analysis of the decoration under various headings. This analysis reveals a lack of uniformity throughout the Group, so that each work must be assessed separately.

(2) The presence of a contemporary Byzantine element of style and iconography justifies the use of these paintings to assist in a reconstruction of monumental Byzantine art of the period.

(3) It is possible to isolate those local features which could have occurred only in the Cappadocian region of the Empire.

(4) Even in a collection of works grouped according to a style which is distinct from that of Constantinople of this period it is possible to explain the coherence of the group without postulating any local school. Outside influences experienced in common and the copying of some features from local works are sufficient to account for both differences and similarities.

(5) Datable programmes of the tenth and eleventh centuries in Cappadocia apparently change from being arranged in narrative cycles to being organized as a shorter sequence of selected festival icons.

This paper is based on a London Ph.D. thesis. Research was facilitated by grants towards travel and photographs from the Central Research Fund of London University, and travel in Turkey and Greece was also aided by grants from a State Studentship and a Greek Government Scholarship. All the illustrations are after Jerphanion, except IV, 1 (after Omont).

VII

The Classical Tradition in the Byzantine Provincial City: the Evidence of Thessalonike and Aphrodisias

The intention of this paper is to ask whether the classical tradition can be measured in terms of the environment of the Byzantine citizen outside Constantinople. I have chosen the cities of Aphrodisias beyond the Maeander in Asia Minor and Thessalonike in North Greece, and will discuss a selection of monuments, using for my argument art historical material rather than documents of administrative institutions, although an analysis of the development of administration could also illuminate the nature of changes in society in these cities. Let me admit at the outset that my choice of cities is an arbitrary one, which derives from my own interests,[1] but I hope that by making some comparisons, a few conclusions will emerge.

Today the appearance of these two sites offers the greatest possible contrast, with Thessalonike being a metropolis with a high urban density while Aphrodisias is being cleared of the few remaining villagers and their dilapidated cottages (and the village of Geyre never occupied more than a part of the medieval city). Both were important cities in antiquity but neither was a *polis* of the classical Athenian type. Thessalonike probably lies over the small town of Thermae but as the major city of the Thermaic Gulf it was a Hellenistic foundation as a result of the merger of 26 local communities: the new foundation dates to ca.316 B.C. under Cassander, who is said to have called the new city Thessalonike after his wife, the sister of Alexander. The site was significant as a potential port, and it is on the route from the Mediterranean into Central Europe up the Axios river (or its valley). Its citizens were part of the Kingdom of Macedon until 146 B.C. when Thessalonike was established as the capital of a Roman province of Macedonia (with a resident governor).

1. The printed text differs little from the lecture as given at the symposium. It would have been possible to extend its range indefinitely with discursive footnotes. I have resisted this temptation, and hope to justify certain statements in future publications on both cities. My knowledge of the archaeology of Aphrodisias is based on two study seasons there (1977 and 1978), and I am grateful for this opportunity to examine the Byzantine material which Professor Kenan Erim made available to me. My photography in both cities was assisted by the loan of a camera by the Central Research Fund of London University.

For summaries of the present state of knowledge of the classical period in both cities, see R. Stillwell ed., *The Princeton Encyclopaedia of Classical Sites,* (Princeton, 1976), 68-70 for Aphrodisias (by K. Erim), and 912-3 for Thessalonike (by M. Vickers).

The Roman period was for Thessalonike a time of security and relative peace, and it was presumably then a centre of trade and an important port.[2] In the third century Thessalonike was an objective of Gothic attackers but not taken; in the first decade of the fourth century the Tetrarch Galerius built his palace here, including his intended mausoleum. In the middle of the fifth century the Praefectus Praetorio per Illyricum moved his headquarters from Sirmium to Thessalonike, and after this time, there was always some strong military presence in Thessalonike. The layout of Hellenistic Thessalonike with a grid system of streets and a central agora can still be detected,[3] but at the beginning of the Byzantine period, the classical past would have been most conspicuous in public and private buildings of the Roman Imperial period.

Aphrodisias owed its urban development to Roman interest in the cult site of Aphrodite in the second half of the first century B.C. and ambitious building projects date in the time of the Julio-Claudians and Hadrian. Major building operations seem to continue into the sixth century (when probably the city name changed into Stauropolis or, more simply, Caria). No doubt Aphrodisias was laid out in a grid system of streets, but so far it has not been possible to excavate whole sectors of the city. The marble sculptors of Aphrodisias not only decorated massive Roman monuments along the streets and in the agora, but exported works of Carian marble elsewhere in the Mediterranean. The Byzantine citizens looked back to a classical past of great urban prosperity in the Roman Imperial period, as did the citizens of Thessalonike. Unlike Thessalonike, Aphrodisias lacked the continuing military presence; though more off the beaten track, it was also under Gothic threat in the third century. In the Byzantine "Dark Ages" of the seventh to the ninth centuries, when both cities faced attack from foreign invaders, Aphrodisias failed to survive at the same level of urban activity as Thessalonike; it is not yet clear from excavation whether the population of Aphrodisias huddled on the Acropolis or even moved to settlements nearby – but both cities went through a period of revival in the tenth and eleventh centuries. Aphrodisias went into a decline in the twelfth century, from which it never recovered. Thessalonike differs in this period, and in the early fourteenth century became the most important city outside Constantinople. It can be noted that Aphrodisias was only about half the physical

2. M. Vickers, "The Byzantine Sea Walls of Thessaloniki", *Balkan Studies*, 11 (1970), 261-78.

3. *Idem*, "Towards a Reconstruction of the Town Planning of Roman Thessaloniki", *First International Symposium 'Ancient Macedonia', Thessalonike, 1968* (Thessalonike, 1970), 239-51; *idem*, "Hellenistic Thessaloniki", *JHS*, 92 (1972), 156-70. *Tabula Imperii Romani* (Ljubljana, 1976), 139-47 (the section on Thessalonike is by Anna Avraméa and includes a useful bibliography); N.C. Moutsopoulos, "Contribution à l'étude du plan de ville de Thessalonique à l'époque romaine", *Atti del XVI Congresso di storia dell'architettura, Atene 29 Settembre-5 Ottobre 1969*, (Rome, 1977), 187-263.

Opposite:
Fig. 1: The Theatre at Aphrodisias

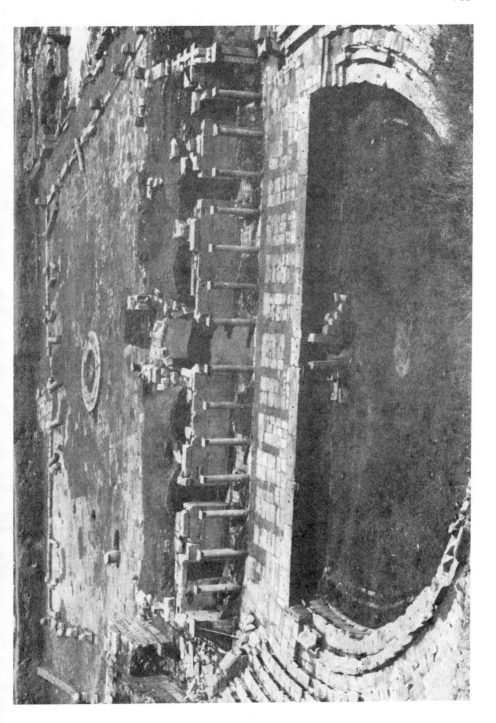

size of Thessalonike and was always a poorer and more remote city. Both places were surrounded by excellent agricultural land.

The basis for civilised urban life in both cities was established in the Roman Imperial period. The question can therefore be asked; what happened to their monuments and the environment in which they were established during the Middle Ages? What traditions survived or died or were resisted or revived? I shall take a number of examples to consider the question.

Walls

One legacy to both cities from antiquity was their physical extent. Both kept the full area of the classical city, despite fluctuations of population. The actual fabric of the walls of the medieval city in both cases shows panic building and the demolition of parts of public buildings for the rapid acquisition of materials.[4] The citizens of Thessalonike could have noticed blocks of seats from the hippodrome built into some sections of their walls, while the citizens of Aphrodisias could have read parts of broken classical inscriptions or noticed many pieces of sculptured reliefs in their walls. The circuit of the walls of Aphrodisias extended to the north in order to include the stadium, but the reason for this decision was not necessarily due to the urban development of the site, for to have left the stadium outside the walls would have been to supply an enemy with too useful a base of operations. The walls of Thessalonike extended up the hill to the north to include the acropolis (a citadel where the exiled Cicero in 58 B.C. sheltered from invading Thracians). Aphrodisias too had an acropolis (originally an artificial mound of the prehistoric period), and this was given its own circuit of walls in the Middle Ages: either in the seventh century after the theatre collapsed and went out of use, or in the late eleventh century. By the twelfth century, there were regular habitations on the Acropolis.

Throughout the Byzantine period the citizens of both these cities lived within walls laid out in antiquity and passed through Roman gates (for example the gate at one end of the main street of Thessalonike remained in its mid-second-century form until 1874). The grid system of streets survived probably intact until the seventh century, but after this time not all the streets in either city were maintained. Abandoned areas of both cities came into the hands of the church, and were redeveloped (as the Triconch church at Aphrodisias and the Panagia Chalkeon at Thessalonike show).

4. The catalogue of inscriptions of Aphrodisias is being prepared by Joyce Reynolds and Charlotte Roueché; the date of the latest inscription built into the walls is fourth century and is likely to provide the best dating indication. For the dating of the present circuit of the wall of Thessalonike to the middle of the fifth century, see the bibliography in the *Princeton Encyclopaedia*, to which should now be added: J.A.S. Evans, "The Walls of Thessalonica", *Byzantion*, 47 (1977), 361-2, and B. Croke, "Hormisdas and the Late Roman Walls of Thessalonica", *GRBS*, 19 (1978), 251-8 (Croke dates the walls to 442/3).

THE BYZANTINE PROVINCIAL CITY

Public Buildings

The stage buildings of the theatre at Aphrodisias (fig. 1) were redecorated with frescoes in the sixth century, evidence that the building was still in use though not necessarily for performances as the content of the paintings was Christian. Later on in the century or at the beginning of the seventh, the *scaenae frons* and its sculptural decoration collapsed forward into the orchestra, and became in due course the foundations for Byzantine and later Turkish houses. The stadium of Aphrodisias was at some time adapted for use at the east end only (perhaps after the collapse of the theatre). So this stadium, like that at Ephesus, was converted from use for athletic competitions for some other entertainment. The stadium continued in good condition through the Byzantine period, as did the odeion.

At Thessalonike there was a Roman theatre in the agora, and this is the so-called stadium of the Middle Ages, which was still in use in the ninth century for a public meeting.[5] As for the Tetrarchic Hippodrome, the use of some of its seating in the walls in the middle of the fifth century implies it went out of use for chariot racing by that time, although it has recently been suggested that it was patched up with makeshift seating and used even into the sixth century.[6] There is again a hint that this was used in the Middle Byzantine period for public meetings.[7]

The evidence of these monuments in both cities is that the places for public entertainment gradually went out of use, but the buildings were left to deteriorate. Sometimes they were used as a piecemeal source for materials, but they were never systematically redeveloped. Such buildings are therefore examples of the Byzantines living in the wreckage of the classical world. The church disapproved of the entertainments connected with these buildings, but hostility was not great enough to lead to organised demolition.

Palaces

The hippodrome of Thessalonike was constructed by Galerius to connect with the palace establishments. The Tetrarchic palace was apparently abandoned in the middle of the fifth century when the Prefect arrived from Sirmium and substantially redeveloped the city. In addition to the rebuilding of the walls and the construction of several major churches (including that of St Demetrios), a new palace and military headquarters must have been made. There is not the evidence to say if this was on the site of the quaestorium mentioned by Cicero or in a new location. There is a difficulty in accepting that the site for the new palace was in the area where the Nea Mone of Choumnos (church of the Prophet Elijah) now stands, as the *Miracula* of St Demetrios describes it as some distance from the basilica of St Demetrios; the palace may in fact have been located down near the

5. See the *Princeton Encyclopaedia* for a bibliography on the stadium.
6. M. Vickers, "The Hippodrome at Thessaloniki", *JRS*, 62 (1972), 25-32, and J.A.S. Evans, *art.cit.*
7. M. Vickers, "Observations on the Octagon at Thessaloniki", *JRS*, 63 (1973), 111-20, and *idem*, "A Note on the Byzantine Palace at Thessaloniki", *BSA*, 66 (1971), 369-71.

Constantinian harbour.[8] Although the site of this fifth-century palace is not yet clear, at least it can be said that the secular administration of the city was centred in the Middle Ages in a setting developed as part of the extensive redevelopment of the early Byzantine period.[9]

The identification of the palace of the Governor at Aphrodisias is not yet certain, but the large building which includes a triconch hall is the most likely candidate of the public buildings so far excavated. This complex may in turn have become the medieval bishop's palace; if this transition did occur, it would be a good symbol of the change in the status of the church during the history of the city and of the growth of a new kind of permanent authority in provincial Byzantine cities.[10] A number of Late Antique wall paintings was found in this complex. The subjects were the three Muses and a Nike. One is bound to wonder if these pagan figures remained visible through the Middle Ages.

Temples and Churches

The most important buildings for the consideration of the classical tradition are the ambitious cult buildings of the two cities. Aphrodisias owed its development in the classical period to the cult of Aphrodite. Thessalonike developed for different reasons and its classical temples were not the centre of great cults (an archaic temple and the Hellenistic Serapeion or Roman temple of Roma and Augustus are known from partial exacavation). The function of one mid-second-century building which survived through the Middle Ages is unknown: its colonnade, known as Las Incantadas (the Enchanted Ones) by the Spanish Jews of the Ottoman period, stood in the city until its removal to the Louvre in 1864. Its caryatid decoration, if not the complete building, was part of the environment of the medieval citizen.[11]

The main cult site of Aphrodisias, the Temple of the Goddess, was converted to use as the main church of the city. In Thessalonike the large Rotunda built by Galerius in the first decade of the fourth century to act as his mausoleum (fig. 2) is an equivalent example of a major building which was early on converted into Christian use.[12] The evidence of each of these conversions can be considered in turn.

8. Cf. R. Janin, *Les églises et les monastères des grands centres byzantines* (Paris, 1975), esp. 398-9; for the text of the *Miracula*, see now P. Lemerle, *Les plus anciens recueils des miracles de Saint Démétrius*, I (Paris, 1979), 66, lines 19-20.

9. For the changing status of the prefect of Thessalonike, see P. Lemerle, "Invasions et migrations dans les Balkans depuis la fin de l'époque romaine jusqu'au VIIIe siècle", *RH*, 211 (1954), 265-308.

10. Cf. J. Herrin, "Realities of Byzantine Provincial Government: Hellas and Peloponnesos, 1180-1205", *DOP*, 29 (1975), 255-84.

11. M. Lyttelton, *Baroque Architecture in Classical Antiquity* (London, 1974), esp. 281-2.

12. M. Vickers, "The date of the mosaics of the Rotunda at Thessaloniki", *BSR*, 35 (1970), 183-7 and W.E. Kleinbauer, "The Iconography and the Date of the Mosaics of the Rotunda of Hagios Georgios, Thessaloniki", *Viator*, 3 (1972), 27-107.

Opposite:
Fig. 2: Galerius' Rotunda, Thessalonike

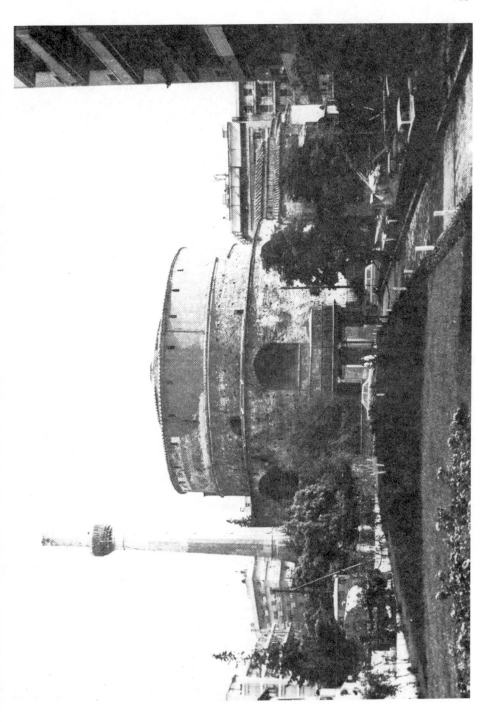

VII

The Temple of Aphrodite dominated the northern part of the city of Aphrodisias (fig. 3). It was an Ionic temple dating (to judge from its style) no earlier than the first century B.C. in this form; the temenos was built in the time of Hadrian. This major temple of antiquity was the building converted into a church by Christians who buried the cult statue of the goddess under a wall on the south side of the temple.[13] There is no recorded testimony of rioting at the time of the conversion which may give a clue that the alterations were not earlier than the middle of the fifth century. So far the best context for the conversion that can be suggested is the visit of Theodosius II to the city in 443 when he donated privileges to the bishop; perhaps the conversion followed soon after this visit.[14] The Christians decided not to pull down the symbol of classical paganism in the city but to transform it into the main church of Aphrodisias, the cathedral dedicated to St Michael.

The architectural conversion of the temple is one of the more radical of those known. The number of columns in the Ionic temple was 13 x 8; the Christians shifted those columns on the short sides and added them to the long sides. This alteration is easiest to detect at the north-west corner where the column with its original corner capital is in position, but the colonnade now continues out further to the west and rests on a makeshift foundation. Such a relocation of the columns as well as their capitals called for considerable engineering expertise and a large team of labourers.[15] The new cathedral was a large basilica with the new long colonnade dividing it into a church with a nave and two aisles, with apse and side rooms at the east end. The entrance of the temple must have been from the east, and probably the present apse foundation was an altar platform. The west court-yard and the narthex was formed out of the Hadrianic temenos. The outer walls of the church beyond the colonnade have now mostly fallen but in the Middle Ages these concealed the columns entirely from the exterior and were the supports for a double-pitched wooden roof. The church was decorated with mosaics and a cut marble floor. Marble parapet slabs and a chancel were cut for the liturgical arrangements of the fifth century, and at some date the capitals were gilded.

The converted temple remained the cathedral throughout the Middle Ages. It needed repairs and alterations in the tenth century, when apparently the liturgical arrangements were altered and a new sanctuary screen installed which reused

13. Cf. G. Fowden, "Bishops and Temples in the Eastern Roman Empire A.D. 320-45", *JThS*, 29 (1978), 53-78.
14. The evidence concerning Theodosius II will be discussed by C. Roueché in her publication of the Byzantine inscriptions. A useful review article with a bibliography on church conversions is that of J.-M. Spieser, "La christianisation des sanctuaires païens en Grèce", *Neue Forschungen in griechischen Heiligtümern, Deutsches Archäologisches Institut, Abteilung Athen*, (Tübingen, 1977), 309-20.
15. Professor K. Erim has suggested to me that some of the capitals were carved at the time of the conversion.

Opposite:
Fig. 3: The Temple of Aphrodite at Aphrodisias

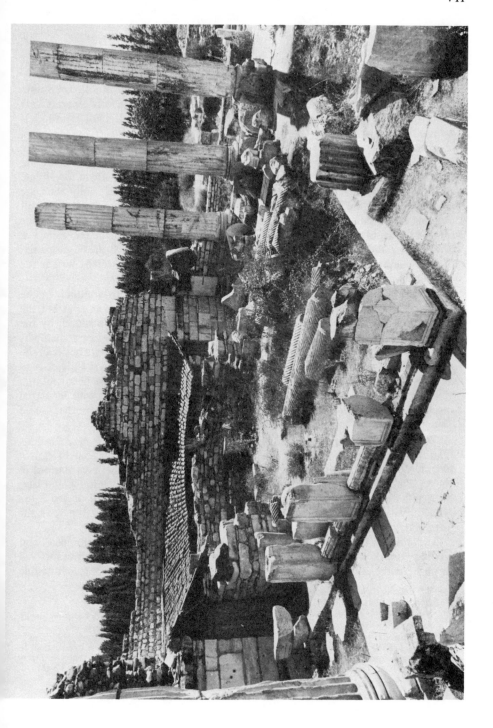

available marble items piecemeal (including a fragment of the Price Edict of Diocletian which had originally been set up in the agora basilica). The passageway behind the *synthronon* was painted with a cycle of figures in the Middle Byzantine period and was perhaps used as *prothesis* when the side-chapels were separated off from the nave. The precise date of destruction of the cathedral is not known – it went out of use after a fire.

Throughout the history of Byzantine Aphrodisias the main church was the prominent converted classical temple of Aphrodite. It is an example of the literal way in which a building from antiquity could continue in active use in the Middle Ages. In several ways its classical elements were transformed; not only were the columns moved and concealed within a masonry wall but it changed from a cult building to a regular assembly hall, and in due course came to contain tombs. The earliest tombs of the bishops have been found in a necropolis outside the walls, but tombs along the aisles of the cathedral indicate one way in which the development of Christianity changed the classical customs of burial. These tombs within the cathedral were most likely for bishops or prominent citizens.

Thessalonike also gives evidence of a major conversion into a church in the middle of the fifth century. Here it is not a temple that was taken over but the unused circular mausoleum of Galerius.[16] This was enlarged into a church by the addition of an ambulatory, an extended apse, and a number of subsidiary chambers (the columns in the niches were removed and these areas became bays between the central circular nucleus and the ambulatory). This conversion too was a major engineering operation. Enormous constructions of scaffolding would have been required also not only for the architectural alterations but for the mosaicists who decorated the vast dome with a scheme of martyrs in a heavenly setting and with other sacred figures above them (mostly now lost).

There is no clear evidence of the dedication or function of the new Rotunda church. It would seem that the cathedral of Thessalonike was under construction at the same time that this conversion was taking place, as was the large Basilica of the Virgin.[17] The most conspicuous church construction of this period would have been the memorial transept church of St Demetrios to the north of the agora (which had revetment on its walls in direct continuation of the types of the Tetrarchic palace, and might even incorporate reused elements).

The apse of the Rotunda suffered damage, probably from an earthquake, and was redecorated with wall-paintings in the late ninth century. As a church it survived throughout the Byzantine period; its superb fifth-century mosaics remained visible

16. G. Velenis, "Some observations on the original form of the Rotunda in Thessaloniki", *Balkan Studies,* 15 (1974), 298-307.
17. The entry on this church in the updating article on the inscriptions of Thessalonike needs to be supplemented: see D. Feissel and J.-M. Spieser, "Inventaires en vue d'un recueil des inscriptions historiques de Byzance. II. Les inscriptions de Thessalonique. Supplément", *TM,* 7 (1979), 303-48, esp. 312. To this article add: Ch. Bakirtzis, "Sur le donateur et la date des mosaiques d'Acheiropoietos à Thessalonique", *Atti del IX Congresso internazionale di Archeologia Cristiana. Roma 11-17 Settembre 1975* (Rome, 1978), 37-44.

(presumably even during Iconoclasm) and might have acted as a source of inspiration to artists of any period who worked in Thessalonike. Its architecture would have been of less artistic interest than its decoration.

In Thessalonike the environment of the city was considerably changed in the fifth century at the time the Rotunda was converted and several large churches were built, aligned to the existing grid system of streets. Only one more very large church was built at a later period in Thessalonike. This was the domed basilica of St Sophia which I believe was constructed in the 780s and intended as a new cathedral which like the sixth-century Great Church of Constantinople was surmounted by a large central dome. This means that Thessalonike differs from Aphrodisias in being brought up to date in the post-Justinianic period. The bishop of Aphrodisias had to remain satisfied with a large basilica, which in the tenth century was trimmed down in size, either for reasons of economy or because of the reduced size of his congregation. The bishop of Thessalonike gained a new centrally-planned cathedral in which he could copy the liturgical arrangements of St Sophia in the capital and on the walls of which new mosaics in the ninth century and wall-paintings in the eleventh century showed his harmony with new artistic ideas of the capital. One might say that Aphrodisias retained a cathedral of the lintel and column architecture of the Greek and Hellenistic tradition, while Thessalonike in the eighth century gained a masonry church with a dome of the Roman tradition.

Medieval Developments
The evidence which has been mentioned so far points primarily to survivals of features in the two cities which show how their classical core survived, either virtually unchanged as in the street system, agora, or walls, or in a much altered form, as in major buildings converted into churches and so surviving in a camouflaged setting. It might therefore be commented that this evidence shows less the continuation of a classical tradition than the survival of antiquity itself, which was then available as a potential stimulus for Byzantine work at any later period. The Byzantine period might on this evidence be characterised as a time when an antique environment was maintained. The circuit of the walls was maintained, although principles of defence might change in response to developments in warfare. The cathedral of Aphrodisias and the Rotunda of Thessalonike were carefully maintained throughout the period despite the need for expensive work of restoration. Similarly, the fifth-century church of St Demetrios had to be reconstructed and redecorated after a major fire in the seventh century.

To give a different perspective on the nature of the classical tradition in the cities, I shall select two examples of new Christian buildings of the Middle Byzantine period. There are two roughly contemporary churches in the two cities which are therefore suitable for a comparison. In Thessalonike there is the Panagia Chalkeon dated by inscription to 1028 and so belonging to a period of prosperity and expan-

sion after the triumph of Basil II against the Bulgarians (fig. 4).[18] The Panagia Chalkeon was built as the family mortuary chapel of the katepan of South Italy, and to judge from the wording of its inscription it may have been maintained as an oratory rather than as the katholikon of a monastery (the same status may be suggested for the tenth- or eleventh-century church of St John in Troullo in Constantinople). In Aphrodisias a church of similar period has been partially excavated, and may be referred to as the Triconch church (fig. 5). My dating to the late tenth or early eleventh century derives from a stylistic analysis of the carving of its templon screen. It seems most likely that this church was the katholikon of an urban monastery but a decision on this point must wait for further excavation.

The Triconch church lies in the area to the south-west of the Acropolis of Aphrodisias. The church is entered through a narthex and the naos takes the form of a triconch with an extended east apse and side chapels. The triconch form was popular on Athos and elsewhere at this period, particularly for monastic use. The materials used in the construction are informative about the attitudes of the builders of the city at this period. The main door into the naos has an opening constructed entirely of reused classical marble pieces. The vaulting of the naos has not survived but there can be little doubt that it was some form of cupola. What is clear is that this cupola was supported on four huge monoliths on octagonal bases which now lie collapsed in the naos. These four columns and their tall bases are not productions of the Middle Byzantine period but are reused pieces of the classical city. Furthermore they are reused on their original site. In antiquity they formed a monumental Tetrakionon at a crossroads in the city. The floor of the naos of the Triconch consists of the paving stones of these streets. The architects have built the church around the surviving Tetrakionon. It follows that in the Middle Ages this road system in this part of the city had gone out of use and lay abandoned. The walls of the church have several pieces of reused marble in them, one of which comes from some earlier church. The eastern sanctuary is raised up, and the steps on to the platform are reused pieces of marble. Pieces which are clearly derived from the same source are carved to form the templon of the Triconch, and this makes it clear that the building all belongs to one constructional phase. In the carving of this templon one can recognize similarities with other western Asia Minor sculpture of the medieval period and no influence in style or technique from the famous Aphrodisian style of antiquity such as in the Baths of Hadrian (some of this classical sculpture was taken from the site to the Archaeological Museum of Istanbul at the beginning of this century).

The masonry technique of the apses of the Triconch is identical with that found in the fifth-century apse of the cathedral, and with that of the governor's palace

18. K. Papadopoulos, *Die Wandmalereien des XI Jahrhunderts in der Kirche Panagia ton Chalkeon in Thessaloniki* (Graz and Cologne, 1966).

Opposite:
Fig. 4: The Panagia Chalkeon at Thessalonike

114

WEST ELEVATION

(which also uses the triconch format for one of its halls). It would seem that a local technique of handling stone survived from Late Antiquity into the Middle Ages, and so in one sense one can point to the survival of a classical tradition and the reuse of classical pieces; but the type of architecture and its function for the monastic liturgy had no counterpart in the classical city. It is best to see the Triconch as the production of a radically different culture and society than to emphasize any debt it may owe to the classical tradition.

The Panagia Chalkeon in Thessalonike was extensively restored in the 1930s but its original architectural articulation and interior wall-paintings have been preserved. The tenth-century church of the Myrelaion at Constantinople shows a parallel interest in exterior surface effects. The masonry technique has no connection with the earlier brick constructions of Thessalonike for the Panagia Chalkeon is one of the first examples of a new technique of the eleventh and twelfth centuries, the so-called recessed brick technique (where alternate courses of bricks are set back into the wall and then plastered over to give the impression of very thick plaster beds).[19] This church in Thessalonike is therefore a good case of a new kind of medieval institution which has no forerunner in antiquity. The Panagia Chalkeon takes us far from the classical tradition. Yet it might not be unreasonable to see at least one architectural element in it which looks back to the classical world: the west facade does after all have the tripartite system of a Roman arch or gateway or of the architecture in the mosaics of the Rotunda. So even in a building of a developed medieval nature, elements occur which do remind us of the classical background of Byzantine culture. To some extent therefore it becomes a matter of personal judgement in interpreting how far such elements of classical derivation should be emphasized in the analysis of urban environment.

So far the excavations of Aphrodisias have uncovered no buildings later than the Middle Byzantine period. With the arrival of the Seljuks, the city went into decline and it never revived. One feels that the weight of the classical past did become almost a literal fact of life. When an antique building fell over on to a street, that street would be abandoned for lack of engineering skill and manpower in removing the marble debris. The sheer bulk of its classical monuments therefore imposed its character on to the medieval citizens. It was in the construction of churches that they transformed the character of some sectors; and the theatre slowly disappeared below their houses on the acropolis.

Thessalonike continued to transform the classical background of the city in the fourteenth century which was a new period of local prosperity. A substantial number of new small monasteries was constructed in the upper city. The most ambitious was that of the Virgin of 1310-1314 (now known as Holy Apostles). Even the church of St Demetrios was altered by the addition of the chapel of St

19. P.L. Vocotopoulos, "The Concealed Course Technique: further examples and a few remarks", *JÖB*, 28 (1979), 247-60.

Opposite:
Fig. 5: The Triconch Church at Aphrodisias

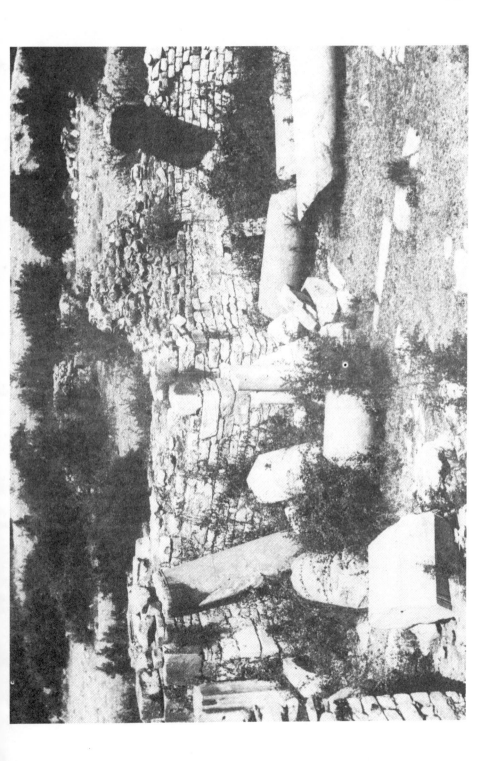

Euthymios at the east end in 1303 (fig. 6). The evidence of this tiny basilica is worth emphasis. The architecture of Thessalonike is dominated by the commissions of successful generals, as for example the mausoleum of the fourth-century Tetrarch Galerius and the more modest mortuary church of the eleventh-century katepan of South Italy. The church of St Euthymios was also built by a major military leader, the Protostrator Glabas (whose mortuary chapel is preserved as the *parakklesion* of the Fetiye Camii at Istanbul). In no way can one see this minuscule church in Thessalonike as following a "classical tradition" of triumphal architecture of great generals. St Euthymios shows the kind of transformation of society which occurred in the Byzantine period and which allowed Glabas to build this small oratory in honour of an early Christian monk for whom he had a special affection and admiration.

This comparison of two provincial cities of the Byzantine empire must necessarily be too arbitrary to merit a systematic conclusion, yet their evidence gives some insight into the term "classical tradition". Both cities were developed in antiquity in different circumstances, and an awareness of the classical past was dominant in some aspects of their Byzantine development. In comparison with each other, Aphrodisias appears like a Roman city in a state of decline with certain traditions remaining strong; although the expertise of the sculptors of Aphrodisias was apparently lost in the fifth or sixth centuries and never regained, the same traditions of building masonry continued from Late Antiquity into the Middle Ages. Thessalonike on the other hand transformed itself from a standard Hellenistic foundation to become a thoroughly medieval city where discontinuity is more significant than continuity or survivals of the classical tradition: in this city the classical is only one of several traditions within which its architects and artists worked. In other words, the citizens of these two cities lived in an environment which owed much to its classical past, but to speak of a living classical tradition would be to ignore the realities of life in the Middle Ages. Buildings survived for centuries not because there was any aesthetic wish to preserve ancient monuments, but because they were originally built to last. The classical tradition in the Byzantine provincial city needs very careful analysis; it is a much more negative factor in everyday life than it was in literature.

Opposite:
Fig. 6: Chapel of St Euthymios, St Demetrios, Thessalonike

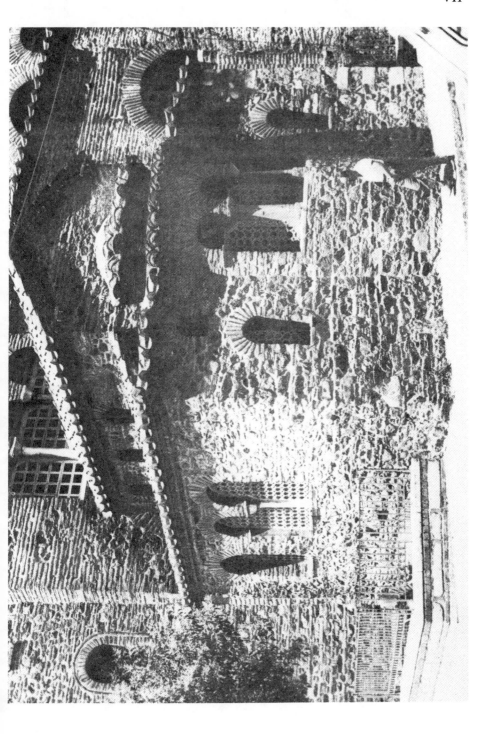

VIII

INTERPRETING THE MOSAICS
OF S. SOPHIA AT ISTANBUL

THE STATE OF RESEARCH

Fifty years ago, in June 1931, the Turkish government gave permission to the Byzantine Institute of America to uncover and conserve the mosaics of S.Sophia. By that time all the figurative mosaics of S.Sophia had been progressively concealed during the use of the building as a mosque since 1453. The work of discovery in S.Sophia was described as 'deliberate and unhurried' by Thomas Whittemore, founder and director of the Byzantine Institute, but a considerable amount had been achieved by the time of his death in 1950 and the debt owed to him for his initiative is immense.[1] Work in S.Sophia (and in other Byzantine monuments in the city) was continued under the control of the new field director, Paul Underwood. Publications of the work of the Byzantine Institute now appeared not in separate *Reports* but in periodicals, first in the *American Journal of Archaeology*, and then regularly in the *Dumbarton Oaks Papers*. An announcement was made in 1964 by the Center for Byzantine Studies at Dumbarton Oaks (Washington DC) in an editorial note:[2] this said that the Byzantine Institute, whose archaeological work had been directed by members of Dumbarton Oaks staff since 1950, ceased operations in the field on 31 December 1962, and that, beginning with the season of 1963, fieldwork would be carried on by Dumbarton Oaks under its own auspices. It seems today that this highly productive phase of activity has come to an end with the termination of a fieldwork programme in S.Sophia (and elsewhere) by Dumbarton Oaks, although the scale of work which still needs to be done in the Byzantine world, and particularly in its capital, is enormous. It is also the case that the pace of discovery of new Byzantine material over the last fifty years has been breathtaking, and archaeological discovery has progressed more swiftly than the absorption of these finds into art historical thinking. The aim of this paper is to take this moment to take stock and to look critically at discussion on the mosaics of S.Sophia, and in particular to ask what progress has been made in understanding the visual language of Byzantium on the basis of these mosaics.

The importance of the discoveries in S.Sophia might be assessed in three main ways. First, they have given us first-hand examples of the best work in the

medium produced in Byzantium. There can surely be no doubt about the superb quality of most (if not all) of these mosaics. The qualification once expressed by Demus cannot be allowed to pass without challenge.[3] He agreed that the mosaics now existing in S.Sophia must have been among the best of which the Empire's capital was capable, but went on to remark: 'yet these also, for all their excellence, give the impression that there must have existed others of almost unimaginable grandeur.' This qualification is another example of what is almost a mania in Byzantine studies for postulating lost masterpieces, and so downgrading, if not ignoring, the quality of what can be seen. The case should be made that S.Sophia, with its interior space covered by a vast dome and with its decorations, represented for the Byzantines the paradigm of a church, what was seen in the inner eye when asked to describe the ideal Christian church.

The result of the discoveries in S.Sophia has been, second, the opportunity to observe mosaics which had never suffered interference from post-byzantine restorations. Due above all to the sensitivity of Ernest Hawkins in his work in S.Sophia, there has been virtually a revolution in the precision of mosaic study in recent years.[4] No one could now argue that mosaics were made in sections in studio conditions and then transferred to their prepared surface in a church. The process is now recognised as pragmatic, with artists making decisions on the spot about their choice of tesserae, the angles at which these were set, the need for final touching up with paint and so on.

The third aspect of the discovery of this material in S.Sophia is the one which will be pursued in this paper. Art historians are now in the position where most of the mosaics can be exactly dated, and consequently the patron and the historical circumstances should be deducible. This is therefore an area of study where questions about the intentions of the patrons can usefully be pursued. Since the personalities connected with the cathedral of Constantinople and site of the major public imperial ceremonial are those most likely to be documented, analysis of these mosaics should be a way of entering into a society which is not as anonymous as so often claimed.[5] The art historian must hope that future research will build up a history of Byzantine art in which the achievements and influence of individual artistic personalities are recognised (some characterised on the basis of stylistic analysis, some from signatures and some from literary references). As for unravelling the intentions of the patron and the instructions given to the artists or their initiatives, the problem in this sphere is the notorious reticence of Byzantine literature.[6] The difficulty of entering into the thoughts of patrons, artists, and the public is increased by the various levels of literary language. The language and content of such a work as the eighth- or ninth-century *Narratio de S.Sophia* indicate its character as a popular guidebook; it is full of misinformation, but from time to time comes out with otherwise undocumented bits and pieces.[7] Such a book is unhelpful when looking for intellectual conceptions of art. Similarly the guides who took the Russian pilgrims round S.Sophia from the twelfth century onwards were better at retailing stories about the relics on display than at giving the meaning of the mosaics (though Antony of Novgorod around 1200 was told the names of two artists who worked in S.Sophia: Lazaros in the ninth century, which

may be an incorrect attribution, and Paul, apparently an artist of the second half of the twelfth century.[8] For the purposes of interpreting the intentions of the iconography of the mosaics of S.Sophia the best literary aids belong to the 'high-brow' milieu of Byzantine society. S.Sophia is a place where an aristocratic patronage can be assumed.

S.Sophia can be taken as the most important single monument of Byzantine culture, and must be a pivot for medieval art history. Anyone who studies the church is fortunate that another project was started in the 1930s. This is the complete measurement of the building undertaken by R. L. Van Nice: one volume of the scale plans has been published, and the final set, in preparation at Dumbarton Oaks, is promised soon.[9]

MOSAICS DURING THE REIGN OF JUSTINIAN (527-65)

Only a small proportion of the mosaics which belong to the foundation of the present church by the emperor Justinian between February 532 and December 537 has so far been uncovered from beneath their Islamic concealment. The evidence is fairly definite that all the original vault mosaics were non-figural and consisted of hundreds of crosses or ornamental designs. Priority in the exposure of the Byzantine mosaics has been given to figural compositions. The locations of these in the building were discovered from a number of sources of which the most important are the drawings and records made by the Fossati brothers who were employed on a massive and remarkable restoration of the monument between 1847 and 1849.[10] There has been little study of the sixth-century non-figural designs (as of Byzantine ornamental art in general), and this is an obvious field for future work. Less interest has been shown in the creative processes behind these mosaics than in the fidelity of later ornamental mosaics in the church to the sixth-century vocabulary by means of which a unity of decoration was achieved throughout the building. Of course this care to repeat forms in the later decorations gives rise to consequent difficulties in dating what is Justinianic and what is medieval work in the same tradition.[11]

Any attempt to interpret the visual language of the original mosaics is hedged in with two main uncertainties. The first problem is to explain why a totally non-figural mosaic scheme was adopted at all. The choice does not correspond with the picture of art in the reign of Justinian which one might be expected to reconstruct on the basis of existing rich figural cycles in San Vitale in Ravenna in the 540s or on Sinai at the end of the reign, or even in the church in the capital, now the Kalenderhane Camii, which had a sanctuary decoration in mosaic from which only the panel of the Presentation has survived, possibly to be attributed to the period of Justinian.[12] The lack of monumental images in the church of S.Sophia and the consequent lack of visual focus in the building which may, by hindsight, remind us of the aesthetic of an Islamic mosque, was presumably mitigated by the presence of portable icons and other figural images (and very soon by a circuit of relics for the visitors to see and worship). But the decision to omit any figural mosaics from the church must have some explanation.

133

VIII

One answer for the lack of a complex cycle of figural mosaics is that it was not a positive decision, but simply the most rapid kind of vault decoration to carry out in a church said to have been completed in under six years. A variation on this answer is to say that the architects Anthemios and Isidoros (whose interests were in mathematics and engineering) were not concerned to design surfaces for a cycle of mosaics, in any case a major difficulty in a cupola church of such a height; they might, like other famous architects in other periods, have lacked interest in conspicuous decoration. The architecture is certainly not very suitable for pictorial compositions — the vaults are high and the surfaces for decoration relatively small in area: in all the later figural panels the artists have encountered considerable visual problems in the design of the compositions.

An alternative approach to the explanation of the non-figural decoration is to find some theological reason. An argument has been made that, at precisely the time that S.Sophia was being constructed, Justinian and his wife Theodora, who was known to have Monophysite sympathies, also built the grandiose church of SS. Sergios and Bacchos in order to give a community of Monophysite monks a recognised cult centre in the capital (some historians have also attributed this church to Anthemios and Isidoros). This policy of détente towards Monophysites might be seen as the explanation for the lack of images in S.Sophia, for the avoidance of figural images may have been a Syrian predilection at this time.[13] No final decision can be made on present evidence, and one has to opt for an explanation in terms of response to practical conditions or in terms of a resistance to images among some church thinkers at this period. The former view is probably less controversial than the latter.

The second problem about the mosaics of the Justinianic period (and this applies equally to the rebuilding of the damaged dome and its redecoration with a central cross between 558 and 562) is how did the planners of the mosaics expect the spectator to react to and interpret this programme? On this issue there are a number of pertinent texts of the period. It is worth quoting the poem of Paul Silentarios, *Descriptio S.Sophiae*, recited early in 563, which says this of the dome decoration:[14]

At its very summit art has depicted a cross, protector of the city the sign of the cross is depicted within a circle by means of minute mosaic so that the Saviour of the whole world may for ever protect the church.

In this passage a Byzantine intellectual expresses a belief in the power of the cross; the mosaics could on this evidence be seen as art in the service of superstition. In course of time the cross in the dome was replaced by an actual representation of Christ (after Iconoclasm ended in 843) which may have taken on some of this attributed function.[15]

In another passage about the mosaics, Paul Silentarios writes this:[16]

The roof is compacted of gilded tesserae from which a glittering stream of golden rays pours abundantly and strikes men's eyes with irresistible force. It is as if one were gazing at the midday sun in spring, when he gilds each mountain top.

These sentiments give no evidence that the Byzantine spectator gave any precise interpretation to each element of the scheme of the church. The same conclusion is suggested by the 'official' description of the architectural patronage of Justinian written by Procopios a few years earlier than the poem. The experience of looking at the vaults is described like this:[17]

> The vision shifts constantly around, and the beholders are quite unable to select any particular element which they might admire more than all the others.

Such sentiments written by court panegyricists in honour of Justinian do not give the reasons for the choice of non-figural mosaics, but they do suggest that there was an aim in the scheme not just to spread a pattern over the vaults, but to express through the use of crosses some hint of the presence of God. Possibly such a general and somewhat ambiguous message was normally inherent in Byzantine works of art, and should be taken into account in the interpretation of figural representations.

PATRIARCH PHOTIOS AND THE TRANSFORMATION OF THE MOSAIC DECORATION

The interior of the church has retained no evidence that in the next centuries after Justinian there was any enterprise to introduce figural mosaics and so to alter the original scheme. Only in the ceremonial rooms of the patriarchal palace, which were added to the south-west corner of S.Sophia during the reign of Justin II (565-78), was a small-scale figural scheme carried out, limited to bust portraits of Christ and a number of saints. Despite the privacy of these rooms, the figures were in due course removed by the Iconoclastic patriarch Nicetas (in 768/9), and a set of crosses was substituted within the original mosaic medallions.[18]

The whole effect of the interior of S.Sophia was transformed in the course of the ninth century as the vaults were for the first time redecorated with figural compositions. The patriarch Photios, one of the great intellectuals of Byzantine history, seems to have been the key figure in the revival of art after Iconoclasm, though the implication is clear in his Homily 17 on the inauguration of the first new image in the church that the finance came from the reigning emperors.[19] It has been shown on archaeological grounds that the present apse mosaic of the enthroned Virgin and Child between archangels is in all probability the image inaugurated on 29 March 867 and described in this homily (plates 1 and 3).[20] As the patriarch in office, Photios must have been the guiding mind in the new scheme of decoration inside the church carried out over a number of years and presumably complete by the end of the ninth century. It can be taken that his choice of the Virgin for representation in the apse implies already a decision to place a figure of Christ at the apex of the main dome, below which a hierarchical scheme of representatives of the Christian community in Heaven was worked out.

VIII

What is the message of the apse image? The verse inscription which was set in mosaic around the semi-dome is one aid to an understanding of the iconography. It read:[21]

The images which the heretics had cast down from here, pious emperors have set up again.

The heretics of the epigram (which was presumably composed by Photios) must be the Iconoclasts, while the pious emperors, to whom the commission is attributed, must be Michael III and Basil I. The text would seem to be historically untruthful in claiming the removal of images from the apse by the Iconoclasts — the only clear evidence of their activity was in the private rooms of the patriarchal palace (mentioned above), where the crosses substituted for portraits of saints are still visible, an act of iconoclasm recorded in the Byzantine histories of the period. Even if Photios is guilty of exaggeration in claiming that the Iconoclasts altered the apse, yet the epigram points to an anti-Iconoclast meaning for the mosaic. The underlying reference of the mosaic is not difficult to suggest. It was a major argument of the iconophile party that the Incarnation of Jesus in human form was the justification for pictorial representation of the Christian God in human form — it was proper for him to be shown as a man, since he took this form on earth.[22] It can therefore be argued that the choice of the Virgin and Child for the first mosaic in S.Sophia after Iconoclasm has a consciously iconophile purpose. It is worth turning to the Homily 17 delivered by Photios at the inauguration of the image to see if there is confirmation for this iconophile interpretation.

This homily is obviously important for the dating of the mosaic to 867, and it is also notable for its language of art criticism in favourable assessment of the artist's achievement. To the modern eye, Photios may seem perverse in calling the Virgin and Child 'lifelike' and 'realistic' (though we must take care not to exaggerate the 'abstraction' of the figures). However, after a century of Iconoclasm, conceivably the less tutored Byzantine eye looking up into the vault of S.Sophia might have accepted the idea; but, whatever the actual response of the ninth century, the inspiration of the critical language of Photios was less the study of works of art than the great literary knowledge he had of the statements on art of classical antiquity.

Leaving aside the aspect of critical standards, the homily gives some clues to the patriarch's use of art. Photios attacks the Iconoclasts for heresy, and then speaks of the welcome sight of the Virgin. He says:

Even in her image does the Virgin's grace delight, comfort, and strengthen us.

Then follows the well-known passage on the lifelike qualities of this particular image. Later on Photios gives further clues to the significance of the iconography. He speaks of the gladness and joy of the day, and says:

INTERPRETING THE MOSAICS OF S. SOPHIA AT ISTANBUL

The image of the Mother rises up from the very depths of oblivion, and raises along with herself the likenesses of the saints. Christ came to us in the flesh, and was born in the arms of His Mother. This is seen and confirmed and proclaimed in pictures, the teaching made manifest by means of personal eye-witness, and impelling the spectators to unhesitating assent. Does a man hate the teaching by means of pictures?

Photios then goes on to argue along the following lines: that though the memory of martyrs is contained in books, paintings of these martyrs present their deeds more vividly. In answer to the question whether the memory of these deeds is conveyed better through stories or through pictures, it is the spectators rather than the hearers who are drawn to emulation: it is easier to remember something one has seen than something one has heard.

In this important text Photios explicitly refers to the iconophile argument that the Incarnation was a justification for icons. He then develops a theory that a picture is an actual record of a Christian event and is more lifelike than a written account. Photios therefore has a theory of the didactic value of art in which icons are eye-witness reports of Christian history, and in this sense true to life.

Analysis of this homily helps to show that the choice of a Virgin and Child for representation in the apse of S.Sophia was meant to have a political and theological reference. Yet it was the Byzantine way not to make the iconography too explicit but to choose a picture which would always keep a more general reference. Photios did not convey his message through a particular iconography with a precise reference to his own time. The choice was also subtle in that it could also suggest other ideas. The Virgin and Child as an apse subject had already occurred in churches before Iconoclasm, but with different messages; for example, it could then be taken as a statement of a christological position, stating a theological point about the relation between the two figures. Photios could also have expected the Byzantine spectator to remember a text attributed to the eighth-century patriarch Germanos on the symbolism of the various parts of a church:[23]

The conch is after the manner of the cave of Bethlehem where Christ was born, and that of the Cave where he was buried.

It would be in keeping with the tortuous literary style of Photios for him to have a complex interpretation of the apse composition in mind, and the last passage quoted shows that there was a tradition which encouraged ambiguity of reference in the images in one part of a church. The apse mosaic shows how in 867 an image could be chosen which illustrated topical political and theological concerns but in such a generalised form that the icon could remain the object of veneration over the following centuries when circumstances had changed.

The rest of the interior scheme of S.Sophia of the ninth century may be supposed to reflect the same historical situation.[24] It is possible to detect several levels of interpretation in the iconography of the mosaics of the two great tympana below the dome. In the case of the Church Fathers included in

INTERPRETING THE MOSAICS OF S. SOPHIA AT ISTANBUL

this scheme it has been shown that the individual selection was made to feature saints specially celebrated in the liturgical calendar of S.Sophia.[25] The inclusion of Ignatios, who was the patriarch who preceded Photios and became his bitter rival, takes us nearer to explicit topicality; by the time of the death of Ignatios in 877 the two rival patriarchs had been reconciled and Photios regained the office.[26] But apart from the reference to the celebration of the festivals of these Church Fathers in S.Sophia, some of the saints may have been selected for others levels of interpretation: for example, S.John Chrysostom was famous as an outspoken critic even of the imperial family, and so he would be an obvious choice to convey the suggestion that the power of church leaders should be re-established after a period of domination under the Iconoclastic emperors.

Within the patriarch's private rooms a major mosaic restoration was also carried out in the ninth century.[27] If the circumstances of this work are correctly identified, the scheme is a pendant to the activity of Photios and represents a commission of his rival Ignatios around the year 870, a few years after the apse Virgin. The main room of the patriarchal palace which opened on to the south side of the west gallery of S.Sophia was given a cycle of figures from the Old Testament, New Testament and Orthodox church history. This mosaic community of saints was arranged around the vault of the room, and a focus to the cycle was given by the semi-circular panel over the door into the gallery in which Christ sat enthroned between the two intercessors for mankind, the Virgin and S. John the Baptist (plate 2). This is the compositional scheme which art historians have been recently criticised for being too hasty to call the Deesis.[28] The whole cycle gives the appearance of very careful selection. The topical issue which can be detected is the legitimacy of icons of Christ and the saints. Figures are represented whose importance was that they were witnesses of God seen in human form or that they were the historical patriarchs of the church of S.Sophia who fought for the iconophile victory. Although an interpretation of the cycle can be made in terms of the declaration of Orthodoxy, it is also true that the representation of the heavenly community gave a timeless value to the icons.

THE NARTHEX LUNETTE OVER THE IMPERIAL DOORS

After the time of Photios the interior scheme of S.Sophia remained substantially the same, despite earthquake damage which necessitated the later restoration of some vaults. The most significant alterations in the church consisted of the addition of a small number of special panels. In each case there must have been some precise motivation, and the discovery of this can contribute further to the understanding of the Byzantine use of iconography. The location of these panels was no doubt chosen in order to convey their meaning most effectively. Perhaps the most prominent of all these panels is that substituted for the original Justinianic mosaic above the central door from the narthex into the nave of the church (plate 5). It can be attributed to the period of Photios or reasonably soon afterwards on stylistic grounds (compare, for example, plates 3 and 4), but its precise date depends on a decision about the interpretation of

its message. It was first published by Whittemore, but our knowledge of the mosaic was much refined by a new examination by Hawkins.[29] It is conceivable that this panel was planned by Photios too, but it has generally been regarded as a separate later commission, partly because of its individual stylistic character.

This is certainly the single most discussed mosaic in the church, but the important recent paper of Oikonomides is written with a firmness which might be expected to put an end to further controversy.[30] Although the solution he offers for an interpretation of the iconography has been widely accepted, my expectation is that his study will be more important for identifying the problems than for solving them. The lunette mosaic represents an un-named emperor prostrate before Christ, who is enthroned and holds an open book inscribed with texts. Two other figures on each side of Christ are in bust format within medallions; that on the left presumably is the Virgin and that on the right is most readily to be identified as an archangel. The site chosen for the mosaic is the outer side of the ceremonial door into the church, the place where processions of the emperor and his retinue and the patriarch and his clergy on occasion joined to make their entry into the church. The absence of the emperor's name in the mosaic is hardly likely to be just a lack of information to foil the art historian, but must have had some deeper significance for the interpretation of the panel. Was it omitted, for example, to allow the act of a specific emperor to become in future eyes an act of more general significance?

All previous interpretations of the mosaic were critically reviewed by Oikonomides, and he developed one line of approach: that the posture of the emperor was the expression of his repentance for some wrong. This interpretation has much to support it. For example, it was here in the narthex that penitents prayed until they were permitted to re-enter into full communion with the church; the location of the panel and a function of the narthex could be seen to coalesce. As for the iconography of the panel, this can be read neatly in terms of penitence. The best parallel would be in the scene of the Penitence of David to be found in manuscript examples, particularly Psalters, where the penitent king is shown in the identical position and where the scene sometimes includes an angel, which is to be interpreted, according to Oikonomides, as the 'Avenging Angel'. Oikonomides also designated this angel as the 'Gloomy Angel', but this seems to be a shift in interpretation, for he refers by this term to the appearance of a just angel who appears at the time of death to take away the soul for judgment. If the message of the panel is the repentance of the emperor, then the archangel in the right medallion could be seen as a way visually of portraying the anger of God towards the wrong-doer, while the Virgin on the left would presumably represent an intercessor for the prayers for forgiveness of the penitent. According to this line of interpretation, the message of the mosaic is connected with a public recognition of some wrong done by an emperor.

On the basis of style, the historical event which lies behind the mosaic is likely to fall within a period of, say, fifty years after the production of the apse mosaic of 867. Within this bracket of time it is not difficult to find emperors whose actions might have led them to be represented in extreme penitence. For example Basil I (867-86) was penitent for his assassination of his

VIII

co-emperor Michael III, especially when his favourite son and heir Constantine died prematurely in the summer of 879 and Basil took this as a sign of the anger of God and was virtually mad for the rest of his life.[31] Or there is the next emperor Leo VI (886-912). Leo committed the sin of marrying four times in defiance of Orthodox canon law which forbade marriage three or more times. S.Basil had made the patristic attitude quite clear on this subject: a third marriage was 'polygamy and fornication', while a fourth marriage was 'beastly polygamy', 'a way of living befitting swine and contrary to human nature', and 'a sin worse than fornication'.[32] With this firm tradition behind him, the patriarch Nicholas Mysticos banned Leo VI from entering into the nave of S.Sophia on Christmas Day 906 because of the sin of his fourth marriage. The emperor returned to the church on the feast of Epiphany on 6 January 907, and was to his anger refused entrance again. But this time he decided to accept the ban, and he 'cast himself on the ground and wept'. Oikonomides emphasises that this scene of public humiliation took place in front of the doors above which the mosaic now appears. Leo's method of getting round the problem was to exile the strong-minded patriarch in February 907 and to appoint Euthymios in his place. Euthymios did allow the emperor into the nave of the church, but he made conditions: that Leo like a penitent was not to exercise the normal imperial right of access into the sanctuary and he must stand while attending services.

With these two candidates in the period it might seem straightforward to make a case that one of these two emperors set up this commemoration of his penitence.[33] Oikonomides proposes a more refined interpretation. He denies that it is conceivable that a Byzantine emperor like Basil I could commission a public confession of his crime in a mosaic picture, or that Leo VI had the opportunity to represent himself as 'saved', for he did not officially repent until shortly before his death in 912. His interpretation of the iconography is this: the mosaic was the commission of the patriarch Nicholas Mysticos (who regained office in May 912) and is to be dated to a time immediately after the church council of 920 which finally confirmed the pardon given to Leo VI before his death. According to this view the mosaic records the humiliation of Leo VI after flouting the law of the church; it shows the triumph of the patriarch over the emperor, and was set up as a warning to future emperors with a specific political message.

In this interpretation of the scene, art has been used to reflect a topical issue, but in a much more specific way than in the apse of the church. The main difficulties in the interpretation of Oikonomides are obvious — did Byzantines compose iconography in this way? Does it sufficiently explain the omission of the emperor's name? How exactly is the mosaic to be read — does it show virtually a historical event or is it to be seen in more abstract terms? Is the iconography unique?[34]

It is interesting to find that another scholar, Mango, took this mosaic to exemplify the way in which he understood Byzantines to use art: 'it is characteristic of Byzantine sacred iconography that it should admit various overtones of interpretation.' He gives a suggested interpretation, but allows that 'the primary meaning of the mosaic ... need not be its only meaning.'[35] This

140

mosaic takes us to the heart of the difficulties in interpreting Byzantine icono-
graphy; with so little help from their literature, what are the levels of interpre-
tation which we can attribute to the period?

Some specific difficulties about the study of Oikonomides can be touched
on here. A date of 920 or afterwards is late for the style of the mosaic, although
the lack of dated comparative material makes it impossible to press such a
point. On the question of the patron of the mosaic, it is true that to produce a
mosaic in this location was not as expensive in scaffolding as work in the nave,
for which Photios in his homily of 867 implies a subvention from the emperor
was necessary. However, it is far from proved that it was a patriarch rather than
an emperor who initiated the narthex panel. If one believes that an emperor
should be considered the more likely donor, Basil I or Leo VI might still be
seen as penitents. Alternatively, if Oikonomides is right that neither of these
could represent themselves as penitents, it may follow that not penitence but
some other meaning was intended. Oikonomides mentions that Basil I at the
Council of Constantinople of 869 spoke of his humility and readiness to
prostrate himself before God. Another interpretation is that the emperor in
the mosaic is praying for the gift of Holy Wisdom from the patron of the
church.[36] The last word on the interpretation of this panel has not been said.

THE PANELS OF THE SOUTH GALLERY

The theme of patriarchal rather than imperial patronage is developed by
Oikonomides in a second paper.[37] The mosaic which he discussed is an eleventh-
century addition to the decoration of S.Sophia and is located on the east wall
of the south gallery. Since it is inside the area of the gallery separated from the
rest of the church by a sculptured marble partition and usually supposed to
have the function of an imperial private box, this panel has in previous litera-
ture been attributed to imperial sponsorship.[38] The new suggestion is that the
mosaic was not an imperial declaration of piety and munificence, but the work
of grateful patriarchs. It is this pattern of sponsorship, according to
Oikonomides, which offers an explanation for the curious technical features of
the panel which have puzzled art historians. The technical oddities are to be
explained as the result of economies made by the thrifty patriarch Michael
Keroularios (1043-58). This idea of the disinterestedness of the imperial family
is hard to accept, and it is possible to propose an alternative explanation to that
of Oikonomides for the technical procedures of the panel.

The panel in question (plate 6) shows an emperor on the right hand of
Christ offering a donation of money; the empress on the other side of Christ
holds the contract which would have been given to the church. In his discussion
of the iconography Mango argued that in modern terms the composition,
characterised by its lack of a spatial setting, would be interpreted as symbolic
of a donation, whereas for a Byzantine it was quite explicit – the donation was
being made to Christ and *there* he was receiving it.[39] Since this panel was
apparently unprecedented in the gallery, it must have been intended to record
some very special donation rather than the regular occasions when the emperor

was expected to make offerings.

The interpretation of the panel is complicated by its technical features noticed as soon as it was uncovered by Whittemore.[40] Plate 6 is a photograph taken in 1935 during conservation and is a record of the mosaic surface before toning in. The alterations in the faces and inscriptions would not have been so visible in the Byzantine period when they would have been masked by painted plaster. In the church today the sutures are also masked by paints. The fact is that the panel has two Byzantine phases. The present face of each of the three figures is later in date than the body to which it is affixed. Only the name and identity of one of the figures has been changed, that of the emperor. Zoe was the empress in both phases of the mosaic, for the inscription which identifies her was never retouched. Zoe is to be identified with the daughter of the emperor Constantine VIII who succeeded him in 1028 in the lack of any male heir. She bestowed the imperial rank on her successive husbands.

Studies of the inscriptions, and the events of the period of Zoe have given a fairly close dating for each of the two phases of the Zoe panel. The original mosaic must have illustrated a donation by Zoe and her first husband Romanos III Argyros (1028-34). Their donation is independently documented by literary sources, and it consisted of a supplementary annual income paid to the church out of the imperial treasury; at the same time the capitals of the church were gilded.[41] The alterations of the second phase were made in order to celebrate a new donation by Zoe and her third husband, Constantine IX Monomachos (1042-55). This was apparently a new supplementary income to enable the liturgy to be celebrated daily instead of as previously only on great feast days, Saturdays and Sundays. Although this second donation was probably even more generous than the first, it was not marked by a second commemorative panel which would have proclaimed even more conspicuously the piety of Zoe. Instead the panel was subjected to an adaptation which, however skilfully masked by the artist, meant that Zoe is seen beside the body of her first husband and the head of her third. For some reason, both her head and that of Christ were remodelled also.

Oikonomides offers an explanation for the technical procedures of the second phase of the panel. It would have been the patriarch Michael Keroularios who was probably the recipient of the imperial generosity. He would have felt the obligation to make a public statement of his gratitude but his natural thriftiness led him to an economical solution, the adaptation of the already existing panel. The artist employed on the work had to design a new head for the emperor and alter the inscriptions from Romanos to Constantine, but he managed to find some earlier panel (or panels) from which he transferred the head of Zoe and, presumably, of Christ. He was able to fit these earlier mosaics into the available matrices of the Zoe panel. Oikonomides dates this postulated earlier mosaic of Zoe between 1000 and 1020 when she was in her twenties or thirties. He excludes the possibility that the face in the present panel could have been manufactured after 1042 and before her death in 1050 on the argument that this is the portrait of 'obviously a very young woman'. He 'is confident that no one will maintain that this is a representation of a woman more than sixty-four years of age.'

INTERPRETING THE MOSAICS OF S. SOPHIA AT ISTANBUL

In the following paragraphs I shall offer an alternative interpretation which does indeed propose that this is a portrait of the empress aged sixty-four or more at the time of its production. As I see it, the emperor Constantine, and not a patriarch, was the instigator of the adaptation of the panel. Constantine was a big spender, one of the greatest patrons of mosaic in the history of Byzantine art, with his major commissions documented in the Church of S.George of the Mangana in Constantinople, at Nea Moni on Chios, and in the Holy Sepulchre at Jerusalem.[42] A man of this temperament was hardly likely to miss his chance of a mosaic commemoration in S.Sophia, especially if his donation was meant to overshadow that of Zoe's first husband who was already commemorated and conspicuously visible in mosaic whenever the new imperial couple went to services. But, even leaving aside his feelings towards his predecessor, Constantine had a serious problem. His marriage to Zoe was her third, and so against church law. The patriarch Alexios had refused to marry the couple — the ceremony had to be carried out privately in the palace — but he did concede to crown them in S.Sophia. Constantine's problem was that it was scarcely possible for him to set up a mosaic panel in S.Sophia beside that of Romanos. Are we not in the presence of a more tactful solution in which he visually 'annulled' the previous marriage of Zoe? This removal of an embarrassing circumstance would give a positive reason for the remodelling of the panel.

This cannot, however, be the full reason for all the puzzling features of the second phase of the panel. Why were the faces of Zoe and Christ both changed as well? One explanation which has been suggested is that they were changed in order to maintain stylistic unity with the new head of Constantine. Such a sensitivity to changing trends in style in Byzantium is hard to credit, but the idea does point to something with which I agree: all three faces ought to be attributed to the hand of one artist at one point in time, and a date between 1042 and 1050 would seem to be supported by a comparison with the mosaics of S.Sophia at Kiev and of Nea Moni on Chios. The far-fetched suggestion that two faces were pirated from some pre-existing and no longer required mosaics should be dismissed from further consideration.[43] I also think it would be in line with the reasoning I have suggested for the artist responsible for the adaptation of the panel to the new regime to decide to remove the face of Zoe in the role of the wife of Romanos.

A few points must be made in support of the identification of the portrait of Zoe as a representation of a woman in her late sixties. The mosaic was of course an 'official' portrait, and the artist would no doubt be expected to record her as she wished to be seen. Fortunately we have a literary portrait of Zoe at this age by a courtier who knew her well. Michael Psellos in his *Chronographia* writes:[44]

> Her eyes were large, set wide apart, with imposing eyebrows. Her nose was inclined to be aquiline, without being altogether so. She had golden hair, and her whole body was radiant with the whiteness of her skin. There were few signs of age in her appearance: in fact, if you marked well the perfect harmony of her limbs, not knowing who she was, you would have said

here was a young woman, for no part of her skin was wrinkled, but all
smooth and taut, and no furrows anywhere.

Psellos repeated the main points of this description in another passage on her
appearance at the end of her life:[45]

Although she had already passed her seventieth year, there was not a
wrinkle on her face. She was just as fresh as she had been in the prime
of her beauty.

Zoe presumably achieved her appearance partly through her fanatical research,
which Psellos describes as taking place in her private apartments in the palace,
into the development of new perfumes and the preparation of unguents.

No doubt the mosaicist, like Michael Psellos, had observed the character of
the empress, and understood from his observations how to flatter his clients.
Another factor should be borne in mind. Byzantium was not a society in which
there was a market for professional portraitists. In view of the lack of scope for
this sort of work, the mosaic portrait of Zoe is a considerable achievement, and
one suspects that in it, and in that of Constantine Monomachos, the artist went
some way towards capturing a likeness. But even more difficult than suggesting
a likeness in portraiture is the portrayal of the age of a sitter. The truth is that
the mosaicist has scarcely achieved any rendering of age at all: the indications
of youth or of age are both equally missing.

The faces of the emperor and empress can both appropriately be dated to
their joint reign as the work of one artist who cut out the previous portraits
and adjusted the panel to record the new donation. The greater problem to
explain is why he also remade the face of Christ; no reasonable motive has so
far been suggested. I want tentatively to suggest a solution. There would be a
reason behind the change in the face of Christ if it were accepted that there is
a resemblance between the face of Christ and that of Constantine Monomachos.
There is one other mosaic where a facial resemblance between a ruler and
Christ has been proposed.[46] This is the twelfth-century Sicilian panel in the
Martorana of Roger II crowned by Christ. In publishing this interpretation of
the panel, Kitzinger argued that all the ideas in the mosaic were derived from
Byzantium save this one; this was a conception limited to the West of Europe,
for the Byzantine theory of the icon would not allow any human to be por-
trayed in the likeness of Christ. Yet one can find this idea ingrained in Byzantine
literature. One of the most explicit statements is found already in the sixth
century in the court poetry of the panegyricist Flavius Corippus:[47]

Christ gave earthly lords power over all: He is omnipotent, and the earthly
king is the image of the omnipotent.

If this conception of the relationship of the Byzantine emperor to Christ did
ever pass from literary statement into visual art, it would provide the explana-
tion for the need to reset the face of Christ in this mosaic. Even more so if in
the original panel the representation of Christ had been given a facial

144

resemblance to Romanos III.

Study of the technical features of the Zoe panel helps one to enter into the imperial use of imagery in recording donations to the church and shows the several levels of interpretation. There is another imperial panel in this area of the south gallery. This time the central figure is the Virgin and Child; the other figures are John II Comnenos (1118-43), his wife Eirene and his son Alexios. There is a problem in discussing this panel which can only be clarified by a new examination in the church. Whittemore in the basic publication of the mosaic discussed the extent of the original panel which he thought was narrower than it is now in its final state. Although he could see no visible suture between the figure of Alexios and the rest of the panel, Whittemore did conclude that Alexios was a later addition. He deduced this from a number of anomalies: the figure is set at right angles to the rest on the pilaster to the right, it is not on the same level as the others, and in some parts the tesserae differ slightly in hue from the rest of the panel. Whittemore thought it a work of the same mosaicist, but made a few years later than the main part of the panel.[48] The interpretation which has been accepted on the basis of this relative chronology is that the purpose of the panel was to celebrate the accession of John and Eirene in 1118, and that the figure of Alexios was added as a further commemoration of his elevation as co-emperor in 1122. One would have to interpret the purse held by John as the regular coronation donation at the time of one or both celebrations. More recently Mango has denied the existence of two phases, since there is no visible break, and he therefore dates the panel to 1122 or shortly afterwards.[49] Perhaps it is necessary to try and connect the commission of the mosaic with some special donation between 1122 and 1134 (when Eirene died). If the panel was designed with intentional asymmetry, it would in part parallel the design of the composition of the narthex lunette, possibly for some iconographic reason.

The third panel in the south gallery is on the west wall at the west end of the imperial enclosure.[50] Of this Deesis, something like a third of the original mosaic has survived, the upper parts of the Virgin, Christ and S. John the Baptist (plate 7). The great achievement of the artist is to have composed a work which is massive and monumental in scale, but with figures whose attitudes and expressions make them sympathetic and approachable through prayer. The master of the Deesis of S.Sophia should be recognised as one of the great artists of Byzantium and perhaps the greatest individual influence on late Byzantine art. The ninth-century Deesis in the patriarchal palace nearby (plate 2) is a much weaker version of the same composition.

The publication by Whittemore is unsatisfactory in several respects. The height of the original panel was greater than he thought and his published reconstruction is iconographically misleading as well as aesthetically hideous.[51] There would have been room on the lower part of the mosaic for a small donor figure, and this opens the possibility that the historical circumstances were once easier to recognise. The deficiencies of the publication and the (incorrect) widespread belief that the mosaics do not belong to one homogeneous period have caused the importance of the panel to be underestimated.[52] My interpretation of the panel, taking into account the technical information, is that it has

145

an underlying topical reference and was an imperial commission in 1261; it celebrated the reconsecration of S.Sophia as the Orthodox cathedral after the expulsion of the Latin clergy and formed part of the redecoration of the church at the time of the coronation of Michael VIII Palaiologos. The Deesis would then be another example of how in Byzantine art, as in Byzantine literature, the immediate topical reference is hidden. This must not dissuade the interpreter from searching for the precise occasion which gave the impetus for the commission.[53]

OUTLOOK

The work of the last fifty years in S.Sophia is most notable for its contributions to the archaeology of Byzantine art. My claim at the outset of this paper was that the mosaics are to be seen as the best examples of the medium to have survived. Yet they are also representative works of the culture: generalising from the mosaics of S.Sophia is justified, and is not like generalising about the Doric temple from the evidence of the Parthenon.[54]

There remain considerable areas of mosaic in S.Sophia to uncover and record, mostly from the Justinianic period, but not all so. For example, fragments of an (eleventh-century?) figural cycle in the chapel in the south-west buttress remain to be published. The mosaics already uncovered require vigilant attention and maintenance (as does the structure of the building). For example, the panel over the entrance from the south-west vestibule (plate 8), at present attributed to the ninth or tenth century when this entrance had become more important in the ceremonial of the church, was uncovered by Whittemore in 1933-4.[55] It now needs further consolidation and study. In general terms its meaning seems to be that both the city of Constantinople and the church of S.Sophia are offered to the protection of the Virgin by Constantine and Justinian.

At the present time the work of consolidation and discovery supported by Dumbarton Oaks has lapsed. One hopes that the conservation of the monument will remain a matter for international concern and support. Linked with the work of recording the mosaics is the question of illustration. Although Whittemore and Dumbarton Oaks have published some superb black and white photographs, only a few good colour plates are available. This is the most permanent form of record and more such plates are needed. S.Sophia offers endless scope for the study and interpretation of Byzantine art; because the mosaics can generally be closely dated, they are a channel through which the art historian can hope to discover the methods of Byzantine artists and patrons.

INTERPRETING THE MOSAICS OF S. SOPHIA AT ISTANBUL

BIBLIOGRAPHY

(A chronological list of the main publications of the mosaics of S.Sophia and key to abbreviations used in the notes)

Whittemore (1933)	T. Whittemore, *The Mosaics of St.Sophia at Istanbul. 1931-2. The Mosaics of the Narthex* (Oxford, 1933).
Whittemore (1936)	T. Whittemore, *The Mosaics of St.Sophia at Istanbul. 1933-4. The Mosaics of the Southern Vestibule* (Oxford, 1936).
Whittemore (1942)	T. Whittemore, *The Mosaics of Haghia Sophia at Istanbul. 1935-8. The Imperial Portraits of the South Gallery* (Oxford, 1942).
Whittemore (1952)	T. Whittemore, *The Mosaics of Haghia Sophia at Istanbul. 1934-8. The Deesis panel of the South Gallery* (Oxford, 1952).
Underwood (1951)	P.A. Underwood, 'A Preliminary Report on some Unpublished Mosaics in Haghia Sophia', *American Journal of Archaeology*, 55 (1951), 367-70.
Underwood (1956)	P.A. Underwood, 'Notes on the Work of the Byzantine Institute in Istanbul: 1954', *Dumbarton Oaks Papers*, 9-10 (1956), 291-4.
Underwood and Hawkins (1961)	P.A. Underwood and E.J.W. Hawkins, 'The Mosaics of Haghia Sophia at Istanbul. 1959-60. The Portrait of the Emperor Alexander', *Dumbarton Oaks Papers*, 15 (1961), 187-217.
Mango (1962)	C. Mango, *Materials for the Study of the Mosaics of St.Sophia at Istanbul* (Dumbarton Oaks Study 8, 1962).
Mango and Hawkins (1965)	C. Mango and E.J.W. Hawkins, 'The Apse Mosaics of St.Sophia at Istanbul', *Dumbarton Oaks Papers*, 19 (1965), 113-51.
Kähler and Mango (1967)	H. Kähler and C. Mango, *Haghia Sophia* (London, 1967).
Hawkins (1968)	E.J.W. Hawkins, 'Further Observations on the Narthex Mosaic in St.Sophia at Istanbul', *Dumbarton Oaks Papers*, 22 (1968), 151-66.
Mango and Hawkins (1972)	C. Mango and E.J.W. Hawkins, 'The Mosaics of St. Sophia at Istanbul. The Church Fathers in the North Tympanum', *Dumbarton Oaks Papers*, 26 (1972), 1-41.
Oikonomides (1976)	N. Oikonomides, 'Leo VI and the Narthex Mosaic of Saint Sophia', *Dumbarton Oaks Papers*, 30 (1976), 151-72.
Cormack and Hawkins (1977)	R. Cormack and E.J.W. Hawkins, 'The Mosaics of St.Sophia at Istanbul: the Rooms above the Southwest Vestibule and Ramp', *Dumbarton Oaks Papers*, 31 (1977), 175-251.
Oikonomides (1978)	N. Oikonomides, 'The Mosaic Panel of Constantine IX and Zoe in Saint Sophia', *Revue des Etudes Byzantines*, 36 (1978), 219-32.

Also used in the notes:

Mango, *Art*	C. Mango, *The Art of the Byzantine Empire 312-1453. Sources and Documents* (Englewood Cliffs, New Jersey, 1972).

NOTES

1 Whittemore (1942), 6.
2 *Dumbarton Oaks Papers*, 18 (1964), 319.
3 O. Demus, 'The Role of Byzantine Art in Europe', *Byzantine Art. An European Art* (Athens, 1964), 109.
4 I. Andreescu, 'The Corpus for Wall Mosaics in the N.Adriatic Area', *Bulletin de l'Association pour l'étude de la mosaique antique*, 7 (1978), 317-23. The most recent survey of opinion on mosaic technique is by P.J. Nordhagen, *New Encyclopaedia Britannica* (15th edition, 1974), vol. 12, 462-74 (Mosaic).
5 An example taken at random is D.M. Nicol, *Church and Society in the Last Centuries of*

Byzantium (Cambridge, 1979), 63: writing of the Chora monastery, he says that the mosaics and frescoes were 'executed, as always, by anonymous artists'. In fact artists' signatures become more frequent from the twelfth century; it is also fallacious to suppose that if a work is unsigned no profile of the artist can be pieced together.
6 Much of the material that there is has been collected together by Mango, *Art*; the same scholar in *Byzantium* (London, 1980) has produced an assessment of Byzantine cultural life which will shape future discussions on the subject.

INTERPRETING THE MOSAICS OF S. SOPHIA AT ISTANBUL

7 Mango, *Art*, 96ff. and 263.

8 The translations of B. de Khitrowo, *Itinéraires russes en orient* (Geneva, 1889), are notoriously unreliable. A new edition of the texts is promised by G.P. Majeska, who has published some results of his work, 'St.Sophia in the Fourteenth and Fifteenth Centuries: the Russian Travelers on the Relics', *Dumbarton Oaks Papers*, 27 (1973), 69-87. For Antony of Novgorod, see Mango, *Art*, 237.

9 R.L. Van Nice, *Saint Sophia in Istanbul: An Architectural Survey* (Washington, 1965).

10 The records of the Fossati and other visitors were systematically studied by Mango (1962), a book which put the study of the church on a new footing.

11 See Mango and Hawkins (1972) on the tympana ornamental vocabulary; and Cormack and Hawkins (1977) on the dating of the mosaics of the west gallery, and the question of the alcove in the south-west rooms.

12 For illustrations, see E. Kitzinger, *Byzantine Art in the Making* (London, 1977). To what survives one can add literary descriptions, such as that of the extensive cycle of S.Polyeuctos.

13 C. Mango, 'The Church of Sts.Sergius and Bacchus Once Again', *Byzantinische Zeitschrift*, 68 (1975), 385-92; and M. Mundell, 'Monophysite Church Decoration' in *Iconoclasm*, ed. A. Bryer and J. Herrin (Birmingham, 1977), 59-74, esp. 70.

14 Mango, *Art*, 83.

15 Mango (1962), 87ff. This has not been archaeologically examined, but the fourteenth-century representation is unlikely to have survived.

16 Mango, *Art*, 86.

17 *Ibid.*, 75.

18 Underwood (1951), Underwood (1956), and Cormack and Hawkins (1977).

19 C. Mango, *The Homilies of Photius, Patriarch of Constantinople* (Cambridge, Mass., 1958); and see C. Mango, 'The Liquidation of Iconoclasm and the Patriarch Photios' in *Iconoclasm* (see note 13), 133-40.

20 Mango and Hawkins (1965). The work in the apse has shown perhaps more than anywhere else the value of precise technical observations: most of the conclusions drawn from observations from the ground or from photographs were wrong.

21 Mango and Hawkins (1965) discuss the text.

22 E.C. Dodd, 'The Image of the Word', *Berytus*, 18 (1969), 35-61, argues that the Islamic development of a non-figural art for the mosque might depend on the logic that not Jesus but the word of God came down from Heaven.

23 Mango, *Art*, 142.

24 One anomaly in present research is the portrait of the emperor Alexander, published by Underwood and Hawkins (1961). There is a disagreement in the literature on the date of this mosaic, whether during his sole reign (912-13) or earlier in his lifetime. Until this is resolved, it is hard to say whether the location of the image is whim or planned.

25 Mango and Hawkins (1972).

26 Mango and Hawkins (1972), 38-9, give some support to the suggestion that S.Gregory the Illuminator was chosen to reflect the myth fabricated by Photios shortly before 877 that Basil I was of Arsacid origin.

27 Cormack and Hawkins (1977).

28 C. Walter, *Studies in Byzantine Iconography* (Variorum Reprints, London, 1977), where studies I and II are reprints of articles on the Deesis.

29 Whittemore (1933) showed that the mosaic was a replacement of an earlier decoration, probably a cross of the Justinianic foundation. Hawkins (1968) found that the sigla of Christ were additions, probably of the eleventh century. He found that the tesserae of the boots of the emperor had originally been coloured with red vermilion paint — Whittemore was wrong to look in texts for occasions when the emperor wore white shoes.

30 Oikonomides (1976).

31 For graphic accounts of the moral turpitude of these emperors, see R.J.H. Jenkins, *Byzantium. The Imperial Centuries AD 610-1071* (London, 1966), 195ff.

32 Oikonomides (1976), and in his following paper in the same periodical, gives a full account of the issues and the sources.

33 The articles cited by Oikonomides (1976), 156, of Mirković proposed this in relation to Leo VI.

34 Oikonomides (1976) believes the narthex composition to be unique ('a *hapax* in Byzantine art'), whereas Mango, *Art*, 220, considered an eleventh-century work of art described by John Mauropous in which an emperor is prostrate at the feet of Christ who is flanked by the Virgin and Baptist to be 'an obvious analogy'. Oikonomides, 158, note 24, correctly points out that this text does not describe our mosaic, but he does not take into account the wider iconographic context which this picture and explanatory text offers.

35 Kähler and Mango (1967), 54.

36 Cf. Z.A. Gavrilović, 'The Humiliation of Leo VI the Wise', *Cahiers Archéologiques*, 28 (1979), 87-94, maintains the interpretation of Grabar against that of Oikonomides; this paper is not sensitive, however, to all the observations made by Oikonomides.

37 Oikonomides (1978).

38 Oikonomides (1978) emphasises the patriarchal rather than imperial use of the south gallery, and located the church synods here. While it is reasonable to suppose that the gallery did have a double function, there is room for discussion whether the synods took place inside or outside

INTERPRETING THE MOSAICS OF S. SOPHIA AT ISTANBUL

the marble partition. It seems to depend on exactly where the oratory of S.Alexios was located, in front of which the meetings took place. There is an oratory in the Large Sekreton of the Patriarchate, of which the east window looked out over the south-west of the gallery. Could this have been the oratory of S.Alexios?

39 Kähler and Mango (1967), 56.
40 Whittemore (1942). M. Hendy, *Coinage and Money in the Byzantine Empire 1081-1261* (Washington, 1969), 308-9, connected the panel with the donation of Romanos.
41 Cited by Oikonomides (1978), 223-4.
42 Some work at S.Sophia at Kiev can be attributed to this reign. I do not accept the attribution of the mosaics of Hosios Lukas to Constantine.
43 Oikonomides (1978), 232, refers to the Byzantine re-use of mosaic, but the re-use of tesserae is not the same thing as the transfer of sections of mosaic. Other references to the salvage of tesserae can be found.
44 I quote the translation of E.R.A. Sewter, *The Chronographia of Michael Psellus* (London, 1955), 115 (bk 6, section 6).

45 *Ibid.*, 179 (bk 6, section 158).
46 E. Kitzinger, 'On the Portrait of Roger II in the Martorana in Palermo', *Proporzioni*, 3 (1950), 30-5; reprinted in E. Kitzinger, *The Art of Byzantium and the Medieval West* (Indiana, 1976).
47 Flavius Cresconius Corippus, *In laudem Iustini Augusti minoris. Libri IV*, edited Averil Cameron (London, 1976), bk II, 428; cf. commentary 178-9. I give her translation.
48 Whittemore (1942), 28.
49 Kähler and Mango (1967), 58.
50 Whittemore (1952).
51 Mango (1962), 29, note 34, has pointed out Whittemore's error.
52 Cormack and Hawkins, 'The Deesis Mosaic in S.Sophia and Late Byzantine Art' (forthcoming) attempts to rectify the position.
53 Cf. C. Mango, *Byzantine Literature as a Distorting Mirror* (Oxford, 1975).
54 I take the analogy from A. Cutler, 'The Aristocratic Psalter: the State of Research', *Actes du XVe Congrès international d'études byzantines*, I (Athens, 1979).
55 Whittemore (1936).

ARISTOCRATIC PATRONAGE

OF THE ARTS IN 11th- AND 12th-CENTURY

BYZANTIUM

The aim of this paper is not just to illustrate examples of aristocratic patronage, but to ask if one can find any influence made by the aristocracy as a social group on the production of the visual arts. Even the first of these two possible aims, although conceptually simple, has its difficulties, not least because of the deficiencies of the empirical evidence; for this reason some review is needed of the way in which reference is made to 'aristocratic art' in art historical literature. The outcome of such a review may be to do little more than to expose the isolation of Byzantine art historians from modern sociological theorizing on the issues involved, but even this may help to emphasise the need for a new beginning to be made in the analysis of art as a social production.[1] I at least have found the current exercise an essentially negative one,[2] but it helps to identify the crude ways in which not only art historians but also other historians interpret the visual aspects of Byzantine culture. What is disturbing is not any acceptance that there is a distinct sphere of discourse concerned with art and culture (for this can be justified), but to find such material treated as an optional extra in the study of society and religion or as an aid to mere visualisation of historical personages and their environment (treating art as 'the icing on the cake'). There is much to be done to promote the view that art is an integral component of medieval society and always encodes values and ideology which can therefore be reconstructed by the modern historian.[3] In the case of Byzantine culture the value of studying visual communication needs to be emphasised in the light of recent work on orality and literacy in the Middle Ages.[4] Unlike the literary productions of the aristocracy, the visual arts involved a more complex social construction, involving practitioners, patrons, audiences, theorists and critics, and the products themselves. The question then arises whether aristocratic patrons might be one definable element in this equation, and so, after the discussion of traditional art historical approaches, the latter part of this paper will turn to one area of documentation where evidence of the artistic activities of the aristocracy can be quantified.

I

Art historians rarely refer to ´aristocratic art´ - perhaps under the convention that in the Middle Ages art is the product of the rich, and if it is not aristocratic, it is not art. This would explain why ceramics and some of the ´minor arts´ are so often tacitly left aside by the art historian and have to wait for archaeological analysis. For the study of levels of patronage, it may well be that a medium like pottery with its technical indications of cost and function can lead to firmer conclusions.⁵ Another group of objects which has taken on greater or lesser importance as an indicator of levels of patronage or of developments in the history of art depending on their supposed metallic component is the ampullae from the Holy Land. Greater prominence for these objects in art historical study resulted from the analysis of the collections at Monza and Bobbio by Grabar, but recently his conclusions have been seriously criticised by Engemann.⁶ Grabar for example incorrectly believed that the ampullae (normally dated to the sixth or early seventh century) were made of silver; in fact, as technical examinations have shown, they were less expensive productions in an alloy of tin and lead and were presumably made in quantity.⁷ The social position of the purchasers of this variety of pilgrimage souvenirs has yet to be determined: much also remains to be said about their status as images with ´magical´ properties derived from the oil they contained.

One area of artistic production in Byzantium for which the consumers were entirely limited to the wealthy was that of illuminated manuscripts.⁸ Such books lead us into the select society of the rich in Byzantium, whether one refers to these patrons as the aristocracy, the nobility, the élite or some such category. But there has been some attempt even within this medium to make distinctions between ´aristocratic´ and ´popular´ culture. This attempt has surfaced most clearly in the discussion of one type of book, illuminated Psalters. Although he expressed some reservations in using the term, Cutler in a recent discussion paper persisted in retaining the grouping of the majority of surviving Byzantine Psalters as the "Aristocratic Psalters".⁹ Cutler extended membership of the set from the eight proposed by Tikkanen in 1895 to 49 manuscripts, and he continued to believe that the grouping has real validity over and above the epithet applied to it. He readily admits that the manuscripts in question lack colophons which identify the precise status of the donors, but he feels the term aristocratic to have been shown correct in one case by Belting, who had proved the patron of the thirteenth-century psalter Vatican cod.Palat. gr. 381 rich enough to commission a poet to celebrate his patronage and in the matter of the choice of a model for imitation ready to turn to a famous ´antique´, the Paris Psalter of the tenth century (Paris, Bibl. nat. cod. gr. 139).¹⁰ Of course the patron of the Paris Psalter itself remains elusive. Buchthal sees the surviving book as no more than a heterogeneous manufacture with the miniatures having been intended for a different book than the one in which they are now bound.¹¹ In his current opinion the text of Paris gr. 139 may have been written in ´an imperial scriptorium´ in the third quarter of the tenth century, but the miniatures of this codex cannot be connected with imperial patronage (because of the low quality of some of them) although the cycle of pictures which they are supposed to copy is firmly attributed by him to the ´court atelier´ of Constantine Porphyrogenitus.

The manufacture of the codex which we have may be less complicated than Buchthal's reconstruction of several stages: Dufrenne, for one, is prepared to state that the arguments based on physical evidence that the miniatures (because of their discrepancies in size) are not made to accompany the present text are not at all conclusive.[12] Whether one can go so far as to propose that Paris gr. 139 is the innovating manuscript rather than a slightly later copy of a lost model is very controversial (and contrary to stated opinions), but one thing at least seems clear: the earliest surviving psalter which has been denoted 'aristocratic', and which therefore stands at the head of a series, was unlikely to have been commissioned as a book by an 'aristocratic' as distinct from an imperial patron. Furthermore if what we have is no more than a rehash of a lost imperial production, then the designation of this series of manuscripts as aristocratic is, so far as the sociology of art is concerned, misleading.

The matter of 'aristocratic psalters' cannot be left here with an expression of concern about the implications of the terminology, for the traditional division of illuminated psalters into two categories has come to reflect the interpretation of some art historians of a cultural dichotomy within Byzantine society. The other side of the equation is Tikkanen's second group of psalters, those with marginal illustrations, of which the best known are the Chludov Psalter (Moscow, State Historical Museum, cod. 129) and the Theodore Psalter of 1066 (British Library, add. 19352). Those art historians who have accepted the description of these psalters as 'monastic' have tended also to see their style as 'popular' and so set up a stylistic dichotomy apparently reflecting a social division. Logically enough this interpretation has been extended to other areas of artistic production, and the most obvious connection to make was between the Chludov and other immediately post-iconoclastic psalters with marginal illustrations and the ninth or tenth century wallpaintings of the rock-cut churches of Cappadocia. The criticism of such characterisations of these works is not difficult - for example, the Cappadocian church decorations are sufficiently numerous and varied that their classification into one group is impossible. We only have to take the 'New Church' of Tokali kilise which, as has been made visible by the recent cleaning, benefited from patronage which could afford lapis lazuli in areas of blue and gilding for the haloes; this work can be dated on stylistic grounds to the middle of the tenth century when paintings as poor and limited in material resources as those of Tavsanli kilise could also be produced. Yet despite the necessity of criticism of the crude analysis of Cappadocian and other painting as popular and monastic, the possibility of some kind of interpretation of some of the art of this region in terms of social structure cannot be dismissed, and would be worth attempting.

The theory that the Chludov Psalter was produced by and for use in a monastery and was therefore good evidence of a lively folk tradition within Byzantine society was dealt a critical blow in the 1930s when Malickij identified the liturgical indications in the text as belonging to the chanted office of the Church of S.Sophia in Constantinople itself.[13] Much recent scholarship is consequently dedicated to the question whether one of the immediately post-iconoclastic Patriarchs was responsible for its production. As for the Theodore Psalter, this has a colophon which proves that it was produced for monastic use at the famous monastery of St.John Stoudios

in Constantinople; der Nersessian made an attempt to define what was ˈmonasticˈ about the illustration.[14] The field of reference un-covered by her study shows the social and intellectual range of just one, however special, monastery; in this case from committed ascetics to aristocrats in retirement or even an ex-emperor. The patronage represented by illustrated psalters alone is potentially very diverse, with the possibility of distinguishing imperial patronage, aristocratic patronage etc. or in speaking in terms of the secular clergy, the monastery, the private patron etc.

The traditional dichotomy in which the illuminated psalters have been discussed would seem to have inhibited their understanding as historical documents; unfortunately, as hinted already with reference to Cappadocian painting, the broader study of Byzantine art has also suffered from an uncritical willingness to accept undefined (or undefinable) categories or concepts. Art historians have been fairly unsuccessful in producing satisfactory surveys of Byzantine art (which, if any, can be recommended to the student?), and even the survey of Byzantine painting most frequently accepted as reasonable in its coverage of material, that of the late Viktor Lazarev, lacks subtlety in its conceptual framework.[15] The insecurity of the anti-thesis between aristocratic and popular/monastic can be recognised in the example of illustrated psalters, but the difficulties can be shown in a number of other areas of production. One icon in the collection of the monastery of St.Catherine on Sinai, discussed in a number of publications by Weitzmann and dated by him to the eleventh or twelfth centuries, represents monks climbing up or falling from the ladder which in the writing of St.John Climacus symbolises the virtues needed and the vices to be avoided for a monk to reach heaven.[16] In the icon, a painting of great quality, a monk at the top of the ladder is welcomed into heaven: he is identified by an inscription as John Climacus in person. The larger figure behind him is identified as Archbishop Anthony. In his analysis Weitzmann tries to come to terms with several elements of the visual evidence. Since the icon is now on Sinai and since the treatise was written in the Sinai monastery in the sixth century, Weitzmann deduces that the icon was a special commission for the monastery. He also assumes that Anthony was a historical person at the time the icon was made, presumably the abbot of Sinai, and perhaps the donor. But the style of the icon and its high quality is something which Weitzmann would clearly prefer to connect with a major artist – one from Constanti-nople. Instead of proposing that the icon was made in the capital and despatched to the monastery, Weitzmann prefers the attribution of the icon to the monastery itself, the work of a visiting monk.

The problem of the icon is that its refined style and dramatic use of gold conforms with the notion of its being ˈaristocraticˈ art, but its subject matter in illustrating a text which every Orthodox monk is supposed to read every Lent can only be described as monas-tic. The suggestion that Anthony was archbishop and abbot of Sinai and is prominent because he was also the patron of the icon seems the most reasonable hypothesis, but unless he can be identified, his career and social background remains undocumented. If Weitzmannˈs idea that the artist was a ˈvisiting monk from the Capitalˈ were accepted, then the icon might be considered as a paradigm of monastic art; but this idea is pure speculation and cannot be used as part of any analysis. The icon therefore must be kept in mind whenever a

IX

162

definition of terms and an assessment of their use in the interpretation of visual art is made.

The same stylistic issue is set by the highly refined icon of the Annunciation in the Sinai Collection which Weitzmann dates to the late twelfth century and attributes to a Constantinopolitan artist.[17] Maguire has also connected the iconography of the painting with literary circles in the capital.[18] But the fact remains that its presence in a monastery has to be explained, and whether its unknown patron commissioned it with such a destination in mind. Another example which highlights the possible confusions is the cave church of St. Sophia on the island of Kythira, which contains wallpaintings published by Xyngopoulos as works of ʹmonastic styleʹ.[19] But the information given in his publication reveals that the small church was not directly attached to a monastery complex (he suggests it was an oratory for hermits), that it has no written indication of its patron, and that an inscription in the decoration names the artist as Theodore (historiographos) and includes in his invocation his wife and child - clearly the artist was no monk. The characterisation of the wallpaintings is derived entirely from a concept of style (derived in this instance from a vague comparison with Cappadocia and South Italy). The same point could be made of attempts to ʹexplainʹ the stylistic differences between the mosaics of Hosios Loukas and Daphni; Demus was prepared to speak of the monastic style of the former and of its monkish austerity which he contrasted with influence of the taste of ʹHellenistic Court circlesʹ on the latter.[20] Yet in both cases the mosaics decorated the main church of a monastery complex and would have required very substantial funds for their production. How this money was raised is uncertain in both cases, and an explanation for their stylistic appearances must depend on broader considerations; furthermore both monuments have their stylistic parallels which must be taken into account, as, for example, the conspicuous similarity of some of the mosaics of the metropolitan church of St. Sophia at Kiev with Hosios Loukas.

One reason for the arbitrary nature of the categories used apparently unselfconsciously in art historical discourse lies in the method of approach: the definition of style is undertaken first and then followed up with some kind of explanation. This method is to some extent the legacy of Wolfflin, and it is now a mark of traditional art history to use the visual evidence as the basis for problem discovery. An essential part of this method is comparison, and consequently the tendency is to see the issues in terms of dichotomies. The same visual material can easily be characterised in emotively different terms: some works already mentioned can as easily be found described in the duality of metropolitan/provincial, hellenistic/oriental, or illusionistic/linear as in that of aristocratic/ monastic. To make this point is not to deny that binary oppositions can be valid terms of perception and analysis, but to warn that the terms of reference chosen may lead to fantasy conclusions and that more fruitful concepts may not be developed. The distinction of aristocratic from monastic art is not a justified polarity within Byzantine society; it attempts to interpret stylistic observations within a crude framework of social structures and it ignores such obvious questions as the role of artists and other considerations in the development of Byzantine art.

In the case of one major twelfth-century wallpainting, which is certainly an outstanding masterpiece of the period (even if its innovative appearance may be exaggerated by the losses of material), the preservation of the dedicatory inscription has meant that the aspect of patronage has here been taken into account in the explanation of quality and style. This is the wallpainting of the church of St. Panteleimon at Nerezi, dedicated in 1164 and commissioned by Alexius Comnenus, grandson of Alexius I.[21] Although virtually nothing is known about this member of the family (what his connection was with the region near Skopje, for example), the social status of the patron has been considered in explanations of the expressive narrative art unexpectedly to be found in this monastic church. One meets the (superficial) explanation of the effectiveness of the Nerezi painter in terms of a twelfth-century ´renaissance´, which must presumably be envisaged as initiated by the imperial family, art being used in the service of a political message – the revival of hereditary power – and so in one sense aristocratic in intention.

A different way of taking the patronage of Nerezi into account has been followed by Djurić.[22] He systematically divided wallpaintings into two groups, with numerous examples of each category. Nerezi fell into the first group of art, that ordered and directed by the laity i.e. courtiers or nobles; into the second group fell paintings like the earliest phase in the church of the Mavriotissa near Kastoria (which I date to the period around 1100),[23] which are described by Djurić as made on the order of monks or members of the higher clergy. He argues that the second (monastic) group reflects the social class of the patron in its choice of style; monks preferred clear contrasts of colour. Likewise the first group is distinctive because the laity preferred a richer palette in the tradition of hellenistic art. Djurić states his belief that this stylistically recognisable division occurred in art both before and after the eleventh and twelfth century examples on which his argument was based. Some of the theoretical objections to these two crudely interpreted groups have already been mentioned and do not need to be laboured, but one important point is made by Djurić. This is that the wealth of the patron may be an important factor in the style of a work of art. Is there a relation between quality in medieval art and the funds available to the patron? Do the rich obtain the best artists? It is difficult to pose the issue in the form of questions which could be answered by the available evidence, but the proposition does seem to be generally accepted by art historians. A theoretical justification can be made on the lines that within a didactic religious art system, workmanship is pre-eminently valued, and so the richer patron is the catalyst for quality in its production since he can use the most refined materials and employ the best practitioners.

II

The shortcomings of such art historical characterisations of ´aristocratic´ show how undeveloped is the present discussion of art as a projection of social structures. Within the period and scope of this paper I can do no more than suggest two more historical approaches which might lead to more constructive results.

The important analytical study by Kazhdan of families and the

basis of power in Byzantium emphasises a fundamental division in the aristocracy, and recognises a civil and a military aristocracy.[24] The art historian needs therefore to consider whether such a division of the aristocracy could explain trends of patronage or of artistic development. Can the patronage of such major groupings be distinguished? One place to consider the question in the twelfth century is in the wallpaintings of Cyprus, where at the beginning of the century a number of churches are preserved with their wallpaintings. Recent discussions of these monuments have been in agreement about their significance.[25] The decoration of the chapel of the Holy Trinity in the Chrysostomos monastery commissioned by Eumathios Philokales is seen as the first of a series which includes among others Trikomo and Asinou (the latter being dated by inscription to 1105/6). The Chrysostomos paintings are taken as examples of the transfer from Constantinople of new developments in style brought by a major metropolitan painter (or painters) under the patronage of the doux (governor): the Asinou paintings are taken as an imitation of the new model by an inferior provincial painter working in a badly constructed small monastic church under the patronage of an otherwise undocumented Nicephorus Iskhyrios.[26]

Before commenting on the patronage of these paintings, some qualifications are needed on the art historical side. Although the evidence of the surviving paintings is that a new development begins in Cyprus at Chrysostomos, it is not certain that Eumathios Philokales was the employer who brought the painter to Cyprus, for a major (and now lost) imperial commission was also carried out on the island at this period in the new Kykko monastery for Alexius I. The work at Chrysostomos and elsewhere could therefore represent examples of further commissions on the island by artists who initially came to work for the emperor; this opens up the possibility that the work at Chrysostomos, Trikomo, Asinou, and elsewhere ought to be considered as the works of the same painter and his assistants and are distinguished less by quality of style than by differentials of cost, quantity and range of materials, and of speed of execution. In other words the distinction between metropolitan and provincial in these monuments is not self-evident. Another reason why the dichotomy metropolitan/provincial may be unrealistic in the twelfth century is that the quantity of artistic work carried out throughout the Byzantine world would make it feasible for major artists to have worked almost exclusively in the regions of the Empire and to have done their innovating work outside the capital, training assistants while travelling. The place of training of an artist in this period might be less important for his development than the abilities of his master. It follows that rather than interpreting paintings in terms of their relation to Constantinople or in terms of stylistic 'trends', art historians should in this period be more concerned to identify works by individual artists and to follow the implications of such attributions; such an approach would at least have its historical justification in a period when artists' signatures reflect a growing individualism in the profession.

In the present state of research, it is possible only to link the style of these early-twelfth century churches on Cyprus and not to be definite on how many artists were involved, and, if there were several, where and how they were trained. It is clear, however, that the patrons obtained works of very similar artistic principles.

There is no stylistic distinction in their general appearance. Euma-thios Philokales, despite his military experience, fits into Kazh-dan's category of the civil aristocracy; unfortunately nothing is known of the career of Nicephorus Iskhyrios, but he claims for him-self the title of Magistros, as did other local archontes of the period. If one widens the field to look for works of related style in the early twelfth century, interpretation is still inhibited by lack of evidence about the patron (for example at the Mavriotissa near Kastoria, Episkopi on Santorini etc.), and it is difficult to justify any fundamental differences from such paintings as those of Bačkovo which seem to be around twenty years earlier and at a dif-ferent stylistic phase, even if these are the commission of a member of the military aristocracy of the Caucasus.[27]

Looking at the evidence from Cyprus does not lead to any firm results about the possibility of distinguishing the patronage of the civil and military aristocracy; it does help perhaps to clarify some of the problems and to show the ambiguities which can arise from lack of documentation. We would need to have more information on the artists employed by aristocratic patrons, and whether these practi-tioners adapted their methods of expression to their patrons and to other conscious considerations. It might then be possible to go further than Mango does in a review of the twelfth-century painting on Cyprus in which he is only prepared to see "the sophisticated Comnenian style" as "the style of the Byzantine ruling class".[28]

The second approach which I wish to propose in this paper has the advantage of using as its starting point texts rather than directly formulating problems in relation to observable stylistic nuances. Out of a number of texts containing inventories of monastic holdings I shall here mention only three;[29] each of these represents the possessions commissioned or acquired by an individual aristo-cratic patron, and so falls into a category distinct from lists of items derived from a number of sources. The latter, although extremely valuable, give rise to additional problems of interpreta-tion, which cannot be handled in a paper of this length; the former are more immediately accessible to be treated as a record of the lifetime's religious patronage of each individual. The three docu-ments in question have all received thorough recent editorial atten-tion, but still raise a number of problems of translation of techni-cal terms and they describe works which have in the main not sur-vived, or, if they have, remain to be identified. This material is therefore less likely to advance questions of stylistic change in Byzantium or of relative quality of works of art than to open up new methods of approach in quantifying patronage and identifying taste and preferences in the commission and collection of art.

The earliest of these three inventories is included in the will of Eustathios Boilas, written in April 1059 and bound in an illu-strated manuscript of the Heavenly Ladder of John Climacus (now Paris, B.N. Coislin 263).[30] The will was written out for Boilas by Theodoulos, monk and priest in the church of the Theotokos of Salem (or Tantzoute) which was founded by Boilas in his principal resi-dence; both men are described as Cappadocians, and Lemerle makes the case that Salem is in the region of Edessa (in Mesopotamia).[31] Boilas was a civil official who received recognition in the state hierarchy with the titles of protospatharios and hypatos; his active

career was spent in the service of a <u>Doux</u>. Relevant facts in the interpretation of his will are that his father and brothers died when he was young; his son died a the age of three in 1052/3, and his wife predeceased him too (died in 1055?). His two daughters were alive at the time he drew up his will, and both were married. He was a man aware of the antiquity of his family (the landed gentry of Cappadocia?), but he had no male heir. His possessions passed to the church rather than to his remaining family; no doubt unmarried or childless individuals were the most generous donors to the church.[32] Lemerle understands the will to convey the picture of a man of fanatic orthodoxy and loyalty to Byzantium, whose titles appear in reality to be of the honorific hierarchy, not of the senate (he is <u>protospatharios</u> of the Chrysotriklinion) – perhaps they were purchased. Some of the attitudes of a member of the civil aristocracy whose career was spent in regional administration can be understood from this document.

The list of his bequests give an account of the quantity and range of his acquisitions in the course of his career. If these are divided into four main groups, the figures are of this order:-[33]

 36 liturgical objects and fittings (altar vessels
 of various materials and lights and incense
 holders)

 32 vestments and altar cloths.

 60 icons (large icons, portable small icons and
 copper icons)

 76 books (one Gospel book specified as illu-
 strated – with evangelists and a Nativity; two
 copies of Climacus are listed, but neither is
 said to be illustrated, although surely one
 must be Coislin 263)

The second document which I have selected is the Diataxis of Michael Attaleiates, signed in March 1077.[34] Michael was born around 1020 and died after 1079 and the document concerns the small monastery dedicated to Christ the all-merciful (Panoiktirmon) which he founded in his town house in Constantinople. His successful judiciary and literary career in Constantinople is of course well-documented and he expresses in the document his own assessment of his life: "despite my foreign (<u>xenos</u>) and humble origin, I became a member of the senate and among the best of the senators, for whom the ancient term is <u>aristokratikoi</u>".[35] He is therefore a good example of an aristocratic patron unconnected with the imperial family, but at the same time the extent of his patronage was limited by the extent of his finances (to judge from the lack of references to his monastery in later periods, it seems that his endowment was insufficient to guarantee its future).[36] The inventory of the monastery and its hospice gives the items donated by Michael Attaleiates and other donors; unfortunately one folio has been lost from the manuscript at this point, and what is missing is the full list of icons – the middle section of this list is lost.[37] One can only guess at the number of items which might have been mentioned on this page, and no figure could command much confidence as these inventories are prone

to record multiple small icons in one sentence. Taking into account
the size of the folio and the extent of Michael's patronage of other
categories compared with the other monastic inventories, my own
estimate is that the lost folio might record a minimum of twelve
icons, and probably not substantially more than this.[38]

Dividing the items into the same four groups as adopted in the
case of Boilas, the figures work out as follows:-

15 liturgical objects and fittings.

8 vestments and altar cloths.

estimated 23 icons (i.e. 11 listed plus 12 or
more on lost folio)

27 manuscripts.

The descriptions of some items in the groups make it clear that
they were not commissioned by Michael but were 'antiques' acquired by
him.

The third inventory dates from December 1083 and is included in
the Typicon of the Petritzos monastery (now the Bačkovo monastery in
Bulgaria).[39] It is the list of gifts of Gregory Pakourianos, a
member of the hereditary nobility of the Caucasus and enormously
wealthy; he was apparently a Georgian brought up in Armenian lands
who was an outstanding general of his time and became the Grand
Domestikos of the West. Although 'foreign' (he could not write
Greek), he was keenly Orthodox. The list of his donations is as
follows:-

94 liturgical objects and fittings.

29 vestments and altar cloths.

36 icons

31 manuscripts.

The precise information given in these three inventories can be
exploited for the indications given of the range of materials and
craftsmanship with which these aristocratic heads of families were
concerned in the course of their careers as well as for other aspects
of their religious patronage. The manuscript holdings of the provin-
cial aristocrat Boilas, for example, turn out to be more substan-
tial than those of either of the others, even than those of a Con-
stantinopolitan intellectual. As an instance of one of the ways in
which these inventories can be used, consider for a moment the infor-
mation which can be derived about the production of large special
icons in the second half of the eleventh century. Boilas owned eight
large panels; Attaleiates owned at least eleven large panels; and
Pakourianos owned seven special panels. It therefore emerges that in
the careers of these long-lived aristocrats, each was concerned with
the production of less than a dozen large icons. This figure gives
an indication of the amount of contact such patrons had with the
artists who produced major icons; and, on the other hand, hints at

the total number of such icons which would have been produced in the period. These inventories are also an indicator of the relationships of aristocratic patrons to monasteries, and how objects moved into church possession through the financing of such families. What these aristocrats valued in spending their fortune on art was not to make a display of private secular wealth but to make a public statement of their Christian orthodoxy.

<div align="center">III</div>

To formulate a conclusion to these remarks on the study of aristocratic patronage of the visual arts is hardly possible, but the main point is perhaps worth emphasising. The study of aristocratic patronage, distinct from imperial patronage, seems more likely to gain results if the art historian reconsiders the method of starting from the visual material and deducing naive correlations between style and social class. What is recommended here is to start with theoretical considerations and to use documents issuing from aristo-crats about their particular uses of art. Even such apparently stark legal documents as wills and typika can be handled in such a way as to indicate taste and preferences towards art. Other texts are those which describe their homes and domestic decoration. Visual evidence can be used in an analytic way as well; for example the Lincoln College Typikon gives evidence of how those represented wished to be seen. The combination of such visual evidence with texts could help to define how aristocrats showed their status by what they wore in processions and on official occasions. It might be useful to gain perspectives on the use of art by Byzantine aristocrats by making comparisons with other societies; such a method was constructively used by Peter Burke to study seventeenth century élites.[40] He was able to point to features of the urban Venetian aristocracy and how they chose to display their wealth – notably in great banquets, ostentatious weddings, and in luxurious private palaces with con-spicuous exteriors. As far as Byzantine studies are concerned, the question of the aristocracy and the visual arts in all periods has not been answered; even the ways in which to formulate the issues constructively have not yet been conceptually defined.

NOTES

This lecture was illustrated with a number of colour slides, but the pictorial examples are not integral to the argument, and I prefer to publish the text of my contribution without illustrations in order to emphasise the need for a more theoretical consideration of the problems.

1. Among useful introductions to the sociological literature are V. Kavolis, 'Art Style as Projection of Community Structure', Sociology and Social Research, 48 (1964), 166-75; N. Hadjinicolaou, Art History and Class Struggle, (London, 1978); and J. Wolff, The Social Production of Art, (London, 1981). Two recent studies by Byzantinists advance the study of the sociology of Byzantine art but without overt reference to the theoretical literature: S. Tomeković-Reggiani, 'Portraits et structures sociales au XII siècle. Un aspect du problème: le portrait laïque', Actes du XVe Congrès international d'études byzantines, (Athens, 1981), II, Art and Archaeology, Communications, B, 823-36; and A. Cutler, 'Art in Byzantine Society', JÖB, 31/2 (1981), (= Akten des XVI Internationaler Byzantinistenkongress, 1/2), 759-87. Cutler states (p. 760) that it was social processes and attitudes, not social classes "that served to define the purposes of Byzantine works of art and to steer patronage in the directions it took".

2. A parallel review article is that of C. Mango, 'Lo stile cosiddetto "monastico" della pittura bizantina', Habitat, Strutture, Territorio, (Galatina, 1978), 45-62.

3. Methodological guidance for the study of ancient art is given by R.L. Gordon, 'The Real and the Imaginary: Production and Religion in the Graeco-Roman World', Art History, 2 (1979), 5-34.

4. M.T. Clanchy, From Memory to Written Record: England, 1066-1307, (London, 1979); F.H. Bauml, 'Varieties and consequences of medieval literacy and illiteracy', Speculum, 55 (1980), 237-65; W.J. Ong, Orality and Literacy. The Technologizing of the Word, (London, 1982).

5. As demonstrated by D.S. Peacock, Pottery in the Roman World: an ethnoarchaeological approach, (London, 1982).

6. A. Grabar, Les ampoules de Terre Sainte, (Paris, 1957); and J. Engemann, 'Palästinensische Pilgerampullen im F.J. Dölger-Institut in Bonn', Jahrbuch für Antike und Christentum, 16 (1973), 5-27.

7. A. Cutler, 'Art in Byzantine Society', cited in note 1, 772-6 discusses the problem under the heading 'The hierarchy of metals'.

8. On costs see N. Wilson, 'Books and Readers in Byzantium', in Byzantine Books and Bookmen, (Washington, D.C., 1975), 1-15.

170

9. A. Cutler, ´The Aristocratic Psalter: the State of Research´, Actes du XVe congrès international d´études byzantines, (Athens, 1979), I, 423-49.

10. H. Belting, ´Zur Palatina-Psalter des 13 Jahrunderts´, JÖB 21 (1972), 17-38.

11. H. Buchthal, ´The Exaltation of David´, Journal of the Warburg and Courtauld Institutes, 37 (1974), 330-333.

12. S. Dufrenne, ´Problèmes des ateliers de miniaturistes byzan-tins´. JÖB, 31/2 (1981), (= Akten des XVI Internationaler Byzan-tinistenkongress, 1/2), 445-70.

13. For a recent discussion with references, A. Cutler, ´Liturgical Strata in the Marginal Psalters´, DOP, 34-35 (1980-81), 17-30.

14. S. der Nersessian, L´illustration des psautiers grecs du moyen âge, II. Londres, Add. 19352, (Paris, 1970).

15. V.N. Lazarev, Storia della pittura bizantina, (Turin, 1967).

16. K. Weitzmann, The Icon, (London, 1978), 88-9.

17. Ibid. 92-3.

18. H. Maguire, Art and Eloquence in Byzantium, (Princeton, 1981), esp. 42ff.

19. A. Xyngopoulos, ´Fresques de style monastique en Grèce´, Acts of the Ninth International Byzantine Congress (title in Greek), (Athens, 1955), I, 510-6.

20. O. Demus, Byzantine Mosaic Decoration, (London, 1948), esp. 57-61.

21. G. Ostrogorsky, Zur byzantinischen Geschichte, (Darmstadt, 1973): pp. 166-82, ´Der Aufstieg des Geschlechts der Angeloi´ (reprint of paper published in 1936).

22. V.J. Djurić, ´Fresques du monastère de Veljusa´, Akten des XI. Internationalen Byzantinistenkongresses, (Munich, 1960), 113-121.

23. A.W. Epstein, ´Middle Byzantine Churches of Kastoria: Dates and Implications´, Art Bulletin, 62 (1980), 190-207; D. Mouriki, ´Stylistic Trends in Monumental Painting of Greece during the Eleventh and Twelfth Centuries´, DOP, 34-35 (1980-1), 77-124; the reading of the fragmentary apse inscription to give a date for the foundation of the church in the reign of the Emperor Romanos IV (1068-71) is difficult to accept, see T. Papazotos, ´Christian inscriptions of Macedonia´, (in Greek) Makedonika, 21 (1981), 401-10.

24. A.P. Kazhdan, Sotsial´nyj sostav gospodstvujushchego klassa Vizantii/XI-XIIVV (Moscow, 1974); see also the summary of his arguments by I. Sorlin, ´Publications soviétiques sur le XIe

siècle´, <u>TM</u>, 6 (1976), 367-98. I wish to thank Professor Kazhdan for clarification on points of detail during the symposium.

25. For a bibliography of recent literature, see D. Mouriki, cited in note 23, esp. 98ff.

26. The discussion of Asinou by Cutler, ´Art in Byzantine Society´, cited in note 1, p. 779, is invalidated by his incorrect identification of the donor: on him see C. Mango, ´Chypre carrefour du monde byzantin´, XVe Congrès international d´études byzantines, (Athens, 1976), 3-13, esp. note 14.

27. S. Grishin, ´Literary Evidence for the Dating of the Bačkovo Ossuary Frescoes´, Byzantine Papers, (Canberra, 1981), 90-100 and D. Mouriki, cited in note 23, p. 99.

28. C. Mango, cited in note 26, 8.

29. References to the literature on such texts are most easily accessible in C.Mango, The Art of the Byzantine Empire 312-1453, (Englewood Cliffs, N.J., 1972), 237ff; K.A. Manaphes, Monastiriaka Typika-Diathikai, (Athens, 1970): P. Lemerle, Cinq études sur le XIe siècle, (Paris, 1977). For the piecemeal art historical use of such texts, see most recently M. Chatzidakis, ´L´evolution de l´icone aux 11e - 13e siècles et la transformation du templon´, Actes du XVe congrès international d´études byzantines, (Athens, 1979), 333-66, and (with different results) A.W. Epstein, ´The Middle Byzantine Sanctuary Barrier: Templon Screen or Iconostasis?´, Journal of the British Archaeological Association, 134 (1981), 1-28.

30. For text and discussion, P. Lemerle, Cinq Études, 15-63. The illustrations of the manuscript are discussed by J.R. Martin, The Illustration of the Heavenly Ladder of John Climacus, (Princeton, 1954), esp. 173; the artists were presumably available for employment in the region.

31. See also A. Kazhdan, ´Remarques sur le XIe siècle byzantin à propos d´un livre récent de Paul Lemerle´, B, 49 (1979), 491-503.

32. The corollary is that family groups which reproduced and held on to the land were the least generous almsgivers and appear less frequently in this sort of document: see G. Duby, ´Lineage, Nobility, and Chivalry in the Region of Mâcon during the Twelfth Century´, in R. Forster and O. Ranun, Family and Society. (Baltimore and London, 1976), 16-40 (reprinted from Annales, ESC 27 (1972), 803-22). See above, P. Magdalino, Chapter 6, pp.92ff.

33. In all these inventories it is impossible to be certain when to regard items as referring to one object or more, and so the figures must be rough. I have not included the possessions of his late (married) sister, which are also listed. The value of the liturgical vessels in precious metals is given (300 nomismata); from South Italy in this period there are examples

of icons and silks having a valuation for use as property trans-
actions, A. Guillou, ´Rome, Centre transit des produits de luxe
d´Orient au Haut Moyen Age´, Zograf, 10 (1979), 17-21.

34. P. Lemerle, Cinq études, 67-112; and P. Gautier, ´La diataxis de
Michel Attaliate´, REB, 39 (1981), 5-143.

35. Gautier, p. 21, 11. 44-6; xenos presumably = non-Constantino-
politan.

36. On the nature of the monastery see A. Cutler, cited in note 1,
766-7. The inventory does not list all his possessions, such as
his enamelled ring in the Dumbarton Oaks Collection: M.C. Ross,
Catalogue of the Byzantine and Early Mediaeval Antiquities in
the Dumbarton Oaks Collection, volume two, (Washington, D.C.,
1965), 107, no. 156. A. Cutler, 767, and note 39, refers to the
will of Kalê, wife of Symbatianos Pakourianos, which lists the
personal possessions of a rich woman, including personal jewelry
etc. See above, R. Morris, Chapter 7, pp. 112ff.

37. See Gautier, p. 88, note 9: lost before 1761.

38. The complications arise from the possible omission of multiple
icons, such as the templon with a Deisis and story of S.John the
Baptist: Gautier, p. 89, 11. 1195-6. This text suggests that
the scepticism of C. Walter about the Byzantine use of the term
Deesis to describe the group of the Virgin, Christ, and Baptist
is unnecessary - ´Two notes on the Deesis´, REB, 26 (1968), 311-
36.

39. S. Kauchtschischvili, Typicon Gregorii Pacuriani, (Tbilisi,
1963); and P. Lemerle, Cinq Études, 115-91.

40. P. Burke, Venice and Amsterdam, (London, 1974).

X

Patronage and New Programs of Byzantine Iconography

The Problem

The organisers of this Congress in defining a title for this paper have also defined the problem; they have suggested a conceptual relationship between patronage and innovation. No doubt if there was a direct and uncontroversial connection between the identity and character of patrons and the introduction of new ideas into art, then this paper might be entirely devoted to describing and explaining the changes or continuities in the character of the visual arts during the designated period and ascribing their causes to those individual actors thought to be responsible. In fact such a correlation is by no means straightforward, and it is this concept itself which must be the theme of this paper. Hence the paper will not be packed with examples of patronage or with examples of new programs.

The period involved stretches from the second phase of Iconoclasm until the reign of Basil II.[1] This has been described as a period in Byzantine history of continuing military success and imperial expansion as well as one of consolidation and relative stability.[2] In other words, it was a time of increasing wealth and increasing confidence and security, and so predictably favourable for increased spending on the arts by the emperor and the ruling classes, if not by other kinds of artistic patrons.[3] Periods of conspicuous artistic activity such as this have often tempted art historians to link individual patrons or even classes of patronage with new developments. The most obvious cases where this method has been tried is in relating the character of seventeenth-century Dutch art to the interests of a "bourgeoisie" or in relating the art of the Italian

Renaissance to the rising wealth and aspirations of the bankers of Florence. There has indeed already been a suggestion of this kind in our particular period: The character of tenth-century Byzantine art has been directly linked with the personality of the emperor Constantine VII Porphyrogenitos.[4] In this paper the role of this emperor will be taken to be part of a problem of interpretation, not the whole of an explanation. Patronage will be seen as lodged within the broader structures in which art is produced and functions.[5] The primary aim of the paper is to demonstrate the need for the construction of a new conceptual view of the role of the patron in the production of Byzantine art.

Wealth in Byzantium

It has become a cliché to say that the circumstances of the production of medieval art involved more controlled and circumscribed transactions and commissions than in the marketplace world of the twentieth century. Art was not generally bought ready-made, apart from a few exceptions: pilgrims' souvenirs and a limited "antique" market or exchange, for some of the items owned by Michael Attaleiates in the eleventh century were "secondhand".[6] Byzantine art cannot therefore be treated as the free expression of an artist or as something purchased piecemeal according to the tastes of a public; its production was normally the outcome of a planned transaction. The relation between an artist and his patron (or client) was a personal business one. Consequently the economic practices of the period were in some way embodied in the resultant commission; and more concretely, the resources of the patron were reflected in the cost, types and quantities of the materials used in each work of art.[7] Such a commercial view of the period does not deny that Byzantine artists might independently have made preliminary drawings of their commissions or even produced uncommissioned sketches; but there is no evidence that such works had monetary value or were sought for their aesthetic interest by collectors of "art".[8] Nor were icons or church decorations "investments" in the modern financial sense -- or at least not normally. One can regard as exceptional the cases of a couple of deals in South Italy in the eleventh century in which icons and silks were used by a monastery instead of currency in the purchase of saltmines from the archbishop.[9]

The character of the production of art in Byzantium does lead towards an apparent distinction between "public" works, such as the pictorial decoration of churches, and, on the other hand, items in precious metals or objects decorated with precious

X

stones or even textiles, which did have a cash value
and could be recycled.[10] These portable works might
belong to church or monastery or to emperor or to
private households. But the distinction between forms
of art does not allow the formulation of simple
polarity between public and private art or between
religious and secular art; such clearcut distinctions
cannot be imposed on Byzantine society.

Although the economic processes of commission and
production may be said to lie behind every work of
Byzantine art, a knowledge of the economics without a
knowledge of the social institutions and conventions
would explain little. Even if investment in a work of
art might not, for example, bring financial profit, it
might yet be perceived to purchase power, prestige,
fame or spiritual advantage.[11] Such a qualification
should not be taken to obscure the clear position that
a knowledge of the distribution of wealth in Byzantium
will help to map the areas of likely patronage in the
ninth and tenth centuries.[12]

Obviously the emperor, if he could find the ready
cash, was in a prime position to undertake major
building projects or monumental decorations. Theophilos
is the first example in the period of a major imperial
patron (who included among his projects the [private]
Bryas Palace and the [public] Bronze Doors of the
southwest vestibule of St Sophia).[13] It is probably not
fortuitous that he emerges from texts as one emperor
who had managed to accumulate enormous reserves in
coinage.[14] The second emperor of the period whose
resources are emphasized in the primary sources is
Basil I. In the years after his accession in 867
(initially the treasury was depleted) his assets
increased dramatically; ready cash came from the
discovery of numerous buried treasure-troves, from the
recycling of some of the imperial ceremonial equipment
(sent for melting-down by Michael III), from the
recovery of moneys squandered as gifts by Michael III
and from the enormous donations from the widow Danielis
of Patras.[15] The third emperor of the period whose
reserves are conspicuously recorded in primary sources
are those of Basil II.[16] Theophilos and Basil I were
visibly major imperial patrons of the period; the long
reign of Basil II is harder to assess, but the idea
that he was a soldier/philistine averse to commis-
sioning works of art may be something of a modern
distortion -- one would expect a successful general, or
his benefactors, to ensure some memorial of his
achievements, either at the site of his victories, or
at another place felt appropriate.[17]

A rich emperor was a perennial presence as a
potential patron; yet "Imperial patronage" does not
represent a homogeneous category, supporting a

X

homogeneous type of art, for the social background of
successive emperors might differ. The appearance of any
new emperor as a patron might therefore represent the
rise and interests of new social or political groups,
and might be taken as a reason for artistic change and
innovation. It might, for example, be suggested that
the character of the patronage of Basil I was connected
with a "nouveau riche" background or that of
Constantine VII Porphyrogenitos with the character of
an "antiquarian recluse". This consideration reiterates
the problem of how far character and background are of
substantial relevance in the development of the content
of art. This is a problem which has so far been
attached to the patronage of emperors; but it is one
which concerns all other types of patronage as well.

Apart from the emperor in person, other
individuals or groups with realisable assets for
expenditure on the visual arts can be identified. The
modern characterisation of these groups as a whole
might be expected to be the "rich"; but Byzantine
history knows them as the "aristocracy".[18] Within this
category one finds a complex mixture: relatives of the
emperor;[19] eunuchs (as rich officials);[20] the
traditional and parvenu families, both military and
civil;[21] rich officials and their rich widows;[22] and
provincial landowners.[23] Furthermore it may be
appropriate to include the monasteries and the higher
clergy in the category.[24] A topical difficulty in
characterising the aristocracy in the ninth and tenth
centuries results from the fluidity caused by the
social transitions of the period.[25] The changes
involved the channels of access into the ruling
nobility. If in the early Byzantine period entry into
the ruling class was possible by open competition into
a meritocracy of talent, then a new situation must be
recognised by the eleventh century when the powerful
have become established as a hereditary aristocracy of
families tied together through marriages. The rise of
these great families occurred in the course of our
period. They were predominantly the Anatolian families
living along the eastern frontier deriving their
position from their military commands and expanding
estates who eventually formed a provincial opposition
to the imperial family in Constantinople and to the
established "civil service" of the capital. Basil II
faced rebellion from these Anatolian magnates, but
overcame them. They began after their defeat to move
from their country estates to Constantinople and
established their new base together in the capital.
This gradual translation of the great families into the
city must have influenced the character of social life
there; it must have also changed the visual environment

X

of the city as they constructed and decorated new urban palaces.[26]

Apart from the rich elite there were other possible sources of artistic patronage. At first sight the combination of resources in the lay fellowship which sponsored the display and monthly rotation of an icon of the Virgin in churches of central Greece in the eleventh century might seem to represent the extension of patronage into a poorer social group.[27] Yet even the members of this fellowship probably belonged in the category of rich landowning families in the region of Thebes, and so do not, as patrons, form a separate new category. Likewise the patrons of Cappadocian rock-cut monasteries and churches might seem to represent a wider cross-section of Byzantine society; the quantity of work done in the region is so large that it might look as if all the levels of local society were involved.[28] But once again the actual patrons of the wallpaintings, when inscriptions name them, seem to derive from the local "gentry" or from the higher ranks of the army -- Cappadocia represented a safe region for the siting of mausolea.

The evidence of wealth in Byzantium necessarily emphasizes the rich of the capital, for it tends to reside in the texts written at the centre of the Empire. The evidence that there is of church building and artistic patronage in the other regions of the Byzantine world tends therefore to lack a social documentation. Obviously the conditions for patronage existed, but the shortage of inscriptions and other records about the precise people involved leaves us without any firm evidence about their wealth, standing and origins. To some extent the timing and extent of this provincial patronage appears out of phase with political conditions. Thus in Cyprus the non-figurative paintings in the church of Yeroskipos and the first layer at St Antonios at Kellia are both decorations that one might attribute to the ninth or tenth century period and so before the "liberation" of the island by Nikephoros Phocas in 965.[29] But the identity of the patrons or character of their patronage is unknown to us. Similarly some of the painting at Kastoria seem to belong to the late ninth or early tenth century, which would suggest a program of building and decoration there at a time when the town was presumably disrupted through the occupation or threatened occupation of Bulgarians.[30] Who were the patrons? In addition to church commissions in the Balkans and Greece our period also sees new work in Armenia, Georgia and on the eastern frontier.[31] How far artistic activities necessarily correlate with social and political conditions remains an issue to be explored.

We have reached in the last example of patronage the margins of the Byzantine empire. But Byzantine patronage encompasses the margins of society in another sense also: too little has been said of the extent and character of female patronage.[32] The complications here arise not only from the nature of the evidence but also from the difficulties of exploiting it; it is one thing to see women as connected with the establishment or decoration of monasteries, another to identify this as a simple indication of their legal and economic freedom in society.[33]

The Patron and the Commission

The distribution of wealth in Byzantium maps the sources of patronage, and the material evidence cannot suggest any unexpected types of sponsorship. Our period is marked in a straightforward way by a considerable increase of artistic patronage. The period of Iconoclasm was a period of reduced activity, which is not entirely to be connected with the ideological controversies of the eighth and early ninth centuries. It was also a period when the initiatives came principally from the emperor and not from the church or monastic sector. After 843 Byzantium saw not simply an artistic revival, but inevitably an expansion of the sources of patronage.[34] But this evidence also shows up the immediate difficulties of relating individuals to the "decisions" which were made about the programs of decoration to be undertaken by the artists. This is an issue of equal importance whether the commissions were small-scale works, such as enamels or encolpia, or were cycles of manuscript pictures or full-scale monumental church programs.

The problems are simple to illustrate. Take the central case of St Sophia. Who was the patron of the apse mosaic which was inaugurated on Easter Saturday, 29 March 867?[35] One answer is to say the patron was Photios, the patriarch in office. He might be seen not only as the patron who had started the work in St Sophia but also the person who covered both the vaults of the Chrysotriklinos in the Great Palace and the palatine Pharos church with mosaic decoration. Another answer is that Photios was less the actual patron than a person who took any opportunity to proclaim his personal role in the triumph of Orthodoxy, and who found out the power of the visual arts in promoting himself only through the enterprise and practical support of other organisers, and notably the Bishop Gregory Asbestas.[36] He thus only becomes the "patron" in his role of charismatic head of the church. A third answer is that Photios was not the patron at all; the inauguration sermon might instead be taken as proof of the initiative of the emperors. The problem

here resides in the reading of a text. Does the sermon
show whether Photios was any more than the agent of an
imperial commission? Was the rhetoric of imperial
responsibility just a compulsory flourish on a day when
the emperors normally gave a donation to the church?
Even if information were ever available on the
actual negotiations which led to the completion of the
apse mosaic in 867, one question would remain open. How
far could knowledge of the personality of the patron
supply an adequate explanation of the pictorial
treatment of the subject chosen? Could it be decided in
terms purely of the personality of the intellectual
Chazar patriarch or of the joint pragmatic interests of
Michael III and Basil I? What role is to be given to,
among other considerations, the artist? The Council of
Nicaea in 787 had of course decreed an answer: "The art
belongs to the painter, but the disposition of it is
the prerogative of the venerable Holy Fathers."[37] But
this is theory, not practice. And it is ambiguous --
for it introduces church tradition as a factor,
something which had itself to be interpreted by those
who produced art.
 In investigating innovation in ninth and tenth
century art, a key problem therefore lies in the
character of tradition and the response of the
Byzantines of this period to it. Some works of art may
be characterised from the modern viewpoint as more or
less "traditional". The question is whether the
character of specific works of art can be explained
within the limited parameters of patron and artist, or
whether this is a problem which resides within the
whole grid of the culture. The purpose of the next
section is to consider some of the best documented
examples of our period in order to see whether
information about the character and intentions and the
social positions of the patrons can answer the question
about the sources of innovation. If this section cannot
succeed in linking patrons with new programs, then the
character of artistic production will need to be
considered from a different point of view.

The evidence of Constantinopolitan manuscripts and mosaics

The past efforts of many art historians to uncover
the practical procedures involved in the production of
illuminated manuscripts makes this medium the obvious
area in which to look at the evidence of new programs
and to consider in what manner one might relate these
to patrons. At first sight the illustrations in
manuscripts may also seem the most easily approachable
and revealing. However the relative rarity of the
illuminated handwritten book in the experience of the
Byzantine reader must mean that the medium in the

Middle Ages was particularly precious and special; the patterns of reading texts and pictures do not necessarily correspond with our expectations -- modern familiarity with reading the printed book can too easily anaesthetise us to the medieval experience.[38] There are also special difficulties in discussing "new" programs in manuscript illumination in view of the "disappearance" of the "models" which in so much consideration of the Byzantine book have been taken to be the operative comparative "evidence".[39] While it is salutary to accept the principle that manuscript production involved copying, once the necessary caution has been encouraged in identifying innovation, the further interest in describing the appearance of lost models seems fruitless. These models, so long as they are irrecoverable, can only be reconstructed according to hypothetical principles; and the accuracy of the reconstructions cannot be tested.

Perhaps the most studied type of book in our period is the psalter; it offers the case of a text of immense functional importance in church and monastic life both before and after Iconoclasm, and one to which was added considerable embellishments. Yet ultimately these manuscripts give little practical help in solving the problems of patronage; they only help to understand the limitations of the evidence. The contents of the cycles in the "marginal psalters" of the ninth century appear to be derived from a mixture of old and new elements; the dense cycles of the Chludov psalter can hardly be entirely new creations -- author portraits of David were probably a traditional feature of the (lost) earlier Byzantine psalters, and the pictures with explicit Iconoclast representations cannot be earlier than the eighth century. But this conclusion hardly offers any method of distinguishing innovation from copying, and takes our discussion nowhere.[40] As for the patronage, the position is much the same as will later emerge in St Sophia; candidates have been canvassed, in particular patriarchs Methodios, Ignatios and Photios. The controversy itself spells out the problem; why is the identity of the patron inaccessible to us?

The Paris Psalter of the tenth century has given rise to equally elusive controversies.[41] Although the polarisation of views about this manuscript as either copy of a Late Antique model (with only the format of the page changed) or as pastiche entirely from discrete elements of Late Antique art has been modified, the middle view of it as partly copy of earlier models and partly combination of separate elements still leaves open the exact nature of its "new program". Furthermore as long as the identity of its patron is unresolved, Constantine VII Porphyrogenitos or an unknown courtier,

it can play no useful role in the construction of an argument about patronage.⁴²

This leaves us with the evidence of a few other manuscripts of the period which give more specific information about their patrons. Two major manuscripts of the tenth century actually record the name of their patrons, the so-called Bible of Niketas and the Bible of Leo.⁴³ Apart from work on the sources of the miniatures, more constructive attention has been given in the case of the Leo Bible to the principles of iconographic choice. Leo may be identified as the author of the verses in the frames of the miniatures which act as a verbal pendant to the visual images. The question which therefore arises in a modern interpretation of the cycle is whether one should be looking for the intentions of the patron in choosing each image and judging his originality within the historical development of Orthodox exegesis, or whether on the other hand the personality of this author may be subordinated to the evidence he gives of the ways of thinking of the society in which he was living. Leo has been characterised as an "amateur poet"; but thinking of him in this way (irrespective of whether the judgement is right or wrong) may hinder an understanding of how the verses were constructed. How far did Leo have a free hand in his compositions, and how far did the Nicaean formula of 787 mean that such a patron would necessarily consult with the clergy in his formulations and have his ideas vetted? More important is the consideration of how a tenth-century court official developed his theology; he was no rustic miller, but a conforming member of high society.⁴⁴ Interpreting his logic must give a datum for the thought-world of the tenth-century civil service. We cannot know if Leo was "typical" but his verses and images do represent the scale and range of the "thinkable" within the milieu. It may be true that the manuscript could help to understand the processes of communication between patron and artist; but its importance as an indication of the social use of art seems easier to grasp -- the role of art in prayer, its indications of the preoccupations and perceptions of the wealthy, and its reflection of the authority and predominance of the church.⁴⁵

One further manuscript must be introduced, although its evidence cannot be so precisely explored as in the case of the Bible of Leo: This is the ninth century Homilies of Gregory of Nazianzus, Paris 510.⁴⁶ Here at least we have a manuscript of undoubted innovation in its program, with images of great complexity and some topicality which are unparalleled in other manuscripts of the same texts. But while the mind of Photios can be persuasively connected with its

production, in the final analysis, what seems important
is not what led him to the individual choices of
iconography, but its demonstration for the viewer of
the structures of theological thought and imperial
ideology in the late ninth century. A comparison
between these Homilies and their illustrations and the
illustration of the Bible of Leo documents less the
individual predilections of Photios and Leo, and more
their representation of theologies of their time and
social groups.

The manuscripts can therefore offer some insights
into the interpretation of patronage as a means of
analysis, but only by turning next to the most
prominent artistic productions of the period can the
questions be more definitely examined. Since the
manuscripts considered were most likely produced in
Constantinople, then it seems quite suitable to set
against the evidence of their miniatures the monumental
programs of the churches of Constantinople. Effectively
this means looking further at the mosaics of St Sophia,
and so locating the discussion in the example which
must represent one of the most sophisticated
commissions of the period.

The choice of St Sophia does mean abandoning any
exploitation of the extensive decorations of Cappadocia
which might be thought to offer the most extensive
example of the creation and modification of programs.
But the value of St Sophia is that the bulk of the
material in the church in mosaic from the period either
survives or can be documented from visual records. The
other surviving decorations from Constantinople (or by
the artists of Constantinople as may be suggested in
the cases of the Koimisis church at Nicaea or the
cupola of St Sophia at Thessaloniki) which belong to
this period cannot, even if supplemented by the
descriptions of art in texts, supply a sufficient
picture of the chronological developments after
Iconoclasm. The evidence both written and archaeo-
logical is too incomplete in its indications, and it is
difficult to imagine, as has been proposed, that a
period of revival which had such a variety of sources
from which to derive its ideas could have followed any
simple and rigid evolution from, say, single figure
decorations to increasingly complex arrangements of
figures and scenes.⁴⁷

The mosaic decoration of St Sophia after
Iconoclasm was apparently only begun around 867 and
then continued piecemeal for an extended period of
years.⁴⁸ Whatever the precise dates of the various
parts, the fact that apse and vaults coalesce in their
different subjects suggests that some kind of overall
program was conceived from the beginning, even though
the individual panels and vaults took on additional

X

particular significations.⁴⁹ This decoration therefore offers a paradigm case for the investigation of the question of the degree to which the "meaning" of programs and the notion of their "originality" can be related to the individual character and interests of the (postulated) patrons.

It is the choice of the enthroned Virgin and Child and archangels for the main apse composition, a mosaic set in place before the scaffoldings required were re-erected under the dome, which suggests that a compatible program for the other vaults of the church had been planned by 867. When later carried out, this program comprised Christ in the dome surrounded in the lower vaults by seraphim, archangels, prophets and Church Fathers, and a number of specific New Testament scenes in the vaults of the galleries. Such a program, which has some parallels in other decorations of the period (such as the Chrysotriklinos in the Palace and in the major churches of Constantinople), has been characterised as hierarchical and also as in the nature of a *civitas dei* -- one in which the New Dispensation of the Christian Church was most prominent. The overall effect is less of a narrative cycle than an evocation of the rotating liturgical calendar of the church.⁵⁰

This mosaic decoration of St Sophia can be literally taken to be a new program, for the evidence is that it was the first figurative mosaic decoration ever set in the vaults of the church. Furthermore certain elements in the iconography come together here in what was certainly a new combination: This is quite evident in the saints of the tympana where the ninth-century patriarch Ignatios was included among the Church Fathers. The bishops chosen for representation generally had some special connection with St Sophia. There is a sense in which it is easy to describe this program as the individual formulation of a patron; and this effective patron, leaving aside the practical difficulties which have already been mentioned, was quite likely to have been the patriarch Photios. He may have formulated the reasons for choosing to fill the available spaces with such apparently outré but evocative characters as Gregory of Greater Armenia. He may also have given reasons for choosing to decorate the apse with the composition of the Virgin and Child. Yet even if the speculation is accepted that Photios had particular intentions in drawing up a program for St Sophia, one is bound to question whether an explanation of the program lies in the "genius" of Photios or indeed whether a greater understanding of the program is helped through personalising the patron. Had the program been drawn up by Methodios or Ignatios (which of course it might have been), would this seriously detract from its historical significance?

A hierarchical program was not an innovation of the ninth century; nor was it a pure invention of the artistic mind, but more indicative of the structures of Byzantine society and thought.[51] The mosaics of St Sophia are in this respect a more useful index of the viewer than the patron. As for the choices of such figures as Methodios, Ignatios, John Chrysostomos and the other six who all had their *synaxis* in St Sophia, their selection here depends on the traditions connected with this actual church and its location in the centre of Constantinople where the historical circumstances in which they were involved happened. This is historically a more coherent factor than the internal and irrecoverable processes of the mind of the patron. It is a structure of visual communication which can be compared with other Byzantine programs where the identity of the patron may be unknown or no more than a name; the program of St Sophia can be compared with that of Hosios Lukas, for example, where the choice of those who form the vast company of mosaic saints depends partly on local associations and partly on the functions and ascetic intentions of the monastery. Similarly the twelfth-century wallpaintings of Cyprus contain some local saints whose inclusion can be seen to convey evocations about the past history of the church in the island rather than to offer any insights into the individual processes of thought of their patrons. Even the bizarre programs of the Enkleistra of Neophytos offer more help in understanding the character of Orthodox monasticism and art than they do the particular mental processes of one member of that society. Monumental programs derived their recognisable elements from the location of the church, from its historical connections, or from identifiable topical considerations. In this respect the patron is properly seen as the channel through which the decisions passed. The explanation of the final choices is only historically recoverable if the patterns of social thought are discovered; the psychology of the "inspiration" of the patron or artist can be left to one side.

The obvious test case for this view in St Sophia is the narthex lunette. Some of course have taken the view that this mosaic is not part of an extended program, but a piecemeal addition to the decoration of the church with a unique message. But the fatal objection to the arguments so far adduced in favour of such an interpretation is that they ultimately rest on speculation about the patron and the mental intentions of that patron.[52] This is to enter the realms of historical fantasy. All the traditional art historical approaches to the interpretation of the iconography of this panel meet this difficulty. If it is argued that

the patron was the patriarch Nicholas Mysticos and that his intention in this commission was to proclaim a victory of the church over the attempt by an emperor to flout its laws and to act as a warning to future emperors, how is one to test the identification or to confirm the patron's motives and thinking? Must one attribute innovation to individual creativity as if it came *ex nihilo*? If on the other hand an explanation for the mosaic is only to be proposed on the basis of a Byzantine text which is thought to be the direct influence on the iconography, is one to accept that visual communication works simply by translating words into images?[53] Surely no one takes the trouble to put up a picture simply to make the same point which could be written in a text.

Compositionally the narthex panel which shows an emperor in proskynesis in front of an enthroned Christ and medallions with saints (the Virgin and an archangel) is not unique. A related type of scheme is found in the north inner aisle mosaics of the church of St Demetrios at Thessaloniki (dating probably to the sixth century) and in the description of an eleventh-century imperial mosaic by John Mauropous.[54] However there is no available exact parallel for the precise iconographic components of this panel. The analysis in terms of the patron must necessarily involve constructing the processes of conscious thought which went into the production of the mosaic. To be convincing such an analysis needs to determine the correct patron and actual motivation for the commission and occasion within the life of the patron. The alternative strategy for the historian is to consider the work as it is viewed (either by the Byzantine public or even by other observers). This requires the deduction of codes of communication, but since these are encapsulated within all the texts and other productions of the culture, this method of locating meaning in works of art is liberated from the straightjacket of matching text with picture, one for one.

The economy of signs in this mosaic (as in much of Byzantine art in general) both causes ambiguities of possible meanings and highlights the referential power of each element. The fact that the emperor is not inscribed with his name must, for example, be a significant omission. Of several possible inter-pretations, one must be that it conveys a general statement. The text of Christ is most striking for its inclusion of "Peace" ("Light of the World" being the conventional part of the inscription); how would this be understood by the observer? The gesture of the emperor and of the Virgin is the same, and presumably one of prayer; while the presence of the angel is an

encouraging sign and suggests that the prayer is granted. It would therefore be quite feasible to argue that the Byzantine viewer would read this image to "say" that emperors, whatever their sins in life, will be granted peace and forgiveness in the afterlife. This is a message more tactfully conveyed visually than risked out loud. This type of message is the essence of religious art; images allow the articulation of prayer and the simultaneous promise of fulfillment.

While this kind of semiotic analysis of the narthex mosaic seems to me to be more rewarding than the traditional, sometimes exclusive, considerations from the point of view of the patron and producer, it does not exhaust all the evocations of the image, which I take to be a polyvalent one. So far the viewer has been treated in the abstract; but it is also possible to consider the mosaic in terms of the possible categories of viewer in this part of St Sophia. The penitent, for example, who was not allowed into the nave of the church, but confined to the narthex, might read the penitence and forgiveness of an emperor into the scene. The pilgrim visiting the church might have read the image, placed above a door through which entry to the ordinary person was not allowed, as one of enhancement of the emperor who is placed in a close relationship with Christ and his heavenly retinue; the image expresses the nature of monarchy in the Byzantine state. Another kind of viewer can more closely be considered by the historian through the medium of a number of texts. This is the member of the congregation of St Sophia at services. The ceremonial is not only literally described in the *Typikon* of the Great Church and in the *De Caerimoniis*, but symbolically interpreted in the *Ecclesiastical History and Mystical Contemplation* of patriarch Germanos.[55] The latter text was of dominant importance in our period, representing the "official" view of the symbolism of the liturgy within the visual environment of St Sophia.

The commentary of Germanos represents for the art historian a "text" to be taken in its own right. Considered as theology it may seem confused and contradictory, and it may be possible to explain the overlapping symbolism through source analysis, showing how it is a compilation of various traditions. But this kind of theological exorcism does not explain how the text, once constructed, was understood. It may be true that the procedure of Germanos in the seventh century was to write down the traditional interpretation from the *Mystagogia* of Maximos the Confessor and then to overlay this with the new "Antiochene" level of meaning; but a reading of the text must have encouraged the ambivalent reading of symbols. Let us look for a moment at the text of Germanos which refers to the

ritual at the entrance door over which the mosaic was
later placed (the Introit, chap. 24). It is here that
the liturgy proper is seen to begin; the patriarch
prays that the holy angels may enter with the
congregation, and himself enters the church with the
Gospel book, during the recitation of Psalm 94 (full of
thanksgiving and proskynesis to the Lord and King)
processing to the throne where he sits and says "Peace
I leave with you" (John 14:27). Any Byzantine viewer
present at the liturgy in St Sophia at the time when
the mosaic was set in place would then have been
influenced in a reading of the symbolism by the
evocations of Germanos. The text therefore opens up to
the art historian further levels of interpretation of
the mosaic as part of the setting of the liturgy and as
part of the whole symbolic program of decoration of the
church. This level of interpretation may be understood
irrespective of the precise date of the mosaic or
identity of the patron.

Conclusion

It is this possibility of an analysis of the signs
of ninth- and tenth-century art without privileging the
role of the (too often unknown) patron that undercuts
the title of this paper. My argument is of course not
to deny that any work of art is the product of
economic, social and ideological factors, mediated
through formal structures, all of which might be
symbolised in the particular practices and
personalities of the individual patrons and artists;
but it is to say that one can hope to demystify the
notion of art as being only the outcome of impenetrable
personal creativity and inspiration. If the production
of art and the viewer's responses to it are taken to be
social activities, it follows that the discussion of
new programs can be located within a broader context
than of the individual patron. Innovations in art which
structurally relate to other developments in the
culture should be more possible for the historian to
unravel since they can be observed in a broader
spectrum of material. It is for this reason that
interpretations of the program of the manuscript of the
Homilies of St Gregory of Nazianzus could be proposed
by Der Nersessian without a knowledge of precisely how
the "patron" acted as producer.[56] In the same way much
can be said about the program of the Chludov and
related psalters, though not only the patron but also
the context of production, whether Patriarchal or
monastic, is a matter of uncertainty. In the case of
the Bible of Leo, our knowledge of the patron, limited
as it is, helps to locate the manuscript in its social
milieu; but the character of Leo as personally revealed
in the verses which he contributed is of less concern

now than the evidence of the discourse of the period of which he is but one important witness.[57] This means that one is looking for the understanding of innovation within the wider context of its time. This seems to me to be preferable than to seek for innovation as if the first occurrence of anything is somehow of total significance in itself; that would surely be like asking when the first wheel was invented, rather than asking when the wheel was developed as a working piece of technology. In the mosaics of St Sophia one wants to understand the structures of thought that led to the placing on Church Fathers at the lowest level of the tympana mosaics and chose to include Methodios and Ignatios among these figures. Whether or not it is an innovation to show Ignatios in mosaic and whether or not this was the "decision" of Photios are lesser considerations, and "explain" very little. But such questions as the ways in which visual decoration might enhance the nature of imperial or ecclesiastical power and how the methods, effects and attitudes might change at different periods can be examined without the individual character of the patron being at issue. The identification of patrons may be a meagre field to work in -- unless one is obsessed with names.[58]

Postscript

The question of new programs in the ninth and tenth centuries introduces two related issues which have dominated the art historical literature: that of continuity or discontinuity, and that of the "Macedonian Renaissance". Both seem properly to belong to a postscript, and are two sides of the same coin. To emphasize the legacy of the Antique world to the Byzantine empire has become a commonplace, and there can be no art historian whose eyes are not trained to recognize Classical sources.[59] Yet culturally the oddity of the notion needs emphasis and consideration; the paradox appears hardly to be noticed by Byzantinists. The key feature of Byzantium -- its Christianity -- cannot truly be seen as a legacy from the pagan Greco-Roman world.[60] This must be recognized in any assessment of continuities and discontinuities, for it gives the clue to a possible discourse, and a way out of the dilemmas which thinking in either of these two polarities will cause.[61] It tells us that below elements with similar appearances in Antiquity and Byzantium, whether these are works, institutions or objects, there will be a substantial change of ideology, as different as, for example, that between Roman priests and Christian priests.[62] What matters in the understanding of Byzantium is the processes by which changes in ideology occurred. If the "Senate" appears as an institution in Ancient Rome as well as in

Medieval Byzantium, it explains little to describe this as a continuity; its perceived functions in Constantinople relate to different kind of society. The character of even such functional architecture as baths, theatres or hippodromes likewise was quite differently conceived within the *mores* of medieval Christianity. Applied to even the subject matter of art, one sees that the search for the formal sources of post-iconoclastic programs may conceal the changes of ideology and responses to images. In this respect one must question the interpretative value of seeking, for example, the sources of a representation of the Crucifixion in the Chludov Psalter; if the construction of meanings in the program of the manuscript is achieved through the relationships of the images to each other -- with the Crucifixion (in folio 67 recto) acting as a pendant to a representation of Iconoclasts attacking an icon of Christ -- a knowledge of the "models" adds little to this analysis. Even the long debated issue whether Christ was first shown on the cross with his eyes closed before or after Iconoclasm is best considered in terms of the theological implications of the images than as a simple search for models and copies.[63]

As for the term "Macedonian Renaissance", it acts rhetorically in modern eyes to enhance the character of the artistic production of our period. How far the term would have seemed suitable had more of the art of the period survived is a moot point, though the suggestion that the characterisation can be limited to an aristocratic "movement" within Constantinople is not supported by such evidence as the style of the wallpainting of Tokalî Kilise in the Göreme Valley.[64] The conceptual problem of "renaissance" is more urgent: It is a concept that betrays the viewpoint and bias of the *consumer* of art. It invariably in modern eyes privileges the taste for the styles of Classical Antiquity (in particular the art of fifth-century Athens) and of Renaissance Italy. Conversely the attention which it draws to the taste for a return to the past conceals what was perhaps the hardest and seemingly most intractable problem which the Byzantine artist in particular perpetually faced: the burden of the past.[65]

Whereas any viewer of art can delight in the comforting experience of the repetition of familiar patterns from the past, the artist who works within a guiding tradition is in the position of both viewer and producer; in this double role such an artist needs to adapt the traditions of the past in expressing the ideologies of the present. When art historians locate the sources of a work, they may feel that the perceived transformations are the dynamic which created the new

work. But as artists look at the past they may feel themselves imprisoned in a tradition which has already exhausted all the permutations of expression. For the Byzantine artist the trap must have seemed particularly tight; aristocratic culture tended to the antiquarian (indeed an emphasis on the past might support their claims to power), and the church set itself against innovation or even against the idea that doctrine and belief could have a changing "history". The artist was therefore forced to work within a tradition, one which happened to owe much to Classical art and so one which privileged an aesthetic of the representation of the observed world. Yet Byzantine artists were asked to portray within these conventions the Christian vision of another world beyond, which, on the face of it, would seem to demand a different type of religious art. Early Christian art, despite the shifts in religious ideology from Antiquity, retained many of the conventions of the Classical tradition. It would therefore be reasonable to accept the idea that the renovation of figurative art after Iconoclasm fostered a renewed interest in the old models with a strong Classical character. Much pre-iconoclastic art in the Classical tradition still survived, for example in the churches of Thessaloniki and Cyprus. Periods of intensive interest in past traditions are for the practising artists a time of crisis; they cannot easily immerse themselves in the past, assimilating what has gone before, and at the same time, produce something different from all the models in front of their eyes. Yet they are required to make tradition work for them, and transcend their sources. In the case of the ninth and tenth century in Byzantium, it might be possible to postulate that patrons were in part responsible for demanding that artists turned to past traditions, though it has already been argued that such a monocausal explanation of the whole grid of a culture is not a satisfactory one. But whatever the causes for a new (or at least intense) emphasis on the past, the experience of such artists as those of the Paris Psalter and Joshua Roll with all their notorious "mistakes" in drawing hardly witness a happy outcome of the tension with the past. The style and programs of these manuscripts show inertia in the face of tradition more than innovation; only in some manuscripts of the eleventh and later centuries did artists more obviously break out of tradition.

The theme of this paper was innovation and patronage after Iconoclasm. The period must be viewed as one where the appeal to simple polarities such as retrospection or innovation, continuity or discontinuity, and even to patron or to artist are more likely to obscure than to uncover patterns of change.

After Iconoclasm figurative art was not something that
was simply revived; art was one sign of revival. The
visual arts constructed a new environment and new
values after the failure of Iconoclasm; but this
apparent innovation was in part a reconstruction of the
past in terms of a changed historical state. Patronage
of the arts in the ninth and tenth centuries reflected
the current economic position; but the character of the
social sponsorship of arts remained traditional. Only
later were the initiatives in the commissions of the
visual arts more obviously circumscribed within the
conventions of the monasteries -- where wealth came to
be concentrated through legacies and gifts, and the
consequent investments.⁶⁶ But the changes to be
observed in the contents and style of the art of these
later centuries are as impossible to explain simply in
terms of the character of patronage as is the art of
the period which followed Iconoclasm.

NOTES

1. International conferences have generally treated art history as a field to be surveyed chronologically. The period from Justinian to Iconoclasm was examined by E. Kitzinger (Munich, 1958); the eleventh century by K. Weitzmann (Oxford, 1966); the twelfth and thirteenth centuries by V.J. Djuric (Athens, 1976), the early Palaiologan period by O. Demus (Munich, 1958), and the fourteenth century by M. Chatzidakis (Bucharest, 1971). Unlike these contributions which, in the mould of traditional art history, looked for stylistic change in each periods as the consequence of an internal process of stylistic development or as the *reflection* of cultural or political changes, the present paper focusses on a problem of interpretation using the evidence of the allocated period.
2. A characterization of the period, with bibliography, is offered by W.T. Treadgold, "The Revival of Byzantine Learning and the Revival of the Byzantine State", *AHR*, 84 (1979), 1245-1266.
3. A view of the art of the period is offered by C. Mango, *Byzantium. The Empire of New Rome*, (London, 1980), esp. 268, who sees the phase c. 850 to c. 900 as one of intense artistic activity in which formulas were established which lasted for 300 years; and by J.-M. Spieser, "Image et culture: de l'Iconoclasme à la Renaissance macédonienne", in G. Siebert (editor), *Méthodologie iconographique* (Strasbourg, 1981), 95-106. Much of the evidence for the study of the art of the ninth century was collected by A. Grabar, *L'Iconoclasme byzantin*, (Paris, 1957) and C. Mango, *The Brazen House. A Study of the Vestibule of the Imperial Palace of Constantinople*, (Copenhagen, 1959).
Questions of patronage are considered by M. Mullett, "Aristocracy and Patronage in the literary circles of Comnenian Constantinople" in M. Angold (editor), *The Byzantine Aristocracy IX to XIII Centuries*, BAR International Series 221, (Oxford, 1984), (hereafter Angold: 1984), 173-201, who shows the need for the art historian to define terms. "Patronage" might range from a unique transaction where one product was purchased by a "patron" to the other end of the scale where a producer was supported over a period of time and so entered into a mutual relationship with a "patron"; see also E. Gellner and J. Waterbury, *Patrons and Clients in Mediterranean Societies*, (London, 1977). On the question of how tastes and preferences of patrons might lead to changes and developments in culture, Mullett recommends an empirical and seemingly reductionist programme of network analysis (from J. Boissevain and J.C. Mitchell, *Network Analysis. Studies in Human Interaction*, (The Hague and Paris, 1973). But the artistic production of our period is too sparsely documented to encourage the application of this method, at least not until its value has been justified in a period with more evidence.

Program (programme) is another term often used but seldom
defined. It is here taken to refer to any *series* of picture
units (and not to the individual set of iconographic elements
within any one pictorial composition). Program therefore
describes an integrated and planned set of pictures, such as
the complete decoration of a church, or the cycle of illumi-
nations within a manuscript, or a subset of scenes within a
single work of art. It must however be in theory equally
admissible to describe the total decoration of a church in
which the vaults have been adorned in a number of distinct
historical phases as either a single program (and to analyse
it synchronically) or as a combination of several programs
(and to analyse it diachronically).

 4. For a traditional (if Marxist) approach to the
Renaissance, there is F. Antal, *Florentine Painting and its Social
Background: the Bourgeois Republic before Cosimo de'Medici's Advent to
Power: XIV and early XV Centuries*, (London, 1947); and for an
example of how Renaissance patronage has been divided into
social groups see D.S. Chambers, *Patrons and Artists in the Italian
Renaissance*, (London, 1971). For a different view of the
problems see M. Baxandall, *Painting and Experience in Fifteenth
Century Italy*, (Oxford, 1972) who supplies a wider perspective
for understanding artistic production in which the patron --
or rather the "client" -- and the artist are set within the
institutions and conventions which moulded the pictorial
forms. The interpretation of Dutch art has been reconsidered
by S. Alpers, *The Art of Describing*, (Chicago, 1982).
K. Weitzmann is one scholar who connects Constantine VII
Porphyrogenitos individually with the "renewal" of the arts of
the tenth century: see "The Character and Intellectual Origins
of the Macedonian Renaissance" in K. Weitzmann, *Studies in
Classical and Byzantine Manuscript Illumination*, edited by
H.L. Kessler, (Chicago and London, 1971), 176-223. For the
empirical hazards of correlating clusters of production with
individual postulated patrons in Byzantium, see the cautionary
review of H. Buchthal and H. Belting, *Patronage in Thirteenth-
century Constantinople: an Atelier of Late Byzantine Book Illumination and
Calligraphy*, (Washington, D.C., 1978) by G. Vikan, *Art Bulletin*,
63 (1981), 325-8.

 5. Among the basic critical studies of traditional art
history on the roles of the artist and the patron are
N. Hadjinicolaou, *Art History and the Class Struggle*, (English
edition, London, 1978) and the useful review of the various
positions, both new and old, by J. Wolff, *The Social Production of
Art*, (London, 1981). The questions are discussed with radical
new suggestions by N. Bryson, *Vision and Painting. The Logic of the
Gaze*, (London, 1983). M. Baxandall, *Patterns of Intention. On the
Historical Explanation of Pictures*, (New Haven and London, 1985),
is marked by a refined traditional approach to the mind and
intentions of the artist.

 6. See R. Cormack, "Aristocratic Patronage of the Arts in
the 11th and 12th Centuries", in Angold: 1984, (see above
note 3), p. 167.

 7. The use of expensive materials is strikingly exhibited
by the blue backgrounds of the apse paintings of the New
Church of Tokali Kilise in the Göreme Valley in Cappadocia in
which the pigment is lapis lazuli. This decoration is to be
dated to the tenth century (second quarter?): see
A.W. Epstein, *Monks and Caves in Byzantine Cappadocia. A Photographic
Exhibition*, (Durham, North Carolina, 1983). Information about

X

630

patronage is contained in texts (for example the cost of the construction of San Vitale in Ravenna, see C. Mango, *The Art of the Byzantine Empire 312-1453*, (Englewood Cliffs, New Jersey, 1972), 104-5: Agnellus records the expenditure on the church by Julius Argentarius, presumably a banker, as 26,000 gold solidi); documents (for example Typika and Wills, particularly those of Eustathios Boilas and the Pakourianos family, see R. Cormack, as note 6 above); and inscriptions (for example, Palaiologan inscriptions in Greece with information about multiple patrons, such as the inscription of the church of Kipoula (Mani), dated 3 June 1265, first published by N.B. Drandakes, "The Wallpaintings of SS Cosmas and Damian, Kipoula (1265)", *Arch. Eph.*, 1980 (1982), 97-118 and then by A. Philippidis-Braat in D. Feissel and A. Philippidis-Braat, "Inscriptions du Péloponnèse (à l'éxception de Mistra", *TM*, 267-395, esp. 312-3).

8. The literature on model books, sketchbooks and pattern books is growing as more material is found: see most recently H. Buchthal, *The "Musterbuch" of Wolfenbüttel and its position in the Art of the Thirteenth Century*, (Vienna, 1979) and L. Bouras and M.-Ph. Tzinkakou, "Skedia ergasias metabuzantinon zographon", *Zygos*, no. 62 (1983), 22-30. On drawing see T. Velmans, "Le dessin à Byzance", *MonPiot*, 59 (1974), 137-70.

9. The details are given by A. Guillou, "Rome, centre transit des produits de luxe d'Orient au Haut Moyen Age", *Zograf*, 10 (1979), 17-21 and notes 37-8. In one transaction a gilded icon of the Virgin was valued at 30 nomismata and a silk skaramangion embroidered with gold thread at 20 nomismata.

10. Examples of recycled works are found in the Treasury of San Marco at Venice, see H.R. Hahnloser (editor), *Il Tesoro di San Marco. Il Tesoro e il Museo*, (Florence, 1971) and British Museum, *The Treasury of San Marco, Venice*, (London, 1984). Some items show how in the ninth and tenth centuries, for example, objects from earlier periods were adapted to new uses; those pieces which date back to Antiquity must somehow have been kept as family heirlooms or in church or imperial treasuries and taken for resetting or reuse. For the characterisation of a deduced tenth-century connoisseur see A. Cutler, "The Mythological Bowl in the Treasury of San Marco at Venice", in D.K. Kouymjian (editor), *Near Eastern Numismatics, Iconography, Epigraphy and History. Studies in Honor of G.C. Miles*, (Beirut, 1974), 235-54. An example of the use of such objects as symbols of wealth and power is reflected in the organisation of the entertainment for the Saracen ambassadors (from Tarsus) recorded in *De Caerimoniis*, ed. J.J. Reiske (ed. Bonn, 1829), I, 570 ff: the emperor (Constantine Porphyrogenitos) in order to impress these visitors in the Mangaura requisitioned for exhibition plate and other works in precious metals from the churches in the city. The example shows the powers of the emperor to appropriate such material and suggests the relation between bullion as art and bullion as wealth. Heraklios in 621 was allowed to collect church plate and convert it into coinage, see E. Cruikshank Dodd, *Byzantine Silver Stamps*, (Washington, D.C., 1961), esp. 32-3.

11. For elaborations of a system of exchange see P. Bourdieu, *Outline of a Theory of Practice*, (Cambridge, 1977), Stewart, *Attika*, (London, 1979) and S. Price, *Rituals and Power. The Roman Imperial Cult in Asia Minor*, (Cambridge, 1984).

12. A useful collection of material is in M. Hendy, *Studies in the Byzantine Monetary Economy c. 300-1450*, (Cambridge, 1985): hereafter cited as Hendy: 1985.

13. Lucy-Anne Hunt, "Comnenian Aristocratic Palace Decoration: Descriptions and Islamic Connections", in Angold: 1984, (see above note 3), 138-56, esp. 140 and note 22; and C. Mango, "When was Michael III Born", *DOP*, 21 (1967), 253-58.

14. See Hendy: 1985, 224-5 and note 23 for reference to Theophanes Continuatus, iv.20: Bonn edn. 171-2. Hendy's figure is 7,869,600 nomismata.

15. Hendy: 1985, 206-7 and 225 with references. Hendy's figure is 3,600,000 nomismata.

16. Hendy: 1985. 225. A reserve of 14,400,000 nomismata.

17. For the patronage of Theophilos see R. Cormack, "The Arts in the Age of Iconoclasm" in A. Bryer and J. Herrin (editors) *Iconoclasm*, (University of Birmingham, 1977) and C. Mango, *The Art of the Byzantine Empire 312-1453*, (Englewood Cliffs, New Jersey, 1972), esp. 160-5. For the patronage of Basil I, the text of the *Vita Basilii* (Bk V of Theophanes Continuatus) offers the basis for an interpretation. In the case of Basil II, his connection with Hosios Lukas has been one suggestion to explain the lavish building and decoration of the Katholikon: for a new review of the literature see D.I. Pallas, "Zur Topographie und Chronologie von Hosios Lukas: ein kritische Übersicht", BZ, 78 (1985), 94-107. (The patronage of Basil II accounts for the production of some illuminated manuscripts: the Menologion Vat gr 1613, the Psalter Marciana gr. 17, and possibly the luxury Gospels Sinai 204). The picture of "stagnation" in art over the fifty years of his reign implied by K. Weitzmann, "Byzantine Miniature and Icon Painting in the Eleventh Century", reprinted in *Studies in Classical and Byzantine Manuscript Illumination*, edited by H.L. Kessler, (Chicago and London, 1971), 271-313, depends on the "early" date of the Menologion proposed by Nersessian (on extremely weak grounds). A date in the eleventh century for the Menologion and the Psalter (as I. Ševčenko, "The Illuminators of the Menologium of Basil II", *DOP*, 16 [1962], 245-76 and A. Cutler, "The Psalter of Basil II", *ArtVen*, 30 [1976], 9-19 and 31 [1977], 9-15) would mean readjustments to Weitzmann's picture. I see no reason to accept that the Menologion is a copy of an earlier tenth century "model" (the textual evidence adduced is erroneous). Some of the resistance to accepting that Basil II was active in artistic patronage, as found in S. Runciman, *Byzantine Style and Civilisation*, (Harmondsworth, 1975), p. 108, seems to derive from a romantic notion of the philistine soldier "who resented spending money on the arts"; such views of "art" ignore its integral role in Byzantine life -- Basil II was accompanied on campaign not only by all the accoutrements of the baggage train (see Hendy: 1985, 272-5 and 304-15 for an account of the contents of the imperial baggage train) but also by travelling holy men. No doubt Basil travelled on campaign with portable icons -- he is accompanied by pictures of military saints in his portrait icon in the Marciana Psalter. As for other emperors in the period, their patronage too still needs assessment; the case of Michael III is one where his achievements can be rehabilitated, as by R.J.H. Jenkins and C. Mango, "The Date and Significance of the Tenth Homily of Photius", *DOP*, 9-10 (1956), 123-140.

18. On the aristocracy or nobility, see M. Angold, "Introduction", in Angold: 1984 (see above note 3), 1-9: and in the same volume A. Kazhdan, "The Aristocracy and the Imperial Ideal", pp. 43-57.

19. An example in the reign of Leo VI is the church in Constantinople built by Stylianos Zaoutzes between 886 and c. 893: see Leo VI Sermon 34, edited by Akakios, *Leontos tou Sophou panegurikoí logoí*, (Athens, 1868), translated by A. Frolow, "Deux églises byzantines d'après sermons peu connus de Léon VI le Sage", *EtByz*, 3 (1945), 43-91 and C. Mango, *The Art of the Byzantine Empire 312-1453*, (Englewood Cliffs, New Jersey, 1972), 203-5. A family related to the emperor Phocas might be involved in the patronage of one of the largest rock-cut churches in Cappadocia, see L. Rodley, "The Pigeon House Church, Cavusin", *JOB*, 33 (1983), 301-339 and N. Thierry, "Un portrait de Jean Tzimiskès en Cappadoce", *TM*, 9 (1985), 477-84.

20. The obvious example in the period is Leo Sacellarios, the patron of the tenth-century Bible of Leo in the Vatican: see C. Mango, "The Date of Cod. Vat. Regin. Gr. 1 and "Macedonian Renaissance", *ActaIRNorv*, 4 (1969), 121-26 and T.F. Mathews, "The Epigrams of Leo Sacellarios and an Exegetical Approach to the Miniatures of Vat. Reg. Gr. 1", *OCP*, 43 (1977), 94-133.

21. For examples see M. Angold and A. Kazhdan in Angold: 1984, (see above notes 3 and 18). Perhaps the most spectacular private patrons in Byzantine history are the members of the Pacourianos family in the eleventh century: see Hendy: 1985, 209 ff. Gregory Pacourianos was the founder of the Backovo Monastery. The will of Symbatios Pacourianos (dated 1093) reveals among other things that he had spent the dowry of his wife Kale (3,600 nomismata) on items of plate. Kale in her will (dated 1098) divided her possessions between family and church depending partly on its value and usefulness (jewelry, plate and clothing to nearer relatives and books and icons to monks or nuns).

22. The obvious example of a rich widow being Danielis (see Hendy: 1985 and also S. Runciman, "Women in Byzantine Aristocratic Society", in Angold: 1984, (see above note 3), pp. 10-22). She owned a weaving establishment at Patras (based on flax production) and property in the region; despite gifts and two major donations to Basil I, the first before he became sole emperor and including gold, clothing and trained slaves and the second including domestic servants, women weavers, woven items, precious plate and thick prayer rugs for the Nea church in the Great Palace, and despite her endowment of the Monastery of St Diomede, she was still reputably enormously rich at the time of her death in the reign of Leo VI. The case of Eustathios Boilas in the eleventh century shows the overlaps in the categories: a civil official who purchased properties with his surplus wealth (references in R. Cormack, see above note 6).

23. The case of Philaretos of Paphlagonia is handled in the discussion of his early ninth-century *Vita* by Hendy: 1985, 208-9.

24. Perhaps misleadingly combined into one category, since the secular clergy gradually became less able to afford expensive commissions as wealth was concentrated in the monasteries (as discussed by C. Mango, "Les monuments de l'architecture du XIe siècle et leur signification historique

X

Byzantine Iconography 633

et sociale", *TM*, 6 [1976], 351-65, and C. Mango, *Byzantine Architecture*, [New York, 1977]). However in our period the higher clergy was involved in the patronage of monasteries, as in the case of the (monastic) Patriarch Ignatios who decorated the monastery of SS Sergios and Bacchos or that of the foundation or restoration of the Monastery of Kauleas at Constantinople by the Patriarch Antonios II Kauleas (893-901: see Leo VI Sermon 28 and refs in note 19 above). The precise status of Naucratios who restored the mosaics in the church of the Koimesis at Nicaea is a matter for speculation. It seems that the emperor rather than the clergy was responsible for the two major church restorations of the period, namely the structural rebuildings and the mosaic decorations of St Sophia and Holy Apostles: both seem to have owed much to Basil I (see A.W. Epstein, "The Rebuilding and Redecoration of the Holy Apostles in Constantinople: A Reconsideration", *GRBS*, 23 [1982], 79-92). Both restorations programs were enormous and vastly expensive in terms of expertise and in the cost of materials (though labour costs were presumably cheap). The question remains of how exactly one regards the artistic patronage of such a patriarch as Photios. Was the work in St Sophia a state commission carried out by a "committee"? Or was Photios the "real" patron who manipulated the emperor to gain the funding? It is difficult at this level of enterprise to speak as if one commission had one patron.

25. See references in 21 above.

26. See P. Magdalino, "The Byzantine Aristocratic *Oikos*", in Angold: 1984, (see above note 3), 92-111.

27. J. Nesbitt - J. Witta, "A Confraternity of the Comnenian Era", *BZ*, 68 (1975), 360-84.

28. This observation touches on the controversial problem of the precise dating of Cappadocian churches and of those (fewer in number) which have mural decoration. I take the position that the excavation of most of these churches and other chambers and also most of the decorations belong within the two centuries from the second half of the ninth century until the occupation of the region by the Seljuks of Caesarea around 1067 (including the group of churches "with columns"). This is substantially the same view as that of de Jerphanion (and rejects the datings to the twelfth century of M. Restle and S. Kostov): for a recent review of some of the evidence see C. Walter, *Art and Ritual of the Byzantine Church*, (London, 1982). To date the substantial occupation of the rock-cut hermits and monasteries to two centuries concentrates the patronage into a relatively short period, and effectively suggests a greater social involvement. This aspect of patronage would be altered if one were to accept a greater quantity of activity in Cappadocia before the ninth century; Jerphanion was himself vague on this point. There were certainly built churches in the region before the ninth century, and monastic occupation and development of the various valleys in the period before the ninth century seems historically quite possible. Yet the archaeological evidence gives little definite on which to base attributions to this period. N. Thierry's arguments for Pre-Iconoclast and Iconoclast datings rest on little firm evidence, though in some cases (e.g. the Balkan Dere complex) they are conceivable. From the point of view of this paper the issue is simply whether there is a very high density of monuments in our period (one is concerned in all with the order of 150

X

634

painted programs in Cappadocia) or whether the number is to be diminished by attributions to the earlier period (with the further implications over questions of local traditions and continuities). The dating controversies do therefore impinge on the statistical analysis of the character of patronage in Cappadocia. Other questions still needing resolution are the relative numbers of monastic and secular churches in Cappadocia, the social character of the various clusters of monuments and even the (remote?) possibility of the Byzantine date of the so-called underground cities. See on some of these issues Lyn Rodley, *Cappadocian Monasteries*, (Cambridge, in press).

29. A. and J. Stylianou, *The Painted Churches of Cyprus. Treasures of Byzantine Art*, (London, 1985). For St Paraskevi at Yeroskipos see 382-94, but the attribution of the church and the east cupola paintings before the end of Iconoclasm simply on the grounds of a non-figurative programme is not acceptable. For St Antonios at Kellia, see 433-7, and esp. fig. 260; the style of Abraham is sufficiently close to such paintings as Ayvali Kilise in Cappadocia to suggest an early tenth-century date for the first phase at Kellia (early 11th according to these authors).

30. See A. Epstein, "Middle Byzantine Churches of Kastoria: Dates and Implications", *ArtB*, 62 (1980), 190-207.

31. D. Winfield, "Some Early Medieval Figure Sculpture from North-East Turkey", *JWarb*, 31 (1968), 33-72 on some of the monuments, and also see W. Djobadze in *OrChr*, 52 (1968), 95-7, (review of *Reallexikon z. Byz. Kunst*). S. der Nersessian *Armenian Art*, (London, 1978) and N. Thierry, *Peintures d'Asie Mineure et de Transcausie au X et XI siècles*, (London, 1977). While the paintings of Tatev may belong to the tenth century (930), doubt has been cast on the tenth century date of the visible phase of wallpaintings at Aktamar and these have been redated to the first quarter of the eleventh century by S. Grishin, "The Aght'amar wallpaintings: some new observations", *Parergon*, 3 (1985), 39-51.

32. J. Herrin, "Women and Faith in Icons in Early Christianity", in *Culture, Ideology and Politics*, edited by R. Samuel and G. Stedman Jones (London, 1983), 56-83 reflects the difficulties of deriving the sex of the patron from the subject matter of icons.

33. The optimistic interpretation of the open role of women put forward by A.E. Laiou, "The Role of Women in Byzantine Society", *JOB*, 31/1 (1981), 233-56 (= XVI Internationaler Byzantinisten-Kongress) is in need of reformulation; an alternative interpretation of the same phenomena of apparent female emancipation, in this case in the Hellenistic period, is set out by R. Van Bremen, "Women and Wealth", in A. Cameron and A. Kuhrt, *Images of Women in Antiquity*, (Beckenham, Kent, 1983), 223-42: it is argued that the dissolving of a clear distinction between private and public spheres allowed women to move from traditional female spheres into the male world, but the same social ideology towards women remained and continued to define and constrain behaviour: there was no legal or economic freedom on the part of even wealthy women. The same position would seem to hold in Byzantium.

34. See R. Cormack, "The Arts during the Age of Iconoclasm", in J. Herrin and A. Bryer, see above note 17 (Birmingham, 1977), 44.

35. Some discussion with references in R. Cormack, *Writing in Gold. Byzantine Society and its Icons*, (London, 1985).

36. So C. Mango, "The Liquidation of Iconoclasm and the Patriarch Photios", in J. Herrin and A. Bryer, see above note 17, (Birmingham, 1977), 133-40. The most striking product of the activities of Asbestas was the concoction of an illuminated manuscript in 867 which set beside the text of each act of a (faked) anti-Ignatian Synod a program of seven polemical images, ranging from Ignatios as the Devil to Ignatios as Anti-Christ (see C. Mango, *The Art of the Byzantine Empire 312-1453*, [Englewood Cliffs, New Jersey, 1972], 191). Considered as a new program this decoration corresponds in type to the Chludov Psalter, and so might be related to the patronage of the intellectual higher clergy.

37. Also translated by C. Mango, *The Art of the Byzantine Empire 312-1453*, (Englewood Cliffs, New Jersey, 1972), 172.

38. Michael Camille, "Seeing and Reading: some visual implications of medieval literacy and illiteracy", *Art History*, 8 (1985), 26-49. The rarity of Byzantine manuscripts has sometimes been exaggerated; as an antidote see M.T. Clanchy, *From Memory to Written Record. England 1066-1307*, (London, 1979).

39. The elusiveness of these analyses is most revealed in the study of K. Weitzmann, *The Miniatures of the Sacra Parallela, Parisinus Graecus 923* (Princeton, 1979), who explained the Sacra Parallela manuscript in Paris (gr 923) as the copy of a lost model (supposedly nearly identical in its iconography but different in appearance) which itself was a pastiche made up from a selection of pictures out of a collection of earlier lost books. The point that our example of the *Sacra Parallela* was not a totally "original" production is sufficiently argued, but the concomitant arguments about the relations between manuscripts must remain open to doubt (is it true, for example, that the site of innovation in Byzantium was in the book where the fullest text was illustrated? Or that pictorial compositions can be arranged in stemmata containing "less correct" copies of the original?). On Weitzmann's study of this manuscript see further reviews by R. Cormack in *Burlington Magazine*, 123 (1981), 170-2; C. Mango, in *AntJ*, (1982), 161-3; and J. Lowden in *Art International*, 26/4 (1983), 57-8. A date after 843 for this manuscript is given further support by J. Osborne, "A Note on the Date of the Sacra Parallela (Parisinus graecus 923)" *Byzantion*, 51 (1981), 316-7. A provenance in Constantinople seems to me likely, making the manuscript most relevant to this paper.

40. For a broader view see A. Cutler, "The Byzantine Psalter: Before and After Iconoclasm", in A. Bryer and J. Herrin, see above note 17 (Birmingham, 1977), 93-102; and A. Cutler, "Liturgical Strata in the Marginal Psalters", *DOP*, 34-5 (1980-1), 17-30.

41. For a recent bibliography see A. Cutler, *The Aristocratic Psalters in Byzantium*, (Paris, 1984), 63 ff.

42. The same is of course true about such manuscripts as the Joshua Rotulus in the Vatican or Athos, Stauroniketa 43.

43. H. Belting and G. Cavallo, *Die Bibel des Niketas. Ein Werk der höfischen Buchkunst in Byzanz und sein antikes Vorbild* (Wiesbaden, 1979), but with the important reservations of J. Lowden, "An Alternative Interpretation of the Manuscripts of Niketas", *Byzantion*, 53 (1983), 559-74. For the Bible of Leo see T. Mathews, note 20 above.

44. Unlike the case of Menocchio in C. Ginzburg, *The Cheese and the Worms*, (London and Baltimore, 1980).

45. An example in eleventh century wallpaintings illuminates the same issues, namely the sanctuary paintings of St Sophia at Ohrid. Here the (unique) representation of the bishops of Constantinople in the central apse signifies the primacy of the Byzantine church over the other patriarchal sees included in the program (see C. Walter, *Art and Ritual of the Byzantine Church*, [London, 1982], 175-6 and 193 ff) but is one to attribute the idea individually to the patron (Bishop Leo) or to the special ecclesiastical status of Ohrid which was understood at the time by any churchman. Or in saying that the program of the central apse is liturgical, how far is the representation of the eucharist to be explained by noting that Bishop Leo was involved in active controversy over the use of leavened and unleavened bread (see also A.W. Epstein, "The Political Content of the Paintings of Saint Sophia at Ohrid", *JOB*, 29 [1980], 315-329 and the further consideration by C. Walter, "Portraits of Local Bishops: a Note on their Significance", *ZRVI*, 21 [1982], 7-17). Kitzinger's terms of "inner directed" and "outer directed" do have the virtue of rejecting a straightforward explanation in terms of patron inventing a program and artist translating it into a visual form; but the terms will not be used here, as they introduce their own further difficulties (see *Byzantine Art in the Making*, [London, 1977], and the criticisms, for example, of E.H. Gombrich, *The Sense of Order*, [Oxford, 1979], p. 318, and Dale Kinney in *Byzantine Studies/Études Byzantines*, 9 [1982], 316-337).

46. The classic treatment of this text and its images is by S. der Nersessian, "*The Illustration of the Homilies of Gregory of Nazianzus Paris gr. 510*", *DOP, 16 (1962), 197-288*; L. Brubaker (in press) has suggested further reasons for connecting this manuscript with Photios.

47. This point was made already by R. Cormack, "Painting after Iconoclasm", in J. Herrin and A. Bryer, see above note 17, 147-63, esp. 151, in reaction against, in particular, the influential study of S. der Nersessian, "Le décor des églises du IXe siècle", *Actes du VIe Congrès internationale des études byzantines*, (Paris, 1951), t. 2, 315-20.

48. The chronology is discussed by, among others, C. Mango, *Materials for the study of the Mosaics of St Sophia at Istanbul*, (Washington, D.C., 1962) and R. Cormack, "Interpreting the mosaics of St Sophia at Istanbul", *Art History*, 4 (1981), 131-149.

49. For a recent exploration of the possible connections between the scenes in the gallery vaults and topical theology see K.K. Akentiev, "Mosaics of the Galleries of St Sophia at Constantinople" (in Russian), *VizVrem*, 45 (1984), 140-167.

50. This is the characterisation of C. Mango, *Byzantium. The Empire of New Rome*, (London, 1980), esp. 268. The pioneering study of the symbolic macrocosm of a Byzantine church was O. Demus, *Byzantine Mosaic Decoration*, (London, 1948). C. Walter, *Art and Ritual of the Byzantine Church*, (London, 1982), esp. 166 ff speaks of the sets of portraits of saints as *echelons* whose hierarchical positions changed as in different periods of Byzantine history the celestial hierarchies which mirrored society were differently perceived. For the ranks of Byzantine society in our period see N. Oikonomides, *Les listes de préséance byzantines des 9e et 10e siècles*, (Paris, 1972).

X

51. Various hierarchies already occur for example in San Vitale, both in the overall program and in the individual panels, see E. Leach, "Melchisedech and the emperor: icons of subversion and orthodoxy", in E. Leach and D.A. Aycock, *Structuralist Interpretations of Biblical Myth*, (Cambridge, 1983). 67-88.

52. Identification of the patron (or donor) is taken to be the key to meaning by N. Oikonomides, "Leo V and the Narthex Mosaic of Saint Sophia", *DOP*, 30 (1976), 151-72. An exaggerated view of the determining role of the patrons of the mosaics of St Sophia is also taken by R. Cormack, "Interpreting the Mosaics of S. Sophia at Istanbul", *Art History*, 4 (1981), 131-149.

53. This problem is faced by A. Cutler, *Transfigurations. Studies in the Dynamics of Byzantine Iconography*, (University Park, Pennsylvania, 1975), and by R. Cormack, *Writing in Gold. Byzantine Society and its Icons*, (London, 1985). One related problem which arises in this discussion is how useful the study of Byzantine art in terms of innovation can be. How anachronistic is it to emulate the modern art historian, for whom novelty and originality is both seen as an aim of the artist and as yardstick for the critic committed to "place" each work of art in an evolution?

54. See R. Cormack, as note 52 above.

55. P. Meyendorff, *St Germanus of Constantinople on the Divine Liturgy*, the Greek text with translation, introduction and commentary, (Crestwood, New York, 1984); and R. Taft, "The Liturgy of the Great Church: an initial synthesis of structure and interpretation on the eve of Iconoclasm", *DOP*, 34-5 (1980-1), 45-75.

56. See above note 46.

57. See above 20.

58. The same point is made with respect to naming the artists of the surviving sculptures of the Mausoleum of Halicarnassus by B. Ashmole, *Architect and Sculptor in Classical Greece*, (New York, 1972), p. 168; and, more forcefully, by G. Pollock, "Artists Mythologies and Media Genius, Madness and Art History", *Screen*, 21 (1980), 57-96. See also Wolff, as above note 5.

59. As E. Kitzinger, "The Hellenistic Heritage in Byzantine Art Reconsidered", *JOB*, 31/2 (1981), 657-75. Similarly H. Maguire, *Art and Eloquence in Byzantium* (Princeton, 1981) looks for the Classical, assuming that literary texts influenced by Antiquity directly explain Classical features in pictures which these texts "influence". A more critical view is taken by C. Walter, "Expressionism and Hellenism. A Note on Stylistic Tendencies in Byzantine Figurative Art from Spätantike to the Macedonian 'Renaissance'", *REB*, 42 (1984), 265-87.

60. P. Cartledge, "The Greek religious festivals", in P.E. Easterling and J.V. Muir, *Greek Religion and Society*, (Cambridge, 1985), 98-127, points out that in M.I. Finley (editor), *The Legacy of Greece: a New Appraisal* (Oxford, 1981), there is no chapter on religion (and there cannot be one).

61. For one review of the problems see A. Kazhdan and A. Cutler, "Continuity and Discontinuity in Byzantine History", *Byzantion*, 52 (1982), 429-78. Like C. Mango, *Byzantium and its Image*, (London, 1984), esp. reprints II, III and V, they too emphasize discontinuities and the development in Byzantium of new cultural patterns.

62. See M. Beard and J. North, *Pagan Priests: Religion and Power before Christianity*, (London, forthcoming).

63. H. Belting and C. Belting-Ihm, "Das Kreuzbild im 'Hodegos' des Anastasios Sinaites. Ein Beitrag zur Frage nach der ältesten Darstellung des toten Crucifixus", *Tortulae. Studien zu altchristlichen und byzantinischen Monumenten. Hrsg. W.N. Schumacher*, (Freiburg i. Br., 1966), 30-9.

64. See above note 7.

65. The various consequences of artistic tradition are set out by N. Bryson, *Tradition and Desire. From David to Delacroix*, (Cambridge, 1984).

66. The culmination of the grip of the monasteries over social and economic life is analysed by A.A.M. Bryer, "The Late Byzantine Monastery in Town and Countryside" in A.A.M. Bryer, *The Empire of Trebizond and the Pontos*, (London, 1980), reprint VI (from D. Baker [editor], *The Church in Town and Countryside*, Studies in Church History, 16 [Oxford, 1979]).

ADDITIONAL NOTES AND COMMENTS

STUDY I

I came across the archive of the British School at Athens by chance while working in the Photographic Library of the Warburg Institute (University of London) in Woburn Square. It had, I learned, been transferred there in 1960 for safe-keeping from its previous home in the Department of Medieval and Later Antiquities in the British Museum. I was not the first person to have recognised the importance of the collection, and I discovered that it had been the long-term aim of A.H.S. Megaw to work on the material (he wrote a typescript checklist of it in 1948). It had also been presented in slides by D. Talbot Rice at the International Congress of Byzantine Studies at Thessaloniki in 1953. Professor Martin Robertson wrote me a letter after my publication to tell me that some of the archive (or copies of it) was included in the exhibition arranged by the British School *British Archaeological Discoveries in Greece and Crete 1886-1936* at the Royal Academy of Arts in London in 1936; a brief catalogue of the exhibition was published at the time. A selection of the material was exhibited in Thessaloniki and Athens in 1985 (see Study II). It is planned in 1988 to send the material to Athens, where there is accommodation now available in the extended building. In future it will all be available for study there, including notebooks which have always been in Athens and have not yet been compared with the London material.

Amongst all the drawings and photographs, it still seems clear that the St Demetrios records are of quite outstanding value, since they constitute a thorough survey of the building in 1907-9, before the disastrous 1917 fire. However the complete archive is more substantial; and in a lecture which I gave in Athens at the centenary celebrations of the British School, I illustrated the antiquarian and historiographic significance of the whole collection and of the circumstances between 1887 and 1914 when so much Byzantine research was done by young trained architects under the auspices of the British School (notably by R.W. Schultz, S. Barnsley, W.S. George and W. Harvey).

W.S. George was the major figure in this research. He succeeded Schultz and Barnsley in working on the monuments of Thessaloniki (they had worked in Greece since 1887, in particular on the churches of Hosios Lukas and Daphni). George's draughtsmanship in the field was to my eyes both neater and

more accurate than his predecessors. Like them, George too after several sea-sons working in Greece on the projects of the British School and Byzantine Research and Publication Fund (founded 1908) went into professional archi-tectural practice; in his case in India where he moved permanently in 1915. His work at Thessaloniki was never finally prepared for publication, though it is clear from his various notes that publication of the monuments was the inten-tion. (See further, *Study II* and *Comment*.)

Since the publication of this paper, research on the dating of the pre-ico-noclast monuments of Thessaloniki has continued unabated, and one conse-quence of the severe earthquake in 1978 has been renewed archaeological examination of the monuments of the city, combined with their restoration. The Rotunda was particularly seriously shaken, and has been under consolida-tion and investigation in recent years. As E. Kitzinger pointed out to me in a letter after the publication, the dating of the conversion of the Rotunda is the crucial factor in much of the discussion. The attempts of M. Vickers to date massive alterations to the city in the mid-fifth century, including all the major early churches, mostly appeared after the publication of this paper. They are recently under challenge; see, for example, J.H. Humphries, *Roman Circuses. Arenas for Chariot Racing*, (London, 1986), esp. 625-31, who decides against the idea that the Hippodrome went out of use in 442/3 or that its seats were then a source of materials for the walls. It follows that the development of the city of Thessaloniki as provincial capital was probably piecemeal and slower than Vickers had argued. This means that the dates of the early churches prob-ably spread over a relatively long period of time.

The most recent collation of material on the monuments — J.-M. Spieser, *Thessalonique et ses monuments du IVe au VIe siècle. Contribution à l'étude d'une ville paléochrétienne*, (Paris, 1984) — remains embedded in stylistic ana-lysis for its proposed datings; they are for this reason ultimately unsatisfying, even if serious, propositions (around 500 for the Rotunda mosaics and about 550 for Hosios David). Perhaps the building of St Demetrios does belong to the first quarter of the sixth century as Spieser proposes, though the argument from sculptural decoration (on which he bases his case) remains ambivalent — are all the capitals original or were new elements introduced in the seventh-century rebuilding? Spieser underplays the severity of the seventh-century fire, as Soteriou overplayed it.

I do now concede that the addition of the north inner aisle mosaics might have been piecemeal and done in the course of the sixth century; but I would still insist that the cycle of Maria belongs to one single operation, supporting this with the visual observation that it belongs within a homogeneous framing (but see A. Grabar, "Notes sur les mosaiques de Saint-Démétrios à Thessa-lonique", *Byzantion*, 48 (1978), 64-77; this is a review article of my publication). Contrary to the speculation of Grabar, it seems likely that the British interest

in St Demetrios preceded that of the Russian and French expeditions, for George was already at work in 1907; furthermore this was just one section of a larger project of recording Byzantine monuments in Greece and Turkey.

The north inner aisle mosaics are still underexploited as visual evidence, though individual elements have been studied (such as the *kiborion*, the lyre-backed throne, or the "paradise" garden). I myself discussed this material in *Writing in Gold*, (London, 1985) and in "The Making of a Patron Saint: the Powers of Art and Ritual in Byzantine Thessaloniki", *World Art*, (Pennsylvania U.P., 1988), 417-24 (papers of the International Congress of Art Historians, Washington, D.C., 1986).

One footnote is necessary. In A.H.S. Megaw and E.J.W. Hawkins, *The Church of the Panagia Kanakaria at Lythrankomi in Cyprus. Its Mosaics and Frescoes*, (Washington D.C., 1977), p.103, note 421, the colour description of the ground of the haloes of the two medallion saints in spandrel H (on p.31) is queried: it is suggested that they might be blue. For the record, my description of them as gold is a correct reporting of the watercolour sheet.

STUDY II

I can add now to the biographical information about W.S. George. Walter Sykes George (born 1881; died 7 January 1962) was the son of an active and well-known architect Sir Ernest George (known for his domestic architecture as well as Claridges Hotel). He first appeared at the British School in the season 1906-7, and left the scene in 1915. George went to Delhi in 1915 as the local representative of the imperial architect Baker (who with Lutyens planned and built New Delhi and of whom George wrote in 1960 that he was one of the major architects of the twentieth century). In 1920 he went into private practice, and he remained as an architect in India after the 1947 Independence. His notebooks about his work and aims in India lie unpublished in the British Council Library in New Delhi, just as his Byzantine papers await further study. From statements he made in India we know something of his attitudes to architecture. He hoped that Indian traditions would survive twentieth-century movements towards "internationalism" in architecture. He thought that architects in India should use local materials, both for reasons of economy and because they were best for surviving the climate.

George and the other architects who produced the Byzantine archive of the British School archive all seem to have been permanently influenced by the experience of face-to-face contact with medieval craftsmanship (though this begs the question of how far these men were initially led to Byzantium through a student interest in the Arts and Crafts movement). In their subsequent ecclesiastical architecture, they combined their interest in medieval craftmanship with interest in "primitive" Christian churches. W.S. George's Church of

St Thomas, New Delhi, (completed 1932) tries to keep the massing of traditional Indian architecture, though it remains a brick and "Romanesque" building like Weir Schultz's Anglican Cathedral at Khartoum (commissioned in 1906; Schultz visited Khartoum in 1907, and returned there in 1912 for the consecration of the church — though it was not complete with its tower until 1931).

W.S. George and the other architects represent a growth of British interest in this period, one which had been promoted by such scholars as John Ruskin and W.R. Lethaby. This historiographic aspect is of interest for the development of Byzantine studies in Britain, and for the atmosphere in which much of the important early research was carried out. These men also represent the British tradition of the antiquarian architect who lovingly studied and recorded the past. The elegance and expertise of the record of W.S. George from a time before the use of colour photography is attractive and impressive. But the fact remains that the lost mosaics of St Demetrios are seen as watercolours and so through an interpreter's eyes.

The aim of the catalogue was to document the present state of research on the building and also to explain some of the reasons why the George archive had not been fully published. The plates in this volume are not reproduced to scale. The measurements in the catalogue section are those of the sheets in the archive. It remains a formidable task to integrate all the known materials about the church.

STUDY III

This was the first (and shorter) of two papers which I gave at the Spring Birmingham Symposium in 1975. The issues of art before Iconoclasm and of Cappadocia during Iconoclasm were covered in other papers (the first by A. Cutler through the evidence of Psalters and the second by A. Wharton Epstein). In both my papers time was short and my brief was to give a survey of the two periods (Iconoclasm itself and the aftermath) rather than to propose explanations. Looking at the papers now, I am struck by the consequent dissonance between my survey of material objects and my lack of consideration of their functions as religious objects used in prayer and worship. Both papers treat the period as one which prompts a consideration of the history of style, and ask formal rather than cultural questions. Did pre-iconoclastic *styles* survive a period of low production? What effects did the ninth-century revival of figural art have on *style*? It now seems to me that to phrase the problems within the history of styles inherently limited the dimensions of analysis. To argue that Byzantine *styles* changed little before, during and after Iconoclasm says nothing necessarily about cultural or religious changes or how those changes might be measured. The uses of art, for example, might change radically, even if style does not. The character of the sanctuary screen is a case in point. As this de-

veloped and changed its size and shape and its functions as an icon support over the course of the Byzantine period, it also changed its powers to enhance the mystery of the altar and liturgical rites which might be concealed behind it. Yet the "style" of the icons which may be fixed to it at various times do not on its own reveal such changes.

Both my papers at any rate played down this period as one of religious change. I now see Iconoclasm as of much greater significance in Byzantine history. It is the period not so much when icons were banned or destroyed as the time when people, whether emperors, clergy or the public, were forced to ask what were the functions of images in Christianity. Useful now for a documentation of the period is J. Herrin, *The Formation of Christendom*, (Oxford, 1987), though the considerable role she gives to the crisis generated by the Muslim advance for the birth of Iconoclasm is controversial.

This paper was conceived in the stylistic framework of Kitzinger's 1958 paper "Byzantine Art in the period between Justinian and Iconoclasm". This now seems to me a much less helpful framework, much too dependent on modern perceptions of style as an independent object of study, without sufficient attention to the ways in which icons were perceived and understood. Another difficulty in the paper lies in its use of texts. I now feel hesitant, for example, about my literal interpretation of the *Vita Basilii* and other sources, and about my underplaying of the rhetoric of their composition. None of them are neutral documents.

The bibliography of this field is now immensely extended:

The monograph by U. Peschlow on St Eirene appeared (though it is limited in its analysis to the architecture of the monument and does not discuss the Iconoclast decoration), *Die Irenenkirche in Istanbul*, (Tübingen, 1977). On St Sophia at Thessaloniki, see now Study V in this volume for additional discussion and bibliography. The Turkish holdings of the Sion treasure are kept in Antalya rather than Istanbul; on silver treasures see now M. Mundell Mango, *Silver from Early Byzantium. The Kaper Koraon and Related Treasures*, (Walters Art Gallery, Baltimore, 1986). In a review article on recent publications in the field of sculpture, R.R.R. Smith,"Roman Portraits: Honours, Empresses and Late Emperors", *Journal of Roman Studies*, 75 (1985), 209-221 is sceptical about the production of any imperial statues after c.600. Discussion on the Chludov psalter has continued; most useful on the textual sources of its imagery is C. Walter "Christological Themes in the Byzantine Marginal Psalters from the Ninth to the Eleventh Century", *Revue des Etudes Byzantines*, 44 (1986), 269-87. The Sacra Parallela is the subject of a monograph by K. Weitzmann (Princeton, 1979), but the issue of its date and possible western connections was taken up by J. Osborne, "A note on the date of the Sacra Parallela (Parisinus Graecus 923)" *Byzantion*, 51 (1981), 316-7. A careful study on the ivory of Leo in Ber-

lin is K. Corrigan, "The Ivory Sceptre of Leo VI: a Statement of Post-Icono-clast Imperial Iconography", *Art Bulletin*, 60 (1978), 407-16.

STUDY IV

This paper marks a shift in emphasis in my explanation of the character of By-zantine art away from the artist producer towards the patron. Yet it is still *style* that is being explained. The conclusion of this paper is no longer, on its own, entirely acceptable to me; for some additional thoughts (arguing that Icono-clasm does mark a watershed in the history of art), see my "Icons in the Life of Byzantium", in G. Vikan, *Icons — Holy Images* (Walters Art Gallery, 1988). Also C. Walter, *Art and Ritual of the Byzantine Church*, (London, 1982) for a reassessment of the periodisation of Byzantine art.

Study X in this volume is a reconsideration of artistic patronage in this peri-od. It also supplies a further bibliography; to which can be added L. Brubacker, "Politics, Patronage and Art in Ninth-Century Byzantium: the *Homilies* of Gregory of Nazianzus in Paris (B.N. GR. 510)", *Dumbarton Oaks Papers*, 39 (1985), 1-13. Also A. Wharton Epstein, "The Rebuilding and Redecoration of the Holy Apostles in Constantinople: a Reconsideration", *Greek, Roman and Byzantine Studies*, 23 (1982), 79-92.

The sermons of George of Nicomedia have been further explored by others: for example H. Belting, *Das Bild und sein Publikum im Mittelalter: Form und Funktion früher Bildtafeln der Passion*, (Berlin, 1981) and H. Maguire, *Art and eloquence in Byzantium*, (Princeton, 1981). But art historians still have to jus-tify their methods in using such texts, especially if they accept that to under-stand the meaning of an image requires more than finding a text to match a picture. In this Study, too much emphasis was placed on the "accuracy" of de-scription in Byzantine texts and a sequential "cause and effect" relationship between texts and pictures. In *Writing in Gold* (London, 1985), I argued for a more complex inter-relationship of expression in word and image, and for dif-ferent forms of communication in the different media. A recent treatment of the issues in field relevant to Byzantine studies is J. Bortnes, *Visions of Glory. Studies in Early Russian Hagiography*, (Oslo, 1988).

Writing in Gold also reconsidered the nature of ninth-century art and the cultural attitudes encapsulated within it, suggesting the period be seen in terms of innovation masquerading in the guise of traditionalism. There remain diffi-culties in the interpretation of the precise details of the artistic production of the ninth century. The logic of whether there was "plan" drawn up by Photios which encompassed a whole scheme for St Sophia is likely to be circular. The most bizarre statement in the paper in retrospect is on p.149 where it is ac-cepted that the first images in St Sophia after Iconoclasm were portable icons and that this indicates the "makeshift character" of decoration in the first years

after 843. Since the "triumph" of Orthodoxy was indeed the license to make and display icons (and surely in the first place panel paintings), then the initial display and use of icons in St Sophia after Iconoclasm must have represented a signal victory of the church. Indeed the display of icons was more provocative in a church like St Sophia, for unlike the remote monumental mosaic decoration, icons were accessible, easier to venerate and available for public procession.

STUDY V

This study was a contribution to a volume in honour of Andreas Xyngopoulos. I had met him in Thessaloniki in 1965 in order to discuss his observations on the mosaics of St Sophia which were at the centre of my Ph.D. research. Unlike myself, Xyngopoulos had seen the apse mosaics from scaffolding, though I was sceptical about his interpretations. Debate still continues about the dating and relative order of the mosaics in the church — with different chronologies being proposed on the basis of different observations and arguments.

While I was writing the paper, an important study had appeared by K. Theocharidou, "The mosaics of the dome of St Sophia at Thessaloniki: phases and problems of chronology", (in Greek) *Archaeologikon Deltion*, 31 (1980), 265-73. This paper highlighted the issues of the interpretation of the mosaic surface and was based on observation from scaffolding. After my paper was published another analysis of the inscriptions appeared (written before the article of Theocharidou) which also depended on examination of the mosaic from close-to: Ch. Bakirtzis, "New Observations on the patronal inscription of the dome of St Sophia at Thessaloniki", (in Greek), *Byzantina*, 11 (1982), 167-180. This reached the same conclusions as Theocharidou about the relative order of the dating inscriptions and the Ascension mosaic, supported by a number of different observations and suggestions; Bakirtzis placed the inscription in 690/1, one of the suggested dates in the paper of Theocharidou.

The next stage in the study of St Sophia was reached with the publication of the thesis of K. Theocharidou, *The Architecture of Hagia Sophia, Thessaloniki from its erection up to the Turkish Conquest*, BAR International Series 399, (Oxford, 1988). This gives a comprehensive account of the structural evidence revealed by the stripping of the plaster from the masonry, and offers a full interpretation of the building phases of the monument. These turn out to be more complex than had appeared previously!

It is not the intention of Theocharidou to analyse the mosaic decoration, but the dome inscriptions remain a part of her relative dating evidence, and she attempts to answer the objections which I made to her "early" dating. She deduces a number of building phases, and attributes the nucleus of the present building to the first quarter of the seventh century, replacing an earlier ba-

silica on the same site. A crucial element in her argument is the dating of the mosaic inscriptions in the dome, which she now firmly attributes to 690/1 and uses as a *terminus ante quem* for the building of the present domed church.

I still feel that there are arguments for my own suggested dating of the mosaic, despite its difference from two art historians who have had the opportunity (unlike myself) to examine the mosaic from scaffolding. This is partly because I do not believe that the issue can be resolved until a sondage is carried out in the modern plaster around the juncture of the mosaics. Neither Bakirtzis nor Theocharidou did this. It will also be clear from what follows that the dating of the inscription to the late seventh century and other aspects of Theocharidou's chronology involve their own problems.

In the chronology of Theocharidou, the apse mosaic decoration with its late eighth-century monograms does not necessarily relate to any of her suggested building phases. Neither do the mosaics of the dome with their representation of the Ascension form any part of the building history. In other words, the architectural history which Theocharidou proposes is well nigh independent from the decorative history of the monument. This sequence of events may of course be correct, but it is to me surprising to suppose that a church of this size, needing expensive scaffolding for any constructional or decorative operation, should have a history where these phases do not coincide.

Theocharidou's scheme is as follows:

Phase 1 is the building of present domed church of St Sophia over the ruins and in part on the foundations of an earlier large (and presumably important) basilica. This phase dates roughly c.600 to c.630, and probably near to 600. There is no evidence of its decoration.

Phase 2 (either two periods or one) represents a reconstruction of the superstructure, including the dome and alterations to the roofing, losing the use of west gallery. It probably dates straight after the earthquake of 618, as the building techniques of phase 1 and 2 are of "great similarity". There is no evidence that this operation included decoration.

690/1 saw the decoration of dome with mosaic inscriptions (and presumably some lost dome scheme).

780-797 saw the decoration of the apse and sanctuary (and is possibly connected with a restoration of the building, perhaps the second period of *phase 2*).

The Second half of 9th century saw the redecoration of the dome with the Ascension (dated by style); the earlier dating inscriptions were preserved in the new design.

Phase 3 is the restoration of the gallery area and reconstitution of the west gallery; this is dated to the middle of 10th century (in part through the tricky evidence of coin finds).

Phase 4 is another structural restoration which might include the fresco decoration datable to the first half of the 11th century. There are other later phases too.

If the scheme is laid out like this, some of the disagreements over the history of the church can be better appreciated. Since my own studies on the church have had to be devoted to its decoration rather than its architecture, which I have never studied in such detail as Theocharidou, to a great extent our concerns do not overlap. The precise dating of the church, for example, does not impinge on the interpretation of the non-figurative sanctuary mosaics (except the question of whether the text might refer to the dedication or a re-dedication). However, her dating of the dome inscription does affect my understanding of the historical context of the dome mosaics — are they datable with some precision to the year 885 as the work of Archbishop Paul, correspondent of Photios or are they mosaics produced somewhere between 843 and the middle of the tenth century (perhaps relating to the restoration of the galleries)? And my acceptance of the connection between Paul, 885 and the Ascension mosaics all depends on the relative orders of the inscriptions, figural mosaic and the garland. I have always tried to indicate my awareness of the lightness of the underpinning for the 885 dating!

I am struck by the special pleading needed to argue the 690/1 dating of the inscription, which then supplies Theocharidou with a dated moment within her relative chronology. In her thesis she accepts the argument in my paper that neither the Byzantine year system nor the Proto-Byzantine system can accommodate a two numeral year and a fourth indiction. But she finds an alternative explanation for the discrepancy: that the Roman or Pontifical system was employed, which starts the indiction year on 25 December. So far as I can see from the minimal information given in Grumel (which forms her bibliographical support), this arithmetic does indeed work. But this would then be the only known example of a Pontifical indiction in Greece (although the ecclesiastical status of Illyricum is certainly a special case). Theocharidou needs to put great weight on this inscription. On her argument it becomes an early example of the era of creation, and one where the Pontifical indiction is used; it has to be a two numeral expressed year (but the second letter is lost as is the right-hand side of the inscription); it does not relate to a building phase; the decoration with which it is related is lost; there is no known archbishop Paul at this period. And all this effort is put into an interpretation of the inscription on the assumption that it precedes the Ascension, and not just the garland. It is here that a sondage is absolutely necessary to clarify the relationship between the differ-

ent phases of mosaic.

The issues are further complicated if we consider the implications of the *relative* (rather than *absolute*) chronology of the building suggested by Theocharidou. Ironically, leaving aside all the structural and architectural issues which would have to be fully taken account of in a proper reconsideration of the evidence, her *relative* scheme could still in theory be compatible with a history like my own: construction and first decoration 780 to 797; rebuilding of superstructure and decoration of dome with Ascension in 885; alteration of gallery system in 10th century; more work and redecoration with frescoes and the mosaic Virgin in the apse in the second quarter of the 11th century.

In my own work, I have never disguised the fact that a perennial difficulty I felt in studying the church of St Sophia at Thessaloniki was the tantalising precision of the mosaic inscriptions, but the insufficient empirical understanding to exploit this evidence. The same dilemma emerged in the book by H. Buchwald, *The Church of the Archangels in Sige near Moudania*, (Vienna, Cologne and Graz, 1969) who had independently taken the same line as I had myself in dating the construction of the church, and who reached the conclusion that the simplest solution of the apse monograms was to date the foundation to the reign of Eirene and Constantine VI (780-797). My own paper also resorted to the arguments of "Occam's razor", while admitting that in this church there was no substitute for properly conducted archaeological investigation to resolve the issues. No one can afford to ignore the complex realities of building histories which have emerged in well studied monuments, such as the Kalenderhane Camii or even St Sophia in Istanbul.

The published thesis of Theocharidou supplies a selected recent bibliography of the monument. Now that the nature of the architecture of the church is better established by her work, one aspect of the cathedral of St Sophia which can be more precisely pursued is its ceremonial and liturgical use in the Paleologan period for which there seems considerable textual evidence from the writings of its famous archbishops; see also J. Darrouzès, "Saint Sophie de Thessalonique d'après un rituel", *Revue des Etudes Byzantines*, 34 (1976), 45-78.

STUDY VI

This paper grew out of my research for my Ph.D. thesis. It appeared in this Journal because it was submitted to the British Archaeological Association and awarded the Reginald Taylor Prize and Medal for 1966. Publication was part of the award. The phrasing of the note on p.36 that it was "based" on my thesis has misled some commentators to assume that my thesis was entirely focussed on painting in Cappadocia. The truth is that the thesis was entitled *Monumental Painting and Mosaic in Thessaloniki in the Ninth Century*, (University of Lon-

don, 1968), and the evidence from Cappadocia was only introduced into it as part of the discussion of two issues. The first was to refute the simple notion that an excavated church in Thessaloniki with non-figurative wall paintings was necessarily Iconoclastic in date because of the character of the decoration (the evidence of Tokalı kilise was fundamental in this discussion). The second was to use Cappadocia as a control in the stylistic question of whether the dome mosaics of St Sophia at Thessaloniki derived from purely "local" traditions or were related to the art of Constantinople; the parallelism between Cappadocia and Thessaloniki was used as an argument for a common source in Constantinople. Not all the contents of the paper appeared in the final manuscript of the thesis.

While my visit to Cappadocia in 1965 convinced me that this material was seriously undervalued in Byzantine studies, it was far from a major part of my research interest. I am glad to have since supervised two Ph.D. theses whose writers have gained a far closer knowledge of the region than I have myself. Their most recent books are a source of up-to-date bibliography on the region: Lyn Rodley, *Cave Monasteries of Byzantine Cappadocia*, (Cambridge, 1985) and Ann Wharton Epstein, *Tokalı Kilise. Tenth-Century Metropolitan Art in Byzantine Cappadocia*, (Washington, D.C., 1986). The latter book with its excellent photographic coverage of the paintings after their cleaning by ICCROM between 1973 and 1980 maintains a dating of the two phases of this church to the beginning and to the middle of the 10th century. To me the comparison with the manuscript Bible of Leo (Vatican Reginensis gr. 1) is now even more telling.

When I wrote my paper the bibliography was relatively sparse, and little of it attempted to stand back from the material and to ask what general questions might be addressed. However, enormous energy was already being devoted to the exploration of the region in the hopes of supplementing the nucleus published by G. De Jerphanion — something which has now been achieved. I can only admire the efforts in particular of Madame Nicole Thierry in this difficult area, and have benefited from seeing her magnificent collection of photographs. The selected corpus of M. Restle appeared only after my paper was written (as *Die byzantinische Wandmalerei in Kleinasien*, [Recklinghausen, 1967] and published in English in 1969). I realised from the photographs and stylistic arguments in this book that my two last throw away sentences in the paper had opted for too late a date for the three "Churches with Columns", and that the group should be dated with de Jerphanion in the middle of the eleventh century (though my interpretation of a new "metropolitan influence" would remain an arguable case). I duly criticised the 12th or 13th-century dating of this group in a review of Restle in the *Burlington Magazine*. I still regard as unresolved the question of how much Cappadocian material dates from the period before Iconoclasm. Nor do I think the non-figurative decorations from

Naxos are necessarily from the period of Iconoclasm: see M. Acheimastou-Po-tamianou, "A New Aniconic Decoration on Naxos. The Wallpaintings of the Church of Hagios Ioannis at Adisarou" (in Greek), *Deltion tis Christianikis Ar-chaiologikis Etaireias*, 12 (1984), 329-82.

I would not now approach the Cappadocian material in quite the same way. In particular the aim of the analysis in reconstructing lost Constantinopolitan art seems too limiting — rather more useful surely to analyse their existing wit-ness to the methods and principles of Byzantine art! The paper also tends to exaggerate the importance of the "high quality", that is the supposedly "im-ported" aspects of the painting, rather than to admit that it is the high density of survival at all levels of expertise that deserves extended analysis. It may well be the "low quality" decorations which reveal the most about the production and viewing of Byzantine art. Perhaps also there was too great an emphasis in the article on the crude dichotomy between the traditional and the new; though in the course of the argument this dichotomy fulfilled the (as I still believe) im-portant role of highlighting the complicated nature of paintings previously de-scribed as "Archaic".

I continue to believe that Cappadocia offers very rewarding material for the Byzantinist. It may by now be academically respectable to work on it.

STUDY VII

This paper was invited just a few days before the opening of the 1979 Birming-ham Symposium as a replacement for an absent speaker; but it allowed me to try out the idea of a comparison between these two provincial cities. Some of the difficulties of making the comparison demonstrated as much the problems of the evidence (and its gaps) as the challenge of how one should treat the sub-ject of the Byzantine city. In both cities, but for different reasons, the archae-ological record fails to convey the notion of habitation and the experience of the urban environment. The problem in Thessaloniki is of a city in continuous occupation from Antiquity to the present day with the result that excavation has been piecemeal, often in the form of rescue digs before site redevelop-ment. The history of the excavation of Aphrodisias is quite different. The work since 1961, under the direction of Professor Kenan Erim, has been determined as part of a sponsored plan to investigate the role of the sculpture of Aphrodi-sias in Antiquity and the early Byzantine period. Consequently monuments such as Byzantine churches have been only selectively examined, and even the street system has emerged only gradually as the excavation areas have been ex-panded.

The result of all this is that the paper might be criticised for the traditional art historical "failure" of treating Byzantine cities as clusters of churches! The defence against this criticism is that the context of the symposium was the prob-

lem of Classical continuity, and that this issue could be more precisely formulated through cases of specific monuments. A feature of both cities was the coexistence of the old and the new, but this simple polarity is complicated by redevelopments of the old. For example, in Aphrodisias, the theatre after its sixth or seventh-century collapse became the foundation for medieval housing, stretching from this site over the Acropolis. The medieval environment of Thessaloniki is less clear, though new information has emerged from the recent excavations in the Agora (for a statement on our knowledge of domestic architecture see C. Bouras, "Houses in Byzantium", *Deltion tis Christianikis Archaiologikis Etaireias*, 11 [1982-3], 1-26).

Monuments, like institutions, can appear to "continue" for centuries, but analysis of changes in functions and practical alterations can refine the concept of continuity as well as to question its explicative values. For the character of mid fifth-century Thessaloniki, see now *Comment on Study I*. In Aphrodisias, the key monument which survived the centuries but which signals the religious discontinuities between Antiquity and the Middle Ages is the "Temple". In the Second Conference on Aphrodisias in London in 1988 (in press) I returned to the issues in a paper "The Temple as Cathedral". The temple is currently being further excavated and examined, but no decisive evidence has emerged on the date of conversion (for which I still propose the mid-fifth century). On the question raised on p.108 whether the paintings of the three Muses and a Nike remained visible through the Middle Ages, further examination of the notebooks shows that at some date they were covered over with plaster. For the site see now K.T. Erim, *Aphrodisias. City of Venus Aphrodite*, (London, 1986).

An understanding of the Antique "city" and the transition into the Middle Ages is now much enhanced by several major studies. In particular: K. Hopkins, "Economic Growth and Town in Classical Antiquity", in *Towns in Societies*, edited by P. Abrams and E.A. Wrigley (Cambridge, 1978), 35-76; J.F. Haldon and H. Kennedy, "The Arab-Byzantine Frontier in the eight and ninth centuries: Military Organisation and Society in the Borderlands" *ZRVI*, 19 (1980), 79-116; and B. Ward-Perkins, *From Classical Antiquity to the Middle Ages. Urban Public Building in Northern and Central AD 300-850*, (Oxford, 1984).

STUDY VIII

The periodical *Art History* in which this paper appeared is the quarterly publication of the Association of Art Historians in Britain. Since its British readership consists particularly of specialists in 19th and 20th century art history, any writer must take this non-Byzantinist audience into account. I chose the mosaics of St Sophia for a paper in *Art History* in part at least because the church and its decoration lies at the heart of Byzantium. It can attract the interest of

art historians in general as part of the mainstream of their subject, and not as something marginal. The problems of St Sophia almost necessarily have general art historical implications.

A further reason for a review article on St Sophia was the fifty years anniversary of research into its mosaic decoration. This was an anniversary which in the event only this paper seems to have celebrated; the Byzantine Center at Dumbarton Oaks which had succeeded to the mantle of Whittemore and his Byzantine Institute of America has for the time being discontinued any activities there (for several reasons, not least of which were the problems connected with their purchase of a great part of the Sion treasure from southern Turkey and the complications of title connected with such a purchase). There was an underlying polemic in the paper that the anniversary seemed to mark the retreat of Dumbarton Oaks in Washington from active archaeological and restoration work in Turkey. This was a matter of regret, for the volumes of *Dumbarton Oaks Papers* during the 1960s and 1970s had set standards of publication and reproduction of Byzantine monuments that were the envy of art historians in other areas and which established the importance of the field.

The bibliography of St Sophia has continued to expand. The second instalment of the architectural survey by R. Van Nice appeared in 1987. Another architectural study, R.J. Mainstone, *Hagia Sophia. Architecture, Structure and Liturgy of Justinian's Great Church* (London, 1988), explains the structure and documents the ritual usage of the church. N. Oikonomides, "Some Remarks on the Apse Mosaics of St Sophia", *Dumbarton Oaks Papers*, 39 (1985), 111-115, which argues against the dating of the apse Virgin to 867, fails to understand the character of the archaeological evidence and relies on an over-literal understanding of texts. It proposes the erection of an enormous scaffolding in the sanctuary on at least four occasions (in the eighth century (probably between 787 and 797), in 815, in 867 and in the fourteenth century, before 1383). We are asked to believe that the artists who erected the scaffolding in 867 failed to observe an Iconoclast cover of plaster over an earlier mosaic. The study mentioned in note 8 has now appeared; G.P. Majeska, *Russian Travelers to Constantinople in the Fourteenth and Fifteenth Centuries*, (Washington, D.C., 1984). It is a valuable collection of writings whose value extends beyond their empirical witness of the city to a repertory of the perceptions of medieval viewers. My own research on the Deisis mosaic (see note 52) has expanded into a book *Reading Byzantine Art — the Deisis Mosaic of St Sophia* (Cambridge, forthcoming).

STUDY IX

This paper was written for the Spring Symposium held at Edinburgh in 1982. The eventual publication included a companion paper to mine on "Aristocracy

and Patronage in the Literary Circles of Comnenian Constantinople" by M. Mullett. This was commissioned after the conference — hence the lack of reference to it here (though see below Study X). A comparison of the two papers demonstrates the different problems which emerge for art historian and literary historian of Byzantium. On the face of it, literary evidence provides much more fruitful material, because individual patronage can frequently be precisely identified. It was possible therefore for Mullett to propose to undertake a "complete network analysis of the writers of the period" — something on which she has since made further progress (see also M.E. Mullett, "Byzantium: a friendly society?", *Past and Present*, no. 118 [1988], 3-24).

It is much more difficult to be specific about the activities of commissioners of art; the patrons of art (and the art with which they were connected) are much less well documented than their literary counterparts. So the kind of analysis that Mullett undertakes could never be undertaken for Byzantine artistic production. It might be possible to build up a profile of particular well-documented patrons, such as Theodore Metochites in the fourteenth century. But there are dangers in the over-optimistic characterisation of individual patrons. These are best revealed in the case of emperor Constantine Porphyrogenitos in the tenth century; he has actually been described as one of the greatest art patrons in the period between Hadrian and Lorenzo de Medici, although the known products of his personal patronage are very few indeed.

STUDY X

This paper was submitted several months in advance of the conference held in the summer of 1986, and was printed for circulation among participants. The following studies have appeared since my paper was completed in 1985:

A strongly theoretical book, S. Sinding-Larsen, *Iconography and Ritual. A Study of Analytical Perspectives*, (Oslo, 1984), is also critical of traditional views which exaggerate the role of the artist and the patron (together described by him as the "planners"). He too treats the patron as part of the society in which he or she lives, and not as a unique self-contained individual.

L. Brubacker, "Politics, Patronage and Art in Ninth-Century Byzantium: the *Homilies* of Gregory of Nazianzus in Paris (B. N. Gr. 510)", *Dumbarton Oaks Papers*, 39 (1985), 1-13, works on two levels of interpretation. At one level, she suggests, for example, that the illustration of the Council of 381 reflects a general interest in Councils in the ninth century; this is plausible. At the other level, the specific connections she proposes between the personal intentions of Photios and the imagery of the manuscript raise greater difficulties. The same tension between the linkage of iconographic features to events and ideas of a historic period and the suggestion of special patronal intentions for which there are no related documents is found in the earlier paper of K. Cor-

rigan, "The Ivory Sceptre of Leo VI: a Statement of Post-Iconoclast Imperial Iconography", *Art Bulletin*, 60 (1978), 407-16.

For N. Oikonomides, "Some Remarks on the Apse Mosaics of St Sophia", *Dumbarton Oaks Papers*, 39 (1985), 111-115, see *Comment on Study VIII*.

Related issues of meaning and the intentions of artist or patron are discussed by H. Hoffmann, "Why did the Greeks need imagery? An anthropological approach to the study of Greek vase painting", *Hephaistos*, 9 (1988), 143-60.

In presenting the paper orally at the congress I illustrated my arguments with two comparative examples:

1. *The modern situation of patron and artist*. To say that a certain millionaire decided to commission a work by David Hockney because he met him one day in an airport restaurant would be a poor explanation. To understand a pattern of patronage one needs to explore the status of the artist in the 20th century and the life style of certain successful painters. The individual meeting (if ever it could be firmly documented) is a more trivial part of the explanation of patronage than the eating habits of the cosmopolitan rich (whether artists or patrons)!

2. *The Letters of Cicero and the "revolution" of the Late Roman Republic*. On the basis of the Letters we can build up a detailed network of who knew whom, and who wrote to whom and when; and we can investigate the changing patterns of friendship and enmity between individual political leaders, and their particular aims and aspirations. Yet all this rich information has helped surprisingly little in understanding the pattern of political life in Rome and the momentous changes of the final years of the Republic. Likewise with the comedies of Aristophanes, where discovering the details of the lives and liaisons of the pilloried politicians has helped little in our analysis of the character of Greek Comedy.

INDEX

PLATES

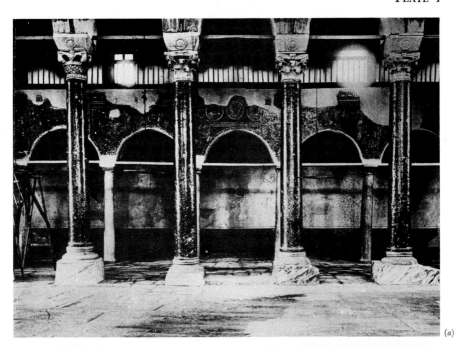

(a)

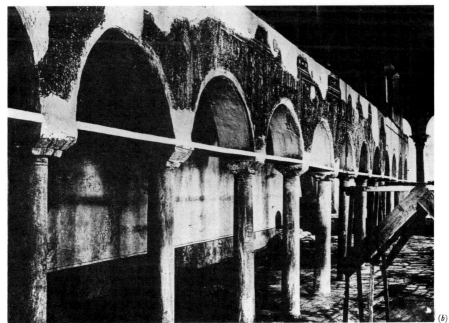

(b)

(a) THE NORTH AISLES OF THE CHURCH OF S. DEMETRIOS, THESSALONIKI. PHOTOGRAPHED FROM THE NAVE BY
N. KLUGE IN 1908
(b) THE NORTH INNER ARCADE LOOKING EASTWARDS (SPANDREL A *et seq.*). PHOTOGRAPHED BY N. KLUGE IN 1908

I

PLATE 10

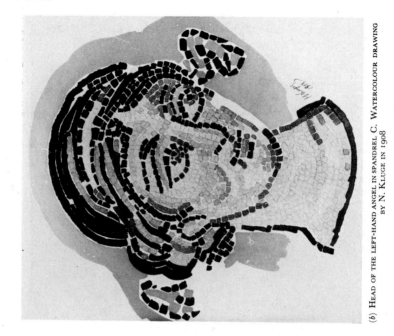

(b) HEAD OF THE LEFT-HAND ANGEL IN SPANDREL C. WATERCOLOUR DRAWING BY N. KLUGE IN 1908

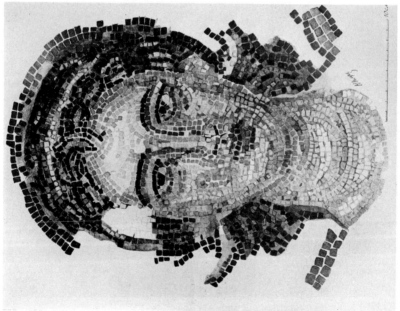

(a) HEAD OF THE ANGEL *Δύναμις* IN THE SANCTUARY MOSAICS OF THE CHURCH OF THE KOIMESIS AT NICAEA. WATERCOLOUR DRAWING BY N. KLUGE IN 1912

NOTE: For references to the plates omitted here, see above Study I, p. 52.

PLATE 11 (a)

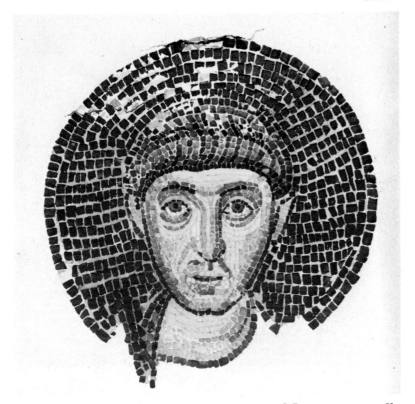

(a) W. S. George, sheet no. 8. Watercolour drawing: head of S. Demetrios in spandrel H.

PLATE 14 (b)

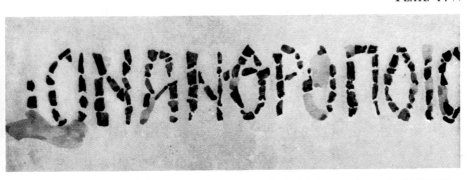

(b) W. S. George, sheet no. 16. Black watercolour tracing: beginning of inscription below the south panel of the north pier at the entrance to the chancel

NOTE: For references to the plates omitted here, see above Study I, p. 52.

I

PLATE 15

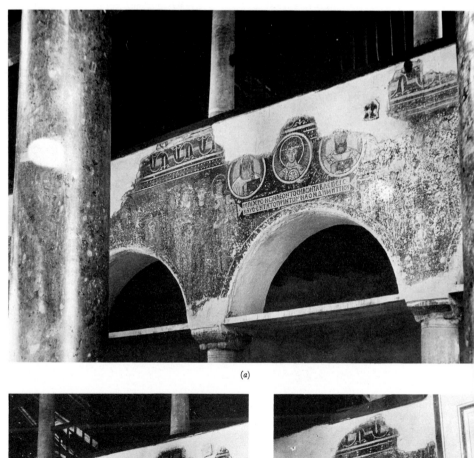

(a)

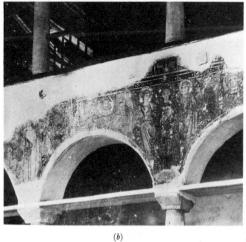

(b)

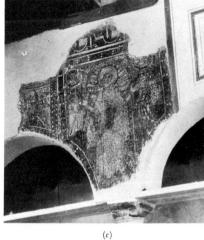

(c)

NORTH INNER AISLE MOSAICS, PHOTOGRAPHED BY W. M. HARVEY: (a) SPANDRELS E AND F
(b) SPANDRELS B AND C (c) SPANDREL H

Plate III a The West Facade

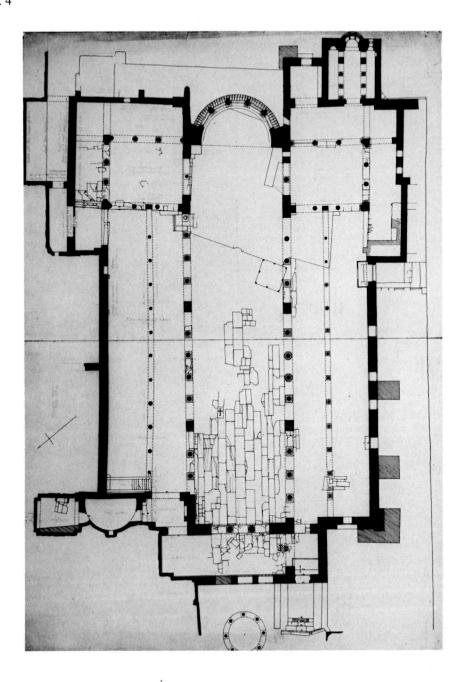

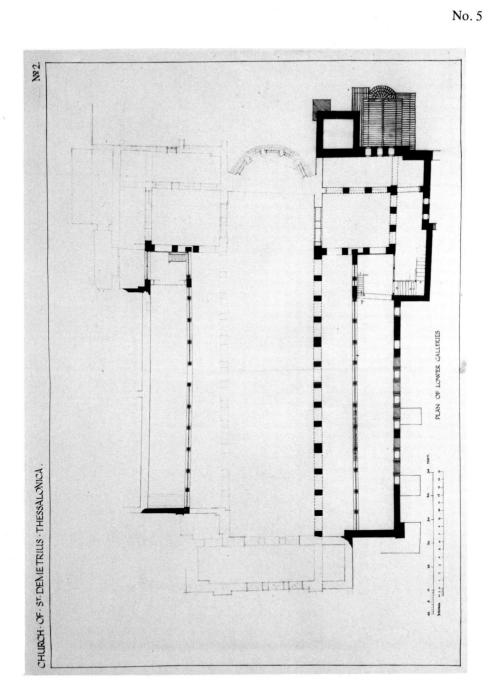

CHURCH·OF·ST·DEMETRIUS·THESSALONICA.

Nº 2.

PLAN OF LOWER GALLERIES

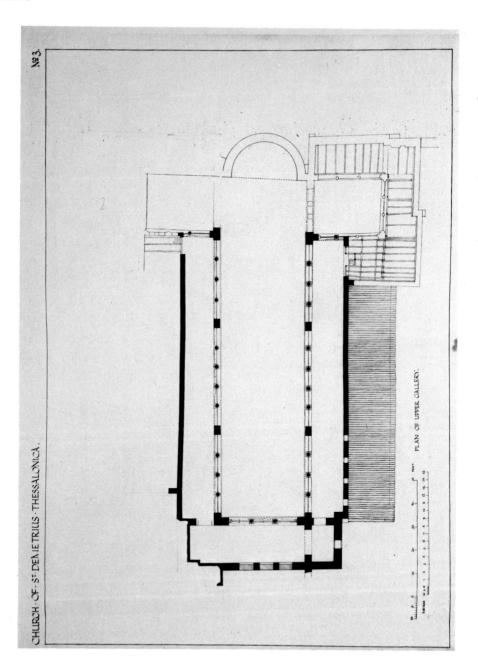

№ 3.

CHURCH · OF · ST · DEMETRIUS · THESSALONICA.

PLAN OF UPPER GALLERY.

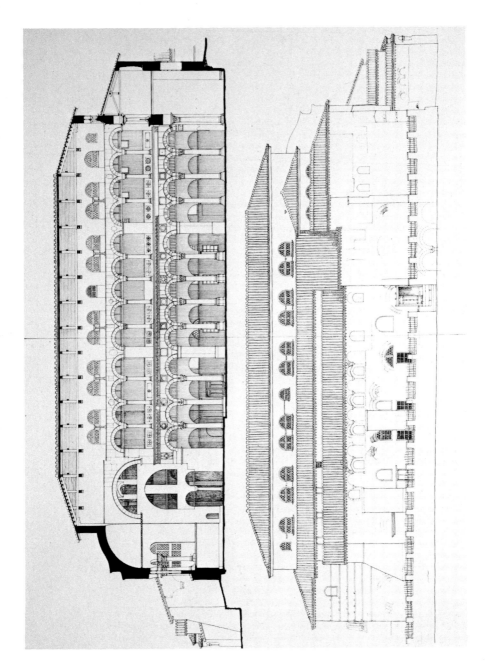

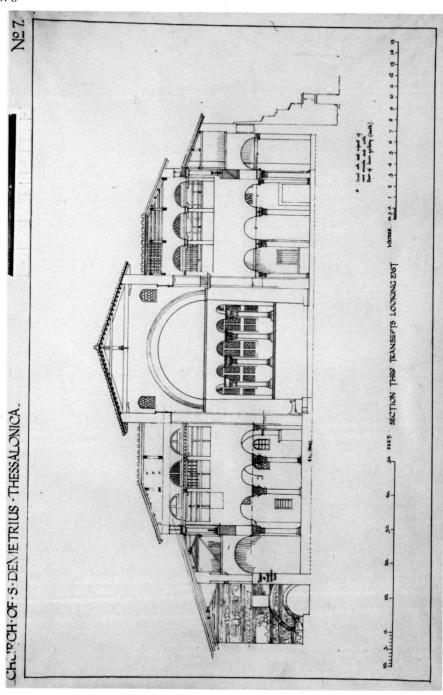

№ 7

CHURCH·OF·S·DEMETRIUS·THESSALONICA.

SECTION THRO TRANSEPTS LOOKING EAST

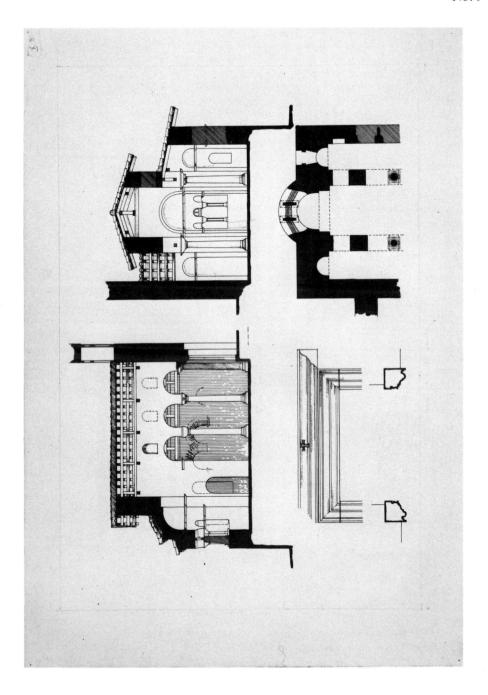

No. 10

No. 11

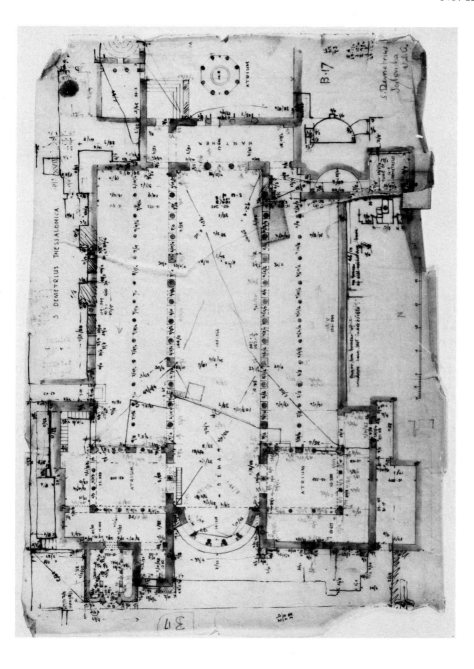

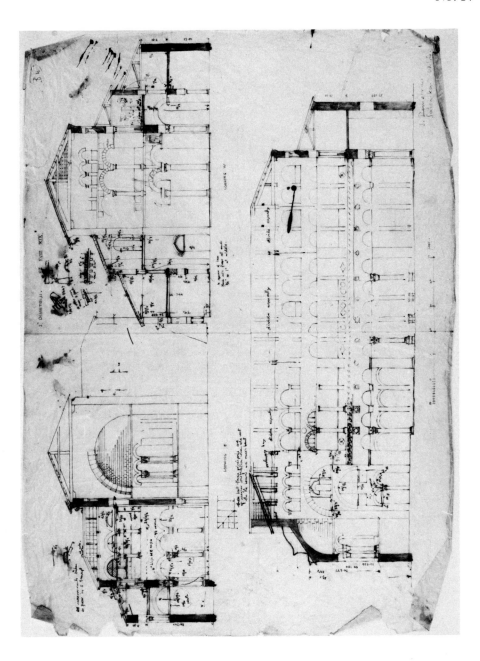

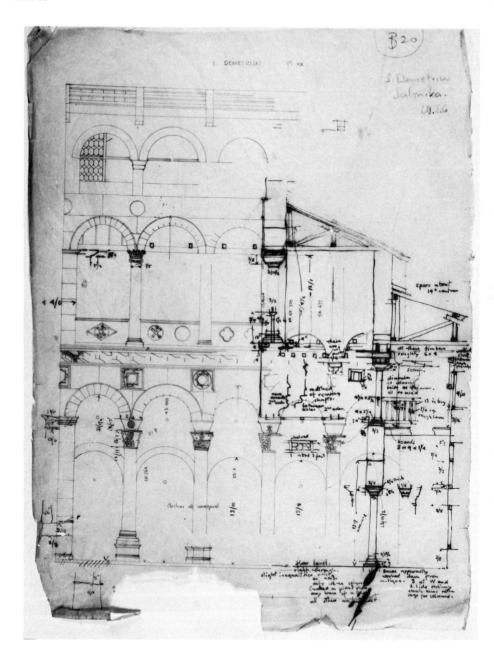

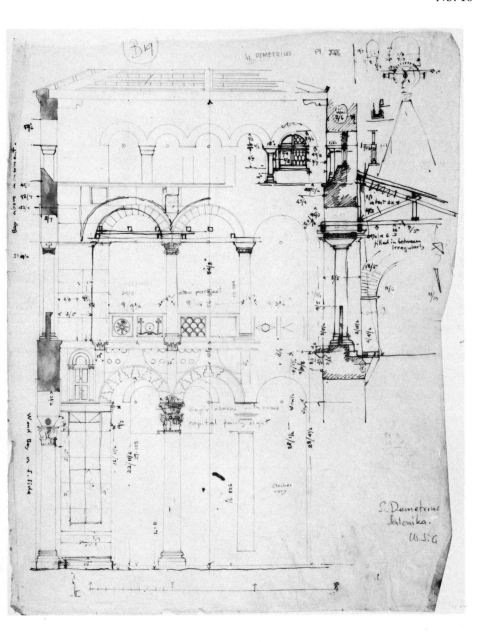

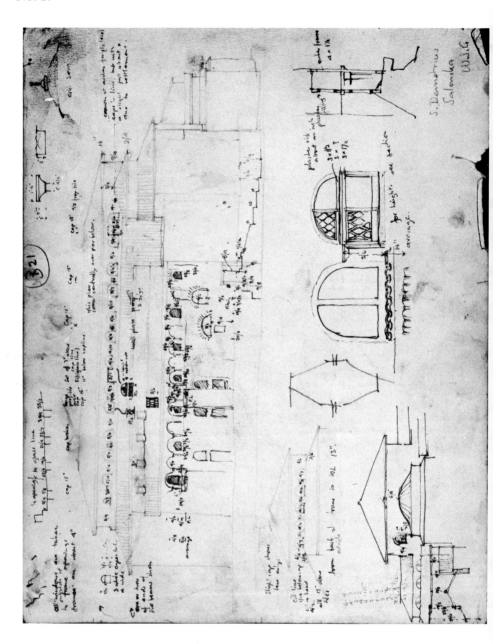

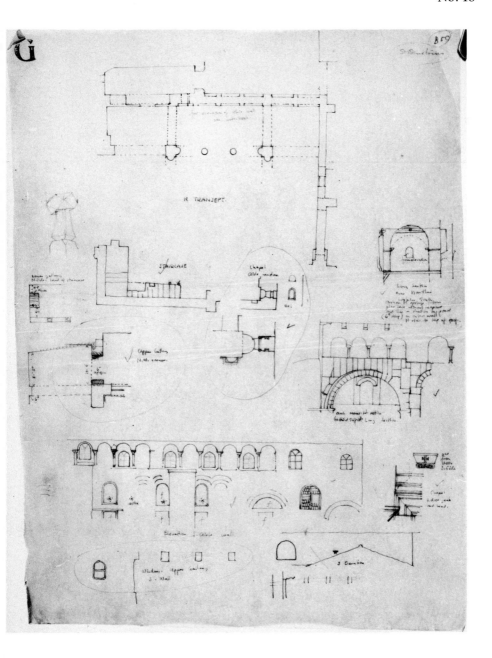

S. DEMETRIUS.

CAP IN NORTH TRANSEPT

The turnover of leaves is a separate piece pinned on.

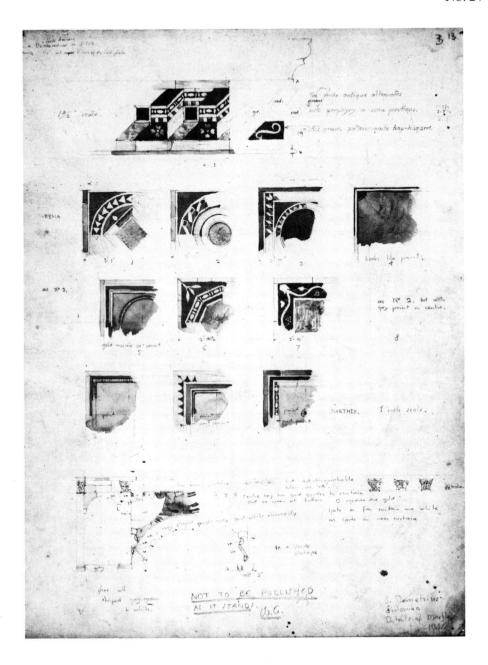

NOT TO BE POLISHED
AS IT STANDS!

No. 25

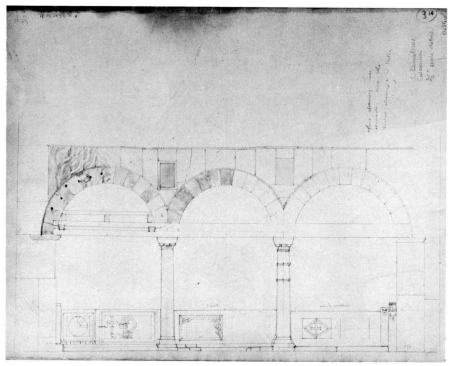

No. 26

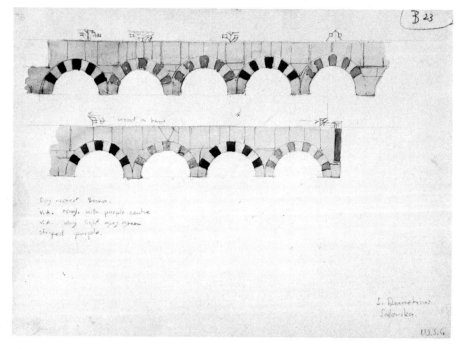

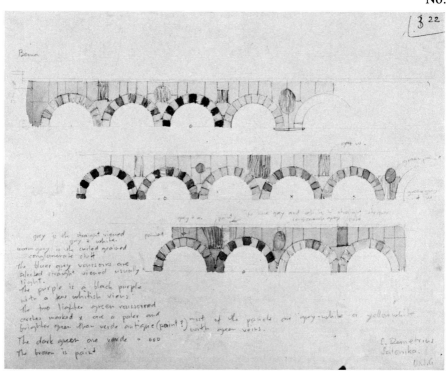

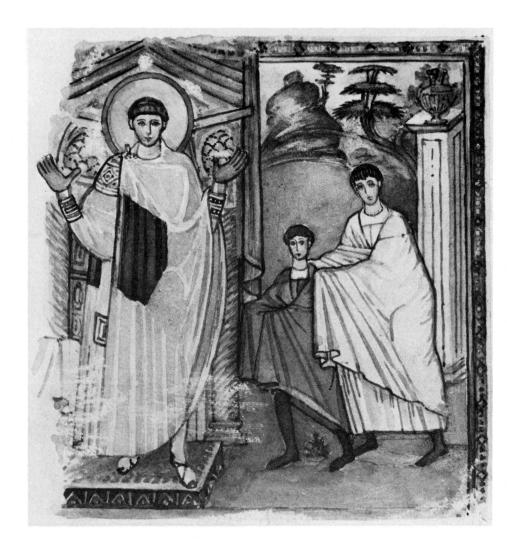

No 1

the full size of
inscription on
relief to No. 30

1 inch scale

No. 31

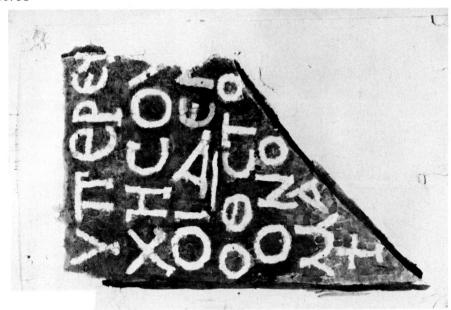

No. 33

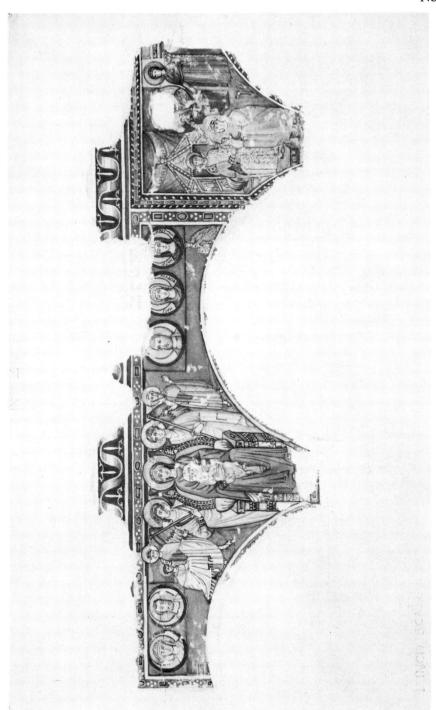

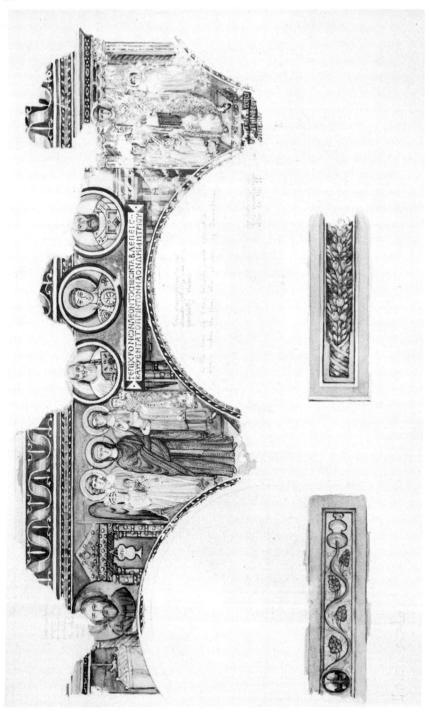

No. 37

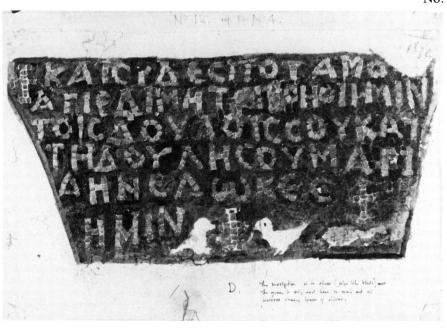

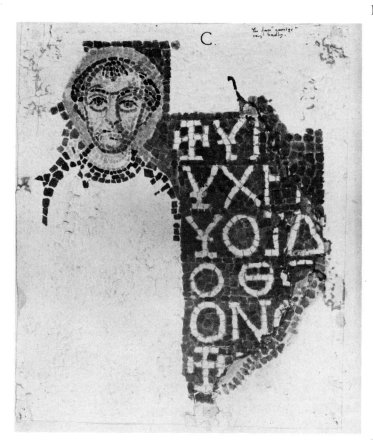

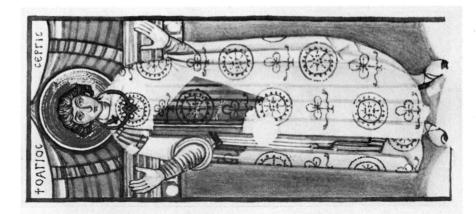

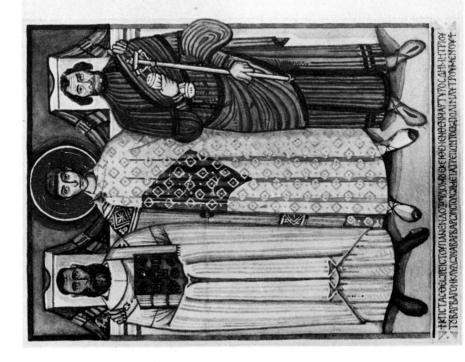

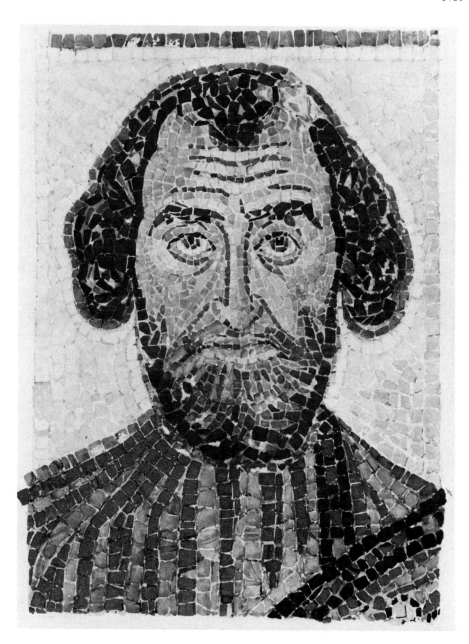

II

No. 42

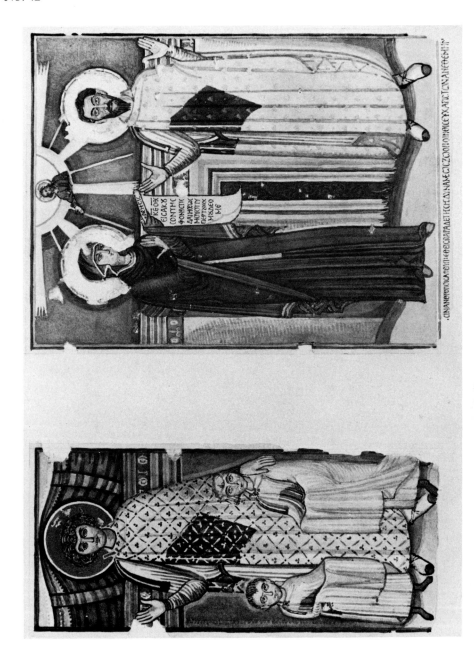

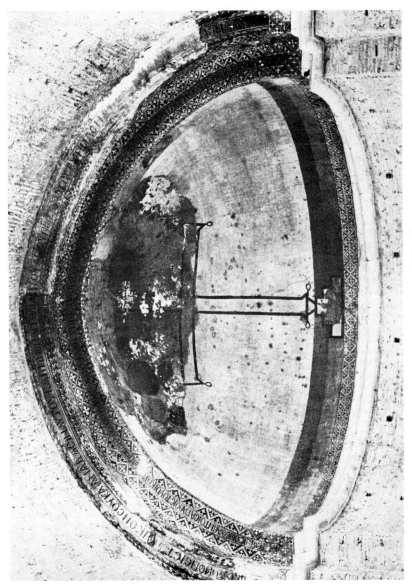

Fig 2. Apse of St. Eirene, Istanbul. Photo: Courtauld Institute.

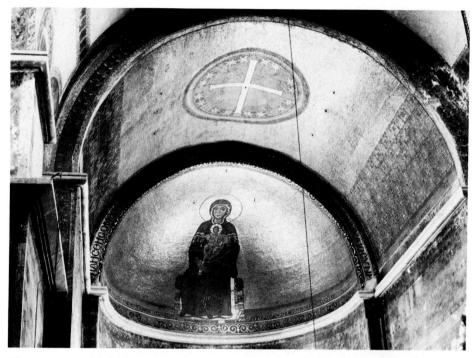

Fig. 4. Apse of St. Sophia, Salonica. Photo: R. Cormack, Courtauld Institute.

Fig. 3. South side of the sanctuary vault of St. Sophia, Salonica.
Photo: Courtauld Institute.

III

Fig. 5. St. Sophia, Salonica, from the north-east, as in 1890. Photo: Courtauld Institute.

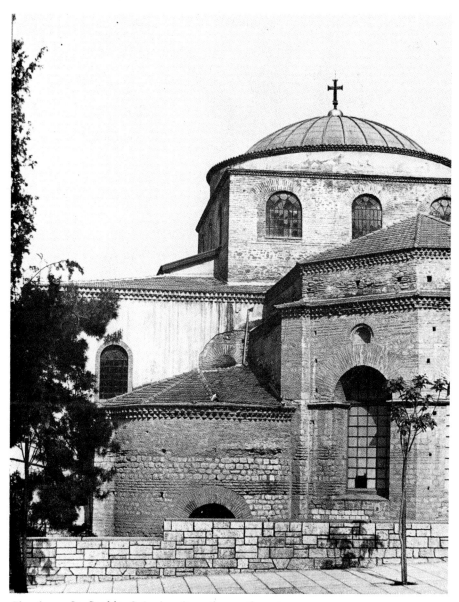

Fig. 6. St. Sophia, Salonica, from the south-east.
 Photo: S. Murray, Courtauld Institute.

Fig. 7. Mosaic crosses in the south tympanum of the rooms over the south-west ramp of St. Sophia, Istanbul. Photo: Courtauld Institute.

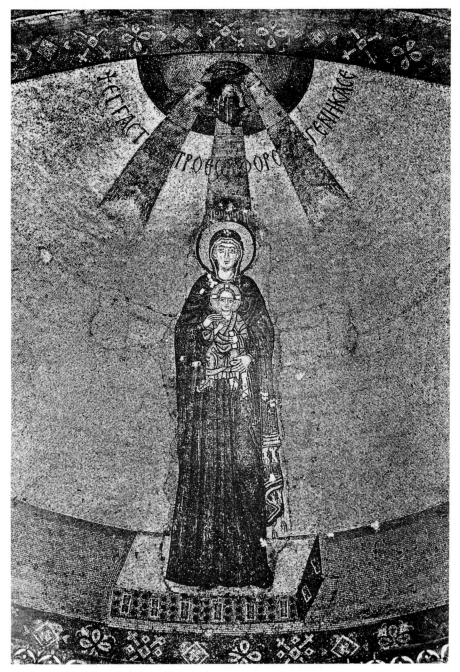

Fig. 28. Apse mosaic in the church of the Koimesis, Nicaea.
 Photo: Courtauld Institute.

Fig. 29.

Fig. 30.

Fig. 29. Fol. 51v, Chludov Psalter, State Historical Museum, Moscow, illustrating the text: "Behold the man who made not God his strength, but trusted in the abundance of his riches, and strengthened himself in his wickedness." Photo: D. Wright, Courtauld Institute.

Fig. 30. Fol. 67r, Chludov Psalter, State Historical Museum, Moscow, illustrating the text: "They gave me also for my meat, and in my thirst, they gave me vinegar to drink." Photo: D. Wright, Courtauld Institute.

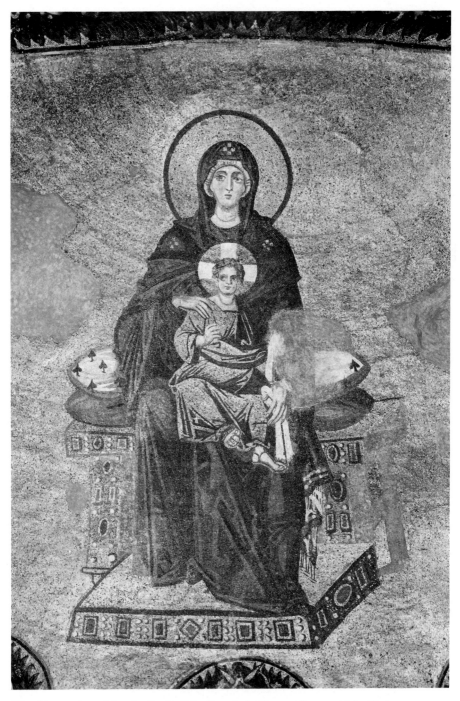

Fig. 31. Apse Mosaic, St. Sophia, Istanbul. Photo: Courtauld Institute.

Fig. 32. Mosaic in the north-east bay of the Room over the south-west
Vestibule of St. Sophia, Istanbul. From left to right: Symeon
Zelotes, Germanos and Nikephoros. Photo: R. Cormack.

Fig. 33. Deesis mosaic above the door leading from the Room over the
south-west Vestibule into the west Gallery of St. Sophia, Istanbul.
Photo: Courtauld Institute.

Fig. 34. Reliquary Box from the Sancta Sanctorum, now in the Museo Cristiano,
Vatican. Lid: Crucifixion. Interior: Christ, Virgin, Angels, Sts. Peter
and Paul. Photo: Alinari.

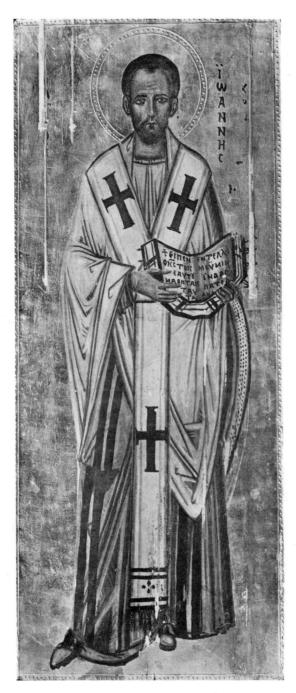

Fig. 35. Reliquary Box from the Sancta Sanctorum. Under-side of Lid:
St. John Chrysostom. Photo: Alinari.

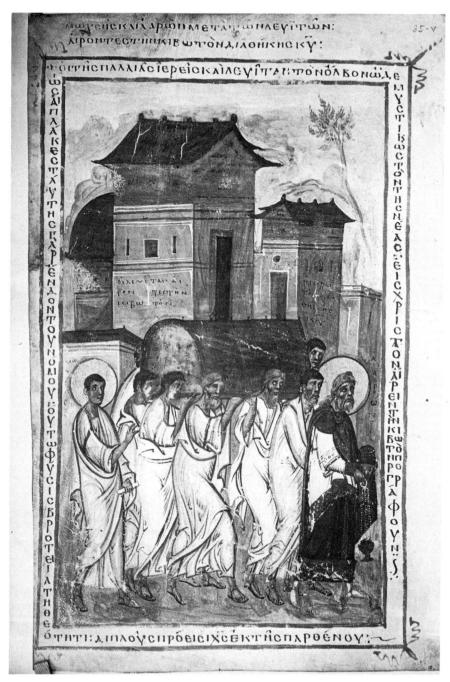

Fig. 36. *Vat. Reg. gr. 1*, the Bible of Leo the Patrikios.
Picture g: The Ark of the Covenant.

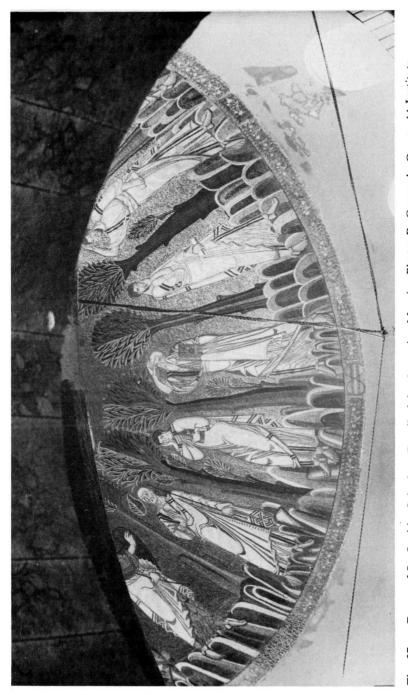

Fig. 37. Dome of St. Sophia, Salonica. Detail of the Ascension Mosaic. Photo: R. Cormack. Courtauld Institute.

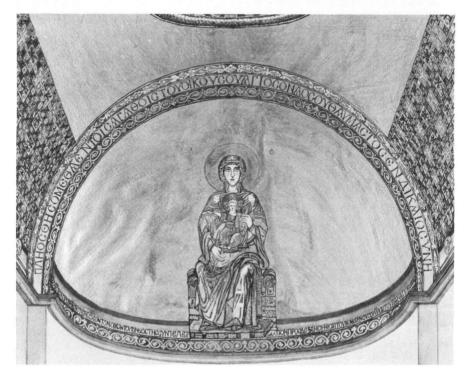

a. Apse of S. Sophia, Thessaloniki. a. Photographed in 1907 (photo. M. le Tourneau).
b. Watercolour by William Harvey in 1908 (British School of Archaeology at Athens).

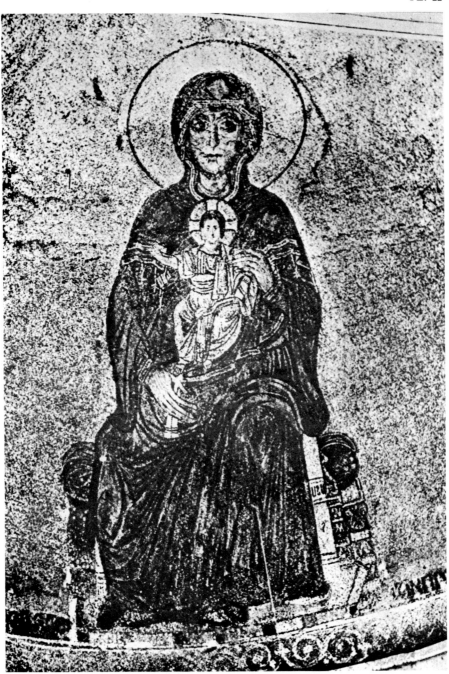

Apse of S. Sophia, Thessaloniki: photographed soon after 1912 (photo. F. Boissonnas).

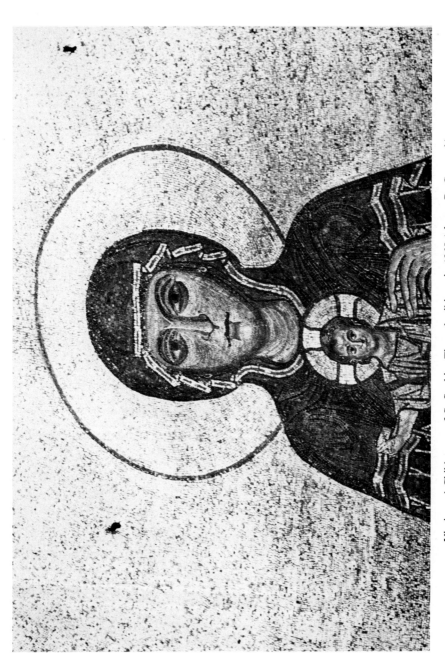

Virgin and Child, apse of S. Sophia, Thessaloniki; as in 1965 (photo. R. Cormack).

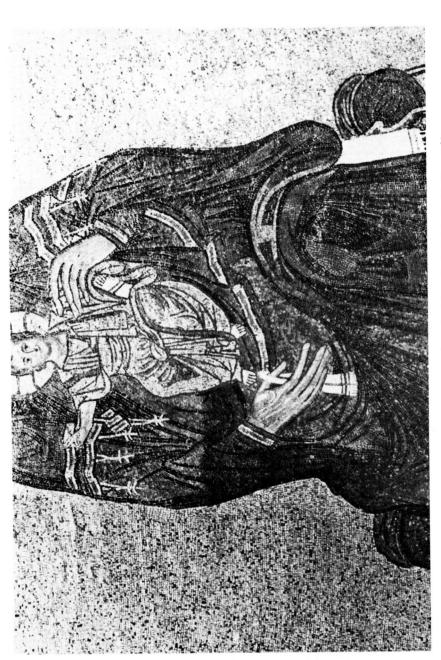

Virgin and Child, apse of S. Sophia, Thessaloniki; as in 1965 (photo. R. Cormack).

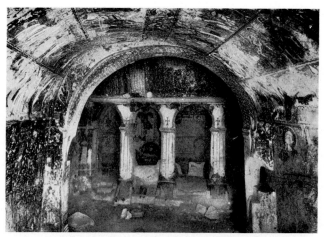

(1) Tokalı kilise: view from the Old Church
looking east into the New Church

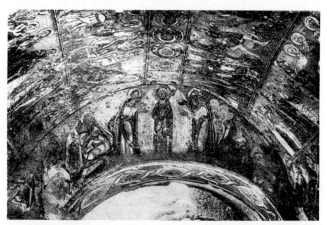

(2) Tokalı kilise: west wall of the Old Church

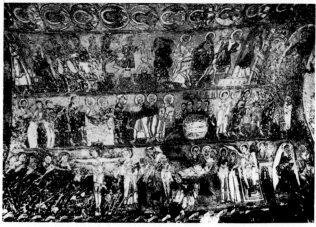

(3) Tokalı kilise: north wall of the Old Church

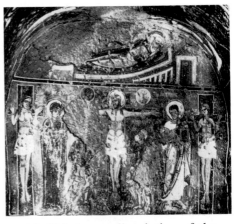

(2) Kılıçlar: wall painting of the
Crucifixion

(1) Detail of folio 30 verso of Paris, Bibl.
Nat. gr. 510

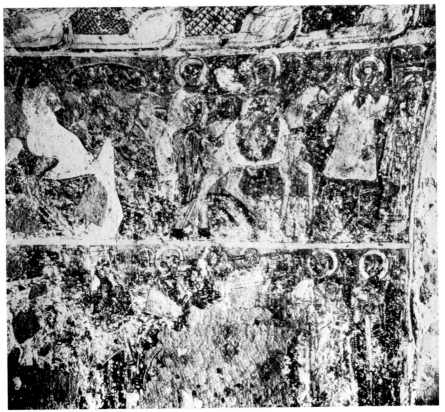

(3) Tavşanlı kilise: detail of north wall

PLATE V

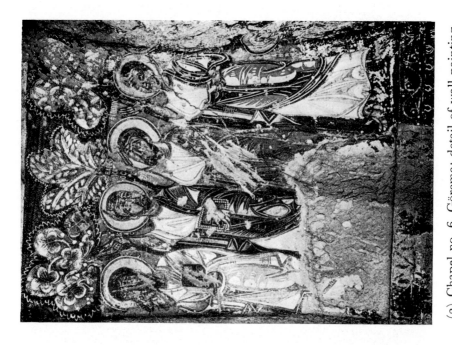

(2) Chapel no. 6, Göreme: detail of wall painting of the Ascension

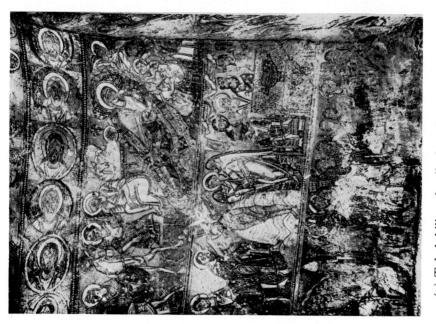

(1) Tokalı kilise: detail of south wall of the Old Church

(1) Çavuş In: east tympanum and barrel vault

(2) Tokalı kilise: wall painting of the Benediction in the New Church

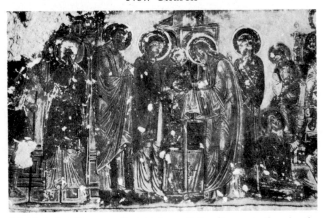

(3) Tokalı kilise: wall painting of the Presentation in the New Church

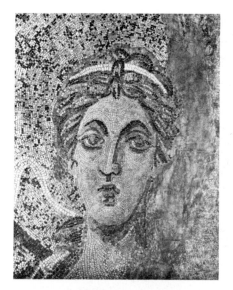

3 Detail of archangel Gabriel, apse 4 Detail of angel, narthex lunette

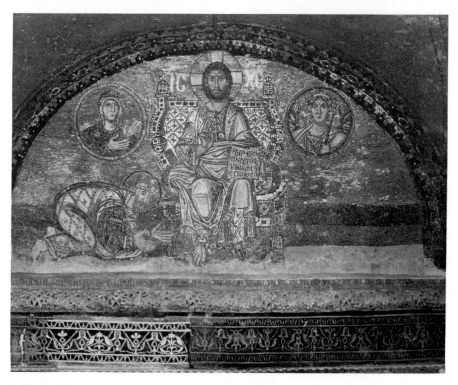

5 Narthex lunette

NOTE: For plates 1 & 2, see above Study IV, figs. 31 & 33.

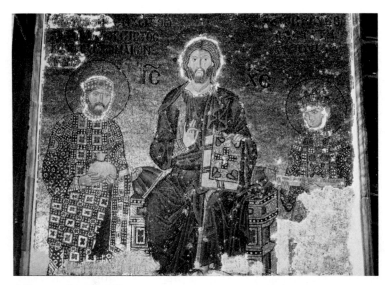

6 Zoe panel, south gallery

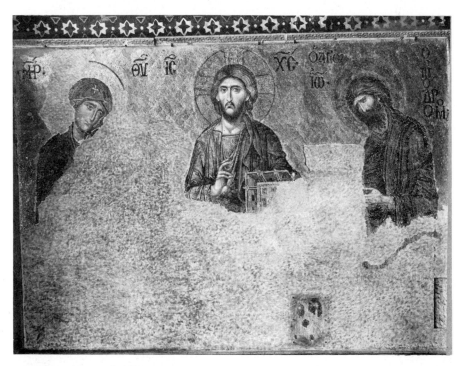

7 Deesis mosaic, south gallery

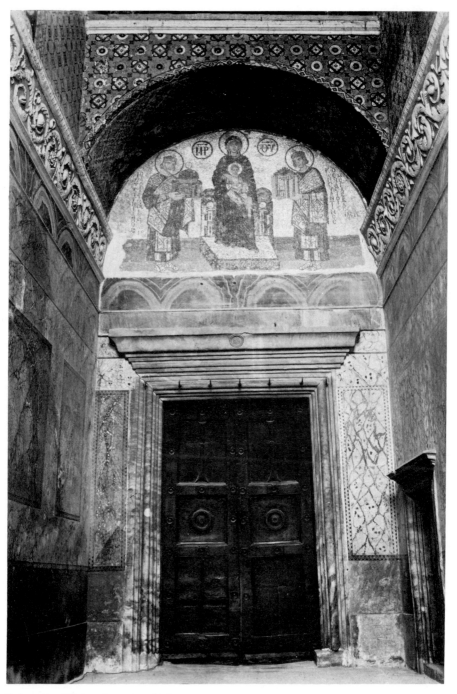

8 Lunette of the south-west vestibule